KU-566-067

The Mystery of
the Bayeux Tapestry

The Mystery of
the Bayeux Tapestry

David J. Bernstein

Weidenfeld and Nicolson
London

To Toni and Gideon

This edition first published 1986 by
George Weidenfeld & Nicolson Ltd
91 Clapham High Street, London SW4 7TA

Copyright © 1986 David J. Bernstein

All rights reserved. No part of this publication
may be reproduced or transmitted in any form or
by any means, electronic or mechanical, including
photocopy, recording or any information storage and
retrieval system, without permission in writing
from John Calmann and King Ltd

ISBN 0 297 78928 7

This book was designed and produced by
John Calmann and King Ltd, London

All photographs of the Bayeux Tapestry
are reproduced by special permission of the town of Bayeux,
to whom the Publishers extend their thanks

Typeset by 🅰 Tek-Art, Croydon
Printed in Singapore by Toppan Ltd

CONTENTS

Preface

'Who would have thought there was anything new to be said about the Bayeux Tapestry?' How often the author has been greeted with this question, sometimes accompanied by a look of incredulity, when he has told librarians and fellow medievalists of his research interests. After all, since the Tapestry is a unique pictorial account of one of the most important events in medieval history, and, indeed, is a precious record of a turning-point in the whole development of western civilization, it has naturally received much attention. With thousands of visitors going to Bayeux each year just to see the Tapestry's depiction of the Norman Conquest of England (now displayed in a dramatic new installation), and with the publication of attractive new books, few people interested in western culture can be unaware of its charms. Of all medieval works of art, perhaps only Mont-Saint-Michel and Chartres so successfully evoke what it was like to live in an age when Europe was ruled by mounted knights and learned clerics, and, more particularly, to live in that era of militant Christianity when bishops might join their princely relations in the thick of battle.

It is therefore reasonable to ask what remains to be discovered that the writers of the 150 publications on the Tapestry have not already revealed.[1] In fact a great deal. Strange to say, although it has been a perennially rich quarry for historians of the Norman Conquest and for people interested in medieval ways of life, the Tapestry has never received careful attention from art historians. The principal reason is its false reputation as a piece of folk art; the colourful figures riding to battle, feasting and building boats or castles, all creations of the embroiderer's needle, mainly eclipse what went before: the inspired and carefully thought-out design. For this design was the work of a master artist, steeped in the most naturalistic narrative pictorial tradition of his day, skilled in the use of subtle irony and as accomplished in the art of politics as he was in the art of war. Rather than being thought of as a charming folk artist, the Tapestry designer should rightly be seen as a master artist who used the artistic language derived from a century of great manuscript illumination to provide a programme for craftsmen who translated it into a spirited, but simply executed embroidery. If ever there was a candidate for reassessment by modern art historical scholarship it is the master artist of the Bayeux Tapestry.

This neglect has had an unfortunate effect on our grasp of the Tapestry's meaning, for without an understanding of the interdependence of its three main visual components – images in the main field, words in the inscriptions, and figures in marginal zones – it is little wonder that parts of the narrative remain baffling. To read the work correctly, both its surface meaning and its deeper significance,

we must see it not in the splendid isolation which results from classifying it as the sole surviving secular wall-hanging depicting military exploits from the early Middle Ages. Rather it should rightly be seen in the context of early medieval drawing and painting, and indeed as the culmination of an extraordinarily rich pictorial tradition known to us primarily through manuscript illuminations. For this reason much of the first part of this book will be concerned with understanding the Bayeux Tapestry's distinctive artistic features within the context of 10th and 11th-century art and the attitudes of that era towards art.

The Tapestry artist was not just working within a particular aesthetic tradition. Called upon to depict the greatest military event of his day, he also had to consider questions of great political delicacy. All the events and individuals involved in the Norman Conquest were controversial. What is the Tapestry's point of view? 'Study the historian before you begin to study the facts' is apposite here: we are naturally concerned with who designed the narrative and who was his patron.[2] Alas, in the case of the Tapestry these are particularly difficult questions to answer because there is not one iota of contemporary documentation. By tracking down clues, however, scholars have been able to make some quite convincing inferences as to who the patron and the artist were. For example, as the reader will see in the first chapters of this book, scholarly opinion now holds that the Tapestry's patron was not William the Conqueror or his queen Matilda, but the Conqueror's half-brother Odo, bishop of Bayeux and sometime viceregent of England. But who was the master artist of the Bayeux Tapestry? Strange as it may seem, scholars are now reasonably certain that this triumphal monument depicting the conquest of England was designed not by a Norman but by an Englishman, and also that it was embroidered not by Normans but by Anglo-Saxons. Curiously, while such a paradoxical situation has been acknowledged to be 'one of the most puzzling in medieval art history', hardly anyone has asked how this most unusual circumstance of the conquered telling the story of their own defeat at the command of the victors affected the way in which the Tapestry recounted the tale of the Conquest.[3] Here indeed is the great mystery of the Bayeux Tapestry.

But how does one solve the puzzle of what difference it made that the Bayeux Tapestry was made in England by Anglo-Saxons? This book will first lay out the evidence for thinking that the Tapestry was designed and embroidered in England for Bishop Odo of Bayeux. It will then argue that the master artist was so familiar with monastic libraries in Canterbury that he was probably a monk, or on very good terms with the monks in one of the two monasteries in that cathedral city. That clue about the master artist's identity will in turn lead us to ask questions about the time and place when the Tapestry was apparently created: specifically, what it was like to be an English monastic artist living in Canterbury in the first years after the Normans had established control over the church there.

With this analysis of the master designer's artistic language and probable milieu in mind we will then turn, in Parts Two and Three, to decoding some of the Tapestry's more puzzling narrative scenes and marginal images. While attention has traditionally emphasized where the Tapestry corroborates contemporary texts, and may possibly borrow from them, our approach will focus as well on why the

8

Tapestry's narrative of the Conquest diverges in so many details from accounts written by contemporary Norman authors. Can such divergences be accounted for by clues in English texts? And what about some of those delightful and constantly varying border figures derived from classical mythology or Aesopic fables which have given rise to wildly diverse explanations?

As we shall see, while some of the puzzling iconography is explicable by comparing it with accounts in contemporary historical writings, particularly some from the English side of the Channel, not all the work's most memorable imagery can be so explained. Such discrepancies naturally raise the possibility that the artist, not attempting to be literally faithful to the history of the Conquest, deliberately invented motifs and incidents, much in the manner of those ancient and medieval historians who invented speeches for the characters in their narratives. If artistic licence is indeed at work, can we detect, in the absence of contemporary documentation about the genesis of the Tapestry, the rationale behind his choice of such uncorroborated details as the blinding of the English king by an arrow at the Battle of Hastings? Is each anomalous detail a curiosity that must forever remain mysterious or is there one plausible explanation that will account for most of them? This author believes there is one explanation and that it is found in materials that have never been related to the Tapestry before, the Hebrew Scriptures. However, to read the mysterious images in the Tapestry is one thing, to understand the reasons for their selection is another. At this point one naturally comes back to our initial paradox: that the Bayeux Tapestry was apparently designed not by a Norman but by an English monastic artist.

Art, history and ideas – these are the subjects of this book. None can be understood separately from the others and all are the creation of men and women living in a particular time and place. To investigate a work of art is also to investigate the lives, attitudes and assumptions of human beings. To keep the history of people in mind, as well as the details of a material object, has been a constant goal. One particular method deserves a word of explanation. To try to understand the purposes behind choices made in an embroidery approximately 900 years old the author has naturally been led to occasional conjecture and hypothesis. If the book loses a certain 'scientific' aura by such conjecture, please note that at each step the author has taken into account specific medieval, especially Anglo-Saxon and Norman, forms of thought. In addition, perhaps the reader will recall the words of a great medievalist. In speaking of 11th-century art, Marc Bloch noted that the visual images in the feudal age were 'very often the refuge, as it were, of certain values which could not find expression elsewhere'.[4]

* * *

This work was begun a number of years ago in circumstances which may explain some of its distinctive features. Having completed my doctorate in European history I had the rare opportunity to study another field – medieval art history – with a master teacher and scholar. In 1972-73, thanks to the generosity of Meyer Schapiro, I began post-graduate study, at Columbia University, of early Christian art, Hiberno-Saxon manuscript illumination and Romanesque sculpture. In one of Schapiro's seminars on the formal qualities of such manuscripts as the

Lindisfarne Gospels and the *Book of Kells*, I undertook an exploration of later works of medieval art which seemed to share some of the formal qualities of these great 7th and 8th-century innovative masterpieces, particularly in such matters as relations between words and images, borders and main fields. One such later work was the Bayeux Tapestry. From a formal point of view I noted many visual cross-currents which made the work more complicated and intriguing than generally thought. For example, rather than finding much of the border imagery 'purely decorative', it appeared that these lively heraldic beasts, animals from fables and humans engaged in pastoral scenes or sexual activities, were designed in connection with the main scenes. If, for instance, one experimented by altering the position or design of particular border scenes, disturbances resulted which were out of keeping with the character of the work. Thus, ironically, this historian's first serious encounter with the Bayeux Tapestry was not iconographic but formal and stylistic.

Inspired by Schapiro's methods of combining analysis of style and meaning, while continually asking why an artist in a particular time and place did what he did, I later turned to the fascinating problems of where the Tapestry was created and how its narrative compared with other contemporary accounts of the Norman Conquest.[5] No one who has not undertaken such investigations can possibly be aware of how much of a debt we owe previous scholars. While I trust that my gratitude to the many excellent publications by medievalists who have written on art, history and ideas is reflected in the endnotes, there is one art historian who deserves a special mention. In his chapter on 'Style and Design' in the still fundamental study of the Tapestry edited by Sir Frank Stenton and published in 1957, the late Francis Wormald published the first evidence to suggest that the master artist of the Tapestry was familiar with illuminated manuscripts in Canterbury. The central question of this book – the possible implications of an English origin for an explanation of the Tapestry's account of history – would not have been posed had it not been for Wormald's pioneering use of visual evidence.

I have had the good fortune to examine the front of the Tapestry on two occasions and, by a stroke of luck and timely assistance, I have also examined the back of the work in the company of a team of textile experts while they were completing their scientific analysis in the winter of 1982-83. Thanks are owed to the head of this team, M. Macé de Lépinay, its members, Véronique Monier, Béatrice Girault, Isabelle Bédat, Marie-Madeleine Massé and especially Naomi Moore, who assisted the author in countless ways to find out what the Tapestry really looks like and how what we see today might differ from what was originally embroidered. It is hoped that the team's efforts, the first scientific study ever performed on the Tapestry, will soon be published by the Monuments Historiques of the French Ministry of Culture. A special debt of gratitude is owed to the Bayeux authorities for their assistance: Jean Le Carpentier, Mayor of Bayeux, Liliane Bouillon, Directrice de la Tapisserie, and Michèle Cohïc, Conservatrice de la Tapisserie.

Without the financial help of a number of very generous institutions this project could never have been completed. Foremost comes the National Endowment for the Humanities which at the initial stage provided seed money for me to undertake

formal studies in medieval art history, and then eleven years later most generously came to my assistance when it was time to harvest results. Another source of aid deserves special notice. With great wisdom and imagination the Andrew Mellon Foundation has aided teachers of the humanities in American colleges. In my case this meant two things: a brief respite from teaching to do research at a crucial moment, and an opportunity to participate in the very stimulating initial seminar for teachers in the humanities, held in 1984-85 at New York University, under the skilful guidance of Norman Cantor. Ideas were clarified and challenged by the guest speakers and fellow medievalists in that gathering. For travel money to examine the rear of the Tapestry I am grateful to the American Philosophical Association, and for assistance to present a paper at the Battle Conference on Anglo-Norman Studies, a most valuable and congenial scholarly meeting held annually under the direction of Allen Brown, I am thankful to the American Council of Learned Societies.

It is a great pleasure to acknowledge the personal assistance of a great many people in the course of this project. Without their generosity of time, learning and spirit the author's research would have been much more difficult. It would also have been a lot less fun. My thanks to J.J.G. Alexander, Maylis Baylé, Giselle Barrau-Freeman, David Bates, Simone Bertrand, former curator of the Tapestry, Michel de Boüard, Richard Brilliant, Herbert Broderick, R. Allen Brown, Walter Cahn, David and Jill Castriotta, William Clark, Rabbi Shaye Cohen, Giles Constable, Margarita Cuyás, Mme Flury-Lemberg, Joseph Forte, Stephen Gardner, Marie-Madeleine Gauthier, Joel Herschman, Nabuko Kajitani, Renee Kent, Ann Lauinger, Ralph Lieberman, Roberte Lipscombe, Dr Barnett Miller, Michael Paull, Rabbi James Perman, Francis Randall, Brigitte Bedos Rezak, Samuel Seigle, Adrienne Shirley, Pat Singer, Robert Tannenbaum, Ilya Wachs, John Williams, Paula Zieselman and Alice Zrebiec. A deep gratitude is felt towards many colleagues at Sarah Lawrence College for their continual enthusiasm and support. I am also grateful to Professor Norman Cantor and Professor George Zarnecki for reading the manuscript and offering valuable suggestions. All errors remain, however, the responsibility of the author. A special thanks to my wife Toni for her support and wise advice on the whole work in its many stages of development. Lastly, I wish to express my debt to three people who in countless ways shaped the creation of this book: Laurence King, David Eccles, and my editor, Paula Iley.

December, 1985

Note on the Photographs and Condition of the Tapestry

The Tapestry is reproduced in full at the back of the book, and plate references to it in the text are given in Roman numerals. Readers may have seen in recent publications that it was said to have been cleaned and restored in 1982-83. Technically one might say that it was cleaned, though it should be understood that this did not involve washing or use of chemicals; it was gently dusted, after careful preparations, with a vacuum cleaner. As for restoration, only strengthening of existing stitches and fabric was undertaken.

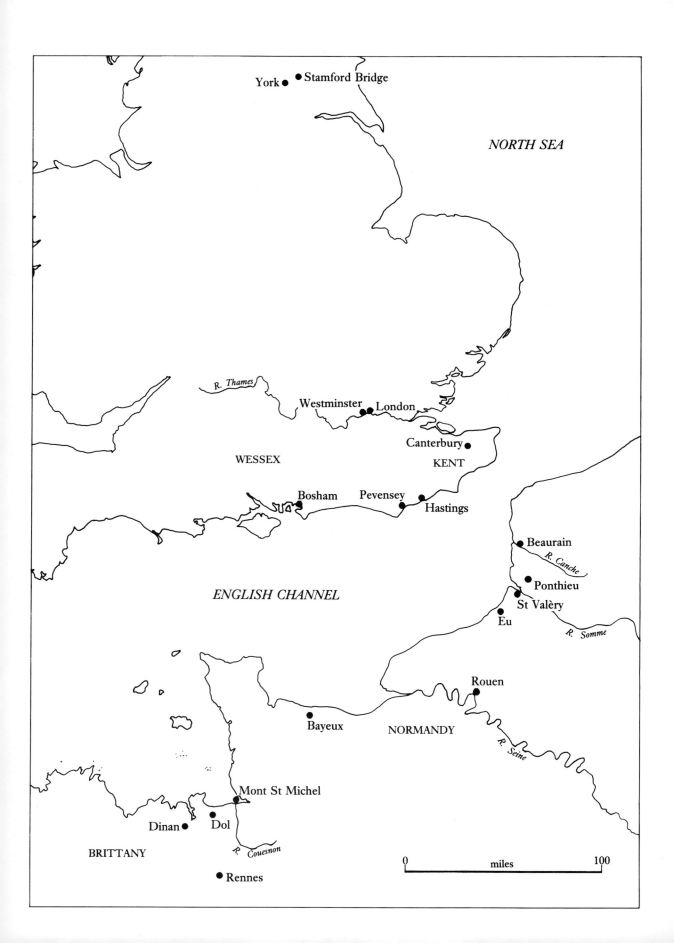

York ● ● Stamford Bridge

NORTH SEA

R. Thames

Westminster ● London

Canterbury ●

WESSEX

KENT

Bosham ● Pevensey ● Hastings ●

Beaurain ●

R. Canche

Ponthieu ●

St Valèry ●

ENGLISH CHANNEL

Eu ●

R. Somme

Rouen ●

Bayeux ●

NORMANDY

R. Seine

Mont St Michel ●

Dinan ● Dol ●

BRITTANY

R. Couesnon

Rennes ●

0 miles 100

CHRONOLOGY

*c.*1003	Birth of Edward the Confessor
*c.*1028	Birth of William the Conqueror
1015-42	Edward exiled to Normandy
1035	Death of Canute, accession of Harold 'Harefoot' as regent, subsequently king of England; death of Duke Robert I, accession of William as duke of Normandy
1036	Murder of the prince Alfred (brother of Edward the Confessor)
1042	Accession of Edward the Confessor as king of England
1045	Marriage of Edward the Confessor to Edith, daughter of Earl Godwin of Wessex
1051	Unsuccessful rebellion of Earl Godwin against Edward the Confessor; Godwin and his sons (including Harold, brother to Edith and to become king of England in 1066) sent into exile. Probably about this time, William (cousin to Edward) is promised the succession to the throne of England
1052	Return to England of Earl Godwin and sons. As a result, many Normans are expelled from England, including Robert, archbishop of Canterbury; the Godwins' nominee Stigand is given the archbishopric
1053	Death of Godwin; Harold Godwinson succeeds him as earl of Wessex
?1064	Harold's trip to Normandy, reportedly to make arrangements for William's succession to the English throne; he is seized by Guy of Beaurain and rescued by William; William attacks Conan, a rebellious vassal, with Harold's help, in Brittany; Harold swears oath of fealty to William
1066	*5 January*: Death of Edward the Confessor and reported nomination of Harold as his successor. *6 January*: Coronation of Harold Godwinson. *Spring*: Norman mission to Rome seeking papal support for William's claim; Halley's comet over Europe. *September*: William's fleet assembles in the Dives. *September*: William's fleet at St-Valèry-sur-Somme, awaiting favourable winds. *September*: Invasion of northern England by another claimant to the throne, Harold Hardrada, king of Norway, supported by Tostig Godwinson. *25 September*: Battle of Stamford Bridge at which King Harold defeats the Viking forces. *28 September*: William lands at Pevensey. *29 September*: William occupies Hastings. *6 October*: King Harold returns to London. *14 October*: Battle of Hastings: the defeat of the English by William's forces. *21 October*: Submission of Dover. *29 October*: Submission of Canterbury. *November*: William in the neighbourhood of Canterbury. *25 December*: Coronation of William as king of England, in London
1067	*c. March-6 December*: Odo, bishop of Bayeux and earl of Kent, acts as viceregent
1070	*January-March*: William's 'harrying of the north', subduing the northern leaders; deposition of Stigand; Lanfranc becomes archbishop of Canterbury
?1070s/'80s	Creation of the Bayeux Tapestry
1082	Imprisonment of Odo by William, possibly for designs on the papacy or for military plans to support the pope
1086	Domesday survey
1087	Unsuccessful rebellion of Odo against the Conqueror's son William Rufus, king of England; Odo's English lands are seized and he is banished from the kingdom
1087-96	Odo goes to Normandy
1097	Odo dies in Palermo on the way to Jerusalem and the First Crusade

Introduction
to the Bayeux Tapestry and the
Norman Conquest of England

Created within a generation of the Battle of Hastings, the famous wall-hanging known as the Bayeux Tapestry is one of the most precious objects to have survived from the early Middle Ages. Its fame rests on three features: it is the sole textile hanging depicting a contemporary historical subject to survive from a period when, as we know from literary evidence, such hangings were quite common in royal and aristocratic circles; second, the particular events and persons depicted are among the most historically significant for the whole development of European civilization; third, no work of art from the early Middle Ages is so well known and so obviously enchanting to people of all ages and backgrounds, children as well as adults, medieval scholars as well as the educated public. Many seem to find in both its subject matter and style an apparently irresistible mixture of *naïveté* and sophistication, seriousness and levity, openness and mystery.

Called 'The *Bayeux* Tapestry' because it has almost always resided in the Norman town of Bayeux since its existence was first recorded in 1476, the work was for a long time also thought to have been made there at dates that varied, according to the speculations of a host of writers, from the late 11th to the early 13th century, though, as we shall see, there is now virtual agreement among scholars on both sides of the Channel that in fact it was made in England within a generation of 1066.

Also, although it is probably the best known 'tapestry' in the world, the work is, of course, not a real tapestry at all but an embroidery since the figures are worked in woollen thread with a needle on to a background of linen rather than being woven with a loom. The Bayeux hanging is thus unlike such later medieval works as the Angers and Unicorn Tapestries in technique and in shape, for if these were designed to cover large panels of wall, the embroidery at Bayeux is more in the nature of a frieze, being, in its present state, approximately 230 feet (70 metres) long but only 20 inches (50 centimetres) high.[1] The Parthenon Frieze (from the Elgin Marbles in the British Museum) and the depiction of the Dacian Wars on Trajan's Column, if these last could be 'unrolled', are the closest comparable continuous narrative in a frieze format still extant from early times, though there is naturally a great difference between embroidery and relief sculpture.

The images are embroidered on coarse linen that is stained and repaired in some places. Eight colours of woollen thread can be distinguished: red, yellow or buff, grey, two shades of green, one bright and the other dark, and three shades of blue. Despite exposure to the light and dirt of nine centuries, the colours are remarkably fresh and vibrant.[2] Two techniques of embroidery are employed, outline or stem stitch for single lines, and laid and couched work for giving colour

and texture to larger spaces in an economical manner. The eight different colours and the embroidery techniques sometimes appear to give a naturalistic impression, though usually this is not in fact the case, for within a scene each hoof of a horse might be a different colour and one man's hair might be green, another's blue, and, as we move along viewing different phases of one action, the same man or horse might reappear in quite different colours.[3]

Who designed the scenes; were the designs done first on parchment and then transferred to the linen; how many people embroidered this enormous project? These are questions for which no answers can be given. Perhaps the scientific analyses performed in the winter of 1982-83 under the direction of the Monuments Historiques, the French governmental agency responsible for the care of France's great artistic heritage, will provide important new data. What seems most probable, given both the unity of the work and minor stylistic differences, is that there was one master designer of the whole programme and perhaps others who assisted in the cartoon, and that the embroidering was done in different workshops.[4] It seems likely for reasons that will become apparent later that the master designer, whom we might call 'the artist', was a male. It is also likely, considering what we know of other embroideries from the Anglo-Saxon world, that the stitching was done by women, either lay or clerical.[5]

Three other aspects of the Tapestry's physical appearance deserve comment. What seems to be a single long strip of linen, is, in fact, made up of eight different pieces of uneven length.[6] Difficult to discern because the embroidery threads deftly go over the seams where two pieces of linen are joined, as in Plate XXX between the words *Et* and *hic*, this segmented construction implies the possibility, at least, of different workshops embroidering simultaneously.[7] A second point is that the Tapestry has been fastened since perhaps the 18th century to another, stronger cloth made of wool, which has the dual advantage of facilitating its exhibition and preventing wear and tear. Alas it also has the disadvantage of making it impossible under ordinary circumstances to examine the back of the work. Since the mid-19th century it seems that only once has the backing been removed, this being in the winter of 1982-83 when the Tapestry was readied for scientific analysis.[8]

A third, and crucial point about the appearance of the Tapestry is that what we see today is not always original embroidery. In the course of 900 years it is understandable that threads have not only faded but actually worn away. Most noticeably is this the case at the end of the work, for after the death of Harold and the flight of his followers the Tapestry breaks off, leaving us to puzzle how much more, if anything, there was and what it depicted. In the last century restorations were undertaken, primarily on sections at the beginning and the end. In a few instances minor additional motifs have been introduced, for instance in Plate XXVII one of the workmen dragging the invasion ships to the shore appears to have freckles, a most unusual detail in medieval art that is in fact accounted for by the later insertion of a piece of lace, no doubt of the sort for which modern Bayeux is justly famous. In most cases, however, the restorers followed the old needle holes still visible in the linen backing, and it is generally agreed that the

majority of the restorations are reasonably faithful to the original design. Not all the restorations, however, have been greeted with applause or an indulgent smile.[9] The most controversial case, that which concerns the depiction of the English king's death at the Battle of Hastings, will be of particular concern to us soon.

In approaching the Tapestry one cannot but be awed by the size and richness of the work: the action is divided into approximately 75 different scenes, composed of a staggering number of figures, 623 persons, only a half dozen of whom, alas, are women, 202 horses and mules, 55 dogs, 505 other animals, 37 buildings, 41 ships and boats, 49 trees.[10] Yet, despite the profusion of imagery and the absence of clear divisions in the form of framing lines between scenes, it is none the less possible to envisage the action as a drama in two acts each containing shifts in scene for narrative purposes. What, in brief, is the story told by the Tapestry?

A PLAY IN TWO ACTS

Prologue: political background

While the Tapestry is always called a depiction of the Norman Conquest, in fact little more than half the work is concerned directly with the military invasion of England; the rest deals with political events in the years before Duke William of Normandy made good his claim to the English throne. The action is set in 1064-66 and turns on the great political question of the day: who is to succeed Edward the Confessor, the aged Anglo-Saxon king reputed for a benign manner and an asceticism which will earn him sainthood and bequeath to his countrymen the evils of a disputed succession.

Since it is obvious that the king will die childless, there are four possible contenders for his throne:

1. An English lad named Edgar the Ætheling, who, as the sole surviving prince of the royal house of Wessex, has the best hereditary claim from old English stock, but no party or power. As it turns out his rights will be passed over at Edward's death.

2. The famous Norse warrior Harold Hardrada, king of Norway, who claims the rule over England which had formerly belonged to his predecessor King Canute, the gifted ruler of Denmark and England. Harold Hardrada's military reputation, extending from Byzantium, in whose service he defeated the Muslims many times in Africa, to the fjords of Norway, makes it most unlikely that he will sit by idly when Edward dies.

3. The third candidate, an English earl named Harold Godwinson, has no royal blood, but he does have a tenuous connection with the throne because his sister Edith is Edward the Confessor's queen. Indeed Harold's family has been the most powerful factor in English politics ever since the Confessor took the throne in 1042. When Edward arrived in England to pick up the crown after his twenty-five year exile spent in Normandy, he showed such preference for things French that it has been remarked that the Norman Conquest of England, although consummated on the field of Hastings in 1066, in fact had its beginning in 1042.[11] To counter the influence of Norman favourites at court the leading English magnate, Earl

Godwin of Wessex, engineered a marriage of his daughter Edith with the new king, and placed his sons in several of the great earldoms.

Although the ascendancy of the Godwins was temporarily cut short in 1051 when Edward felt strong enough to exile the Godwin clan, they returned within a year and overawed the weak king, compelling him to send home most of his Norman favourites. Among these was Robert of Jumièges, archbishop of Canterbury, who was forced to abandon his see in favour of a singularly undistinguished nominee named Stigand put forward by the Godwins. Stigand was to prove a great liability to Harold Godwinson in 1066, for a newly revitalized papacy, unwilling to accept the infringement of power involved in the appointment of a new archbishop before the old one was dead, threw its support to William in the hope that he would remove the uncanonical Stigand and reform the English church along lines acceptable to the papacy.

With the triumphant return of the Godwins in 1052, Edward was a virtual figurehead, and, after Earl Godwin's death a year later, his son Harold became earl of Wessex and the wealthiest, most powerful subject in the kingdom. Educated to be a soldier and ruler, Harold was thought to be wise in the ways of the world, calculating, shrewd and ambitious. Indeed, the steady rise of the earl of Wessex to supremacy in King Edward's court after 1053 is 'the single most important fact in the political history of England' during the years before the Conquest, for it will enable him to be recognized as king when the childless monarch dies.[12]

At the moment of Edward's death Harold's claim to the throne will be based on two points: that Edward designated him as heir on his deathbed, and that on the day after the king's death, the Witan, the council of powerful men in the kingdom, chose him as king. Since no candidate had a strong claim by heredity, Harold's position as the last designated heir of King Edward, and his election by the chief Anglo-Saxon council will give him an exceptionally strong claim.

4. Across the Channel is the formidable William, duke of Normandy, an able general and a creative ruler. The bastard son (born *c*.1027) of Robert the Devil, duke of Normandy, and Arlette, the daughter of a tanner of Falaise, William has so regularly been called a bastard, especially by other claimants to the county of Normandy, that it has almost become a surname, only to be displaced by his more usual one after 1066. When his father died on a pilgrimage to Jerusalem, after having made the Norman barons accept his illegitimate son as the duke-elect, William was a mere boy of eight, and during the terrible anarchy which followed three of his guardians were murdered, while he was kept for a time in strict concealment lest the same fate befall him. Trained in a hard school, he showed a precocious talent for war, asserting his authority by gaining a victory over Norman rebels at Val-ès-Dunes when he was twenty years old.

He also showed great skill at governing a people notoriously difficult to rule. Ever since the Northmen had been established in northern France (911), and gave up their Viking ways to accept Christianity, French language and culture and the political and military organization of French feudalism, a fierce spirit of baronial independence, manifested in castles and private warfare, sapped the strength of

centralized (or ducal) authority. Many of William's efforts before 1066 were directed at eliminating private warfare and subordinating the Norman nobility to his ducal administration.

He was extraordinarily successful in all that he compassed. Completely illiterate, he learned to succeed in a society marked by intrigue and deceit. He was accustomed to using guile to gain his ends, and, failing that, force. To contemporaries his most striking characteristics were his pitiless strength and his inflexible will: 'He was a very stern and violent man, so that no one dared to do anything contrary to his will.'[13]

William's claim to the throne of England will be based on a number of points, as revealed in the eulogistic biography of the duke written shortly after 1066 by the Norman cleric and courtier William of Poitiers. This biography is a principal source for our knowledge of the period, but given the author's aim to glorify William and legitimize his conquests, its evidence must naturally be used with caution. According to William of Poitiers, the Conqueror claimed rights by (1) heredity, (2) designation and (3) confirmation of his rights by a solemn oath. First, although no English royal blood flowed in the duke's veins, William of Poitiers stressed his cousinship with Edward the Confessor, the two men sharing a common Norman ancestor, the formidable Emma, wife of two English kings and mother of two more.[14] Secondly, William of Poitiers claimed that Edward had designated William to be his successor in consideration of his kinship to Edward, William's suitability to govern, and the many benefits Edward and his family had received from Norman dukes, particularly the hospitality shown his family during their twenty-five years of exile in Normandy when England was ruled by Canute of Denmark and his son Harthacnut. Thirdly, William of Poitiers and another contemporary reported that shortly before his death, perhaps in 1064, Edward confirmed his nomination of William as his heir by sending the leading man in his kingdom to Normandy to make final arrangements for the duke's succession. It is with this fateful visit to Normandy by Harold Godwinson that the Bayeux Tapestry commences its story of the Conquest of England.

Act One

At the opening of the drama we find the aged King Edward, identified in the inscription above, seated on a lion throne in his palace (Plate I). He is speaking to two men, one of whom is certainly Harold Godwinson, for in the next scene Harold is shown riding with a hawk on his wrist and his hunting dogs out in front in the company of his followers towards his country palace at Bosham, not far from Southampton on England's south coast (Plate II). After a visit to the local church, Harold enjoys a meal with followers in the upstairs chamber of his seaside house beneath a most improbably cantilevered roof (Plates III-IV). A messenger arrives to tell them that it is time to depart. Taking off their leggings and tucking up their skirts, they wade out to the ships carrying their hawks and hounds (Plate IV).

With 'the wind full in their sails,' according to the inscription, they take soundings of the Channel bottom, sight land from the top of the mast, and find anchor on the French coast in the county of Ponthieu (Plates V-VII). During the

Channel crossing, note that the Tapestry border undergoes a transformation. The sails fill the whole space above, while below the usual pairs of decorative animals give way to a series of Aesopic fables, the fox and the crow, the lion and the lamb, the pregnant bitch, the wolf and the crane, and so on, some of which will also reappear later. Their selection and placement, indeed their very presence, lends a note of mystery to the Tapestry.

Also enigmatic is whether the Tapestry artist wishes us to understand that Harold was sent to France by Edward to confirm arrangements for William's succession, the Norman version of events, or whether he is allowing us to read into his pictures an English interpretation which stressed that Harold went on his own accord against his king's express wishes. What the Tapestry artist intends is not as clear as it might be, perhaps deliberately, perhaps not, because of the brevity of the inscriptions at crucial points in the narrative.[15]

When Harold wades ashore he is immediately seized by Guy [Wido], the local count, and held for ransom at Guy's castle at Beaurain (Plates VII-X). Once there, the two have a discussion, or so the inscription informs us, but clearly this is no conversation between equals, since it is the Norman brigand who dictates terms to an apprehensive Harold, while a mysterious figure behind a column seems to overhear and rush off to get help (Plate X). In this scene the artist has for the first time deftly distinguished Saxon and Norman by hair-styles, with Harold and his attendant sporting characteristically English moustaches and full heads of hair, while Guy and the guard tapping him on the elbow to inform him that visitors have arrived are clean-faced and have their heads shaved at the back in a fashion apparently thought masculine by the Normans.

Harold's release follows, with three episodes that must be read in reverse order (Plates X-XIII); first we see William's towering messengers demanding the release of Harold from an elaborately costumed Guy, while a dwarf holds the reins of their spirited horses; next these two messengers, their hair blown straight back, are seen galloping as quickly as the wind towards Beaurain to issue the duke's command; and lastly we come to the first scene in this episode, William hearing of Harold's plight and ordering the two knights to ride in rescue of Harold.[16] Guy knows better than to disobey the duke of Normandy, and the next scene shows him conducting Harold to William (Plates XIV-XV). His first appearances impressively demonstrate William's ability to bend men to his will.

William takes his guest to his palace, presumably in Rouen, where there occurs what seems to be a heated discussion between William and Harold on an unknown subject (Plates XVI-XVII). Then there comes one of the most mysterious episodes in the Tapestry, which may or may not have a bearing on that discussion. A cleric reaches across an archway to touch the face of a woman; the inscription merely states, 'Where a clerk and Ælfgyva', omitting any verb to tell us what they were doing (Plate XVII). That we probably have here a reference to some sexual scandal can be inferred from the marginal figure whose nudity and posture echo that of the cleric's, and the juxtaposed architectural forms, the open gateway and the tower whose erect shape and profile is not unrelated to the most prominent part of the marginal figure below.[17]

Immediately the scene shifts to a military campaign in Brittany for which our only other evidence is a long section in William of Poitiers' biography of the duke. Harold accompanies William in his campaign against a rebellious vassal, riding past Mont-Saint-Michel, depicted here for the first time in art, then across the river Couesnon, the boundary between Normandy and Brittany (Plates XVIII-XX). Treacherous to this day, the tides and shifting sands would have claimed some men had it not been for Harold's bravery and strength in pulling one man out of the water while another clung to his neck. The campaign against William's vassal Conan now commences. William's men attack Conan's castle at Dol, but Conan escapes down a conveniently bent rope (Plate XXI).[18] He is pursued past the castle at Rennes, where sheep are grazing on the mound, and finally surrounded at Dinan (Plates XXI-XXIII). With the wooden palisades being set on fire and his escape to the right blocked, Conan acknowledges defeat by passing the keys of the castle to William on the end of a lance. For reasons which remain puzzling, the Tapestry's account of this Breton expedition varies in both detail and overall direction from that by William of Poitiers, where, rather than being a success, the campaign in Brittany was clearly a set-back for William.

Harold is rewarded for his part in the campaign by receiving arms from William (Plate XXIV). Note that this is not a simple bestowal of gifts, for in the feudal world such a ceremonial giving of arms signified that Harold, already beholden to William for his release from the clutches of Count Guy, was now formally William's vassal.

The twin themes of Harold's obligation and dependency reach their climax when the two men ride back into Normandy and arrive at Bayeux (uniquely spelled BAGIAS in the Tapestry, Plates XXIV-XXV).[19] According to the Tapestry (Plates XXV-XXVI), it was at or near Bayeux that Harold swore a solemn oath to William (*Ubi Harold sacramentum fecit Willelmo Duci*), the meaning and importance of which is highlighted by a range of body language: William's authoritative gesture of command; Harold's outstretched reach that makes him appear exposed and vulnerable; his position between two carefully distinguished shrines containing relics; and the knowing exchange between the soldiers behind William as they point not just generally towards Harold swearing his oath but towards the inscription, particularly the word SACRAMENTUM [oath].[20] By their gestures these soldiers appear to be informing us, the viewers, *Nota bene*, note this well. What did Harold promise? The Tapestry inscription does not say, but Norman accounts, while they differ on details, are in agreement that in the main Harold swore to be William's vassal in England and to advance the duke's claim to the English throne.[21]

At this point Harold returns to England, going immediately to King Edward (Plate XXVIII). Just as his departure from England was accompanied by marginal fables, so is his return, this time the wolf and the crane, and the fox and the crow being embroidered in the upper border. In a rapid shift forward in time, the Tapestry moves to the climax of the first act, the death of King Edward and the accession of Harold in January 1066. Again the artist has considered it necessary to reverse the action, no doubt in an attempt to give clarity to momentous events that followed one another with extraordinary rapidity. On 28 December 1065, the

abbey church of Westminster which Edward had built was consecrated while both archbishops and most of the magnates, clerical and lay, were at Westminster for the Christmas court. Only Edward was unavoidably absent, he being confined to his bed, where he died a week later on 5 January. On the morrow, 6 January 1066, Westminster Abbey witnessed both his burial and the coronation of Harold as king of England.

In the Tapestry we first see Edward's body being carried, to the accompaniment of chants and bell ringing, to his new abbey at Westminster, which, like all of Edward's personal tastes, was influenced by his long stay in Normandy (Plate XXIX). The installation at left of the weathercock indicates its recent completion; the hand of God emerging out of the clouds its recent consecration. After the funeral cortege we go back in time to the day the aged king was both alive and dead. Propped up in bed, Edward addresses his *fideles*, his faithful ones, a cleric on the far side of the bed, his wife Edith at the foot, and a man, presumably Harold, on the near side touching the king's fingers. What Edward said to his faithful followers is not revealed in the Tapestry's inscription but written accounts, both Norman and English, inform us that in his dying moments Edward nominated Harold to be his successor.[22] Below we see Edward's body being shrouded for burial in Westminster Abbey, where it still lies.

No time was lost in securing a successor. Immediately we see the crown offered to Harold, and the three orders of society acclaim him REX ANGLORUM, king of the English: at left the nobility of the sword, then the clerical estate, in the person of the now excommunicated Archbishop Stigand, and lastly the masses, kept safely outside the abbey in a different chamber (Plates XXXI-XXXII). No doubt the schismatic Stigand is made to stand out so prominently because he was a symbol in Norman propaganda of both the corruption in the English church that they had been appointed by the pope to reform and of that church's ties to the old order, the house of Godwin.

After the king's acclamation, the first act concludes in masterful fashion with a depiction of Halley's comet sailing through the heavens while the populace points in awe and terror (Plate XXXII). What did the comet's appearance over Europe from February through May of 1066 portend? A courtier explains to a frightened king that the comet, known to contemporaries as 'the hairy star', foretold an imminent invasion. As elsewhere in the Tapestry, we read the meaning not in the inscription, but in the marginal imagery, here the five ghostly ships floating on the waters.

Thus, what might be called Act One closes as it opened, with a king of England enthroned, but this last image of a king is very different from the first. Harold sits uneasily on Edward's throne with neither the commanding presence of his predecessor, nor, indeed, that majesty which Harold himself had displayed a scene before at his acclamation. Holding an instrument of war rather than a symbol of kingship, Harold bends his whole body to hear how heaven's ominous signs portend an invasion from across the waters against a faithless vassal and perjurer who accepted for himself the crown which he had sworn on the relics of saints to safeguard for his Norman overlord.

Act Two

The scene now shifts back to Normandy. William receives word from across the Channel that Harold has accepted the crown, and in consultation with a tonsured adviser, unidentified in the inscription but almost certainly his half-brother, Odo, bishop of Bayeux, gives the command to build an invasion fleet (Plate XXXV). Trees are felled, planks are planed and carpenters build the armada. Provisions must be loaded, helmets and swords, and hauberks so heavy that two men are required to carry each one as it hangs suspended from a pole. The French do not venture abroad without their wine, shown here carried in skins and in a hogshead which has to be transported on a cart dragged by two men, with the cart serving double duty as an ingenious transporter of helmets and spears (Plate XXXVIII). Food they planned to secure on landing.

Duke William and his men ride down to the shore (Plate XXXIX). Naturally the Tapestry can only show some of the 600 vessels ready to set sail and the perhaps 7,000 men, including 2,000 to 3,000 knights, some of whom were not Normans at all but adventurers from Brittany, Maine, Aquitaine, Flanders and 'France' (the king of France's territory in and around the Île de France) who responded to William's promise of rewards if success should crown their venture. One can only marvel at the skill with which the designer has imparted a sense of the majesty of this endeavour, the largest single military operation undertaken up to that time in northern Europe and the first requiring the sea transport of many horses, for, after all, fighting on horseback was essential to the whole Norman mode of warfare. By selecting the telling detail and relating each element to the other the Tapestry creates the illusion of a vast panoramic vista filled with the enormous fleet sailing across the Channel (Plates XL-XLIV). Of course many details are missing. The whole has such inevitability and economy of means that one would not know from the Tapestry that the forces had to wait six weeks for a favourable wind, first a month at Dives-sur-Mer and then a further fortnight at St-Valèry-sur-Somme until the wind changed on 27 September, when, according to the Norman chroniclers and poets, the body of St Valèry himself was brought out of the church in procession.[23]

From the Tapestry one would also not know that the northerly winds which kept Duke William in port at St Valèry had carried to England another invasion fleet led by Harold Hardrada of Norway to make good his claim to the disputed throne. Sailing by way of Shetland and Orkney, the king of Norway reached the Tyne, received reinforcements from Harold's treacherous brother, Tostig, and defeated the leading earls of the north two miles from York. Hearing of this successful invasion from the north seas, King Harold had perforce to abandon keeping watch on the southern coast and rush north where he fought a savage battle against the Vikings at Stamford Bridge on 25 September. Three days later, the English leaders were still at York taking rest and re-forming their armies after destroying the Viking forces and killing both Harold Hardrada and Tostig, when William landed at Pevensey, unopposed.

Although the Tapestry completely omits this decisively important northern campaign, it gives a detailed account of Norman activities during the fortnight

between their arrival at Pevensey on 28 September and the Battle of Hastings on 14 October. After disembarking, the troops, one of whom is a knight identified as Wadard, seize the animals which servants will use to prepare a feast in celebration of the successful landing (Plate XLVI). Once again a cleric plays an important role in the Tapestry's version of events, and again, as in the scene where the command is given to construct an armada, the cleric is almost certainly William's powerful half-brother, Bishop Odo of Bayeux (Plate XLVIII). Next comes a council attended only by William, Odo and a Robert who is probably William's other half-brother, Robert of Mortain. Here the strategy of waiting for Harold to move south is decided upon and a command is given to construct a defensive fortification, a castle at Hastings (Plate XLIX). In a memorable scene the Tapestry portrays a woman and child forced to flee a house being burnt down by Normans around Hastings, a grim reminder of the horrors of war for civilians (Plate L).

Meanwhile, as we know from other sources, King Harold and his immediate followers were rushing south over the 200 miles from York to London. From there his hastily assembled army was force marched 50 to 60 miles to the place of battle. The Tapestry shows a messenger bringing news of Harold's movements to William and the Norman troops setting out northward from Hastings to engage them (Plates LI-LIII). In the upper margin are two pairs of nudes, the men being identified as Anglo-Saxons by their moustaches. When William asks a knight named Vital if he has seen Harold's army, Vital gestures behind him towards where scouts from the opposing sides are spying on each other (Plates LIV-LVI).

It is now Saturday, 14 October 1066, the single most important day in the history of medieval England. By nightfall Harold will be dead, as will his brothers, Gyrth and Leofwine, and the greater part of the English nobility. The fate of a country will have been decided in a single day on a desolate hill distinguished only by a lone forlorn feature against the skyline, a 'grey apple tree'.[24] Given the momentousness of the battle, there has naturally been much controversy among historians as to exactly what happened and why, but on the main developments and a few significant details, all that can concern us here, the Tapestry and the written sources agree reasonably well.

Both Normans and English wear similar equipment: conical helmets with a nose piece and ring-mail that covers the body down to just below the knee. Both carry the new style kite-shaped shields designed to protect the lower part of the body, though some of the Anglo-Saxons still use the traditional Germanic round shields. Both armies are made up of un-armoured as well as armoured soldiers, the Normans often with bow and arrow. Despite these similarities between the two sides, there were great differences in the way they actually fought. Norman professional soldiers fought on horseback, cutting with the sword and thrusting with the lance from the saddle, while the English élite, though they rode to battle, dismounted to form a solid wall of foot soldiers. This was the traditional 'shield-wall' made up of a compact group of infantry whose overlapping shields formed an impenetrable barrier to the enemy.

Although not indicated as such in the Tapestry, Harold's troops occupy a well-defended hill eight miles inland from Hastings. Norman and English lookouts

view each other and, in a spirited composition, an English scout runs to Harold to give him news of the approaching Norman army (Plate LVI). The battle is about to begin. The Norman lines move out, first the archers and then the mailed horsemen. From the inscription we learn that Duke William 'exhorts his soldiers to prepare themselves valiantly and wisely for the battle against the army of the English' (Plates LVII-LVIII).

In one of its most memorable scenes the Tapestry captures the essence of what made this a very strange battle, one side being continually in motion, the other standing in one place, as if rooted to the ground (Plates LIX-LXII).[25] There is a serious deficiency in English readiness, indicated by one lone archer among the foot soldiers (in fact the only English archer in the whole Tapestry). But the shield-wall of Harold's finest soldiers withstands a combined cavalry and archery attack. Both English and Normans begin to suffer losses. Harold's brothers, Gyrth and Leofwine, are killed (Plates LXIII-LXIV), but the English, aided by their position on the hill and their formidable axes, withstand the shock of mounted assaults, sending men and horses to the ground in wild confusion (Plates LXV-LXVI).

According to the Tapestry, there occurred at this point one of the flights, real or pretended, of the Normans, and the rumour that their duke was dead. Bishop Odo, wearing a colourful tunic patterned with the triangular design so favoured by the Normans and brandishing a baton, cheers on the young men, while Eustace of Boulogne shouts, 'Here is Duke William' at the moment the Norman leader lifts his helmet so that his face can dispel the fear of defeat (Plates LXVII, LXVIII). The troops rally and the English who had advanced down the hill in pursuit of the fleeing Normans are cut off.

Towards nightfall the Norman knights press their advantage while from the lower margins the diminutive archers with big quivers aim high into the sky towards the summit of the hill (Plate LXIX). The knights have broken through and attack Harold's bodyguards. Passing an unarmed Englishman about to be dispatched, the Norman cavalry reaches Harold's dragon standard, and the king is killed (Plates LXX-LXXI).

Alas, the Tapestry's depiction of the death of Harold, not very easy to read for a number of reasons, has led to enormous controversy. The difficulty is in part due to the fact that our earliest written sources are either silent or uncertain about precisely what happened at this most critical moment in the battle, in part to some puzzling aspects of the composition, and in part to the fact that this scene has required extensive restorations. Under the inscription *Ubi Harold rex interfectus est* [Here King Harold was killed], we see two figures who might be the king. One is trying to pull an arrow out of his head, while the second is lying on the ground, his great battle-axe beside him, as a mounted knight slashes his leg. How is one supposed to read the Tapestry? Is Harold the figure who received an arrow in the head, perhaps in the eye, or the one cut down by a mounted knight, or is he both figures? These are disputed matters to which we shall return. With Harold's death the battle is over and the Tapestry comes to a ragged end with armour being pulled off dead soldiers and the English fleeing into the dusk before the pursuing Normans (Plates LXXII-LXXIII).

Was this the way the Tapestry ended originally? No one knows. It could be that it was never finished. If there was more originally, it could be that it was subsequently so heavily damaged, perhaps in a fire, or in an accident, or by constant winding and unwinding from a great drum, one of the ways in which it was displayed, that the end was thrown away.[26] If there had been more, it is not improbable that it ended as it began, with a vertical decorative border of floral design and a depiction of a king enthroned, though this time it might have been William the Conqueror at his coronation in Westminster Abbey on Christmas Day, 1066, the 'lawful' successor to Edward the Confessor.

Epilogue: results of the Conquest

About William's victory, William of Poitiers said that at Hastings the duke conquered all of England in a single day, and a modern commentator, Sir Frank Stenton, has written: 'Events were to show that he had won one of the battles which at rare intervals have decided the fate of nations.'[27] Certainly there was no more united fighting against the Conqueror, though there certainly were risings, especially in the north, and local resistances throughout the land.

It is extraordinary that this one day's fighting opened the way for a new dynasty, a new aristocracy, a new military and land holding system, a new church rebuilt in a new architecture and a new language. By 1086 when the Conqueror took an inventory of his land in the Domesday Book, only a handful of the 180 great landlords, or tenants-in-chief, as they were called in the new Norman feudal parlance, were English. Everywhere huge circular mounds, like the one in the Tapestry and those still visible at Clifford's Tower in York and in a hundred other places throughout the land, were piled up by the forced labour of English peasants, symbols of conquest and the strongholds of the new, alien ruling class. By the Conqueror's death in 1087 only one of sixteen bishoprics was held by an Englishman. By the end of the 12th century virtually every Anglo-Saxon cathedral and abbey had been demolished and rebuilt in the new Norman (Romanesque) style. For almost two centuries the aristocracy chose to speak French, and the English language, along with much of the precociously rich Anglo-Saxon vernacular culture, was forgotten or relegated to the lower classes.[28]

Most Anglo-Saxon accomplishments were deprecated by the new ruling class, though a few were justly appreciated for the excellence they indeed possessed. Two achievements were put to good use by the Normans. The first is from the world of politics, the other from the realm of culture. In government the English had created the most efficient administrative machine in Europe, with trained officials in both central and local positions. These officials, particularly the shire-reeve or sheriff, were appointed by the crown and responsible to it, a situation unique in a Europe that had almost completely lost the traditions of centralized government during the Viking invasions. Also unique in European politics was the ability to tax the whole country. Originally a symptom of national and royal weakness, the *danegeld* was a national land tax imposed first by the appropriately named Ethelred the Unready as a way to raise protection money against the Danes, but once the danger had passed, the tax, as is usually the case, had not been

removed. One can well imagine the delight with which William the Conqueror heard the news that merely by declaring the need for *danegeld* he would receive cartloads of money. Given the uniquely centralized organs of royal government and the efficient tax system which he found in England, it is little wonder that the Normans made every effort to portray William not as an adventurer who took advantage of an uncertain moment in English political history but as the lawful successor to Edward the Confessor.

In the realm of culture, while the Normans could not take pleasure from English literature, they did take evident delight in the skill of Anglo-Saxon artisans, goldsmiths, ivory carvers, figurative artists and embroiderers. They took to extolling their achievements in writings, and expropriating their creations for churches and castles back home. The alien rulers also commissioned new objects to be made.

Embroidery was one skill in which the natives excelled, as attested by the fact that throughout Europe *opus Anglicanum* [English work] was synonymous during the Middle Ages with English embroidery. Thus, just as it was ironic that the Anglo-Saxon excellence in creating instruments of government gave the Conqueror tools with which to consolidate his victory, so it was doubly ironic that when the Normans wished to have their achievement at the Battle of Hastings commemorated they apparently turned to native English artisans to make a triumphal monument.

But who might have commissioned the English to make this great work known now as the Bayeux Tapestry; where was it most probably made; how does its style relate to the main artistic traditions of the day; why does its account sometimes vary from those contained in contemporary written sources, and what might have resulted from the extraordinary decision to have the conquered people make a triumphal monument celebrating their own defeat – these are the questions to which we must now turn.

PART ONE

The Making of the Tapestry

*A discussion of the Bayeux Tapestry, where
and when it was made, why it has a distinctive
style and shape, its relationship to other works
of art, and how it might have been displayed*

CHAPTER I

The Patron

For whom was the Tapestry made? Since no existing document indicates who commissioned the Tapestry and for what purpose, many colourful legends have grown up, as naturally happens with any popular work of art. Over time these have been discarded by scholars in favour of an ingenious theory that is based on solid evidence, but evidence so oblique that only astute detective work could divine its significance.

'La Tapisserie de la Reine Mathilde'

The earliest statement about the Tapestry is found in the Bayeux Cathedral inventory of 1476. It informs us that among the hangings, carpets, curtains and altar frontals of the church there is 'a very long and very narrow strip [or hanging] of linen embroidered with figures and inscriptions representing the Conquest of England,' and that it is hung around the nave of the church on the Feast of Relics. The inventory says nothing about its origin.[1]

When the Tapestry was first brought to wide public attention in 1729 by the great historian of the monuments of the French monarchy, Dom Bernard de Montfaucon, there already existed a tradition associating it with the Conqueror's wife Matilda.[2] Forty years later, what was only a local tradition had, along with other matters, apparently become an historical certainty to one member of the Society of Antiquaries in London: 'The Conquest of England by William the Norman, . . . was, *by command of Queen Matilda, represented in painting*, and afterwards, *by her own hands and the assistance of the ladies of her court*, worked in *arras*, and *presented to the cathedral* at Bajeux [*sic*], where it is still preserved.'[3] Upon what evidence was it believed that Queen Matilda commissioned a painting and then actually made a tapestry which she presented to the cathedral of Bayeux? Absolutely none. But since the Tapestry commemorates the Norman Conquest it must have seemed self-evident that it had been made in Normandy, and that Matilda spent her lonely hours like a medieval Penelope, embroidering this memorial to her husband's heroic deeds. This tradition proved so tenacious that only recently has the title 'The Bayeux Tapestry' superseded, and then not always, the traditional designation 'La Tapisserie de la Reine Mathilde'.[4]

The Tapestry's popularity, and Matilda's role in making it, were greatly enhanced during the Napoleonic wars when it was brought to Paris in the year XII (1803) to be placed on exhibit in the Musée Napoléon. The purpose? As explained to the concerned citizens of Bayeux, understandably reluctant to part

with this fragile record of French history that had been so miraculously preserved
in their cathedral through fire, war and revolution, 'the dispatch of the Tapestry
was an unavoidable necessity,' for it was hoped that 'the sight of this famous relic
in the capital will add to the general enthusiasm and raise the spirits of the people'
in a time of war between England and France.[5] On its arrival in Paris Bonaparte
himself was said to have studied it (as would Hitler when he too contemplated an
invasion of England), spending a long time brooding over the episode of the comet
with its prediction of Harold's defeat, perhaps with the recent fall of a meteor in
southern France in mind.[6] A topical comedy, entitled *La Tapisserie de la Reine
Mathilde, comédie en un acte, en prose, melée de vaudevilles*, replete with tableaux
vivants of the Norman Conquest while Matilda and the ladies of her court
embroidered and made pointed references to Bonaparte's ambitious invasion
plans against England, was performed at the Théâtre du Vaudeville, one of many
attempts to capitalize on the interest stimulated by this first visit of the Tapestry
to Paris.[7]

Soon after its return to Bayeux near the end of 1803, the vexing question of
origins was much debated by students of the work, with passionate arguments
erupting over whether Queen Matilda, wife of the Conqueror, should be credited
with its creation, or a granddaughter of the Conqueror also named Matilda.[8] While
many scholars in England and France were trying to discover the 'real' Matilda,
19th-century prudishness and scientific historical scholarship joined hands in an
assault on the whole Matilda theory. Some felt that to attribute a work with so
much lewdness to women with fine reputations was an outrage against the laws
of decency.[9]

A scholar named Delauney suggested that since the work had been displayed,
despite its indelicacies, in the cathedral of Bayeux, it might have been given to that
cathedral by a cleric whose morals were not immaculate. Since William the
Conqueror's half-brother, Odo, bishop of Bayeux, was not disqualified on that
score, he being known to have had a mistress and a son, Monsieur Delauney
thought Odo a likely candidate for the role of patron of the Bayeux Tapestry.
Moreover, Odo's positions of power in England gave him the requisite knowledge
of events and his concern for embellishing his cathedral at Bayeux the motive.[10]
As an additional point, Delauney noted that the costumes made it improbable that
the work was later than the Conquest generation. Fashion changed drastically
after William's death: close-fitting garments were discarded in favour of trailing
robes, simple round-toed shoes were put aside for elongated shoes that curled
fantastically at the tip, while shaven heads gave way to flowing tresses.[11] In 1066
the Normans had a particular fascinated aversion for the length of hair of the
Saxons, and indeed the creators of the Bayeux Tapestry give unforgettable visual
expression to the contrasting hair-styles of the opposing sides.[12]

Soon the contributions of other scholars who closely examined the Tapestry and
used auxiliary sources began to build an impressive case that not only was the work
of early date but that, as Delauney had speculated, Odo was the most likely patron.
It was noted, for instance, that Odo played a part in the Tapestry far greater than
in any of the early written sources, where he appears merely as one of two

distinguished prelates accompanying the expedition.[13] Attention was drawn to the fact that as the only Norman ecclesiastic identified in the Tapestry, Odo is depicted as present at two critical moments in the history of the invasion, William's command to construct the invasion fleet and the turning-point of the battle when the frightened knights have to be rallied (Plates 79, 81 on pages 138-39). It was also observed that only the Tapestry associated Harold's oath with Bayeux (Plate XXV), William of Poitiers placing it at Bonneville and Orderic Vitalis at Rouen.[14] Bayeux, of course, was Bishop Odo's cathedral city.

In addition, other unique features were related to the making of the Tapestry with the help of the exceptionally rich documentary sources created during William's reign in England. Only four minor characters are designated by name in the entire Tapestry (Turold, Ælfgyva, Wadard, and Vital). Since the names of the last two are extremely unusual, there being, in fact, only one Wadard in all Anglo-Norman records, Bolton Corney divined that the Conqueror's magnificent record of landholding in his new kingdom, known as the 'Domesday Book' (1086), might contain a clue as to who they were, and why it was that despite the fact that no contemporary history mentions them, they should be identified in the Tapestry. In 1838, Corney used the Domesday Book to demonstrate that Wadard and Vital shared something in common: both were tenants of Odo and held lands from him in the county of Kent, where Odo was earl. Corney also noted that Wadard held lands from Odo in other counties; for instance in Lincolnshire alone he was nine times called HOMO EPISCOPI BAIOCENSIS, the vassal of the bishop of Bayeux. Later research has amplified the evidence and found that the Tapestry's Turold, a person with a much more common name, is probably a tenant of Odo's as well.[15]

In all, three main clues emerged by the middle of the last century linking Odo to the Tapestry: (1) his prominence in the Tapestry's depiction of events in contrast to the near silence in other sources; (2) the identification in the Tapestry of otherwise historically unimportant men who shared one thing in common, feudal tenancy from Odo; and (3) the Tapestry's unique connection of the famous oath with Bayeux. By shifting attention away from purely circumstantial assumptions about medieval women staying at home doing needlework while their husbands were away fighting towards those features which either distinguish the Tapestry's account or link it to contemporary written sources, careful observers like Monsieur Delauney and Bolton Corney helped raise studies of the Tapestry to a new level.

Today, virtually all scholars accept that 'La Tapisserie de la Reine Mathilde' could only have given a starring role to the relics of Bayeux Cathedral, its bishop, and three of his tenants if it had been made for Bishop Odo. Was the bishop the patron as well as the recipient of this grand monument? Although a recent theory proposed that the three tenants who are labelled in the Tapestry may have tried to help rehabilitate their lord at a low point in his political fortunes by sponsoring a work that stresses his loyalty and usefulness, this hypothesis has not found acceptance.[16] The consensus now is that this magnificent account of the Norman Conquest was probably made at the command of Bishop Odo.

ODO, BISHOP OF BAYEUX, EARL OF KENT, VICEREGENT OF ENGLAND AND SIBLING RIVAL TO WILLIAM THE CONQUEROR

Who was Odo? What do we know of his personality and career that might help us better understand the Tapestry?

Normandy

Much in Odo's life is explicable by the accident of birth.[17] He and William were brothers, both having Herleva of Falaise as their mother. William, however, was born of her illicit relationship with Duke Robert of Normandy, while Odo, and a brother named Robert, were offspring of her marriage to Herluin of Conteville. The three brothers seem to be placed together in a kind of family portrait in one of the Tapestry's council scenes (Plate 80, page 139).

The crucial point is that Odo had as his half-brother the duke of Normandy and future king of England. From an early age one was destined for the life of fighting and ruling, and the other for a career in the church. About 1049, when Odo was perhaps thirteen years old, he received the bishopric of Bayeux from William, the first of many ducal gifts that would propel him to the centre of ecclesiastical and political life, while also entangling his considerable ambitions and egotism with those of his more powerful brother. Like all the offices he would receive from William, this one of 1049 was as much political as fraternal, in that William wished to reassert ducal authority in Lower Normandy after his victory over rebels at Val-ès-Dunes two years earlier.[18]

In the years before the Conquest Bishop Odo did not seem to attract a great deal of attention, even from writers who might have wished to make a scandal about his assumption of a bishopric well under the canonical age of thirty or his ties to the secular world. But then, before the heightened awareness of such improprieties that is associated with the reform pontificate of Gregory VII (1073-85), similar practices often passed unremarked. Other Norman bishops owed their ecclesiastic promotion to their lay relatives. Others were no strangers to military operations; it was said of a second bishop who would accompany the expedition in 1066, Geoffrey, bishop of Coutances, that he knew better how to teach knights to fight than clerks to sing.[19] Also, if Odo had a son, the majority of bishops in the first half of the 11th century in Normandy were married men, or at least passed ecclesiastical lands to a son.[20]

The scant records from Normandy in this period mainly show Odo occupied at first with local ecclesiastical matters, attending church councils in nearby Rouen, and continuing the recovery, begun by his predecessor, of the diocesan lands lost during the Viking invasions. In the wake of the Northmen the church in Normandy had been all but destroyed, its buildings in ruins, its parishes unstaffed, and whole regions left to lapse into paganism. All prominent clerics undertook a reorganization of their properties now that more peaceful conditions prevailed, using their newly regained lands to finance ambitious construction campaigns, such as the much larger cathedral Odo built for Bayeux and the new abbey just outside the city dedicated to the popular dragon-slaying local hero, Saint Vigor.[21] If some of these aristocratic prelates were lamentably lacking in

spirituality, they none the less shared with the other members of their class a vigour which would enable the Normans to become the leading people of their age.

The conquest of England

In 1066 Odo entered upon a wider world, adding a more substantial political career in England to his ecclesiastical one in Normandy. As a bishop he would never have been far removed from politics, but the invasion of England was clearly a major turning-point in his life. He took part in councils planning the invasion. He is said to have donated ships to the armada and certainly accompanied the troops across the Channel to Pevensey.[22] Although the Tapestry appears to have exaggerated his role in the campaign, Odo's career in England after William's coronation would not have made his political or military activities in the Tapestry seem far-fetched; indeed, although William of Poitiers circumscribed his role to one of prayer, a contemporary viewing the roles assigned Odo in the Tapestry would have had no trouble imagining him a leading participant in the highest councils of state and swinging his baton in the thick of battle.

After Hastings, William rewarded Odo with the castle at Dover and the earldom of Kent with responsibility for defending the south-eastern coast and pacifying the potentially rebellious area around Canterbury. Then, on William's return to Normandy six months later, he appointed Odo and William fitz Osbern as viceregents over England.[23] With the assumption of these offices began a turbulent public career that would see Odo entrusted with all-but regal power whenever the king was abroad, and then, sixteen years later, lose it all in one crushing blow.

While the sources do not allow us to retrace precisely what powers Odo exercised in England, certain characteristics of his rule are clear.[24] As earl of Kent and sometime viceregent of all England, Odo wielded power with a mailed fist. From the point of view of the author of the *Anglo-Saxon Chronicle* the rule of the viceroys during the first year of conquest was harsh in the extreme: 'They built castles far and wide throughout this country, and distressed the wretched folk.'[25] Other sources speak of them protecting their plundering followers and paying no heed to the complaints of the English; indeed, discontent with their rule may have compelled William to hurry back to England in December 1067.[26] Odo was later called upon to ride against the king's enemies, the rebellious earls Waltheof and Ralf 'the staller' in 1075, and five years later the turbulent north country. This last campaign into Northumberland to take vengeance for the murder of Bishop Walcher of Durham was compared by those at the scene with the ferocious destruction of William's own harrying of the north a decade earlier.[27]

Because of his blood relationship, Odo was able to accumulate enormous wealth in England. His landholdings far exceeded those of any other man except the king, the natural recipient of the lion's share of the spoils, with Domesday listing estates in twenty-two counties valued at £3,050.[28] As earl of Kent it was natural that most of his lands were grouped in the south-east; in that county alone the 184 manors he is said to have held made Odo 'perhaps the greatest single figure in Kentish history.'[29]

Out of his enormous holdings Odo liberally rewarded his followers, men like

Hugh de Port and Roger Bigot, founders of important families, as well as lesser men such as Wadard, the knight who was immortalized in the Bayeux Tapestry for pillaging the countryside shortly after the landing at Pevensey, and Vital, the man who announces the approach of Harold's army to William (Plate LIV).[30] Another tenant was Turold of Rochester, a powerful knight involved along with Odo in the trial at Penenden Heath who is probably the same Turold who is shown in the Tapestry demanding the release of Harold from Count Guy (Plate 33).[31]

In Kent Odo and his vassals possessed most of the lands which did not belong to the church, and some that did. Although the bulk of his property had been a gift of the king, Odo was accused of acquiring wealth by the spoilation of abbeys and churches. The most famous instance, his encroachment on the possessions of the see of Canterbury, resulted in a great public trial between Odo and the archbishop of Canterbury. When Lanfranc became archbishop in 1070 and began surveying the losses which his cathedral had sustained in the scramble for wealth after 1066, it was apparent that the principal culprit was the king's half-brother. The archbishop claimed restitution, and by William's order the suit was heard before the shire-court of Kent at its customary site on Penenden Heath, near Maidstone.[32] During the three days of sessions Lanfranc succeeded in establishing his claim to six estates.[33]

Much English wealth is said to have returned with Odo to Normandy for the building of Bayeux Cathedral, its episcopal palace, and houses for canons. According to a knowledgeable 12th-century observer, 'there is evidence of this [exportation of English wealth] in the buildings that he raised and the furnishings – gold and silver vessels and precious vestments – which he lavished on cathedral and clergy.'[34] Odo was not alone. William of Poitiers eulogized the Conquerer by describing how 'in a thousand churches in France, Aquitaine, Burgundy and Auvergne and other regions, the memory of King William will be celebrated in perpetuity. . . . Some received extremely large gold crucifixes, remarkably adorned with jewels. Many were given pounds of gold, or vessels made of the same precious material. Several received costly fabrics [*pallia*]. . . . What the least monastery enjoyed from his largess would splendidly adorn a metropolitan basilica.'[35]

Odo's fall from power

Fifteen years after the Conquest Odo had reached the zenith of his career. Far and away the wealthiest subject in the kingdom and occasional possessor of regal powers, he discovered, as would Cardinal Wolsey in 1529, that all the wealth and power flowing from the king could be cut off in an instant. In 1082 Odo was arrested, stripped of his English lands and authority, and imprisoned on the king's command. William's motive remains a mystery. No contemporary writer attempted to explain it, the *Anglo-Saxon Chronicle* laconically reporting for the whole of 1082 only that, 'the king seized Bishop Odo.'[36] But in the early 12th century three independent sources said that the bishop had devious designs on the papacy.[37] Apparently a soothsayer had foretold that the successor of Pope Gregory VII would be named Odo. According to William of Malmesbury, Odo

attempted to influence any future election by distributing money to the citizens of Rome through pilgrims whose pouches had been stuffed with gold. It was also reported that he had a palace built by the Tiber and adorned with such splendour that there was nothing else like it in all Rome.[38]

Of far greater seriousness in the king's eyes would have been the charge that Odo had induced knights from all parts of England to join him in a military expedition over the Alps. If Odo had indeed planned to march on Rome, his motives can only be conjectured. As the pope and the Holy Roman Emperor were at war, with the emperor threatening Rome in 1081, perhaps Odo hoped to make himself indispensable to the *curia* and the populace by appearing with an army for the pope's defence. Whatever the motives, in William's eyes this must have been a test case of the royal prohibition against using knights for private warfare. About the trial itself we know almost nothing, except that when Odo claimed ecclesiastical immunity, William replied, apparently on the advice of his loyal archbishop, Lanfranc, 'I do not arrest the bishop of Bayeux, but I do arrest the earl of Kent.'[39]

Pope Gregory VII severely censured William for the treatment of his bishop, but the king remained adamant up to the end of his life, keeping him imprisoned in Rouen.[40] When on his death-bed five years later William ordered all prisoners to be released, he specifically excepted his brother. Fortunately for Odo, the urgent pleading of his other brother, Robert of Mortain, prevailed and the king reluctantly gave way. Odo immediately returned to the political arena, taking a prominent part in the 1087 rebellion of the nobles against William Rufus, the Conqueror's son who had gained the crown of England. When that rebellion failed the worldly bishop lost all his English lands and was forever banished from England for his treason. Returning to Normandy, he aspired with more success to gain power there under the weak rule of another nephew, Robert 'Curthose'. In 1095 he was present at the council of Clermont to hear Pope Urban II proclaim the first crusade, and in the following year, whether out of religious enthusiasm or concern over being left to the mercies of William Rufus when his patron Robert decided to take the cross, Odo set out towards Jerusalem. Stopping in Rome, he received the pope's blessing, and, we may conjecture, examined the depictions of triumphal Roman military campaigns on such monuments as the columns of Trajan and Marcus Aurelius with some interest. He then crossed over to Sicily, where in 1097 he died in Palermo. In its cathedral he was commemorated by a splendid tomb appropriately situated near the remains of noble Normans who had conquered Sicily in the same wave of outward energy which had propelled William and Odo to England.

Virtues and vices strangely mingled

No contemporary wrote a biography or even a lengthy account of Odo's career and character. In the short statements in William of Poitiers and the *Anglo-Saxon Chronicle*, each author's sympathies predominate, the former eulogizing him and the native English writers hating him for his ambition, cruelty and avarice. William of Poitiers says that he governed his church at Bayeux wisely and adorned it

magnificently; that he was astute and eloquent; that his munificence was unsurpassed in Gaul; that he was outstanding in both secular and ecclesiastical affairs; that he never took up arms, but that he was feared by those who did because he 'gave aid in battle through his most excellent advice'; and finally that he was 'uniquely and constantly loyal' to his half-brother the king.[41] From its vantage point, the *Chronicle* complains bitterly of his treatment of the poor, of his inaccessibility to those seeking redress, and of his castles that were centres of oppression.[42]

By far the fullest and fairest evaluation of Odo is found in the *Ecclesiastical History* of Orderic Vitalis, written between 1123 and 1141 by a man who was born in England but at an early age became a monk in the Norman abbey of St-Evroul. His enormous work, six volumes in modern editions, contains a number of discussions of this most famous of Norman bishops. Unlike either William of Poitiers or the Anglo-Saxon Chronicler, Orderic attempted to balance the bishop's faults with his achievements and thereby more successfully caught the different facets of the bishop's life. Orderic noted that Odo was a 'slave to worldly trivialities,' accumulating wealth by dubious means and yielding to temptations of the flesh, fathering a son named John, who appears in many charters between 1104 and 1131 as John of Bayeux, chaplain.[43] Nevertheless, Odo performed many praiseworthy deeds: as bishop, he defended his clergy by words and actions; he enriched 'his church in every way with gifts of precious ornaments'; he founded the monastery of St-Vigor and chose Robert of Tombelaine, a pious, learned man, author of a 'profound commentary on the Song of Songs,' to be its first abbot. Orderic expanded on Odo's concern for learning, not by mentioning any of the bishop's intellectual accomplishments, which appear to have been slight, but by describing him as a patron of young 'promising clerks' sent to 'Liège and other cities where he knew that philosophic studies flourished'.[44] Of his activities in England, that part of his career which most relates to the depictions in the Tapestry, Orderic summed up matters this way:

What shall I say of Odo, bishop of Bayeux, who was an earl palatine dreaded by Englishmen everywhere, and able to dispense justice like a second king? He had authority greater than all earls and magnates in the kingdom, and gained much ancient treasure, as well as holding Kent. . . . In this man, it seems to me, vices were mingled with virtues, but he was given more to worldly affairs than to spiritual contemplation.[45]

To a modern viewer, the striking features of Odo's career are the near perfect manner in which his life illustrates the dual character of a higher ecclesiastic in the 11th century and the scale on which such prince-bishops lived and acted. While other bishops might plead that their intense preoccupation with worldly affairs was the inevitable result of a social and governmental system which forced baronial status upon them, Odo gloried in the role of a baron, taking his place at the council table or on the battlefield without regret. In addition, everything about Odo was on a grand scale. In Normandy his feudal complement was three times as large as that of any other Norman bishop, and no Norman layman had as many knights at his disposal.[46] His cathedral was served by a body of clergy of unprecedented

numbers, there being over thirty canons while in the same period Coutances had fourteen.[47] On this grand Romanesque cathedral he lavished wealth and decorative objects, including sculptural reliefs and a *corona*, or candelabrum, which hung at the crossing of the nave and transept and was so enormous that visitors singled it out for remark.[48] In establishing his monastery at St-Vigor-le-Grand outside the walls of Bayeux he pushed to the extreme the powers of a founder of a monastic community, limiting the influence of the monks by insisting that the bishop of Bayeux elect and consecrate every new abbot, contrary to the reform ideal of monastic autonomy.[49] In England, he was, after his brother, the wealthiest and most powerful man in the kingdom. One suspects that his style of life, whether at his houses in Caen, Rouen and London, or at the episcopal palace in Bayeux and at Dover castle, was commensurate with his wealth and vanity.

If Odo's achievements were impressive, so were his enemies and his set-backs. At various times in his political life he had ranged against him two kings of England and the archbishop of Canterbury.

Given what we know of his enormous ego and ambitions, his acquisition of spectacular wealth and power, his patronage of learning and his munificent gifts to his cathedral, it is not surprising that a worldly bishop like Odo was the patron who commanded that the epic events of 1066 be celebrated on a grand scale in a wall-hanging over 200 feet (60 metres) long. Here was to be a triumphal monument unequalled in the West since the fall of the Roman Empire. It is also not surprising that the relics of his cathedral are singled out for notice, that no other Norman cleric be depicted, and that Odo would be allotted a prominent role in the Tapestry as cleric, counsellor and fighter. What is somewhat surprising, however, is where Odo turned to have the Tapestry made.

CHAPTER II

Provenance: Normandy or England?

1 Drawing by David Smee. From *Punch*, 15 June 1966.

Before the reader is a cartoon published in *Punch* during the celebration of the 900th anniversary of the Battle of Hastings (Plate 1). [1] Without any words this delightful drawing suggests what most people, medievalists included, seem unconsciously to assume about where and when the Tapestry was created and why it has the qualities of an 11th-century documentary. Apparently only by embroidering while the events were taking place could the artist have created events and personages so vivid, so particularized, and so naturally human in their responses to one another that they appear real to our imagination.

If the cartoonist gently satirizes our attitudes, he also implicitly raises many of the right questions which ought to disturb us about the Tapestry's origins. What can we find out about the master artist who devised the programme for the Bayeux Tapestry? What, if anything, was witnessed at first hand; what was read in books; what was learned by word of mouth; what was artistic licence? For what purpose were certain aspects selected from the rush of events? And, if the embroiderers were not on the sidelines sewing frantically while Normans and Anglo-Saxons hacked away at each other, when and where did they make the Tapestry?

When was the Tapestry made? Scholars today generally agree that although no precise date can be offered, if one assumes that Bishop Odo indeed commissioned the work, he most probably would have done so before he was thrust into prison by William in 1082. [2] Many speculate that it might have been completed in time to celebrate the consecration of his newly-built cathedral in 1077. Yet, to this observer, it seems unlikely that the Tapestry was finished so quickly after the

Conquest. Until approximately 1077 a person accorded great prominence in the Tapestry was out of royal favour. This was Eustace of Boulogne, shown pointing to William at the critical moment of the battle when the duke reassures his troops that despite rumours to the contrary he is still alive (Plate LXVIII). Because Eustace had suffered royal disfavour for almost a decade since his rebellion in 1067, it is improbable that he would have been placed so prominently in the spotlight by the artist during the period of his disgrace.[3] Another reason to doubt work was completed for the cathedral consecration of 1077 is that the Tapestry does not appear to have been designed for a cathedral space, a matter to be discussed later.[4]

Where was the Tapestry actually designed and made? Was it created by a Norman artist and embroiderers in Normandy, as would seem most likely given its subject matter and ultimate location, or was it made in England by native artisans? Strange as it may seem, much evidence has been discovered during the last half century that this monument celebrating the Norman victory at Hastings was not in fact made in Normandy but in south-east England by Anglo-Saxons. This discovery is certainly one of the triumphs of the modern historical method, and a testament to the generations of scholars who have tried to penetrate the darkness surrounding the creation of this great work.

Circumstantial evidence of English origin

The most critical general point is that at the time when Anglo-Saxon women were well known for skills in an art which would later be celebrated throughout Europe as *opus Anglicanum* there was no comparable tradition in pre-Conquest Normandy of embroidery as an art form.[5] Alas, aside from the Tapestry, only fragments remain of what our written evidence suggests was an astonishing output of decorated textiles in 10th and 11th-century England, and no doubt much of the Tapestry's good fortune can be ascribed to the fact that, unlike most of the hangings we read about from this period, it had no gold thread or glistening pearls to tempt the rapacity of later generations.[6]

Texts reveal that embroidery was a skill practised by women of all classes in Anglo-Saxon society and that foreigners spoke most appreciatively of what they saw. A Fleming named Goscelin, who was so sympathetic towards the natives that he became English by adoption, related how the women embellished the garments of princes of the church and of the princes of the realm with gold embroidery. William of Poitiers, a Norman with few kind things to say for a people he found barbaric, none the less lavished praise on the English skill in all the arts, not least upon those women 'very skilled with the needle and in weaving with gold.'[7]

The conquerors acquired many of these precious embroideries for sending abroad and commissioned new ones as well. We read, for instance, in Domesday that an Anglo-Saxon embroideress in Wiltshire named Leofgyth was retained to make gold embroidery for William and Matilda just as she had for Edward and Edith before the Conquest, and that in her will, Matilda spoke of another Anglo-Saxon needlewoman at Winchester who was making a chasuble at her behest.[8]

In addition to lavish gold and jewelled ecclesiastical objects, textile hangings portraying contemporary military heroes were also made in late Saxon England.

Ælfflaed, the widow of an East Anglian leader and hero named Brythnoth who was immortalized in the Anglo-Saxon poem *The Battle of Maldon*, presented the monastery of Ely with a tapestry commemorating her husband's deeds.[9] If Odo was in fact the patron of the Bayeux Tapestry, a factor in his decision to commission such an embroidered narrative of the Conquest might have been that he had seen some such hanging as the one at Ely depicting the epic deeds of Anglo-Saxon heroes in battle.

Internal clues: words and 'quotations'

We need not rely on circumstantial evidence alone to help locate where the Tapestry was made, for clues within the work point unmistakably to English workmanship. First, Anglo-Saxon forms of lettering and spelling leave little doubt that English workers were engaged in its manufacture.[10] Could anyone but an English-speaking clerk have spelt the name of Gyrth (Plate LXIV) with a barred D (Ð) for TH, a form of the Runic letter *thorn*, or set down AT HESTENGA-CEASTRA (Plates XLIX-L) with AT for *ad* and CEASTRA for *castellum*?[11] Edward the Confessor appears twice as EADWARDUS instead of EDWARD, and William the Conqueror appears in different spellings, but only three times is the Norman form of *Wilgelm* used compared with fifteen instances in the way it is found in Anglo-Saxon texts, *Willelm*.[12]

Second, a comparison of the Tapestry's figures with those in contemporary English and Norman art has yielded a great deal of impressive, indeed, astonishing evidence in favour of an English provenance. Even though only a tiny amount of Anglo-Saxon textiles and wall murals remains, we do have a significant number of English manuscripts with pictorial art. The late Francis Wormald, distinguished palaeographer and historian of illuminated manuscripts, was the first to note a significant number of parallels between figures in the Tapestry and images in pre-Conquest English manuscripts. Although Wormald added the proper cautionary reminder that any argument in favour of the Tapestry's English origin based upon style alone would be weakened by the fact that Norman manuscripts in the last half of the 11th century were deeply indebted to Anglo-Saxon influences, his pioneering demonstration of not just stylistic affinities between the Tapestry and Anglo-Saxon manuscripts, but of closer ties – what might be called visual 'quotations' from Anglo-Saxon books – has been enriched and broadened by subsequent research. Lending credence to the view that the Tapestry's master artist had been familiar with these Anglo-Saxon manuscripts was the fact that they were not scattered throughout the land but located in one place, Canterbury.

Wormald pointed out, for example, that the Norman marauder carrying what appears to be a coil of rope on his shoulders in the scene where Normans forage for food on their arrival at Hastings seems to be a quotation of a figure personifying Labour in an 11th-century version of the *Psychomachia* of Prudentius, an allegorical poem about the battles between virtues and vices. A tell-tale clue to the fact that the artist had access to English models of this much-copied late classical book is that only a Canterbury manuscript of the Prudentius has this peculiar substitution of a coil of rope for the prototypical boulder carried by Labour (Plates 2, 3).[13]

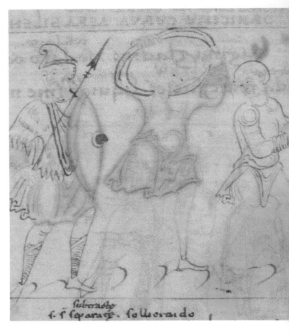

2 (*left*) Norman forager. From the Bayeux Tapestry, Plate XLV.

3 (*above*) Labour and other allegories. From Prudentius, *Psychomachia*, Christ Church, Canterbury, late 10th century; in the British Library, Cotton MS Cleopatra C.VIII, f. 27.

A second example adduced by Wormald was the bird slinger in the lower border of the Tapestry, a figure whose gestures and sling, including the tassel on the end, are almost identical to those in a depiction of Abraham with a slingshot in the Ælfric Hexateuch, a richly illustrated Old English paraphrase of portions of the first books of the Bible (Plates 4, 7).[14]

Since Wormald's astonishing revelations of the Tapestry artist's apparent indebtedness to Canterbury manuscripts, scholars have found additional evidence confirming his fundamental point. For example, the same mid-century Ælfric

4 Abraham as a bird slinger. From the Ælfric Hexateuch, St Augustine's Abbey, Canterbury, mid-11th century; in the British Library, Cotton MS Claudius B.IV, f. 26v.

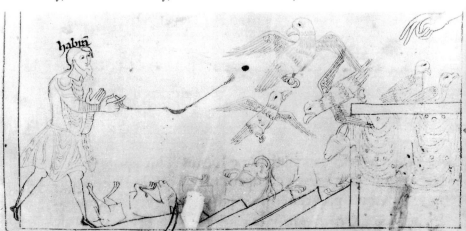

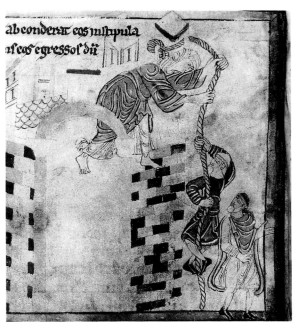

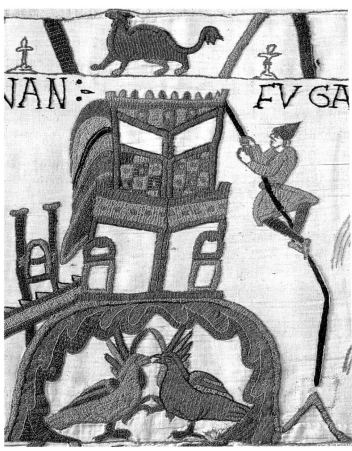

5 (*above*) Rahab lowering Israelite spies from the walls of Jericho. From the Ælfric Hexateuch, St Augustine's Abbey, Canterbury, mid-11th century; in the British Library, Cotton MS Claudius B.IV, f. 141v.

6 (*right*) Conan escaping from Dol. From the Bayeux Tapestry, Plate XXI.

manuscript has two other figures which correspond with distinctive men in the Tapestry. Compare the famous scene in the Tapestry of Conan escaping from Dol by sliding down a rope with another escape scene from the Book of Joshua in the Ælfric Hexateuch (Plates 5, 6). In the Joshua story the Israelite being let down a rope from the top of a building by a harlot so that he could escape troops dispatched to capture him wears a short skirt, is mid-way down the rope, and has his legs crossed in the same balletic manner as does Conan. There is also an evident fascination with patterned façades in both works.[15]

7 Bird slinger. From the Bayeux Tapestry, Plate XI.

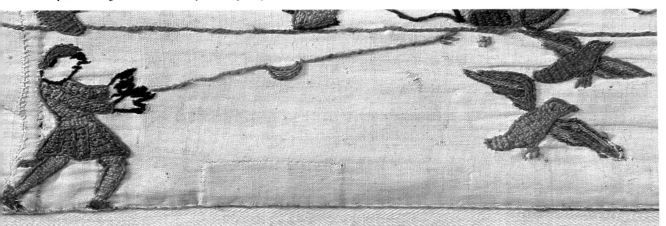

8 Servant carrying a bowl and napkin. From the Ælfric Hexateuch, St Augustine's Abbey, Canterbury, mid-11th century; in the British Library, Cotton MS Claudius B.IV, f. 57v.

9 (*above right*) Council in front of a pedimented building. From the Utrecht Psalter, Reims, *c.* 820; in Utrecht, the Bibliotheek der Rijksuniversiteit, MS Script. Eccl. 484, Psalm 57 (58), f. 32v.

Another memorable figure from the Tapestry is the servant at the Norman feast who carries a bowl in one hand while draping a long thin napkin over the other. In the Ælfric manuscript there is a servant waiting on a table who is very much like this Tapestry figure even in the way his napkin terminates in two points (Plate 8: compare Plate 17, page 48).[16]

What of other manuscripts that can be assigned with reasonable certainty to Canterbury at the time of the Conquest? The most celebrated is the Utrecht Psalter, then located in Canterbury where it was much admired and even faithfully copied. This masterpiece of the Carolingian revival of Roman culture is filled with classical motifs, personifications and building types. If we ask where the Tapestry artist might have found inspiration for a certain curious non-medieval architectural form he has placed in medieval Normandy, we have but to turn to the first page of the Utrecht Psalter, or of its Anglo-Saxon copy. Compare the little pavilion, sometimes identified as a summer house or Temple of Love, which William's messengers gallop past on their way to gain Harold's release from Guy, with a very similar looking structure in the Utrecht Psalter (Plates 11, 12). Although admittedly more complicated than the pavilion in the Tapestry, it seems quite likely that here is the model for a classical building surprisingly situated by the Tapestry artist in 11th-century Normandy. Even the Psalter's fleur-de-lis finial has been retained.[17]

A second simplified classical form in the Tapestry can also be traced to the Carolingian Psalter. When William, Odo and Robert decide to build the first Norman castle in England their meeting takes place rather incongruously within

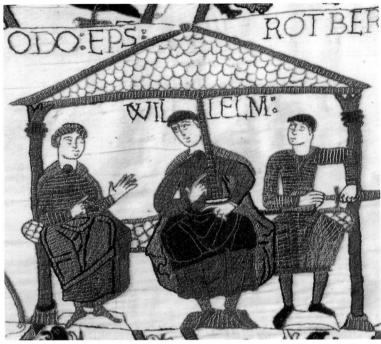

10 (*right*) Council in front of a pedimented building. From the Bayeux Tapestry, Plate XLVIII.

a pedimented structure. For a possible source of this most unmedieval building type, compare the Psalter's rendering of Psalm 57, where a group of officials, also located on a common cushioned seat, are situated in front of a pedimented building (Plates 9, 10).[18]

There is also a possibility that an obscure element of the Utrecht Psalter's iconography for Psalm 2 was used by the artist in one of the Tapestry's most important scenes, the depiction of the death of Harold. Consider an image from Psalm 2 in the English copy of the Carolingian Psalter alongside what is perhaps the most famous, certainly the most controversial, depiction of Harold in the Tapestry (Plates 13, 14).[19] We have in the Psalter illustration a warrior being struck by an arrow, while bracing himself against a rocky outcrop. Resting on his shield, he clutches his broken lance in one hand while attempting to pull an arrow out of his head with the other. If one juxtaposes this wounded figure with Harold pulling an arrow out of his brow in the Tapestry, it appears that the Tapestry artist knew of this apparently unique figure and used him as a model for Harold in his death scene: both hold a lance and a shield in the left hand, while with the right both try to extricate an arrow from the head.

As a final example of how the Tapestry artist seems to have used Canterbury manuscripts as a thesaurus of models for some of his compositions let us turn to the carefully arranged Norman feast scene. It has long been noted that this celebratory feast, despite its appearance of being as contemporary and secular as the preparations for the meal, is actually based on a centuries-old religious prototype. If we turn to depictions of meals in early medieval manuscripts, the

11 (*left*) Circular pavilion. From the Bayeux Tapestry, Plates XI and XII.

12 (*above*) Circular pavilion. From the Harley Psalter (the first English copy of the Utrecht Psalter), Canterbury, *c.* 1000; in the British Library, Harley MS 603, Psalm I, f. I v.

Bayeux Tapestry artist's dependence on a religious model is unmistakable. Compare the Tapestry meal with a Last Supper illustration in the 6th-century Italian manuscript known as St Augustine's Gospels that was believed to be one of the books given by Pope Gregory the Great to St Augustine in 597 at the start of his mission to convert the Anglo-Saxons. Later in the Middle Ages it was preserved at the abbey he founded in Canterbury (Plates 17, 18 on pages 48 and 49). Both Odo and Christ are in the same central position with the diners facing towards them while placing one arm on the table. Both circular tables are shown without legs and are cut off by the lower margin. Both Odo and Christ have identical gestures, and, as the Tapestry inscription makes clear, Odo blesses both food and wine. The borrowing from some such model is clear; indeed, years ago Laura Hibbard Loomis pointed out the dependence of this scene upon a religious prototype, perhaps this very manuscript.[20] If so, both the general composition of the feast scene and the servant could reasonably be attributed to manuscripts believed to have been located at St Augustine's Abbey, Canterbury.[21]

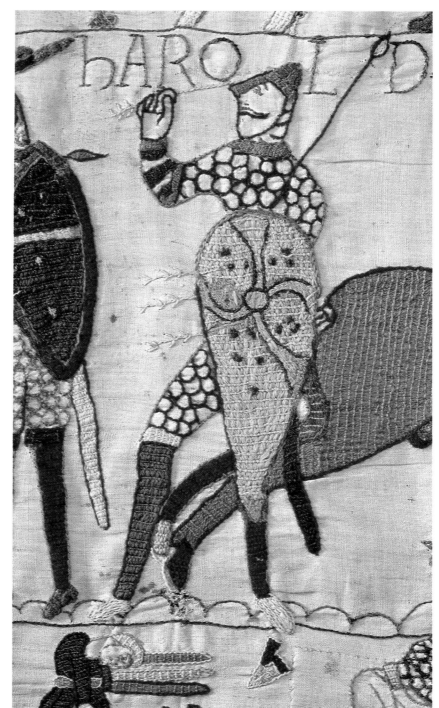

13 Detail: Harold struck by an arrow. From the Bayeux Tapestry, Plate LXXI.

14 Warrior struck by an arrow. From the Harley Psalter, Canterbury, *c.* 1000; in the British Library, Harley MS 603, Psalm 2, f. 2.

To summarize these findings. The following are the manuscripts that are generally accepted as being in the possession of Canterbury monasteries at the time of the Conquest along with the figures in them which appear to be the source of distinctive, often incongruous figures in the Tapestry:

1. *Prudentius 'Psychomachia':* the quirky personification of Labour shouldering a coil of rope.

2. *Ælfric Hexateuch:* Abraham as bird slinger; the Israelite escaping down a rope; the servant with the bowl and long napkin.

3. *Utrecht Psalter* and its English copy, the *Harley Psalter:* distinctive classical architectural forms (the circular pavilion and the pedimented façade); the image of a warrior pulling an arrow out of his head.

4. *St Augustine's Gospels:* unique rendering of the Last Supper.

Clearly a significant amount of evidence has accumulated to substantiate Wormald's hypothesis that Canterbury was the most likely site in England to create such a work as the Bayeux Tapestry. While it is puzzling that more visual 'quotations' from Canterbury manuscripts have not yet been located, still, the eight noted above are eight more than connect the Tapestry with any other location, in England or on the Continent.[22]

Norman illumination

Can we be reasonably certain that the designer was English or is there a possibility that he was a Norman who visited Canterbury and either remained there or returned home to make the cartoon for the Tapestry? Three points make it most improbable that the artist was Norman. First, there are the English spellings in the inscriptions. Second, as we shall see in discussing the 'politics of art,' the iconography appears at times to lean towards an English interpretation of events, indeed towards an interpretation known to us from an English Canterbury monk that is very different from that espoused by Norman authors. Third, it is of fundamental importance that nothing in pre-Conquest Norman art anticipates a work like the Bayeux Tapestry.

What were Norman illuminated manuscripts like? Compared with what was being created in Anglo-Saxon *scriptoria*, 11th-century Norman manuscripts were a marvel for accuracy of text, regularity of script and layout, and easy legibility.[23] But what about the illustration of these more accurate, more legible texts? Here one finds a major difference between English and Norman books that is central to any question about the genesis of the Bayeux Tapestry. While pre-Conquest monasteries in England were producing sumptuous Latin and vernacular books containing dozens or even hundreds of pictures, as well as the elaborate initials so favoured at all times during the Middle Ages, Norman scribes were mainly content to decorate their texts with intricate initials and portraits of the authors, if they embellished the text at all.[24]

As an example of the Norman approach, let us look briefly at the appearance of books made at the cathedral monastery of Christ Church, Canterbury, in the years 1070-1100. These books were made by Norman scribes brought over by the new archbishop, Lanfranc, as part of his more general programme for reforming

15 (*left*) Norman initial B. From St Augustine, *Commentary on the Psalms*, Christ Church, Canterbury, *c.* 1070-1100; in Cambridge, Trinity College, B 5 26, f. 1. 16 (*right*) Anglo-Saxon initial B. From a psalter, probably Winchester, *c.* 980; in the British Library, Harley MS 2904, f. 4.

(i.e., Normanizing) native ecclesiastical culture. Eight volumes written at that time are still extant. In these eight books there is a total of only nine illustrations, and these nine are almost all in the form of decorated letters. For comparison, the Harley Psalter's English artists had copied dozens of pictures from the Carolingian prototype, and the highly original Ælfric Hexateuch, admittedly a very profusely illuminated manuscript even by Anglo-Saxon standards, has 394 illustrations in varying states of completion.

Since the decorated letter was the characteristic form of Norman pictorial art, let us look at one of the more elaborate of these 'Lanfranc' initials with a comparable English one of an earlier date. Some crucially important distinctions between Norman and English art will be apparent (Plates 15, 16). Both are renderings of the initial B, a favourite letter in medieval illumination since, as here, it opens the first verse of the Psalter, *Beatus vir*, 'Blessed is the man. . . .' Both are intricate constructions. In the English case the letter is made of panels framing acanthus leaves, abstract interlace and vine tendrils that curl in a three-dimensional manner. A powerful lion's mask holds the bows of the letter together.

The format and style of the Norman B, while obviously a pale derivative of the Anglo-Saxon tradition – as seen in the simplified acanthus leaves set into panels, the vegetation, here flat and rather limp, and the tiny lion's head – none the less adds a feature not found in the English example, or, for that matter, in most letters created by Anglo-Saxon artists: human figures illustrating the text.[25] In this case

47

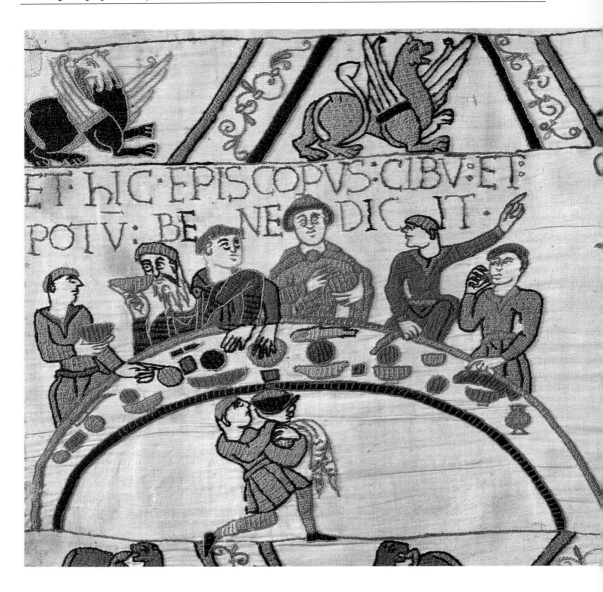

we find King David seated in the upper bow on a bench, while a dove, personifying the Holy Spirit, enters near the curtain hanging from the letter. Below is a musician playing a rebec while another figure juggles knives. It is noteworthy that while no letter containing figures like this is known to have been made in Anglo-Saxon England, this particular iconography does appear to have been derived from English models. Compare the 'Lanfranc' letter with a full-page illumination from an English manuscript of about 1050. The Norman-trained artist seems to have adapted his iconography from some such Anglo-Saxon manuscript, leaving out two figures and miniaturizing the others, so that figures from a full-page composition would fit within the bows of the letter B (Plate 19).

Taking this letter as representative of the type, not the quality, of manuscript illumination practised by Normans at the time of the Conquest, Norman pictorial

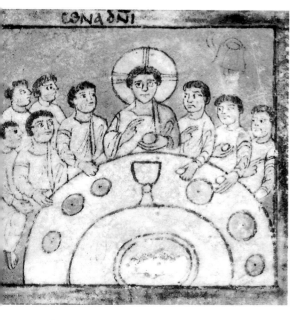

17 (*far left*) Norman feast. From the Bayeux Tapestry, Plate XLVIII.

18 (*left*) The Last Supper. From *St Augustine's Gospels* (a 6th-century Italian manuscript, probably kept at St Augustine's Abbey, Canterbury for the rest of the Middle Ages); in Cambridge, Corpus Christi College, MS 286, f. 125r.

19 (*left*) David playing his harp, with musicians, a juggler and the Holy Spirit. From an Anglo-Saxon psalter, Winchester, *c.* 1050; in the British Library, Cotton MS Tiberius C. VI, f. 30v.　**20** (*right*) Norman letter B with scenes from the life of David. From St Augustine, *Commentary on the Psalms*, St-Evroul, early 12th century; in Rouen, the Bibliothèque Municipale, MS 456, f. 1.

art can be characterized by (1) a dependence on Anglo-Saxon models and (2) a preoccupation with initials at the expense or relative absence of large-scale, major picture cycles. What was novel was the impulse to inhabit the initials with figures placed against a strongly coloured, often harsh background. While these new emphases in Norman book production would eventually enrich English art and lead to such masterpieces as the Bury and Lambeth Bibles of the 12th century, in the short run they were only gradually absorbed. They certainly did not lead to a work like the Bayeux Tapestry.

There was also an attitude towards space in Norman illumination which was totally at variance with ideas found in pre-Conquest English manuscripts and in the Tapestry. One very rarely finds in English art an instance of the Norman fascination with entangling figures in a maze of vines and branches. A splendid example of the Norman style is found in a manuscript of Augustine's *Commentary on the Psalms* written and illustrated at St-Evroul in Normandy.[26] Here one inhabited initial contains no less than three episodes from the life of David, and all are situated in a labyrinthian environment (Plate 20).

Much favoured in Norman art, this entanglement of figures within a letter was destined to have a profound impact on post-Conquest English manuscripts and on Romanesque and Gothic art in general.[27] Yet, while important for the future, such an attitude towards picture space, aptly characterized as 'interwoven' in contrast to the fluid space found in classical and in much Carolingian art, did not, indeed, could not, lead to telling a story in the spacious, continually unfolding manner of the Bayeux Tapestry. 'The very nature of this system precluded the rise of narrative art. . . . How could stories be understood if they had to be read between the windings of twisting coils, or if they had to be pieced together like a charade from elements hidden in the meshes and inlets of an ornamental thicket?'[28]

* * *

There are thus many compelling reasons for saying that the Tapestry was made in England and that the master artist was creating within an English tradition: Anglo-Saxon spelling and word forms appear in the inscriptions; Canterbury manuscripts seem to be the source for distinctive figures in the Tapestry; Norman culture had neither a tradition of artistic embroidery nor of pictorial narration comparable with those in England. Within England, the fact that Canterbury is the most likely place of origin should not surprise us, since it was far and away the country's most important centre for the pictorial arts. In the making of illuminated books, 'from 1070 until about 1120 the field was dominated by the two houses at Canterbury'.[29]

In conclusion, let us not forget that Canterbury was also the territorial and personal base of Odo's feudal power in England. As earl of Kent, he was the largest landholder around Canterbury and it was in this important south-eastern county that he had many vassals, including Turold, Wadard and Vital. That these three men, identified by name in the Tapestry, were also vassals of the great Canterbury monasteries is yet another piece of evidence pointing to Canterbury as the Tapestry's place of origin.[30]

CHAPTER III

Canterbury: from Anglo-Saxon to Norman

THE TAPESTRY AND THE CANTERBURY COMMUNITIES

Judging by visual affinities between figures in the Tapestry and figures in manuscripts at the two great monasteries in Canterbury, the master designer of the Bayeux Tapestry must have been a monk, or a layman quite familiar with monks, in that cathedral city. Can we tell with which monastic community he might have been affiliated while making the Tapestry? If one asks which house possessed the manuscripts identified above as likely models for 'visual quotations', while two (the Ælfric Hexateuch and St Augustine's Gospels) have been associated only with St Augustine's, no clear answer is possible since the collection of the cathedral library seems to have been involved as well.[1] Anyway, since the two monasteries were only a few minutes' walk apart (see Plate 21), such visual evidence would not be conclusive unless it were overwhelming and unambiguous, which is not the situation here.[2]

A stronger case can, however, be made for one house, St Augustine's Abbey, on two other grounds: the persistence of pre-Conquest ways of making illuminated books into the Norman period, and that monastery's close connections with Bishop Odo. Let us take each in turn.

Very slow to change was the manner in which the Anglo-Saxon monks at St Augustine's wrote and illustrated books while under Norman rule. Whereas on Lanfranc's arrival at Christ Church immediate change in something so fundamental as styles of writing takes place, the handwriting undergoing a sudden shift from the rounder Anglo-Saxon hand to a closely-written angular Norman style, at St Augustine's the handwriting remains predominantly Anglo-Saxon until the end of the century, and even into the beginning of the 12th.[3] The Old English language also remained current at St Augustine's.[4] Novelty did arrive in the illuminations, for the Norman taste for decorating initials had impact here as elsewhere, but the manner of treating figures and space within those historiated initials is purely Anglo-Saxon. A splendid example is found in a manuscript presently in the British Library that was made about 1110 at St Augustine's. In this *Passionale*, or collection of the Lives of the Saints, each saint's life is introduced by a decorative initial. Plate 22 (page 53) shows a letter T containing illustrations of the life of Saint Caesarius, a deacon from Africa martyred in 300 at Terracina in Italy for speaking out against the practice of pagan sacrifice. With great ingenuity the artist has compressed a sequence of narrative scenes into the panels and roundels of his letter form. At the top (centre) the haloed saint watches a

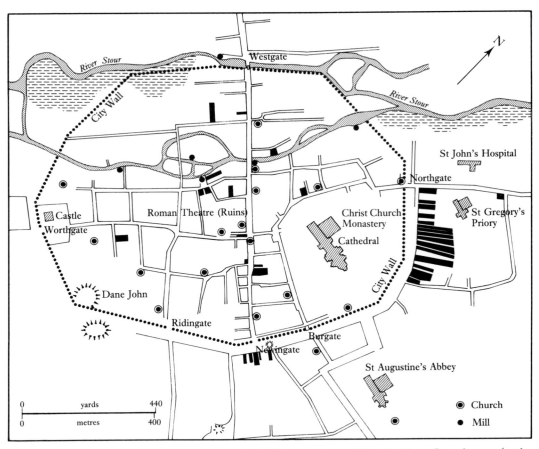

21 Canterbury, showing the sites important in Anglo-Norman times. After W. Urry, *Canterbury under the Angevin Kings*, 1967.

sacrifice; Lucian, the victim, first sacrifices in a temple on the left and then rides to the top of a mountain to hurl himself from its summit, a human sacrifice in honour of Apollo. At right, spectators watch, and at the bottom, Caesarius is first condemned for sorcery and then thrown into the sea in a sack.

A number of points about this illumination from St Augustine's Abbey relate to our inquiry about the origins of the Bayeux Tapestry. The Norman preoccupation with the initial is here joined with the Anglo-Saxon ability to narrate a story in open space. Figures do not have to cut their way through branches or climb over any entangling vines. Second, the viewer reads sequential stages of an action rather than just emblems of different activities, as was the case above in the initial from St-Evroul depicting three scenes from the life of David (Plate 20). Third, the lively narrative style found in this life of Caesarius has clear affinities with the style of the Tapestry.[5] As in the Tapestry, the men and horses are drawn in a vigorous, animated fashion. Both works show a predilection for falling figures, with Caesarius' horse, his tail and feet in the air, being particularly well drawn, as is Caesarius himself tumbling head first while clutching his spear, his shield falling freely ahead of him.[6] Both works also employ an interaction between marginal and main scenes, with the action either spilling out over the framing lines,

or figures from the bounding areas moving into the main scenes or looking on at what occurs there.[7] As we shall see, all of these features are shared by the Tapestry and all have Anglo-Saxon precedents.

Another set of promising clues as to which house might have been associated with the creation of the Tapestry concerns the personal relations enjoyed with each community by the man thought to be the patron. Here the evidence is less ambiguous than it was in the case of the manuscript quotations. As we have seen, starting with the trial on Penenden Heath in 1072, Odo was involved in prolonged litigation with the cathedral community at Christ Church over lands which he and his tenants had usurped in the scramble for wealth after 1066. As initiator of this effort to regain cathedral property from the bishop of Bayeux and his vassals, Archbishop Lanfranc, who was also the head of the monastic community at Christ Church, emerges at this trial in clear opposition to Odo. This is a role Lanfranc will maintain for the rest of his life. In 1082, Lanfranc again led an attack on Odo, when he advised the king on how to circumvent the prohibition against imprisoning an ecclesiastic ('arrest the earl not the bishop'). Odo was imprisoned until William's death five years later, at which point Lanfranc became the close adviser to William Rufus when that young king needed his help in crushing a baronial rebellion led by Odo in favour of Robert Curthose. Given this pattern of legal and political opposition to the bishop of Bayeux, which must also have involved a fundamental difference in outlook on what constituted the proper ecclesiastical life, it would be most unlikely that Lanfranc would have tolerated

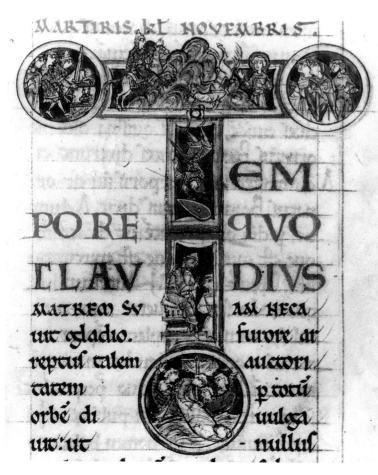

22 Letter T containing scenes from the life of Saint Caesarius. From *Passionale*, St Augustine's Abbey, Canterbury, *c.* 1110; in the British Library, MS Arundel 91, f. 188.

53

the manufacturing of a monument glorifying Odo and his men within the walls of his cathedral community.

On the other hand, St Augustine's Abbey appears to have enjoyed much better relations with Odo and his vassals. Two of Odo's knights mentioned in the Tapestry, Wadard and Vital, also held lands of St Augustine's.[8] There were disputes about land, to be sure, but there are also records of gifts and favours bestowed by Odo on the abbey.[9] After Odo's death, his benefactions were remembered with gratitude by at least one St Augustine monk when composing a list of donors to be commemorated.[10]

NORMANIZATION AND RESISTANCE IN POST-CONQUEST CANTERBURY

It is thus probable that the master artist of the Tapestry was more closely linked with St Augustine's than with the cathedral monastery of Christ Church. Yet, since the two were so close together, and since the artist seems to have had access to both libraries, if we wish to know how life at St Augustine's after the Conquest might have had a bearing on the creation of the Tapestry, we really need to look briefly at both great monastic communities. In each case we will first see some of the major changes forced by the newcomers on English ecclesiastical and cultural life, and then some of the tensions which resulted.

Christ Church

At the time of the Conquest, Canterbury was the most important centre of religious and cultural life in England.[11] When William landed at Pevensey, Christ Church, like most English religious houses except for the Confessor's own favourite at Westminster, was staffed and led by Englishmen.[12] To assure the loyalty of the monasteries and of the church in general – institutions which controlled much of the landed wealth of the country as well as its ideas and sentiments – and to carry on in England reforms which had been begun in Normandy, the Conqueror hastened to replace any rebellious or even neutral leaders. The result: within a year of his death in 1087 only one of the twenty-odd English monasteries about which we have information still had an English abbot.[13]

The leadership of the monastic community at Christ Church, vested in the archbishop, was Normanized within four years of the Conquest. After Archbishop Stigand was deposed in 1070 William hastened to secure the election of his trusted adviser and friend, Lanfranc. One of the great men of his age, Lanfranc was a successful north Italian lawyer who travelled over the Alps to Normandy and became, in turn, a monk at Bec, a hermit, a distinguished teacher and writer, a counsellor to Duke William, the first abbot of his great new monastery of St-Etienne in Caen, and ultimately primate of all England.[14]

1. Architectural and religious reform

What William of Malmesbury would write in the 1120s of the impact of the new Norman churchmen on the English church in general was true to a special degree at Christ Church, Canterbury: 'With their arrival the Normans breathed new life into religious standards, which everywhere in England had been declining, so that

now you might see in every village, town and city churches and monasteries rising in the new style of architecture.'[15] A new art and architecture, an active programme of religious reform, and the Norman Conquest were all intimately bound up with Lanfranc's tenure as archbishop of Canterbury.

Immediately on his arrival, Lanfranc set about rebuilding a cathedral and monastery which had burnt down a year after the Conquest. In the remarkably short space of seven years a Saxon cathedral which was arranged in some respects like Old St Peter's in Rome was replaced by a building whose plan was modelled on those of Norman abbeys. Even its dimensions were a virtual copy of those at St-Etienne in Caen, the abbey founded by Duke William and to which he had appointed Lanfranc as abbot in 1066.[16]

Along with these material changes, the new church leaders also wanted to reform English church life by restoring monastic discipline and bringing observance into line with customs in Normandy.[17] That the Normans found much in Canterbury to shock them is well attested. For example, Eadmer, a Canterbury monk of English parentage and sympathies whose writings from the first decade of the next century are our most valuable source for the transition from Saxon to Norman Canterbury, recalled what Christ Church discipline and *mores* were like when he was a boy early in Lanfranc's tenure. Before reform could take hold, his English brothers lived the lives of earls rather than monks, 'in all worldly glory, with gold and silver, with changes of fine clothes and delicate food, not to speak of the various kinds of musical instruments in which they delighted, nor of the horses, dogs, and hawks with which they sometimes took their exercise.'[18] Assuming that this characterization of the worldly life enjoyed by Christ Church monks in the 1070s is not too exaggerated, and that these words could also have aptly characterized conditions a few hundred yards away at St Augustine's Abbey, Canterbury appears to have been not only a religious community in need of reform, but one eminently suited to create a worldly triumphal monument like the Bayeux Tapestry.

2. Lanfranc and Christ Church Library: texts and images

Norman church leaders brought new currents of intellectual life from the Continent to English monasteries. For example, Lanfranc and the monks he brought with him from Bec and Caen set about improving the Christ Church Library, introducing books that reflected their interest in the writings of the fathers of the church, Augustine, Jerome and Ambrose, or in the novel theological or philosophical activities which were then energizing intellectual life in northern France.[19]

If content was different, so was appearance. A Christ Church monk would have found that the manuscripts brought by Lanfranc to England or the new ones made there looked quite different from those already resting in his monastic library:

In every way the books of the new library are distinguished from the old: they are larger, more handsome, more stately; they are models of accuracy and careful calligraphy even down to the smallest details of punctuation; ... these manuscripts attained a level of beauty and legibility which was never surpassed and not long attained.[20]

What about illustrations in these more accurate, more legible texts? As previously indicated, while English books might contain dozens or even hundreds of pictures, as well as the elaborate initials so favoured at all times during the Middle Ages, Norman scribes were mainly content to decorate their texts with portraits of the authors or the kind of intricate initial from St-Evroul illustrated above (Plate 20, page 49), if they embellished the text at all.

3. Tensions

Great changes were made, but the new order engendered bitterness and conflict. Given the fact that Lanfranc brought over perhaps only a dozen foreigners to a house inhabited by thirty to forty Englishmen, this was bound to happen.[21] Strains naturally developed in a community made up of men who did not speak the same language. There was the incident of a young English monk, Ægelword, who went mad while serving at mass and threatened to expose widespread homosexual activities among the monks. Eadmer observed that as the monks stood around the poor frenzied sufferer, some spoke French which the English monks could not understand, and that the young monk was ultimately thought to have had a miraculous cure when he not only understood what the French were saying but could outdo them with a pun in their own *Francigena lingua.*[22] Incidental references reveal Lanfranc himself occasionally recoiling from the prospect of dealing with the natives in an unknown tongue, and Anselm consoling the archbishop's nephew on being sent to St Albans to live among uneducated natives.[23]

Another point of tension was the disrespectful attitude shown by Lanfranc, and many Norman abbots, towards the old English saints. The newcomers were sceptical of their alleged saintliness, partly because of their 'uncouth' names, partly because the only saints' Lives were written in Anglo-Saxon and therefore unintelligible to the Normans. Thus, the new abbot of Abingdon refused to allow any feast of St Æthelwold or St Edmund on the grounds that the English were boors. When Lanfranc's nephew arrived at St Albans he slighted the tombs of his predecessors, referring to them as uneducated simpletons.[24] At Evesham, Abbot Walter, acting on Lanfranc's advice, examined all the relics and put doubtful ones to the test: a kind of ordeal by fire.[25]

In Canterbury, while making changes in the rituals at Christ Church, Lanfranc cast doubt on the traditional calendar, suppressing some festivals, slighting the great St Dunstan, and showing particular concern about the presence of Ælfheah, an archbishop killed by the Danes in 1012, and revered by Christ Church monks as a martyr.[26] Lanfranc's scepticism as to whether Ælfheah was truly a martyr persisted until his scruples were answered by Anselm on a visit to Canterbury around 1080, and eventually Lanfranc seems to have learned to appreciate his Anglo-Saxon predecessor, for in his listing of all the principal feasts of the church, the celebration for the originally suspect Ælfheah appears very high.[27]

Thus, ultimately, the hostilities at Christ Church evident in the first years after the Conquest were resolved, but during those early years mutual suspicions and the inability to communicate deeply felt feelings made for tense situations between Normans and Anglo-Saxons. Despite the fact that all of these men were

Benedictine monks, there were major differences in language, race, historical traditions and even religious practices. The extent to which the English monks attempted to preserve a continuity with their past and a sense of their own dignity in the face of Norman disdain for their traditions is not well documented. In this regard, it is an interesting phenomenon, and one not sufficiently investigated, that some of the saints to which the English most tenaciously held in those difficult years were 'martyrs' killed by Norse invaders. Perhaps historians should inquire if such determination is not a form of 'national' resistance, similar to the cultural and national resistance displayed by the church of Poland in our own time.

St Augustine's Abbey

Most of the same directions of change which we have observed at Christ Church were also taking place at the other important Canterbury monastic community, St Augustine's Abbey. Like Lanfranc, the new abbot from Mont-Saint-Michel, a Norman named Scotland, undertook a building campaign involving the erection of a larger church that would be sounder and better suited to the liturgy favoured by the Normans.[28] Like Lanfranc, Abbot Scotland also brought over books with which he was familiar for the abbey.[29]

However, what distinguishes St Augustine's Abbey in the years after the Conquest is not its conformity to the usual pattern of Normanization, but its resistance to change. St Augustine's was a house very proud of its past. Buried here were the founders of Roman Christianity in England: St Augustine, the celebrated Roman missionary to England, King Æthelbert, who converted from paganism after receiving Gregory the Great's messenger in 597, and many illustrious successors, both ecclesiastical and royal. A series of charters and privileges, mainly forged in the post-Conquest period, but none the less expressive of attitudes at St Augustine's, emphasized the complete liberty of the house from all outside jurisdiction.[30] They speak, for example, of the abbot of St Augustine's being inferior to no ecclesiastical authority in England, including the archbishop of Canterbury. Reinforcing this sense of importance was the fact that the abbey's wealth was hardly less impressive than that of Christ Church. As Domesday informs us, St Augustine's had an annual income of £635, only £53 less than what was enjoyed by the cathedral monastery.[31]

Resistance to Normanization at St Augustine's

Preserving a continuity with the English past and even deliberately resisting Normanization can be detected in a number of details about life at St Augustine's. We have seen the continuity of Anglo-Saxon calligraphy, language and art into the Norman period. There was also political resistance. As was true elsewhere in 1066, Canterbury church leaders with links to the class of English landowners who were the country's political and military élite took an active part in resisting the invaders. Thus, when the city of Canterbury surrendered peacefully fifteen days after the Battle of Hastings, Abbot Æthelsig of St Augustine's Abbey is said to have organized resistance to William in the Kentish countryside.[32] Also, a martyrology composed at the abbey in the early 12th century has a short but

evocative entry for 14 October that reminds the monks to pray for 'Harold, king of the English, and very many of our brethren'.[33]

Resistance to Normanization at St Augustine's continued, flaring up in a tragic incident shortly after Abbot Scotland's death in 1087. Lanfranc consecrated as his successor a Christ Church monk named Wido (Guy), who, judging by his name, was a Norman. When the archbishop, supported by Odo of Bayeux, arrived to install Wido against the unanimous wishes of the monks, he ordered that anyone who would refuse obedience to the new abbot should leave his presence. When all of the monks left the monastery, the new abbot had to be installed in an empty church. To show his authority, Lanfranc then transferred several of the monks and their prior to Christ Church, while the ringleaders were imprisoned in the recently erected Norman castle. The remainder, after some initial refusal, did return to the monastery and solemnly swear obedience to their new abbot on the body of St Augustine. Those who remained obstinate were then plucked by Lanfranc from Canterbury and scattered in monasteries throughout England until they had learned their lesson, at which point Lanfranc brought them back.

But resistance to the new abbot did not cease. Lanfranc called one of the malcontents, Columbanus, before him. 'Would you kill your abbot?' asked Lanfranc. 'Certainly I would if I could,' replied the monk. Thereupon Lanfranc caused him to be tied naked in front of the great door of St Augustine's and flogged while all the people looked on. Columbanus was then driven from the city with a mark of his ignominy, a shaved head. 'Thus,' according to the author of the *Acts of Lanfranc*, a contemporary recital of the archbishop's deeds written by a monk who remains anonymous but appears to have been one of the archbishop's supporters from Christ Church, 'did Lanfranc enforce obedience, and so long as he lived he broke down the opposition of the rest by the dread of his name.'

The matter did not end there, however. In a short time the great archbishop died and open rebellion broke out, with the monks of St Augustine's enlisting the aid of the citizens of Canterbury in their struggle against the new abbot. When an attack was made on Wido in his abbatial lodgings, a scuffle ensued with many on both sides being wounded or killed, and the abbot barely escaping into the safety of the cathedral. As no new archbishop had yet been appointed to replace Lanfranc, the king sent some bishops and nobles to hear the case of the rebellion at St Augustine's Abbey. After investigation, punishment was ordered for the guilty monks: they were to be publicly flogged. But the monks at Christ Church, moved by compassion and a concern that such a public ceremony would cause the people to lose respect for the monastic life and those who followed it, persuaded the bishops that the floggings should take place in the church with only a select few as onlookers. Two monks of Christ Church, Guy and Norman, both newcomers to England, judging by their names, inflicted the punishment on the contumacious English monks of St Augustine's. Then these rebels were dispersed throughout England and twenty-four monks transferred from Christ Church to fill their places. And what of the citizens who had been incited to join with the monks in the attack on Wido? Those who could not prove themselves innocent

were dealt with in the Norman fashion. They were punished by blinding.[34]

Curiously, although we have details on what happened after Lanfranc imposed the new abbot on the community, the sources leave us uncertain as to the motives of the English monks: how much was 'racial' antagonism and how much was a wish by an ancient house to assert its rights to elect its abbot freely is still unclear.[35] What is evident, however, is that the hostility between Anglo-Saxons and Normans, which at Christ Church had apparently reached a reconciliation over the course of Lanfranc's tenure, was at St Augustine's the cause of this tragic conflict.

* * *

Such are some of the changes that altered life in the two ancient Canterbury communities where the master artist of the Tapestry probably worked on his ambitious programme. Would that we could know more. Would that we could also be more precise than simply saying that the artist was *most probably* an English clerk living in Canterbury, *perhaps* at St Augustine's Abbey, who *seems* to have created the cartoon in the 1070s and 1080s for embroiderers who evidently took great pleasure in sewing their *opus Anglicanum*, and that the Bayeux Tapestry was *in all likelihood* commissioned by Bishop Odo; but, for the present, certainty is not possible in such matters. Perhaps it never will be. Still, the evidence upon which the above deductions rest is hardly meagre or inconsistent. To move forward in analysing the Tapestry's style and meaning, to try to solve some of the mysteries of its unusual imagery, one must, I believe, assume that these hypotheses are valid until proved otherwise.

If one makes that assumption, a programme for further investigation becomes clear. What is called for is an attempt to assess the implications of the theory that an English monk, or, less likely, a person on good terms with monks, was the master designer of the Bayeux Tapestry. In a sense, then, the remainder of this book is an attempt to understand the significance of this evidence that the artist of the Tapestry was probably an English monk living at the very centre of England's intellectual and artistic life. Our task will be two-fold. First, we must grasp the deeper implications of a Canterbury provenance for the Tapestry's artistic language – its distinctive style, its use of border imagery, its unusual format. Thus, the remainder of Part One will be concerned primarily with the distinctive visual features of this extraordinary work of art.

Having gained an understanding of the artist's visual language, and of his historical and artistic milieu, we will then turn in Parts Two and Three to the central mysteries of the Bayeux Tapestry's iconography. Why is its account sometimes at variance with contemporary written texts? Why does the Tapestry have messages which are at odds with one another? Why does the artist draw on traditional imagery when narrating contemporary history? To try to solve such mysteries we will raise questions about what an English monk might have thought about having a Norman prince-bishop as his patron, perhaps a monk living in a religious community as resistant to Normanization as St Augustine's Abbey, Canterbury.

CHAPTER IV

The Englishness of the Tapestry: Style

It is certainly ironic that the Norman Conquest was the occasion for the last and most spectacular masterpiece of Anglo-Saxon pictorial art. The unique Anglo-Saxon pictorial style, virtually submerged within a generation of 1066 beneath Continental influences, had given birth to some of the most extraordinary and delightful pictures made during the whole of the Middle Ages. Known to us primarily from illustrated books, of which only a small part of what was originally created survives, these drawings and paintings none the less display a level of excellence and originality which justifies calling the century before the arrival of the Normans one of the great periods of English manuscript illumination.[1]

THE GOLDEN AGE OF ANGLO-SAXON ILLUMINATION (966-1066)

English pictorial art in the century before the Conquest was dominated by two traditions. The first centres on an immensely creative style of outline drawing associated in name and in fact with the celebrated Utrecht Psalter, while the second is a distinctive painterly style linked to the so-called Winchester school. Both begin in the second half of the 10th century as part of the revival of monasticism and learning that followed the terrible destruction of church life by the Vikings, and both reach their apogee in the early to mid-11th century. Promoted by kings Æthelstan (925-39) and Edgar (959-75), and the famous monastic reformers Dunstan (d.988) and Æthelwold (d.984), both the Utrecht and the Winchester styles look abroad to Carolingian art for inspiration, yet both also continue narrative tendencies already apparent in the earliest Christian art created in the British Isles, that from the 7th and 8th centuries, the age of Bede.

The 'Utrecht' style

The first, and perhaps the more important, development in English art in the century before the Conquest that affects the Tapestry's style is the rapid growth of a tradition of drawing associated with that astonishing Carolingian manuscript known as the Utrecht Psalter, so named because of its present location. The manuscript contains an elegantly written Latin translation of the psalms of the Hebrew Bible along with ingenious, captivating and quite unforgettable illustrations. Because it came to England around the year 1000 at a time when native artists were searching for an expressive and lively style similar to that achieved a century and a half earlier by the unknown Carolingian monks of Hautvillers, a monastery near Reims, the Utrecht Psalter was of capital importance for the future of English medieval art.

It is not surprising that a psalter would be an extremely popular book in the Middle Ages, given the fact that the psalms were recited in full by monks in every monastery across Europe during the course of every week, and were also the basis for much private devotion.[2] What is unusual is that one solution to the difficulties of illustrating the text should have so completely captured the English imagination. The compelling attraction of this Carolingian Psalter to artists in Canterbury, where it continued to reside through the rest of the Middle Ages, is evident from the fact that it was copied there on at least three different occasions, each time in the prevailing style of the day.[3]

As literary texts the psalms are not easy material for an illustrator, each one being written in poetry rather than the narrative prose found in most of the Hebrew Bible. The solution chosen by the Carolingian artists was to insert before each psalm rectangular pictures composed of small scenes illustrating some of the verses of that psalm, the whole unified by a consistent style and a single landscape. Clearly poetic language does not lend itself easily to illustration, but the artists who drew these delightfully animated figures imagined how to capture vividly those words and phrases capable of being illustrated. Perhaps the best way to grasp the logic behind the endeavour, which seems to be an attempt to create what have been termed visual 'charades,' is to correlate the text word-by-word with the Psalter's images.[4]

Let us take the illustration of Psalm 103 (104 in the King James Bible), first in the original Carolingian version and then in the earliest English copy, as examples of the unique qualities of the Utrecht Psalter and what it meant to Anglo-Saxon artists (Plates 23, 24 on pages 64 and 65).[5] The psalm is a hymn to the Creator, an exclamation by the psalmist of admiration and praise at the wonders of creation. In the upper part of the picture God is in His heavens:

Verses 1-4

Bless the Lord, O my soul! O Lord my God, thou art very great! Thou . . . who ridest on the wings of the wind, who makest the winds thy messengers, fire and flame thy ministers.	The Lord, a cross-nimbed Christ, holding a book and accompanied by four angels, i.e., His 'ministers,' walks upon 'the wings of the winds,' personified by human heads blowing upon the earth.

Verses 19-20

Thou hast made the moon to mark the seasons; the sun knows its time for setting. Thou makest darkness, and it is night	To the right and left in the cloud-streaked sky are the moon, stars and setting sun, also personified in the classical manner.

Below are shown God's creations on Earth, which the psalmist points to with his left hand while his right is raised towards the Lord:

Verses 8-13

The mountains rose, the valleys sank
 down
 to the place which thou didst appoint
 for them
Thou makest springs gush forth in the
 valleys;
 they flow between the hills,
 they give drink to every beast of the
 field;
 the wild asses quench their thirst.
By them the birds of the air have their
 habitation;
 they sing among the branches.
From thy lofty abode thou waterest the
 mountains . . .

To the left are the valleys and mountains, as well as the springs which run among the hills; wild asses bray and different sorts of beasts of the field quench their thirst in the stream; birds build their nests and sing among the branches, the cedars of Lebanon mentioned in verse 16; water pours down upon the mountains.

Verses 14-15

Thou dost cause the grass to grow for
 the cattle,
 and plants for man to cultivate,
that he may bring forth food from the
 earth,
 and wine to gladden the heart of
 man,
oil to make his face shine
 and bread to strengthen man's heart.

A ploughman with his team of oxen symbolizes the man who cultivates, while men seated at a table set with bread and other foods for what is presumably their evening meal, it being sunset, are served wine by one attendant while another anoints a diner's head with oil.

Verses 20-23

 . . . it is night,
when all the beasts of the forest creep
 forth.
The young lions roar for their prey
When the sun rises, they get them away
 and lie down in their dens.
Man goes forth to his work and to his
 labour until the evening.

To the right the lions pounce on their prey, a goat and a man; on the left, the man working until evening is appropriately placed under the rising moon and stars. One fears for the 'wild goat' raised up on his hind legs feeding in the 'high mountains' (v.18) now that the sun 'knows its time for setting.' (v.19)

Verses 25-26

Yonder is the sea, great and wide,
 which teems with things
 innumerable,
 living things both small and great.
There go the ships,
 and Leviathan which thou didst form
 to sport in it.

The stream-fed sea abounds with creatures, including a sea monster, and two ships.

When we recall that there are 150 psalms in the Hebrew Scriptures, the enormity of the task facing the various artists at Hautvillers must have been staggering. That it was accomplished at all reveals a great deal about the latent energies harnessed to the production of fine books in this, the first cultural rebirth in European history. For the creation of the Utrecht Psalter and the other magnificent books which distinguish the Carolingian age, artists looked for guidance beyond the barbarian art of the Celts and Germanic tribes, highly sophisticated but essentially decorative, to classical precedents. Thus the Utrecht Psalter's script is in Roman capitals written in the traditional way without spaces between the words; there are classical personifications and architectural forms, as well as a lively impressionistic style derived from Hellenistic painting but rendered in sketchy outline drawings.[6]

The Harley Psalter

About a century and a half after being created near Reims the Utrecht Psalter found its way to Canterbury and there began to exert a tremendous influence on Anglo-Saxon art. Responding to the originality and charm of the illustrations, and to the intense animation of the figures, Canterbury artists around the year 1000 studied the Psalter, based their work upon it, and offered the great tribute of making an extremely faithful copy of the original. This first copy, known as the Harley 603, in the British Library, is the work of two scribes and several artists, working at different dates across a hundred year period.[7] Clearly the Carolingian Psalter appealed to something basic in the English temperament of the time: its imaginative, and at times playful, renderings of the literal and figurative language of scriptural poetry must have agreed with their own predilections; its idiosyncratic way of rendering the world in nervous, excited lines must have also been compelling (for why else would one so faithfully copy a unique style?). As can be seen by a comparison of the Harley 603's version of Psalm 103 with that in the original manuscript, the English copy provides an accurate rendering of the iconography, and a reasonably faithful version of the style (Plate 24). Small differences do appear: the English ships are slightly more in the Viking style, and there is more concern with pattern for its own sake, as can be seen by comparing the treatment of the upper parts of the trees. There is, however, one major difference between the two. The drawings done by a quill pen in monochrome ink in the Utrecht Psalter become multicoloured in the Harley 603, the English artists employing a variety of different coloured inks (blue, red, green and black) in what is apparently an Anglo-Saxon innovation in the art of manuscript illumination. Interestingly, the practice of drawing in inks of different colours, so consistent with the early English love of colour and patterning, is quite possibly derived from, or at least stimulated by, the related art of embroidery.[8] The use of these coloured inks in images and texts, applied in an arbitrarily decorative manner, is the distinctive Anglo-Saxon addition to the great Carolingian prototype.[9]

English artists did not merely copy the Utrecht Psalter. Much original drawing, under the influence of the Psalter from Carolingian Gaul, was done as well. From over sixty surviving manuscripts containing Anglo-Saxon drawings two examples must suffice to illustrate how the lively calligraphic qualities of the original were combined with native tastes to create a distinctive English style.

ETMEMORESSUNTMANDA TESUERBUMILLIUSADAU MINATIONESEIUS
TORUMIPSIUS·ADFACIEN DIENDAMUOCEMSERMO BENEDICANIMAMEADN
DUMEA: NUMEIUS

CIII IPSIOAUTO
BENEDICANIMA
MEADÑO DNEDSMEUS PERPENNASUENTORUM A BINCREPATIONETUAFU

23 (*above*) Illustration to Psalm 103 (104). From the Utrecht Psalter, Reims, *c.* 820; in Utrecht, the Bibliotheek der Rijksuniversiteit, Script. Eccl. 484, f. 59v. **24** (*right*) Illustration to Psalm 103 (104). From the Harley Psalter, Canterbury, *c.* 1000; in the British Library, Harley MS 603, f. 51v.

The first is from a Psalter in the Vatican Library made, possibly at Canterbury, for Bury St Edmunds sometime around 1035 (Plate 25). While its linear style is related to that in the Carolingian manuscript, we find to an even greater degree than in the Utrecht Psalter extremely elongated figures animated by dramatic gestures and swinging draperies. In this Bury Psalter, marginal drawings around the text have replaced the unified pictures preceding each psalm, and the iconography, while it sometimes draws upon the Utrecht Psalter, shows many independent and highly original solutions to the problems of illustrating biblical poetry.[10] In this case the pictures do not try to capture each phrase in Psalm 68 but instead all of the illustrations respond to a single idea inspired by verse 18: 'Thou didst ascend the high mount,' a foreshadowing for Christian readers of the ascension of Christ. Angels point on high and the Apostles twist and turn, some craning their necks, others seeming to turn in an ecstatic motion that anticipates the Romanesque sculptures of Moissac and Souillac, while at the top, in an innovative way of depicting the ascension that is distinctly Anglo-Saxon, Christ disappears off the top of the page into the heavens.[11]

What happened to this Utrecht tradition at the Conquest? Evidently the coming of the Normans did not see an immediate end to the interest in these manuscripts or in their style, a point that can be established with some certainty by Canterbury drawings made after 1066, one of which is reproduced, with a detail from the Harley Psalter which might be called its prototype (Plates 26, 27 on pages 66 and 67). At the top of a chronological table is an animated drawing of St Pachomius receiving from an angel a scroll with instructions for finding the correct day on which to celebrate Easter Sunday. If one compares the jagged outline technique used for the clothes of these monks with those of the ministering angels in the

E memoref funt mandatox tef uerbu illiuf ad audien morn loco dominationef
ipfiuf ad faciendum ea dá uoce sermonum eiuf; ei benedic Anima mea dno;

CIII IPSLO AUTO·
RENEDICANIMA tuum; qui ambulaf super stabunt aquae

Harley Psalter, as well as the violently expressionistic large hands, a continuity of
tradition between the St Pachomius drawing and the English Psalter illustration,
which, of course, looks back in turn to the Carolingian exemplar, is apparent.
Certain changes have naturally occurred as well. In the post-Conquest drawing

um difcernit caeleftif regef fup eam
niue dealba buntur infelmon:
monf dei monf pinguif
onf coagulatuf monf pinguif utquid
fufpicamini montef coagolatof
Monf inquo bene placitum eft deo habi
tare inco eccñi dñf habitabit infinem·
urruf dei decem mili b: multiplex milia
latantium dñf meif infyna infancto·
fcendifti inaltum cepifti capturatate·
Accepifti dona inhominibuf·
tenim non credentef inhabitare
dominum deum·
enedic tuf dñf die cotidie pfpum faciam
nob df falutarium noftrorum·
fñt df faluof faciendi
ecdñi domini exituf moftif·
erumptamen deuf confringet capita
inimicorum fuorum uerticem capilli
per ambulantium indelictiffuif·
ixit dñf exbafan conueftam·
conueftam inpfundum marif·
tmtin guatur pef tuif infanguine·

25 Ascension surrounding Psalm 67
(68). From a psalter, Bury St Edmunds,
second quarter of the 11th century; in
Rome, Vatican City, the Biblioteca
Apostolica Vaticana, Reg. Lat. 12,
f. 73v.

65

26 St Pachomius receiving the Easter Tables. From Christ Church, Canterbury, *c.* 1073; in the British Library, Cotton MS Caligula A.XV, f. 122v.

there are marked tendencies towards exaggeration, as in the treatment of the rounded shoulders and protruding heads, and in the sudden shifts from very delicate to very thick pen strokes.

Another post-Conquest work which we find influenced by the Utrecht tradition is, of course, the Bayeux Tapestry. Despite obvious differences occasioned by a shift in medium from pen and ink to needle and thread, the Tapestry continues the Utrecht style of extremely active, animated figures who make their points with dramatic gestures. The Tapestry also uses a technique of coloured outline and lettering within a limited colour range that reminds one of the Harley Psalter. Then, too, one notes that in the Tapestry, particularly in the famous Ælfgyva scene and in the comet episode, there are marginal illustrations which appear to be pictograms not unlike those found in the Utrecht Psalter's rendering of biblical imagery. It is also interesting that the Tapestry even borrows certain late Utrecht-tradition mannerisms manifested in the drawing of Pachomius receiving the Easter Tables. Compare, for example, the exaggerated posture and gesticulation of Harold and his attendant returning to England from the fateful journey to Normandy with the rendering of Pachomius and his fellow monks made in Canterbury a few years after the Conquest (Plates 26, 28).[12] In both cases we meet the distinctive rounded shoulders and extraordinarily large open hand; in both we find a treatment of the head characterized by unusually large, square jaws. Evidently, the Utrecht style, though in a mannered fashion, did not cease with the coming of the Normans to Canterbury.[13]

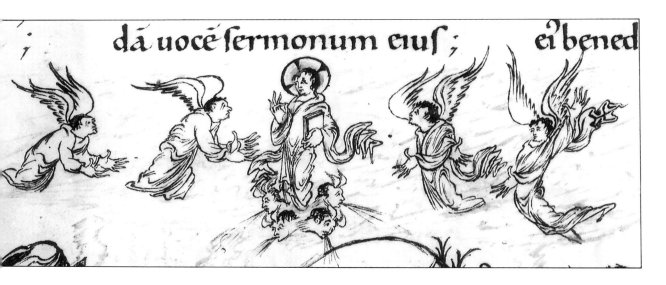

27 Detail: ministering angels from Psalm 103 (104). From the Harley Psalter, Canterbury, *c.* 1000; in the British Library, Harley MS 603, f. 51v.

The 'Winchester' style

The second main tradition of Anglo-Saxon art during its Golden Age, that associated with the so-called Winchester school, is epitomized in that profusely illustrated, magnificent, but slightly unnerving book known as the Benedictional of St Æthelwold.[14] This collection of special prayers used by a bishop when saying solemn blessings at mass, made expressly for St Æthelwold, bishop of Winchester from 963 to 984, contains twenty-eight full-page illustrations (fifteen more are probably missing), of which the majority depict Gospel scenes. Many allot a major role to Mary, as in the Death of the Virgin (Plate 29, page 68). The Virgin lies in a bed in the centre of the picture surrounded by three attendants, while overhead a crown held by the hand of God and four angels, one with a sceptre, emerges from behind the arch which frames the whole composition. Below are the Apostles, some behind, some in front of the frame; particularly upsetting to our sense of spatial arrangement is the way the Virgin's bed floats at mid-picture in front of the arch.

What is characteristic of the Winchester style of painting in this scene? First, the artist's profuse use of gold and heavy colours makes for an overwhelmingly lavish appearance. Painted in mauve, deep blue, brown, dull red, orange, green, ochre and yellow, these miniatures are further enriched by overpainting and an outline technique wherein the firm black outline is often shadowed with white. Second, although this is a representational picture, the artist is as much concerned with overall decorative effects as he is with the story, evidenced by the fact that no piece of cloth has a straight hem. Instead our eye continually moves over ruffled drapery surfaces whose restless, jagged folds, accentuated by heavy outlines in light and dark, seem to have been drawn by a nervous hand. A third Winchester characteristic, perhaps the hallmark of the style, is the overwhelming presence of the surrounding frame, not just as an enclosure but as an integral part of the composition, carrying out a dual role of representation and ornament. In the

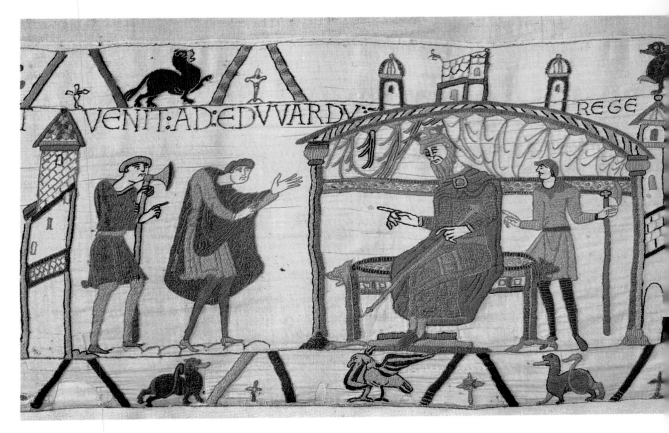

VENIT:AD:EDVVARDV: REGE

28 (*above*) Detail: Harold returning from Normandy. From the Bayeux Tapestry, Plate XXVIII.

29 (*right*) Death of the Virgin. From the Benedictional of St Æthelwold, Winchester, *c.* 975; in the British Library, Add. MS 49598, f. 102v.

68

30 Saint John the Evangelist. From the Grimbald Gospels, probably Canterbury, early 11th century; in the British Library, Add. MS 34890, f. 114v.

manner in which the acanthus leaves fill the thick arched frame, ornamental possibilities continually vie with the representational demands, for while some leaves are enclosed within the architecture, others actually make up the bases and capitals, clinging to or curving around the architectural forms as though endowed with life. Like the draperies from which they are in places barely distinguishable, their intricate patterns animate a composition made up primarily of stationary figures with impassive expressions and restricted gestures. It is thus fundamental to the style of these Winchester miniatures that no sharp distinction can be drawn between the ornamental and narrative elements; all parts of the picture are fused to achieve an expressionistic effect.[15]

Enormously popular, the style epitomized in this Benedictional was widely influential on artists working in other places and other media, for instance exquisite ivory carvings, as well as on painters illustrating lavish books.[16] In a page from one of the most handsomely colourful books of the early 11th century, the Grimbald Gospels, a work thought to have been made in Canterbury, we see the Winchester style ingeniously applied to a very different iconography: a portrait of the evangelist John.[17] In the portrait of John composing his Gospel we find drapery with ruffled surfaces and jagged edges similar to that in the Benedictional of St Æthelwold, as well as an equally intimate connection between the framing border and the central figure (Plate 30). This time the frame consists not of an arch but of panels and roundels, while acanthus leaves have given way to diminutive figures, Apostles and saints, kings and angels, the latter holding the souls of the blessed

69

in a napkin. The Trinity in the top roundels is also held aloft by symmetrically arranged pairs of angels, whose wings and feet are patterned as if they were substituting for decorative acanthus leaves.[18] As we shall see, the fact that the frames in these 'Winchester' compositions are not just boundaries but essential parts of the composition was to have a decisive effect on the outlook of the master designer of the Bayeux Tapestry and his co-workers.

<div align="center">

THE BAYEUX TAPESTRY
AND THE GOLDEN AGE OF ENGLISH ILLUMINATION

</div>

There are, I believe, five features of the Tapestry which give it a distinctive style and appearance. These are: (1) a pervasive naturalism, liveliness and lightness of spirit; (2) a fondness for decorative patterning; (3) the combination of two embroidery techniques as the medium of expression; (4) the various roles played by the borders; and (5) a use of continuous narrative, rather than discrete individual scenes, sequentially arranged on a most unusually shaped textile. It will be convenient to deal with them separately in this order, reserving the last two for discussion in separate chapters.

1. Naturalism

The story of the Norman Conquest is told with a remarkably fresh naturalism in the conception of whole scenes and individual subjects. By naturalism I do not, of course, mean that the trees in England looked like the palmettes with interlacing branches one finds in the Tapestry or that the ground at that time consisted of scrolls, but that the artist has observed the behaviour of people and animals and imparted touches of individual behaviour into his stylized renderings.

To gauge how distinctive the Tapestry is, compare a contemporary northern French manuscript illustration of Norman soldiers making a sea crossing with a scene depicting a similar event in the Tapestry (Plates 31, 32 on page 72).[19] In the French work it is the massing of a unit of soldiers into a patterned arrangement that creates the overriding impression of disciplined force. In the front row the armoured soldiers are lined up in a series without distinguishing characteristics, while behind there are a series of spear shafts and domed helmets. Only the helmsman appears as a distinguishable figure and his individuality is limited to his being depicted without armour, in three-quarter view, and performing a specialized activity. Of this manuscript painting it has been said that the 'artist's style is vehement, schematic, repetitive, and inhuman'.[20]

How different is the Tapestry's conception of a Channel crossing. Some figures talk to one another while others are engaged in activities appropriate to the action – one seems to be testing the rigging while the lookout steadies himself by holding on to a forestay. Although there is a symmetrical arrangement in the design of the ship and placing of figures, four men and four horses on either side of the mast, the natural behaviour of the figures animates a scene which in other hands might have been schematic. Then, too, one should not ignore such details as the bearded man before the mast, the nodding horses who seem to enjoy communing with each

other, and the shields hung from the prow adorned with a dragon's head sure to frighten any opponents with its fiery tongue.

Virtually every Tapestry scene reveals that the artist and his workers had a keen interest in details of how people lived and acted, whether this be how men take off their hose and tuck the skirts of their tunics into their belts when they step out into the Channel, thereby exposing the legs up to the waist (Plate IV), or how they take soundings from the bow of the ship as they approach shore to make sure they will not hit bottom (Plate V). From the Tapestry we have visual confirmation that Saxons and Normans wore completely different hair-styles, and that the former also favoured a distinctive moustache.

Not just humans but horses too were carefully observed in different settings and depicted with evident joy. We see horses obviously enjoying the sea trip, horses disembarking at Pevensey, horses galloping, horses tossing their heads and pawing the ground, horses waiting to be mounted, horses charging in battle and horses somersaulting over one another (Plate 34). We also see that many of the horses, particularly those used by the Normans, were extremely virile (Plate 33).

In certain places we can even discern an interest in going beyond generalized lifelikeness towards incipient realism, as in the apparently quite accurate rendering of such implements as carpenters' tools and agricultural equipment.[21] There is in the Tapestry an evident fascination with how things looked and how they were made. Think of the scenes depicting the construction and loading of the Norman ships, where we even find them being dragged to the shore by means of a pulley (Plate XXXVII), or the detailed preparation of the feast (Plates XLVI-XLVII), or the digging of earthworks for the castle at Hastings (Plates XLIX-L). All these scenes attest to the Tapestry designer's wish to make the work vital and real, arranging whole groups of workers in progressive stages of their activity, rather than simply showing one or two symbolic figures. Before the feast, for example, two cooks attend to the pot suspended over flames while another removes bread from a portable stove to a trencher; attendants hand skewered meats and chickens down the line of servants until they reach a sideboard where the food is assembled with cups and bowls on to makeshift trays, themselves shields pressed into domestic service. Finally, when the diners are called to the table with the blast of a horn, the servant next to the horn blower seems to register his physical discomfort by pulling away from the noise.

Within a work devoted to war and politics, there are even bucolic scenes of men engaged in hunting and farming (Plates X-XIII). In the border beneath William's messengers arriving to demand Harold's release from Count Guy we find a remarkably detailed depiction, considering the confines of space, of a heavy northern wheeled plough being drawn, in a puzzling detail, by a donkey (Plate 33). Further along in the same scene, after the man sowing seed broadcast in such an efficient way that it appears to fall only in parallel rows, is a horse pulling a harrow (Plate 33).

An extraordinary 'first' in our visual knowledge of medieval civilization, this scene is apparently the earliest pictorial example of European man employing a horse to work the fields rather than oxen. As demonstrated by modern

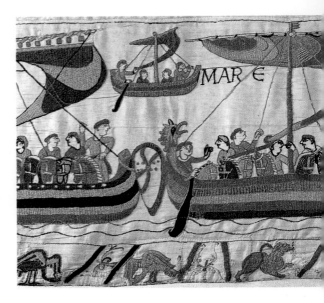

31 (*above*) Normans in a ship. From *Life of St Aubin*, St Aubin monastery, Angers, *c.* 1100; in Paris, the Bibliothèque Nationale, MS Nouv. acq. lat. 1390, f. 7r. 32 (*above right*) Detail: Normans in a ship. From the Bayeux Tapestry, Plates XL-XLII.

experiments, horses and oxen exert about the same pull, but while the horse moves much more rapidly and has more endurance than an ox, medieval people had to invent an appropriate harness in order to make use of this greater speed and staying power. What was needed was a new type of harness to replace the old neck straps notorious for pressing on the horse's windpipe and jugular vein (Plate 35).[22] Partly because of such technological innovations, often known to us from marginal illustrations in religious works of art, the 11th and 12th centuries saw an explosive release of productive energies, making possible, among other things, a rise in population and the complete rebuilding within a century of all of England's cathedrals and abbeys in the imposing new Norman style. It is no wonder that the makers of the Bayeux Tapestry show such evident joy in depicting the horses, both those that fought and those that worked, which made possible their dynamic civilization.[23]

33 Two horses held by a dwarf while William's messengers demand Harold's release from Count Guy: note the agricultural scenes in the lower border. From the Bayeux Tapestry, Plates X and XI.

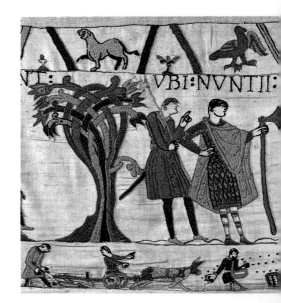

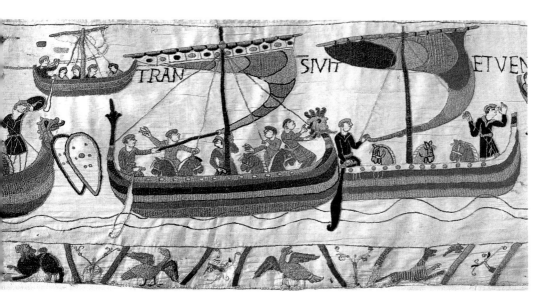

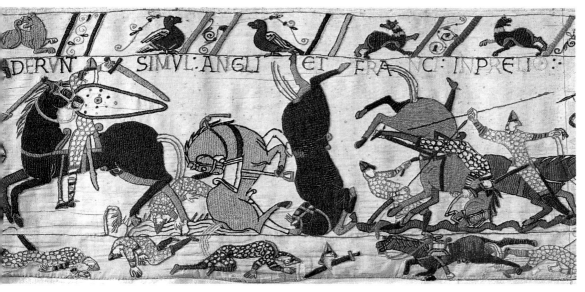

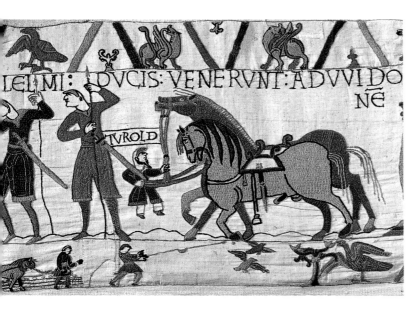

34 (*above*) Somersaulting horses. From the Bayeux Tapestry, Plates LXV and LXVI.

73

35 Horse with stiff padded collar pulling a harrow. From the Luttrell Psalter (English), *c.* 1340; in the British Library, Add. MS 42130, f. 171.

Where in European art of the pre-Conquest period do we find such joy in observing the world of work and skill in rendering it so accurately? Absolutely unique in the art of the early Middle Ages are some extraordinarily naturalistic depictions of the 'labours of the month,' that is activities associated with particular times of the year. As an illustration accompanying a monthly listing of local saints' days and festivals in religious calendars, such a depiction might show men ploughing in January, pruning the vine in February, digging, raking and planting in March, feasting in April, etc. Illustrated here are two such seasonal activities from an 11th-century calendar which is thought to have been made in Christ Church, Canterbury (Plates 36, 37).[24] What is so remarkable about these vivacious and utterly charming drawings is that, first of all, one finds 'complex genre scenes, with landscape and whole groups of co-operating figures' instead of the single labourer at work who was traditionally inserted in calendar illustrations.[25] Locating

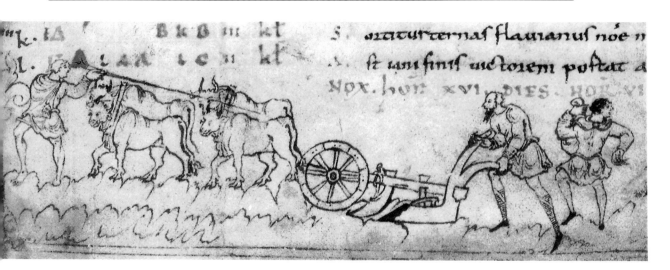

36 Winter ploughing and sowing (January). From a hymnal and calendar, probably Canterbury, early to mid-11th century; in the British Library, Cotton MS Julius A.VI, f. 3r.

such complex bucolic scenes in an illusionistic space rather than situating a single emblematic figure within a roundel was no doubt inspired in part by scenes in the Utrecht Psalter, which contributed as well to the very style of drawing in these English calendars. But that the calendar artist was not content merely to copy old formulas is evident in the realistic way he depicts the contemporary heavy wheeled plough, with its cutter, knife and mouldboard, that is so different from the traditional light Roman plough found, for example, in the Carolingian manuscript (Plate 38).[26]

These drawings were not isolated phenomena. It is noteworthy that the calendar illustrations were felt sufficiently interesting to be copied in a painted, fully coloured version (Plates 39, 40 overleaf).[27] In two renderings of the same 'labour' we see that while the iconography of the painted scene closely corresponds with that of the drawing, the painted one being either a copy of the above manuscript

37 (*left*) Threshing (December). From a hymnal and calendar, probably Canterbury, early to mid-11th century; in the British Library, Cotton MS Julius A.VI, f. 8v.

38 (*right*) Agricultural scene illustrating Psalm 103 (104), 'man going forth to this work'. From the Harley Psalter, Canterbury, *c.* 1000; in the British Library, Harley MS 603, f. 51 v.

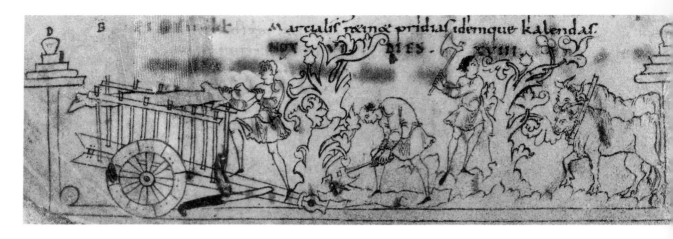

39 (*above*) Cutting wood, outline drawing. From a hymnal and calendar, early to mid-11th century, probably Canterbury; in the British Library, Cotton MS Julius A.VI, f. 6r. **40** (*right*) Cutting wood (painted). From a volume of astronomical treatises, Canterbury, early 11th century; in the British Library, Cotton MS Tiberius B.V, f. 6r.

or of a common relative, the technique of execution is very different. Sketchy impressionistic drawings have been replaced by framed, fully painted miniatures with figures and details strongly outlined in black. Also, the painted version reveals a greater tendency towards abstract patterning. One finds, for example, that in the painted copy's treatment of vegetation the sturdy, bucolic trees have been transformed into ever more intricate patterns, the branches interweaving with each other in an ornamental fashion.

41 The building of the Tower of Babel. From the Ælfric Hexateuch, St Augustine's Abbey, Canterbury, mid-11th century; in the British Library, Cotton MS Claudius B.IV, f. 19.

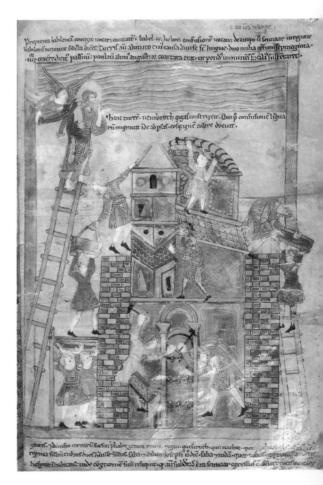

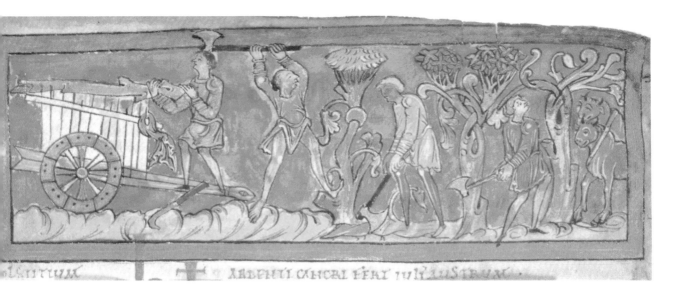

IANTIVM · XRDENTI CXHCRI FFRI IVR IVSTRVM ·

Yet despite the stylistic differences what is most important is the natural way these Anglo-Saxon artists have rendered the world around them, imparting an active spirit to their compositions by the arrangement in irregular spaces of many figures each one of whom works energetically at his task. The precocity of these early 11th-century calendar images is such that, except for one other work of art, we have to wait centuries, until such late medieval masterpieces as the Luttrell Psalter (Plate 35) and *Les Très Riches Heures du Duc de Berry* (1413-16), to see again

42 Detail: patterned building. From the Bayeux Tapestry, Plate XIII.

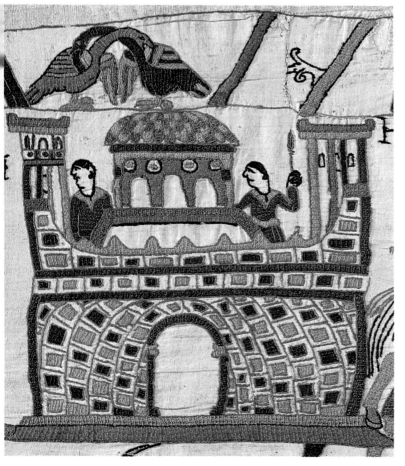

77

such a realism of details and vitality in the rendering of agricultural life as we find in Anglo-Saxon 'labours of the month.'[28] That singular exception is the Bayeux Tapestry.

2. Decorative patterning

One also observes throughout the Tapestry a fondness for the decorative, both in the movement of linear forms and surface patterns. Think, for example, of the interlacing branches of the trees, the multicoloured façades and roofs of buildings, or the elaborately designed tunics of Guy, William and Odo.[29] The Englishness of this tendency to see decorative patterns in nature is apparent if one compares the 'cedars of Lebanon' in the Canterbury copy of the Utrecht Psalter with their original in the manuscript from Reims (Plates 23, 24 above), or if one observes the abstract patterning of tree branches in the painted calendar illustration of men cutting trees (Plate 40). Note also the way the interweaving branches in that painted calendar scene are not unlike what we find in the Tapestry (Plate 33).[30] One more example of the love of patterning in Anglo-Saxon art must suffice. This is a delightful 'Building of the Tower of Babel' that combines to an extraordinary degree both a love of patterning, particularly in the multicoloured bricks placed in purely decorative patterns, and a fascination with the world of work (Plates 41, 42). Our energetic masons are found in the Ælfric Hexateuch, which it will be recalled was made at St Augustine's Abbey, Canterbury, shortly before the Conquest.

3. The medium: two embroidery techniques

Obviously related to the love of patterning is the very medium by which the Tapestry tells its story. The Tapestry displays a combination of two techniques of embroidery. One is achieved simply by outline while the other uses overall colour within a distinct contour line. Each is accomplished by a different method. Stem or outline stitch is used for the thin lines that make up the lances, arrows and lettering, as well as for the outlines of the hands and faces.[31] Stem or outline stitches also make up the contours of all the fully-coloured shapes, as well as the fillings of some figures, e.g., the chain mail or the lines which indicate the folds of clothing. Full colouring of shapes, on the other hand, is accomplished by laid and couched work, a technique whereby the threads are first laid over a given area and packed together to give a massed effect which fills the contours of a figure; then a second series of threads, not necessarily of the same colour, is laid at right angles, in short intervals; finally, these are 'couched' down with the same thread to hold the whole complex in place. For covering large areas with relative speed, laid and couched work is extremely effective (Plate 43).[32]

As an example of the usage and combination of the two techniques of embroidery, let us examine details of the scene where Harold receives word from a scout that William's troops have been spotted. If the reader compares a photograph of this section taken from the front of the Tapestry with the same scene as viewed from the back, details of technique will become clearer (Plates 44, 46). Outline stitch can be observed in the verticals of the A and the L (hence

43 The techniques of stem stitch and laid and couched work employed in the 'tapestry'.

the straight line seen in the view from the back) while the horizontals of these letters and the upper border line reveal a slight overlapping characteristic of the closely related stem stitch. The contours of Harold's body, shield, and horse, whether filled with colour or not, are also in outline or stem stitch. However, the blue-green helmet, the red shield, and the very dark horse are all fully coloured by means of laid and couched work. One advantage of this technique for larger surfaces is apparent from the rear: it is very economical, since most of the threads lie on the front surface, and only those used for couching down are lost to view.

In this rear view the reader may also be interested in certain details of execution, for instance in how a single thread is used for different functions, the dark green wool thread used for the letters A and R being passed through Harold's face to form his eye.[33] In connection with the love of colouration and patterning mentioned above, note also the alternation of colours in the letters and the way in which a thread creating a contour is almost always of a different colour from that used in the laid and couched work within the figure. Finally, observe how patterning is created by the contrast between threads laid on the horizontal in the shield and on the vertical in the horse's neck, with yet another contrasting border for his mane.

It is worthy of note that these two techniques of embroidery are not without parallel in Anglo-Saxon manuscript illuminations of the Utrecht and Winchester styles. Thus, stem stitch is roughly comparable to working in pen or pencil for outlines, and laid and couched work is not dissimilar to using coloured washes or pigments for covering surfaces. One even finds some English pre-Conquest artists combining the painted and outline techniques in a single composition.

44 Harold on horseback, as seen from the back of the Tapestry (the image has been reversed).

45 Detail: Saint Benedict and the monks of Christ Church. From the Eadui Psalter, Christ Church, Canterbury, early 11th century; in the British Library, Arundel MS 155, f. 113.

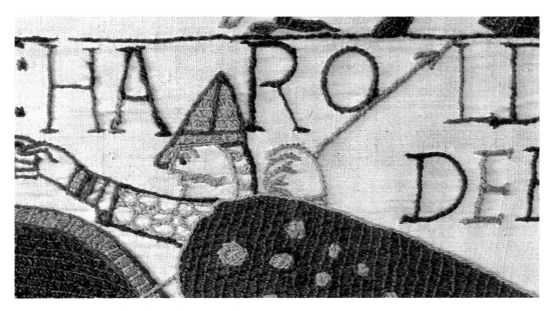

46 Detail: Harold on horseback. From the front of the Bayeux Tapestry, Plate LVI.

Perhaps the most famous example is the representation of Saint Benedict and the monks of Christ Church, from a Canterbury Psalter of the early 11th century (Plate 45). Benedict is seated while a group of monks approaches, the leader (just seen on the right) carrying a book inscribed with the opening words of Benedict's Rule. Of this page it has been said that it is 'the best surviving example of a deliberate marriage between line-drawing and fully-coloured painting, the two main figures Benedict and Eadui, carried out in full colour and gold and the group of monks simply outlined in ink, with light touches of sepia, blue and violet'.[34]

In such manifold ways the Tapestry partakes of the rich tradition of Anglo-Saxon art which began in the 10th century and reached its peak in the generations before 1066. Quite clearly the Utrecht tradition, no doubt in its later manifestations, had the major impact on the appearance of the Tapestry, yet, as we shall see next, the Winchester school was not without major significance. In particular, its attitude towards the borders of a picture as not just a bounding frame but as an essential part of the composition would have a profound influence on the creation of the Tapestry and contribute to its unmistakable Englishness.

CHAPTER V

The Englishness of the Tapestry: the Borders

One of the most distinctive features of the Tapestry is the way the artist and his embroiderers continually experimented with the borders around the main narrative, often allowing these framing areas to enter into dynamic relationships with the narrative field. Modern artists who consciously evoke the Tapestry in their work are inevitably attracted to the possibilities opened up by the use of such marginal imagery (Plate 47).[1]

Frames in all medieval art, but especially those in manuscript paintings done in the British Isles from the time of the great Gospel books associated with Lindisfarne and Echternach (8th century) through the late Gothic period (15th century), were conceived in a manner dramatically different from the way they had been in classical antiquity and would be again in the Italian Renaissance. If in classical art the frame had generally been a regular enclosure that belonged to the world of the spectator, much in the manner of a window frame which served to isolate the field of representation from the surrounding surfaces and heighten the illusion of deepening space, in medieval art the frame might appear as part of the space of the image.[2] Since the frame was no longer necessarily a part of the viewer's space, it and the figures within could touch, with the images standing on the frame or bracing themselves against it, as in the first Winchester style manuscript, the representation of King Edgar offering his Charter for the recently refounded New Minister Abbey (Winchester) to Christ (Plate 48). Mary, St Peter and King Edgar stand on the trellis-like frame while three of the four fluttering angels who hold the mandorla enclosing Christ delicately steady themselves with one or both feet against the frame.[3]

Unlike the frames around manuscript illuminations, with which one must perforce compare the Tapestry in the absence of other contemporary large-scale monuments, those in the Tapestry are unique. Not only are they immense, running in continuous fashion for over 200 feet (60 metres) on the top and bottom, with a short opening vertical section filled only with vegetation, but even what we mean by a frame is more complex than in most works, for in the Tapestry it appears in different guises: (1) the thin lines above and below the main scenes; (2) the decorative borders running parallel to the narrative, and (3) the enclosing lines

47 (*left*) D-Day, by Rea Irvin. Detail from the cover of *The New Yorker*, 15 July 1944.

48 (*right*) King Edgar offering his Charter for the New Minster to Christ, Winchester, after 966; in the British Library, Cotton MS Vespasian A.VIII, f. 2v.

around the figures inhabitating those borders. Lastly, there is an extraordinary range of inhabitants within the borders and a great variety of purposes behind their selection, placement and disposition. It is little wonder that we find in the Tapestry almost the whole repertoire of medieval frame-field relationships.

What are some of the principal uses of the borders in the Tapestry and how do these draw on earlier English experiments? Let us concentrate on three types: (1) the tangible frame, which, as in the New Minster page, might be part of the physical space of the image (2) the frame as carrier of symbolic meanings, helping to convey the iconographic content of the main scene (3) the frame as expressive participant in the total composition, wherein the frame and field are connected by a shared (or contrasting) vocabulary of ornament, colour and design. Needless to say, these categories are not mutually exclusive, and the best artists combine two or even three uses of the frame in one composition.

The tangible frame

For the artist of the Bayeux Tapestry, as for his forerunners, a framing device was a tangible object that could exist within the milieu of the image depicted. In the border above Harold and his party making their way towards Bosham (Plates II-III) two birds are straining to look down on the mounted travellers and their frisky hunting dogs. But these birds are not free to move. With one wing cruelly snared by diagonals framing their compartments, these marginal creatures are just as bound as the hawk on Harold's wrist. Further along above William's attack on Dol the ferocity of a boar, an animal identified with violence, is heightened by having him bite the frame that contains him (Plate XX).

The way these animals bite their frames, or are literally constrained by their surroundings, is reminiscent of depictions found in earlier English works of art: for instance, the four ferocious lions gnawing on the corners of a full-page image of Christ surrounded by heavenly saints in the 10th-century Athelstan Psalter, or Lucifer's desperate clutching of the frame surrounding him in the frontispiece to

the mid-11th-century Hexateuch of Ælfric illustrated at St Augustine's Abbey.[4] Perhaps the most novel example of the Anglo-Saxon use of the tangible frame involves a deliberate effort at breaking down barriers between the depicted figure and the spectator. In the *Marvels of the East* we see that one of the monsters of the world, a horrible headless figure with his face on his chest, is made even more frightening by the way the artist has him grasp the frame at either side in an effort to step out of his milieu into the space of the viewer (Plate 50).[5] The frame that either confines or is overstepped, here clearly an expressive device explored with great wit and ingenuity, became part of a tradition in English art that would persist after the Norman incursion.

In addition to using the frame as a physical object that grasps or is grasped, the Tapestry artist also allows some images in the main field to cross the frame, as if the frame were part of a background located in a simulated space *behind* the figure. While most figures in the story keep within their apportioned space, those who occasionally do cross the thin framing line that serves as the top border appear to do so for a purpose, as when one of William's enormous messengers is made to appear all the more towering by two devices: contrast (a dwarf is placed next to him while he demands Harold's release from Count Guy), and upsetting expectations (his spear is allowed to penetrate the upper border, a feature unique to this standing figure in the Tapestry) (Plate XI).[6]

Some images in the main field are of such magnitude that they do not merely cross the framing line and intrude into the space reserved for border images, they even displace the border's usual occupants. In the Tapestry, when Mont-Saint-Michel rises into the border, or when the castles at Dinan and Bayeux extend beyond the frame, the normal occupants are not merely partially covered, but move aside or disappear altogether (Plates XIX, XXIII, XXV).[7]

But the most dramatic instance of images displacing the startled birds and beasts who normally inhabit the upper border is when the armada crosses the Channel (Plates XL-XLIII). Here the expanse of the sea and the sheer magnitude of the invasion fleet are memorably depicted, though neither the waters nor the ships are rendered in a naturalistic fashion. How does the artist conjure up a sweeping panoramic vista crammed with loaded vessels? Part of his technique lies in crowding the scene with ships, and having them overlap, particularly as the fleet approaches the English shore. But much of his achievement depends on doing the unexpected. For the first time in the Tapestry, he manipulates the placement of similar objects so as to create an illusion of diminishing perspective: three ships are located above and behind those in the foreground in a manner that suggests, despite their apparently smaller actual size, that they are being viewed from a great distance. Then, note what happens in the upper regions. As William leads his army down to the shore, the tip of his lance and the attached pennon cross over the inner frame into a border emptied of its usual inhabitants and diagonal lines. From now until the armada reaches Pevensey, that inhabited border disappears, and the ships, the wind full in their sails, seem all the larger and more numerous because their masts and sails can extend to the uppermost limits of the Tapestry.

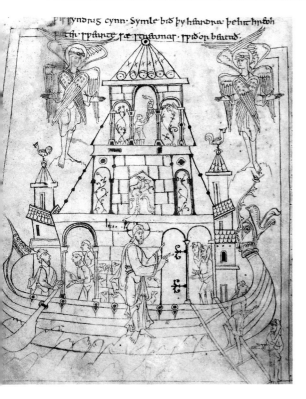

49 (*above*) Noah's ark. From the Caedmon
Genesis, probably Christ Church, Canterbury,
c. 1000; in Oxford, the Bodleian Library, MS
Junius II, p. 66. **50** (*right*) Headless monster.
From *Marvels of the East*, *c.* 1000; in the British
Library, Cotton MS Tiberius B.V, f. 82r.

The frame as bearer of meaning

The primary means of conveying meaning through the border in medieval art was
not with a frame consisting merely of lines, as in the *Marvels of the East*, but rather
in the common practice of placing figures within the frame or even beyond it.
Ultimately the medieval inhabited frame seems to owe its origins to two sources:
barbarian art and late classical relief sculpture. Whether animal figures in the
shoulder clasp from Sutton Hoo have a symbolic association with the main field
is a moot question, but borders inhabited by figures that do have an iconographic
connection with the central images appear early in medieval illumination, with an
origin that is clear: the art of the Mediterranean world.[8] But medieval artists more
fully and self-consciously explored the possibilities of having an inhabited frame
act as an extension of the narrative and symbolic space of the field it contained.
Recall two manuscripts we have had occasion to look at previously: the Grimbald
Gospels where figural scenes illustrating theological subjects in the panels and
roundels are set in the borders around the St John portrait page (Plate 30), and
the psalter made for Bury St Edmunds where the text is surrounded by marginal
images illustrating the Ascension of Christ (Plate 25).

One of the most interesting Anglo-Saxon precedents for a frame itself entering

into the meaning of the story is a delightful depiction of Noah's ark in the Caedmon Genesis (Plate 49). In the lower right, at the foot of the ladder and in front of the frame, stands Noah's wife, the last person to enter. One son summons her to hurry, for the Lord, standing on the waves, is about to close the door. No doubt this placing of Noah's wife outside the frame draws inspiration from popular legends that she resisted to the last her husband's bizarre idea that every living creature would be destroyed in a great heaven-sent flood except those he took on his ark. Whereas one commentator has found this composition a naïve attempt to follow some lost prototype and that the artist 'has not bothered, or known how, to adapt to his space or to the formal composition of a miniature in a frame', to this viewer the apparent childlike simplicity conceals a series of ingenious choices, each one involving the frame as a bearer of meaning.[9] The Viking-type ship that touches the frame on both sides and at the top is suggestive of the world-wide importance of Noah's actions. Also, what happens on this ship is of cosmic significance, since it symbolizes the Catholic church, inside of which one finds salvation, outside which is death and destruction.[10] At the top, the two angels who stand on the mountains overlap the upper frame in a manner consistent with their ability to move between the earthly and heavenly realms.[11] And, of course, let us not forget Mrs Noah, that woman of little faith, now outside the frame, about to cross it and climb the ladder to safety.

While there is ample precedent in Anglo-Saxon art for the use of the frame to add to a composition's meaning, the Bayeux Tapestry is unique in the number of differing roles bordering figures are allowed to play. Characters exit and enter via the margins, perhaps in a literal sense, as when soldiers fall out of the bottom of the picture, or, alternatively, when figures outside the main picture physically enter the narrative. The prime instance of an enlargement of the stage and cast of characters is the extended series of diminutive archers marching beneath William's knights at the Battle of Hastings. Marginal pictorially, hence militarily and socially as well, these archers none the less give covering fire to the advancing troops, and after hitting many shields and a few ordinary soldiers, one even lets fly the fateful arrow that strikes Harold's eye.

Border images serve as extensions of the narrative in other ways as well. Some are pictograms that communicate what is left unstated in the inscriptions above, as in the case of the ships floating on the water under Harold while a counsellor tells him the import of Halley's comet or that of the gesturing nude who is equally integral to the mysterious Ælfgyva scene (Plates XXXII, XVII).

Then there are the animals. Predators carry off the corpses of their victims under the battle scenes, while above ravens and eagles eagerly await their carrion, reminiscent of the familiar 'beasts of battle' motif in Anglo-Saxon poetry.[12] There is also the possibility that animals in the margins might be correlated by their placement and disposition with characters within the story, thereby playing a politically symbolic role which anticipates the kind of animal symbolism one finds in Geoffrey of Monmouth's *Book of Merlin*, a 12th-century work filled with animal symbolism about conquests of England, including that by the Normans.[13] In addition, contrary to the view of a number of scholars that the marginal 'fables

serve a purely decorative purpose and cannot be related to the main scenes', we shall see that they appear to be employed sometimes as agents of foretelling or remembrance, and at other times as metaphors for clarifying and heightening meaning.[14] Most interesting will be the distinct possibility that, on occasion, the artist will employ a border image in a more complex role, somewhat like words written in the margins of a manuscript which comment on (or gloss) the main text. Some of these images even introduce motifs contradictory to those in the main scene, thereby leaving observers with a sense of uncertainty or ambiguity.

The border as expressive participant

Lastly, but often unnoticed in the literature on the Tapestry, is the way the borders are expressive participants in the total composition. Here one thinks of how expressionism was not confined merely to gesture and facial expression in medieval art. By a shared, or contrasting, vocabulary of ornament, colour and design an entire composition conveyed mood, tone and feeling. Recall, for example, the Winchester manuscripts and the varying expressive uses of acanthus leaves in the frames. How different the frame is on a page devoted to a joyful event – the founding of the New Minster by King Edgar, where all the leaves are fresh and vibrant, some open and extended like the hands of Edgar and the angels – compared with the border around a melancholy subject, the Death of the Virgin (Plates 48, 29). In the Death of the Virgin in the Benedictional of St Æthelwold the only strong and vibrant leaves in the composition are at the keystone of the arch, from which area descend the four angels and the hand of God holding the Virgin's crown, while adjacent to the dying Virgin and her saddened companions the leaves which make up the capitals and the bases of the framing arch are limply bent downward, as if sharing the grief experienced by the pair of mourners beside the dying Virgin.[15]

In the Tapestry, the borders are filled with numerous birds and beasts whose dispositions and activities can be seen as sharing in the mood of the scenes they frame. One thinks, for instance, of the lone dog beneath Edward's funeral procession who howls while looking upwards at the mourners and the coffin (Plate XXIX). Delightfully expressive is the activity of another animal directly above William attacking Conan at the castle of Dol (Plate 6). There a quadruped struggles unsuccessfully to escape by pushing up on the roof of the frame confining him, an action which might be read as an ironic counterpoint to the scene below of Conan successfully escaping from the castle by sliding down a rope. In an embroidery, it is fitting that mere thread serves as both a device of entrapment and a means of escape. Each viewer will no doubt find his own favourite instances of attempts to heighten themes in the story – aggression, trickery, betrayal, sexuality, confinement, excitement, triumph – by the treatment of framing figures.

Another use of framing figures in the Tapestry, apparent to anyone who has observed spectators making their way along its narrative, is that they slow the viewer down in his progress through the story. The placing of trapezoidal compartments of approximately similar size above and below a continuous narrative imposes by itself a certain rhythm on our progress. When these are

inhabited by ever-changing creatures, some of whom invite speculation as to their identity and purpose, we are forced to be even more attentive. Because of this, it appears that the Tapestry was not only meant to be appreciated from a distance; some of it must have been intended to be studied as closely as a manuscript.

Since the reader may perhaps be wondering if we exaggerate the importance of the borders and whether medieval viewers were really attentive to details in marginal areas, I would like to conclude with a few excerpts from a remarkable text of the 12th century. It is an account of the translation of the remains of St Cuthbert (d.687) into the new cathedral at Durham in 1104, written about seventy years after the event by a monk of that cathedral who apparently had access to an eye-witness's testimony.[16] In his description of the saint's clothing, Reginald of Durham pays close attention even to such matters as the choice and placing of colours:

The most subtle figures of flowers and little beasts, very minute in both workmanship and design, are interwoven in this fabric [of the outer garment]. For decorative beauty its appearance is varied by contrasted sprinklings of rather uncertain colour that proves to be yellow. The charm of this variation comes out most beautifully in the purple cloth, and fresh contrasts are produced by the play of scattered spots. The random infusion of yellow colour seems to have been laid down drop by drop; by virtue of this yellow the reddish tonality in the purple is made to shine with more vigour and brilliance.

Reginald describes the precious silks wrapped around the saint's body:

All around the edges of this rectangular sheet the weaver had ingeniously worked a border an inch in breadth. On this material may be seen a most subtle relief standing out in considerable elevation from the linen warp and bearing the forms of birds and beasts, inserted somehow into the border. Yet between every two pairs of birds and beasts there emerges a definite pattern, like some leafy tree, which here and there separates these motifs and isolates them distinctly.

Two points about Reginald's description deserve underscoring. The cloths used to wrap this saint and other holy objects were often made in another time and culture. From the eastern Mediterranean came precious silks with decorative animals that were the source for much medieval animal art, and were no doubt the ultimate source for many of the birds and beasts in the Tapestry's borders.[17] Yet, while the Tapestry artist and his embroiderers may have admired Byzantine or Muslim fabrics, they used marginal figures in spontaneous, lively and varied ways that are totally non-eastern. The animals and figures in the Tapestry borders are not 'merely ornamental' in the manner of eastern textiles: one cannot superimpose an animal from one section of the story on another further along. Indeed, if half of the border imagery of the Bayeux Tapestry had been lost, we could not have reconstructed the missing portion from what remained.

Second, this careful, nuanced description of a decorative silk reminds us that art in the Middle Ages was not necessarily intended to be taken in at a glance, and that just because an area was 'marginal' it did not necessarily have less interest. We in the 20th century can find in Reginald's description a worthy guide when we turn to contemplate such an astonishingly varied work as the Bayeux Tapestry.

CHAPTER VI

Continuous Narrative, Distinctive Format and the Idea of Triumph

Thus far, we have spoken of features which the Tapestry shares, to a greater or lesser extent, with other works of English pre-Conquest art. Now we may turn to two interrelated features that distinguish the Tapestry from virtually any other surviving work of art from the early Middle Ages in Europe: (1) the way in which it tells its story in a fluid, continuous narrative style without using framing devices between scenes that are extrinsic to the action, and (2) its almost ribbon-like format.

A fundamental distinguishing characteristic of the Tapestry is its way of telling a story. Rather than employing a succession of individual framed episodes, the Tapestry uses the method of continuous narration. No vertical lines foreign to the story separate scenes; instead, trees or buildings or pointing figures serve as visual punctuation marks, some of which bring the eye to a complete stop, while others indicate that one should only pause briefly, in the manner of coming upon a comma while reading a text.[1]

Since many of the scenes succeed one another with smooth transitions, the story being told is alive in a way unique to this type of visual art. Instead of seeing a mere succession of isolated events, we sense that we are witnessing a series of interconnected historical events that do not just happen to appear one after the other, but whose ordering reflects causal relationships in the way they actually occurred.[2] As this technique of telling the story by means of continuous narration was begun in classical times but used very rarely in early medieval art, perplexing questions are raised about possible models which the artist and the patron had seen or heard about, as well as about how such a long, thin object was supposed to be displayed.

SOURCES AND ANALOGUES

In evaluating whether the Tapestry was unique in its time or whether its method of narration and form were common, we are unfortunately faced with a poverty of evidence. We know, for example, that large-scale works of art designed to celebrate military triumphs were quite popular in that bellicose age. Just as Constantine had a palace decorated with scenes depicting his triumph over Maxentius at the Milvian Bridge, the momentous victory which led to his conversion to Christianity, so the Carolingian emperor Louis the Pious had his council chamber at Ingelheim on the Rhine decorated with scenes of the victories of his illustrious predecessors, Charles Martel, Pepin and Charlemagne, founders of the Frankish Empire. Henry I of Germany commanded that his victory over the Hungarians in 933 be painted in his hall at Merseburg, and the eastern

emperors enjoyed being reminded of their personal exploits by palace murals in Byzantium.[3] But about these monuments, alas, we have historical texts which only tell us of their existence, not of their style or dimensions.

In addition to these historical accounts there is also evidence from literature that textiles woven with narrative stories were quite common in both palaces and churches. *Beowulf* does not say whether the rich hangings in Hrothgar's hall were filled with narrative scenes, but the *Edda* describes how Gudrun made a tapestry depicting the deeds of Sigmund's heroes. In the *Volsunga Saga* we hear of how Brunhilde 'sat, overlaying cloth with gold, and sewing thereon the great deeds which Sigurd had wrought, the slaying of the Worm, and the taking of the wealth of him, and the death of Regin withal'.[4]

The most directly relevant literary evidence comes, however, from a long and learned Latin poem addressed to William the Conqueror's daughter Adèle by Baudri, abbot of Bourgueil, written around 1100. In over a thousand lines of Latin verse he describes what he calls the Countess's bedroom, clearly a fanciful setting, and the various hangings he imagines on her walls. Thereupon are depicted her celebrated father's deeds in the context of events from biblical and classical history. Starting with the Creation and the Flood, the hangings went on to illustrate the stories of the patriarchs; then came Moses, Joshua, David and Solomon, followed by the siege of Troy and the history of Rome, with the entire historical part of the cosmic programme culminating in the Norman Conquest of England. Because Baudri's description of some events in this imaginary wall-hanging closely resembles those in the Bayeux Tapestry, there is considerable debate as to whether Baudri had actually seen Odo's hanging and based his poetical account on it.[5] Be that as it may, the important point here is the fact that the physical description of the invented tapestry does not fit the real object. From Baudri's verses we have to imagine a true tapestry, not an embroidery, woven of gold, silver and silk threads, with an uncertain narrative style. Since it is also encrusted with pearls and jewels, and of much smaller dimensions than a work that fits the nave of a cathedral far better than a bedroom, Baudri's poem is very informative about the medieval literary imagination, but quite unhelpful with respect to the physical appearance and narrative style of a work like the Bayeux Tapestry.[6]

To account for the Tapestry's singular method of narration and its unusual size we must turn from verbal descriptions to the actual remaining physical objects from the period. There are three types of object, reflecting three different traditions.[7] Since each has a bearing on either the form or the narrative technique of the Bayeux Tapestry, or in some cases both format and style, let us take each in turn.

The northern textile tradition

First, there is the tradition of early medieval textile hangings. Scandinavian archaeology has yielded some precious fragments of early textile hangings that show some analogies with the Bayeux Tapestry. From the Oseberg ship burial (8th-9th century) come pieces of what was apparently a long and narrow textile

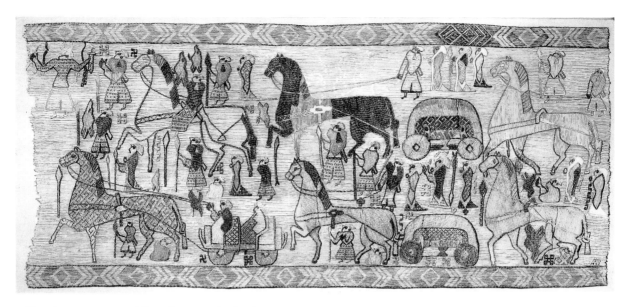

51 Hanging reconstructed from fragments in the Oseberg ship burial, *c.* 850; in Oslo, the Universitets Samling av Nordiski Oldsaker.

with soldiers, horses and carts moving in a procession-like manner, the main field bounded by decorative borders (Plate 51). From the 12th and 13th centuries come other long, narrow cloth bands, known as *tjell* or *refill*. Some of these *tjell* are not true embroideries, since they are hand loomed, but others are worked in a technique similar to the laid and couched work of the Bayeux Tapestry and most show secular scenes. A colourful 12th-century tapestry that is often considered in connection with the Bayeux embroidery shows two of the months of the year, April (a man beside a tree with birds) and May (an equestrian knight) (Plate 52).

For some historians this northern textile tradition is the major factor in accounting for the appearance of the Tapestry. For example, after describing the few early medieval fragments remaining, George Wingfield Digby noted that the narrow textile band with scenes either embroidered or woven thereon was common throughout northern Europe. Its distinctive shape was determined in part, at least for true tapestries, by the size of looms. Yet, as Digby recognized, for an embroidery such as the one at Bayeux, loom size would not have been a determining factor in its unusual format since only the linen ground, not the images are woven. Because the Tapestry's extraordinary ribbon-like appearance is created by sewing together eight pieces of linen, a different configuration, conceivably large wall-size panels, could have been accomplished in the same manner.[8] Thereupon, Digby concluded that 'conventions and convenience of usage must have played the predominant part in determining this [long, narrow] form,' not the size of the loom.[9]

Yet one wonders if convention and convenience of usage are sufficient explanations. The fact that none of the extant fragments of other northern textiles show a pictorial style as lively or as sophisticated as that in the Bayeux Tapestry

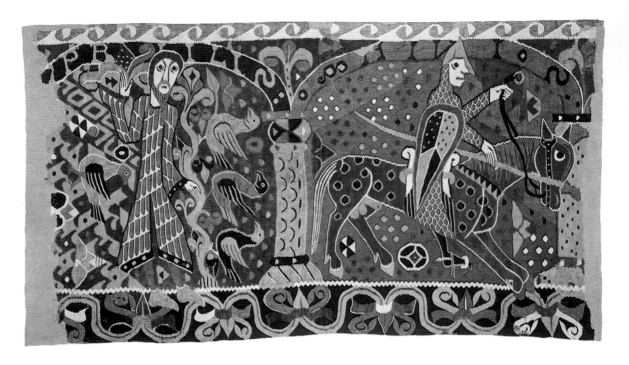

52 Two panels representing April (a man with birds) and May (an equestrian knight). From a tapestry from Baldishol church, Norway, 12th century; in Oslo, the Kunstindustrimuseet.

suggests that while the northern tradition of the *tjell* probably played some role in determining its form, there might have been other factors at work as well. What might these have been? Since our analysis has suggested that the artist of the Bayeux Tapestry worked in the artistic centre of Anglo-Saxon England, and would therefore have been aware of pictorial and literary creations much more cosmopolitan than the folk styles of indigenous textile art, let us turn to the second tradition which has a bearing on our questions, that of biblical manuscript illumination.

Narration in biblical manuscripts

In Canterbury, most probably towards the middle of the 11th century at St Augustine's Abbey, an illustrated Anglo-Saxon paraphrase of the Five Books of Moses and the Book of Joshua was produced with an astonishing number of illustrations. Three hundred and ninety-four panels of pictures, some with more than one scene, illustrate this work. Although the style is often much cruder than in other contemporary English manuscripts and many are unfinished, this Ælfric Hexateuch has an important place in the development of narrative art in pre-Conquest England, and judging from the visual 'quotations' in Chapter II, Plates 4, 5 and 8, the master designer of the Bayeux Tapestry appears to have known this work, or a version of it.[10]

All of the pictures in the Ælfric Hexateuch have rectangular frames, but there are some pages which show the artist combining different episodes of a story into one continuous narration. In the illustration of the sacrifice of Isaac the action begins in the lower right (Plate 53).[11] Abraham leads Isaac and the two servants

92

carrying the sacrificial sword and wood up the mountain designated by God as the place of the offering. As the party ascends the zigzag mountain road, we next see Abraham and Isaac in the middle zone taking the instruments of sacrifice and proceeding upwards without the servants and the ass. Abraham carries the sword and the fire, Isaac the wood on his shoulder. At the top is the climax. Abraham is stayed from slaying his son by the descending angel who informs him that the ram entangled in the bush is Isaac's substitute. In this page of the Ælfric manuscript we see continuous narration involving three distinct but consecutive episodes of one story within a single framed composition. No frames intervene between episodes, yet changes in location and temporal progress are clearly legible from the way the ground line zigzags up the mountain.

Other narrative techniques in this Ælfric manuscript also anticipate those in the Tapestry. For example, when depicting a confrontation of two characters the artist sometimes avoids the usual static composition by showing them travelling from different directions. This technique is found also in the Tapestry as when William rides from the right to meet Count Guy and the soon-to-be-freed Harold rides towards him carrying hawks (Plates XIV-XV).[12]

Another technique of continuous narration in art, the duplication of a figure within a scene, is also found in Canterbury manuscripts, one famous example being the translation or ascension of Enoch in the manuscript known as the

53 (*left*) Abraham and Isaac. From the Ælfric Hexateuch, St Augustine's Abbey, Canterbury, mid-11th century; in the British Library, Cotton MS Claudius B.IV, f. 38. **54** (*right*) Ascension of Enoch. From the Caedmon Genesis, probably Christ Church, Canterbury, *c.* 1000; in Oxford, the Bodleian Library, MS Junius II, p. 61.

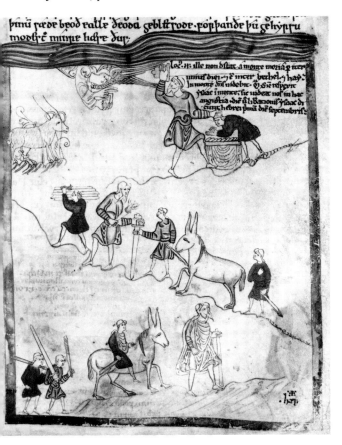

Caedmon Genesis (Plate 54). We see Enoch first at the bottom as he is about to lift off with the help of two angels, and then a second time as he vanishes from sight, half-hidden by the clouds.[13] In the Tapestry, it is quite possible that we find such duplication of characters in several places. Brooks and Walker pointed out that what has usually been read as two English scouts (Plate LVI) appears in fact to be the same person shown first looking out and then running towards Harold with news of William's approach. Also, since it is most unlikely that at the battle Harold was accompanied by two dragon standards held by two bearded banner carriers, they pointed out that it is more likely that the same banner and carrier are shown twice, erect and fallen, just as Edward, Gyrth and Harold are depicted both alive and dead in their respective death scenes (Plates LVII, LXIV, LXXI).[14]

These two extant manuscripts, the Ælfric Hexateuch and the Caedmon Genesis, attributed to Canterbury in the pre-Conquest period, have many of the narrative techniques we find in the Tapestry. Is is not therefore likely that the Tapestry master combined two elements that were already existing in his milieu – the long, narrow textile hanging and the advanced narrative devices found in the biblical manuscripts – to create the distinctive format and continuous narrative style of the Tapestry? This may well be the case, but two reservations give one pause. First, although the Ælfric and Caedmon artists have created small units of continuous narrative which escape the limitations usually imposed by framed illustrations, a programme of continuous narration in the manner of the Tapestry has no precedent in any existing Anglo-Saxon art, nor, except in one unusual case of Ottonian art (10th and 11th-century Germany) to which we shall return, was it practised on the Continent. A second reason to doubt that the Tapestry's distinctive format and narrative style arise solely from a fusion of existing elements is that while no precedent appears to have been created in either English or French early medieval art, there were classical models prominently situated in Europe which have a striking resemblance to the Tapestry. Montfaucon, writing in 1729, mentioned a similarity between such antique works and the Tapestry, but it was not until 1976 that an art historian, Otto Werckmeister, seriously addressed the question of classical inspiration for the Tapestry's distinctive form and narrative technique in a wide-ranging article that offered a most engaging solution to these problems.[15]

Roman triumphal columns

Werckmeister speculated that the master designer of the Bayeux Tapestry might have got the idea of continuous strip narration within a long, narrow pictorial field from surviving classical monuments.[15] These would have been the Column of Trajan and the Column of Marcus Aurelius, both of which used spatial continuity as a narrative method. Since these sculptural monuments were much admired in the Middle Ages, Werckmeister hypothesized that the Tapestry artist had made his way to Rome, seen the columns, and absorbed their unique artistic message. Distinguished by the use of relief sculptures arranged in long, uninterrupted, narrow spiral bands to tell their stories, both Roman columns, but especially Trajan's, provide a clear formal correspondence with the Bayeux embroidery.

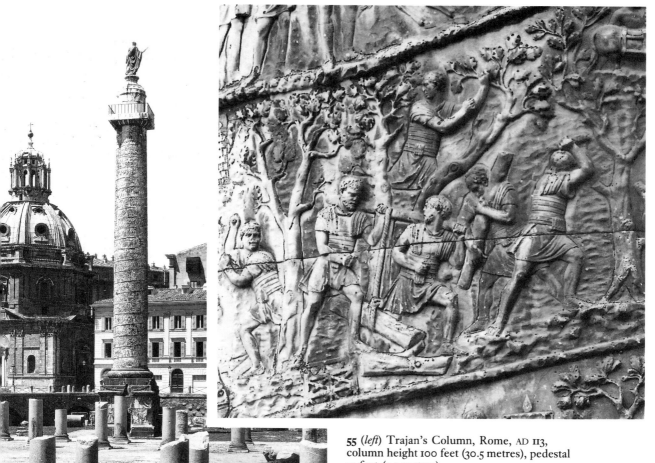

55 (*left*) Trajan's Column, Rome, AD 113, column height 100 feet (30.5 metres), pedestal 17 feet (5.2 metres).

56 (*above*) Soldiers cutting trees. From Trajan's Column, scene XV.

There are important thematic parallels as well. The free-standing monumental columns of Trajan (AD 113) and Marcus Aurelius (AD 180) commemorate contemporary military campaigns of victorious emperors. As both depict in great detail the preparation for battle and the actual combat, they are replete with scenes of fortifications being constructed, as well as scenes of emperors receiving messengers, marching with their troops, directing campaigns, and offering the obligatory sacrifices.[17]

As evidence, Werckmeister juxtaposed photographs of scenes on the Roman columns, especially Trajan's (Plate 55), with scenes from the Tapestry, suggesting 'that [the designer] actually looked at it in order to gather the basic concept of the continuous pictorial method as well as the scenic typology of the methodically planned victorious campaign.'[18] One such comparison is between men cutting down trees to construct William's invasion fleet and a scene from Trajan's Column showing soldiers also cutting down trees (Plates 56, 57). Alas, at this point, such a tempting theory is open to a serious objection.

None of the specific visual parallels between Trajan's Column and the Tapestry are of a sufficiently unusual or idiosyncratic nature to make the argument of direct,

95

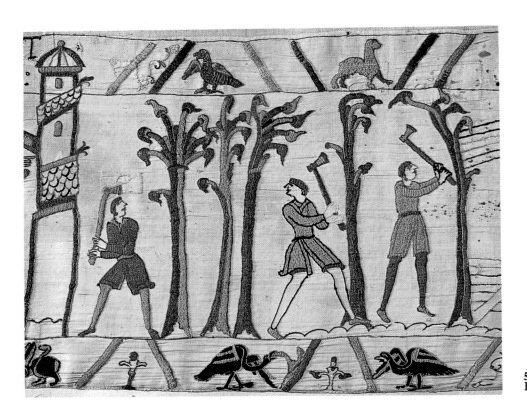

57 Men cutting trees. From Bayeux Tapestry, Plate XXXV

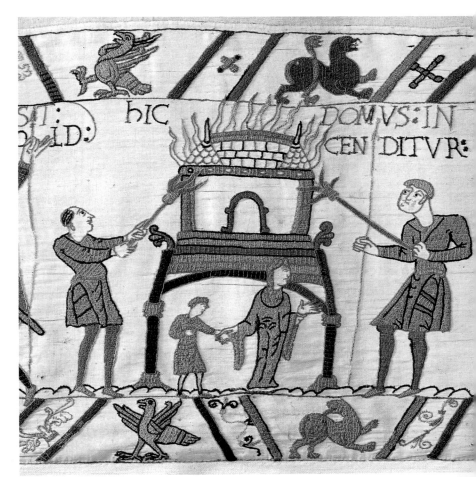

detailed observation and copying convincing. Take, for example, the comparison adduced between the tree-cutting scenes. To explain why there are similarities one might more simply posit that both artists had arrived at a similar way of depicting men swinging axes. Moreover, the Tapestry master did not have to travel to Rome for an artistic model, should he have wanted one, as we see when we compare the Tapestry's tree-cutters with English calendar depictions of men occupied with cutting and collecting wood (see Plates 39, 40).[19]

Werckmeister however did present one compelling correspondence between the Tapestry and the column imagery. This is the startling similarity between a depiction of a woman leading a child away while Normans set fire to a house and similar scenes on the Column of Marcus Aurelius (Plates 58, 59). One such comparison cannot, of course, prove that the artist had been to Rome, but the correspondence of certain elements is so close that one assumes some kind of connection between the Tapestry and Roman imperial art that has yet to be explained.[20]

Thus, taking into account the insufficiently compelling evidence produced so far that the Tapestry artist recalled visual details from such notoriously difficult-to-read monuments as the columns of Trajan and Marcus Aurelius, I think we must reject the theory that the designer drew inspiration for *specific* compositions from monuments in Rome until more convincing proof is presented.

58 (*far left*) Woman and child escaping from their burning house. From the Bayeux Tapestry, Plate L.

59 (*left*) Woman and child escaping from their house. From the Column of Marcus Aurelius, scene XX.

97

Nevertheless, the *general* correspondence in narrative style, strip format, subject matter, and celebratory purpose is so striking that Werckmeister's main point about the artist and patron drawing inspiration from the classical columns for the Bayeux Tapestry does not seem unreasonable, especially when one considers that pagan monuments in Rome were much appreciated by medieval Europeans.

From Anglo-Saxon England and Normandy many travellers, both dignitaries and ordinary folk, made their way to Rome.[21] Eleventh-century travellers included the last Saxon abbot of St Augustine's Abbey and his replacement, Abbot Scotland, as well as Geoffrey, bishop of Coutances, a Norman bishop who accompanied the invasion of England, and Lanfranc, both in 1050 and 1071.[22] Many ordinary folk also undertook the long and difficult journey for business with the *curia*, or for learning, or to seek cures for their afflictions at the tombs of the saints.[23]

Those who had journeyed across the Alps brought back many cultural objects to England, including textiles of Byzantine design, and, no doubt, memories of the city's celebrated shrines and monuments. In the 11th century, Canterbury would have been the most logical place for Roman ideas and styles first to take root in England.[24] New archbishops went in person to receive their *pallia* from the pope, and much official business had to be conducted between the administrative centre of English Christianity and the *curia*.

For Christians in all times, the extraordinary triumphal columns that stood amidst the ruins of the Capitoline recalled the greatness of imperial Rome, and stimulated the imagination of pilgrims, writers, historians and artists.[25] Well known and admired, Roman triumphal columns also inspired at least two important medieval artistic creations. Because in both instances it is the general idea of a Roman triumphal form that is important, not the copying of details, let us inquire more closely why people in both medieval Germany and Byzantium consciously evoked such a distinctly Roman imperial art form. Knowing more about analogous situations may provide clues as to what might have motivated the artist and the patron of the Bayeux Tapestry.

Bishop Bernward's triumphal column

Between 1015 and 1022, Bishop Bernward of Hildesheim had a huge bronze column erected and placed in the east choir of his church of St Michael's (Plate 60).[26] The 12 foot (3.7 metres) high column, thought by some to be a Paschal candlestick, while small compared with the 100 feet (30 metres) of the Roman original, is in form an obvious imitation of Trajan's Column and clearly presupposes, despite the enormous difference in style and subject matter, just that classical association to make its effect on the spectator. Trajan's Column, with its ascending spiral of scenes celebrating the emperor's victorious campaigns, was put to Christian uses in the Paschal candlestick, though on a miniature scale, with the eight spirals representing the public life of Jesus culminating at the top in the triumphant entry into Jerusalem.

Why did Bernward engage in this sculptural conceit of a triumphal candlestick

60 Triumphal bronze column with scenes of Christ, in the form of a candlestick, Hildesheim, *c.* 1020; in Hildesheim Cathedral.

with a continuous narrative laid out in long, narrow bands? There seems to be a convergence of personal and political factors. The bishop had accompanied the young Emperor Otto III to Rome as a tutor and lived with him in the imperial residence on the Aventine. During a visit to Rome in 1001, Bernward won an administrative triumph over a rival who had to concede to him the long-contested rights to an important convent. As expressed by Panofsky, 'It is, perhaps, not too hazardous to suppose that this unique monument, patterned after the triumphal columns at Rome, commemorates the major success of St Bernward's administrative career as well as his devotion.'[27]

99

61 Two adjacent scenes: the Gibeonite messengers and the miracle of the sun standing still. From the Joshua Roll, Constantinople, *c.* 1000; in Rome, Vatican City, the Biblioteca Apostolica Vaticana, MS palat. gr. 431.

The Joshua Roll

The second example of a medieval work which appears to have been deliberately designed to evoke memories of Roman triumphal columns comes from Byzantium, presumably 10th-century Constantinople. This is an extraordinary picture book called the Joshua Roll, 33 feet 3 inches long by 1 foot high (10.14 metres by 31 centimetres). Accompanying the biblical text are continuous illustrations of the Jewish hero's military campaigns done in the manner of the spiral bands from the ancient columns, although the spectator studies a book which is unrolled on a table in front of him in sections instead of an ascending spiral carved on a column (Plate 61). Why, in 10th-century Constantinople was a book form as deliberately archaistic as a scroll, with its ribbon-like appearance, used when the modern form of the codex was prevalent, and why did continuous pictorial narration reappear at this moment and place? The most plausible answers offered to date may give us clues as to how patrons, artists and spectators in post-classical cultures thought about a quintessentially Roman form of triumphal art.

In the early history of Constantinople, columns depicting military triumphs had been erected by Theodosius (386) and Arcadius (402) to give the new Roman capital on the Bosporus something of the aura of the old cosmopolis with its columns of Trajan and Marcus Aurelius. From the 4th century on, however, the practice died out, the eastern and western emperors having few such great triumphs to celebrate. Even such a successful leader as Justinian in the 6th century turned away from large sculptural monuments towards intricate church structures filled with glittering mosaics. When, 400 years later the Byzantine court was again captivated by the notion of recounting military triumphs in the ancient style, such a deliberately evocative choice appears to have been prompted by political and cultural conditions.[28] By creating a continuous pictorial roll of Joshua's campaigns

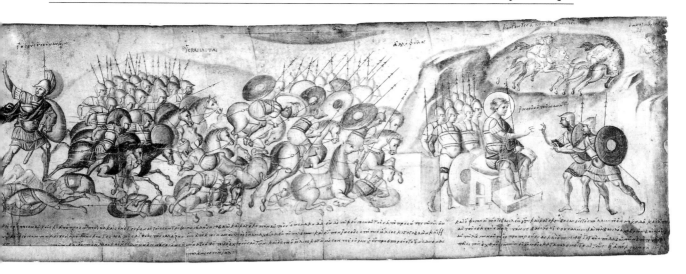

to gain the land of Canaan for the Jews after their forty years of wandering in the Sinai, the artist was not just illustrating a biblical text; he was probably also making an identification between past triumphs and the military campaigns of his day. First, in choosing a certain content, Joshua's re-conquest of the Holy Land, he was perhaps recalling for the Byzantines their own recent victories over the Saracens when Byzantium regained the same land that had been gained in battle by the 'Chosen People'.[29] Second, by choosing the then archaic format and style of the ancient columns he was associating contemporary political and military leaders with victorious heroes of the Roman past, Trajan, Marcus Aurelius, Theodosius and Arcadius.[30]

THE BAYEUX TAPESTRY AND THE IDEA OF TRIUMPH

Turning from Ottonian Germany and 10th-century Constantinople to Anglo-Norman England, what insights might be applied from what is known about Bernward's Column and the Joshua Roll to our questions about the format and narrative style of the Bayeux Tapestry? We are inclined to follow Werckmeister's suggestion that the Bayeux Tapestry should be seen in the context of Roman triumphal monuments. While the evidence for borrowing of specific scenes from the columns is not sufficiently convincing, it appears to this observer that the Tapestry's frieze-like format and method of continuous narration may have been inspired by a triumphal monument like Trajan's Column. The folk tradition of Scandinavian hangings no doubt played a part in shaping the Tapestry, and the narrative conventions of English manuscript illumination certainly gave the artist key ideas on how to tell a sequential story, but it is difficult to ignore the fact that both the style and the format of the Bayeux Tapestry are more analogous to what we find on the triumphal columns than on any known textile, mural or book from the early medieval world of northern Europe.[31]

Evocations of Rome in Norman writings

This view of the Tapestry's origin as a work consciously designed to evoke comparison with Roman triumphal monuments seems somewhat more plausible than the idea that it is merely a sophisticated version of a Scandinavian *tjell* for a number of reasons. Just as the 10th-century Byzantines perceived their leaders in terms of emperors of old, so Norman writers and propagandists compared the Norman Conquest of England with great conquests from the past. When William of Poitiers, chaplain to Duke William, wrote his laudatory biography of the Conqueror in about 1070, it was not surprising that he continually compared William with individual heroes of ancient history or epic, almost invariably to William's advantage. Agamemnon had a fleet of a thousand ships, William had even more.[32] With many other kings to help him, the fabled Greek king took ten years to capture Troy; with little help, William conquered England in a day.[33] However, most of William of Poitiers' learning was bestowed on an ingenious but perfectly appropriate comparison between the respective conquests of England by William and Julius Caesar, again not without some partiality. While the duke was both the commander and a hero in battle, Caesar usually had only directed the battle from the sidelines.[34] Caesar had trusted to his luck, but William proceeded by careful planning.[35]

Contemporary writings do not show just a detailed awareness of the content of classical history and lore in their comparisons of William with past heroes. The forms of Latin civilization were also admired, and even imitated in the Anglo-Norman world. William of Poitiers, for example, was sufficiently well acquainted with classical writings to imitate the style of a number of ancient authors, and was even fully capable of choosing a model stylistically appropriate to the subject. Thus, the extended comparison between William and Caesar shows him fully at ease with Caesar's *Gallic Wars*. He might also write on obedience in the manner of Cicero, on victory in the manner of Caesar or Sallust, on the sailing of a fleet in the manner of Virgil. As a recent student of William of Poitiers' eulogy has commented, 'the classical view is important and sets the tone of the whole work'.[36] Thus, if the Tapestry was deliberately made in a form and style reminiscent of the ancient columnar narratives of war and triumph, such a conscious evocation would have been consistent with contemporary Norman literary interest in Roman imperial culture and its forms of expression. What could have been a more appropriate model than Trajan's Column for celebrating one of the few early medieval events that could justifiably be likened to a Roman triumph of old?

Creating a work on the scale of the Bayeux Tapestry, with its inherent power of evoking Roman victories, would also have fitted in with another great movement of the time, the arrival of Romanesque architecture in England. This was the great period of Norman building: cathedrals, churches, abbeys and castles sprang up everywhere. After the conquerors had begun to find out how wealthy they had become in their new land, they set about rebuilding in whole or in part an extraordinary number of churches. The list of those done by the turn of the century is astounding: the cathedrals of Canterbury, Lincoln, Old Sarum, Rochester, Winchester, London, Chichester, Durham and Norwich, as well as the

major abbey churches at Battle, St Albans, Bury St Edmunds, Ely, Gloucester, Tewkesbury, Chester and St Augustine's, Canterbury. All were built before 1100.[37] Aesthetically, the Norman style, with its bulk and massiveness, its monumental columns and vaulted ceilings, inevitably brings Roman analogies to mind. In the nave elevation of Jumièges (*c.*1050) or the transept elevation of Winchester Cathedral (*c.*1080) we see again the components of a Roman aqueduct or colosseum with their huge pillars, pilasters and levels of arches superimposed one on another.[38]

The Normans and the papacy

The evoking of a classical triumphal monument which is linked with one place in Europe, the city of Rome, coincides as well with a momentous time in medieval political and religious history when the Normans were forging a special relationship with the papacy. In 1066, Duke William sent an embassy to Rome to ask for a favourable judgement from Alexander II in the dispute with Harold over who had the legitimate right to the English throne. When William landed at Pevensey it is said that he came with the pope's public approval of his mission, which according to William of Poitiers, was symbolized by the gift of a papal banner so that 'he might the more confidently and safely attack his enemy.'[39] A conquest undertaken with papal support was followed by the deposition, with papal approval, of the English archbishop of Canterbury, Stigand, and his replacement by Lanfranc. William was blessed as king by a papal legate in 1070 and undertook reforms of the English and Norman churches in line with those parts of the reforming programme being preached at Rome by Gregory VII that were consistent with his own proprietary views of his responsibilities in the government of his church.

It is, of course, impossible to assess the precise effects of these political and military links between the papacy and the Normans on the creators of the Bayeux Tapestry, but when we consider these special relationships, including the pope's blessing of William's expedition, and the likelihood that the reason William imprisoned Odo in 1082 was that he had organized an expedition of Norman knights to 'rescue' the papacy from advancing German troops, it is clear that Rome was very much on men's minds in Anglo-Norman England. Recall that it was also said of Odo that he possessed a palace in Rome which he was equipping with costly furnishings, part of a plan to make himself a candidate for the papal throne.

* * *

Thus, to understand the distinctive format of the Bayeux Tapestry, as well as its use of the continuous method of narration, it seems to this observer that we should consider the artist and his patron as working within three traditions: the Scandinavian folk tradition of long, narrow wall-hangings, the precocious Anglo-Saxon developments of biblical narrative illustration, centred, it should be noted, in Canterbury, and the conventions of antiquity magnificently displayed on Roman triumphal columns. If this analysis has appeared to give undue importance to the possibility of a classical model, this is done in the belief that form and style cannot

62 Replica of the Bayeux Tapestry displayed in Bayeux Cathedral.

63 (*right*) Procession of Martyrs, mosaic above the nave arcade, Sant' Apollinare Nuovo, Ravenna, 6th century.

64 (*far right*) Westminster Hall, *c*. 1097.

be explained merely in terms of conventions and using what is ready to hand. Ecclesiastics in Anglo-Norman England were aware of distant classical traditions and of the evocative power inherent in distinctive classical forms, as is evident in their historical writings on the Conquest. Format and style are not just physical attributes of a specific work of art; they also have a cultural resonance which is part of the consciousness of an age.[40]

DISPLAY

A final question remains with regard to the unusual form of the Tapestry. Where was it intended that it be displayed? The traditional view is that it was planned to be shown in Bayeux Cathedral.[41] There are three arguments in favour of this possibility: the near certainty that it was commissioned by the bishop of Bayeux; the fact that it is the sole source suggesting that Harold's famous oath was taken on the relics of Bayeux; and that, as we know from the cathedral inventory of 1476, it was definitely displayed around the nave in the 15th century.

Against this traditional interpretation a stimulating and perceptive argument was made in 1966 by the English art historian C.R. Dodwell.[42] He pointed out that the supposition that the Tapestry was intended for a religious setting confronts us with difficulties: certain border scenes have an obscenity that is 'difficult to reconcile with a cathedral setting', and the narrative is 'obstinately unreligious and secular in interpretation'. The Conqueror is never shown at prayer; Odo is only once making a blessing, and then at an elaborate secular feast. Thus, Dodwell argues that although the work was probably made for Bishop Odo, it must be kept in mind that he was not a bishop in the tradition of Lanfranc or Anselm; rather Odo was a man who lived and fought like a feudal baron. Since he was apparently the kind of ecclesiastic who would have been more comfortable listening to the *Song of Roland* than to a debate on transubstantiation, Dodwell suggests that the

Tapestry may not have been made for his cathedral at all, but for private display in a great hall. Just as many feudal magnates had hangings in their palaces and castles, so we might imagine Odo commissioning this great embroidery to adorn the walls of one of his palaces.[43]

Is a princely hall a more likely setting than Bayeux Cathedral for displaying a triumphal monument of the format, style and content of the Bayeux Tapestry? To my mind, there are more compelling reasons for thinking that the Tapestry was not designed to be hung around the nave of Bayeux Cathedral than its 'secular' content and occasional 'lewd' imagery. There is, first, the Tapestry's unusual shape. When a modern replica was draped from column to column at Bayeux it appeared quite out of place in a large cathedral (Plate 62). If the original had been hung low enough to be seen in detail, 11th-century worshippers would have been constantly knocking it down and perhaps even igniting it with candles.[44] If, instead, it was to be more safely placed against a solid wall, this would have had to be above the nave arcade, in a position similar to the location of the long processional mosaics at Sant' Apollinare Nuovo (Plate 63). In the much loftier Romanesque cathedral, however, the embroidered images and inscriptions would have been illegible.[45]

If the Tapestry would have looked incongruous hung around the nave of a church, how would it have been better suited to the interior space of a princely hall? This is a question to which Dodwell did not address himself. Evidence is admittedly scanty.[46] The main survivor of the great Norman halls is the famous royal hall erected at Westminster by William Rufus shortly before 1100.[47] Some 240 feet (73 metres) long and 67 feet 6 inches (20.6 metres) wide, it must have been by far the largest hall in England, perhaps in Europe, at the time (Plate 64). Splendidly re-roofed with a hammer beam ceiling in Richard II's time, the walls, in spite of much refacing, are still substantially Norman in appearance below the

65 The Bayeux Tapestry imagined hanging in the great dining hall of Dover Priory, Kent. Drawing by Dr Barnett Miller.

level of the string course. Up to a height of nearly 20 feet (6 metres) the side walls were of plain rubble that had been plastered over and probably brightly painted with ornamental designs. It is easy to imagine a tapestry hung along such a solid lower wall beneath the Romanesque windows.[48]

Less grand, but still very imposing, is the refectory built in Kent in 1139 at the priory of St Martin, at Dover.[49] Used as a barn in the 19th century, the refectory was then still in a reasonable state of repair. The interior, a large rectangle as at Westminster, though naturally smaller, had measurements of 100 by 27 feet (30 by 8 metres). Again, the lower part of the wall was entirely blank, this time up to the height of 12 feet 6 inches (3.8 metres). There were no openings in the lower wall except one doorway in the south-east corner. Above the blank portions of the wall was a lofty arcade with some of the arches pierced for windows. The placement of windows so high up was no doubt motivated by the desire to minimize draughts while gaining a maximum amount of light.

If we imagine Bishop Odo possessing at least one hall of the rectangular shape and approximate dimensions of this monastic one at Dover Priory, whether in England or Normandy or both, we have a room large enough for the Tapestry. Its present 232 feet (70.7 metres) would easily fit within a hall 254 feet (77 metres) in perimeter, with sufficient space for scenes at the end that are probably missing.[50] If we also consider that the hall probably had plain, plastered walls up to a height of approximately 12 feet (3.6 metres), there would have been a solid unpierced surface on which it could have been displayed without the inherent problems of

106

hanging it from column to column in the nave of a cathedral, or on the flat surface above the nave arcade. In terms of safety and visibility, the Tapestry would have fitted nicely around such a hall (Plate 65).

There are also certain circumstantial considerations that make it likely that the primary location for the Tapestry was a great hall. A hall was the physical and social centre of all medieval great houses, whether these be of a king or a bishop, or of a knight. Its origins in England go back to early Anglo-Saxon times, as we know from *Beowulf* and excavations at Yeavering in Northumberland.[51] It was here that the whole round of daily life, including the entertainment of a court took place. We know, too, that such halls were decorated with hangings. The fact that the Tapestry shows preparations for an elaborate feast in such great detail certainly suggests that the artist had in mind a setting where this kind of domestic iconography would have been most appropriate. One might even consider the artist calculating the placing of the feast scene to align with where the bishop would say grace while sitting at the high table surrounded by his followers.[52]

Then, too, we should take into account that great halls were not devoted exclusively to 'secular' matters. Halls such as the one 'of no little size' built by Odo's contemporary, the bishop of Coutances, might combine the sacred and the profane by having what appears to be a chamber for relics attached to the area reserved for dining, entertainment and holding court.[53]

A final circumstantial detail that supports the likelihood of the Tapestry being at home in a great hall concerns the decorations from Westminster. In 1835 ten sculptured capitals of the late 11th or early 12th century that appear to have been part of the decoration of Rufus' great hall were found re-used in the later refacing of the exterior. Nine of these capitals survive, and their style as well as their subject matter display many close similarities with those of the Bayeux Tapestry. One that shows an assault on a castle has a tower similar to that at Dinan in the Tapestry, and the attackers, who wear short tunics and carry a round shield in one hand and an axe in the other, are like the Saxon infantry in the Tapestry. There are also two capitals depicting Aesopic tales, including the famous one of the wolf and the lamb also shown on the Bayeux Tapestry.[54]

Such are the reasons for thinking that the Tapestry was not designed *primarily* for display in a Romanesque cathedral, but was possibly conceived as belonging to the furnishings of a great baronial hall. However, a key point about the Tapestry is that since it is made only of simple, flexible materials, woollen threads embroidered on linen cloth, it could have been transported to different sites. When necessary, it could have just been folded over upon itself like a ribbon and placed within a wooden case about the size of a funeral casket.[55] Such flexibility would have been extremely important in an age when the needs of government required men like Odo to ride constantly from castle to castle and across the Channel.[56]. There might even have been the thought of sending it to a more distant location, perhaps even to Rome, where, it will be recalled, it was said that a palace was being erected by the bishop of Bayeux.[57]

CHAPTER VII

Conclusion to Part One

In summarizing the major findings about the making of the Bayeux Tapestry, several apparently contradictory points have to be made. First, despite the fact that there is not one word of explicit documentation regarding the work until the brief description included in the 1476 inventory of Bayeux Cathedral, scholars believe that we can identify who probably commissioned it, as well as where and when it was created. By analysing puzzling features, looking for patterns, and relating internal clues to external evidence, students of the work have proposed quite convincing solutions to these questions about its genesis. It is interesting to speculate, however, whether the answers accepted today will be greeted by future generations with the same incredulity with which we treat the fact that the Tapestry was for so long universally known as 'La Tapisserie de la Reine Mathilde.'

A second apparent anomaly arises when we consider the appearance of the Tapestry in relation to the now widely accepted hypothesis that Canterbury was its place of origin. In contrast to any other extant monumental work of art from the early Middle Ages, the Bayeux Tapestry is manifestly secular in content and spirit; yet the artist who designed the Tapestry appears to have been so familiar with manuscripts located in Canterbury monasteries that he must have been a monk at Christ Church or the abbey founded by St Augustine, or on very close terms with monks in those communities. How can this contradiction between secular content and religious provenance be explained? First, it is well to keep in mind that a distinction between the secular and the religious may be sharper to us than it would have been to a contemporary. Eadmer's testimony that before the reforms of Lanfranc took effect the monks at Christ Church lived luxuriously, indulging in music, riding and hawking, reminds us that monastic discipline in Canterbury at the time of the Conquest was, to use a euphemism much favoured by ecclesiastical writers, 'relaxed'. In art, as in life, the worldly and the religious intermingled, most noticeably in the extraordinarily realistic depictions of the labours of the months in Anglo-Saxon ecclesiastical calendars and in the numerous details taken from life that find their way into illustrations of biblical stories. Then, too, Canterbury was not an isolated monastic retreat. As the centre of church administration for much of England and a town with several hundred burgesses, secular forces inevitably made their impress on monastic lives, and the monks at Christ Church and St Augustine's, in their capacity as heads of two of the wealthiest lordships in the land, perforce had business dealings with their tenants.[1] For these reasons, we must be careful not to force our later categories of analysis on Canterbury culture in Anglo-Norman times.

A third apparent anomaly, the combination of inventiveness and copying, is also rendered less puzzling if we keep in mind that just as modern assumptions about the sacred and the profane might not fit the realities of the Middle Ages, so too our attitudes about the relationship of an artist to his artistic tradition are different from those which obtained in medieval times. For example, whereas 20th-century artists usually prize being innovative, medieval artists almost always worked within existing pictorial traditions. Rather than inventing new scenes, they might employ pattern books and even copy directly from manuscripts at hand, as we have seen in the case of copies made in England of the Utrecht Psalter. More often, an artist adapted a composition to his particular needs, as seems to have been the case when the Tapestry master 'quoted' from a biblical manuscript, perhaps an illustrated Carolingian Psalter or its English copy, or from a picture-filled English paraphrase of the opening books of the Hebrew Bible. What is striking, then, is not that the artist of the Bayeux Tapestry copied traditional materials, for this was done by virtually all medieval artists; what is so remarkable is that elements from separate religious models were so successfully fused with a continuous frieze narrative of secular historical events that the biblically inspired elements can only be detected by careful comparison with earlier manuscripts.

It is time now to turn from apparent anomalies to serious problems which must be faced by any modern, that is, post-1957 historian of the Tapestry. As we have seen, 1957 is a turning-point in all studies of the Bayeux Tapestry because in that year Professor Wormald's fundamental new finding about its origins was published in the now classic study of the Tapestry edited by Sir Frank Stenton. All interpretation must now take into account his evidence that the artist apparently adapted scenes from Canterbury biblical manuscripts in his depiction of the Norman Conquest of England.

How radical are the implications of these new inferences about the origin of the Tapestry? To judge by recent literature, not very. As often happens when new evidence is brought forth with the potential of upsetting established views, few of its possibly radical implications were initially discussed or even articulated. Even though evidence was presented by Wormald that the artist seemed to know manuscripts in monastic libraries, the possibility that the master designer of so worldly and secular a work as the Bayeux Tapestry might be a monk rather than a layman was not even mentioned in print for over twenty years.[2] In fact, ever since Wormald's presentation of the Canterbury manuscript evidence, historians of the Tapestry have primarily employed that data, and more published subsequently, to establish the Tapestry's provenance. Otherwise, the new insight that the Tapestry was most probably designed by an English cleric has by and large been grafted on to traditionally held views about the purpose and the meaning of the work.[3]

In my opinion, this kind of patchwork will not do, for the likelihood that the artist created the Tapestry cartoon within a Canterbury monastic milieu contains a challenge to many of our conventional views on the Tapestry. At least four traditional ideas will have to be re-examined. First, there is a widely accepted assumption that the Tapestry is a skilful piece of folk art. Second, there is the idea

that its naturalistic imagery provides an almost 'documentary' account of the manners and customs of the Anglo-Norman world at the time of the Conquest. Third, there is the belief that the work presents, apart from the emphasis on the oath taken on relics, a completely secular version of history. Lastly, there is the almost universally accepted notion that the Tapestry's story is told from a totally Norman point of view. In the light of the new evidence about where the artist lived and worked, and of his links with certain artistic and historical traditions in Canterbury, I believe that each of these traditional views is wrong, or highly questionable at best.

With regard to the first idea of the Tapestry as folk art, the evidence presented in the preceding three chapters on the style and distinctive features of the Tapestry indicates that its artistic language is not folkloric at all but derives from 11th-century English manuscript painting as practised at the main centre of book production in Anglo-Saxon England. Our discussion of the Tapestry's links with contemporary works of art has allowed one central point to emerge with great clarity. The designer of the Tapestry must have been one of the outstanding artistic personalities of his time, a man who combined technical skill, great wit and imagination, and an awareness of the rich pictorial language of Anglo-Saxon illuminated manuscripts. He may very well also have been acquainted with Roman triumphal monuments. On the basis of this evidence, the traditional view that the designer of the Bayeux Tapestry was a skilled lay person portraying the events of his day in the idiom of contemporary folk art can no longer be sustained. If much in the Tapestry has the charm and simplicity of folk art, this is no doubt partly a result of the medium employed. In addition, it is as well to remember that English manuscript artists had also combined naïve elements and high art. It has been said of the Caedmon Genesis and the Ælfric Hexateuch, those two English vernacular versions of biblical texts, that their 'illustrations have the naïvety of folk-songs,' and that in the former the 'not infrequent lapses in the drawing are charmingly atoned for by its naïve verisimilitude'.[4] In joining folk and high art the Tapestry demonstrates yet another link with English illumination during its Golden Age.

The second assumption undermined by the now impressive amount of evidence that the artist modelled scenes on previous works of art is the notion that the Tapestry is virtually a medieval documentary of contemporary life. That the work is almost a documentary, a view gently satirized in the *Punch* cartoon illustrated at the beginning of Chapter II, is enshrined in almost every discussion of the Tapestry. However, if the artist was not embroidering from life, but often adapted figures, buildings and even whole scenes from manuscripts, what are we to make of the Tapestry's much vaunted verisimilitude? Disturbing questions are raised. While it seems quite clear that the Tapestry often captures 'contemporary' life in the broad sense of that wonderfully imprecise word, one wonders if we are looking at customs contemporary with the artist, or those contemporary with earlier 11th-century generations when the great illuminated manuscripts in the Utrecht and Winchester styles were made, or, as is most likely, both of the above, plus traces of even earlier medieval and classical traditions, all mixed together indiscriminately.

Although this book is not concerned with whether the Tapestry is a sure guide to such matters as how people dressed for war in 1066 or how they constructed and sailed ships, the reader should know that for all his naturalism it is by no means certain that in some cases the artist has got things right. For example, is it likely that the Norman knights wore trousered mail as shown in the Tapestry? Protection provided by trousers for the inside of the leg may have been useful for the English foot soldiers, but for a knight on horseback to wear mailed trousers would have involved such discomfort that it is hard to believe that the Normans, despite their reputation for being the toughest of men, were so outfitted. Not only is it improbable, but Continental art, both in sculptures and manuscript illuminations, uniformly depicts mounted warriors wearing skirted rather than trousered mail garments.[5] If the Tapestry artist failed to observe the Norman mailed outfits in this detail, one naturally wonders how trustworthy he can be on other matters for which his work is taken as evidence of how things really looked in 1066.

The third assumption challenged by the artist's familiarity with illuminated manuscripts is that the Tapestry is almost completely secular in its outlook. Apart from the importance attached to the oath on relics, which has also recently been questioned, the accepted view about the Tapestry is well expressed by C.R. Dodwell when he says that 'everything is read in feudal and secular terms'.[6] Yet, since we surmise that the artist was familiar with a wide range of illuminated religious manuscripts and was most likely a monk by profession, is it not possible that there are religious or symbolic dimensions to the Tapestry's iconography which have not been previously noticed? To explore this possibility might we not consider the visual quotations noted above not just as indications of where and how the artist worked but clues to his patterns of thinking as well? It might be profitable to ask, for instance, why the artist chose the particular visual models that he did. Why, for example, did he have Conan coming down a rope from the top of his castle, and why did he have Harold wounded by an arrow to the head – two details which are unknown to contemporary authors. Was the artist making allusions which a knowledgeable contemporary would have appreciated or was it only convenience that governed his choices? The fact that so many of the visual quotations are from biblical iconography at least raises the distinct possibility that if the Tapestry's realism is not as trustworthy as often believed, it may not be so obstinately secular either.

The fourth common assumption that is called into question by the new insight into where and how the artist worked concerns the Tapestry's point of view on the events of 1066. 'If the cartoonist was English, the patron was Norman: if the embroideresses were Anglo-Saxon, they were – whether they knew it or not – depicting an account of a turning-point in the history of their own country which was seen *entirely* from the point of view of the Norman invader.'[7] Given the general correspondence of the Tapestry's account with those found in Norman sources this is certainly an understandable point of view, but there are also problems with the generalization that all of the Tapestry presents a Norman version of history. At some places the Tapestry is most ambiguous: on the purpose of Harold's fateful visit to Normandy, for instance. At other times – the Breton expedition and the

death of Harold – its account varies markedly from that contained in Norman writings.[8] Then, too, there are the mysterious bordering fables.

In conclusion, now that we are reasonably certain that the Tapestry's master designer was a mature artist familiar with the great traditions of early English religious art and that he lived in the intellectual centre of Anglo-Norman England, should not the iconography of the Tapestry be reconsidered? We need to ask, for example, whether we can continue approaching the Tapestry as a straightforward chronicle of events seen entirely from the Norman point of view or whether a different approach needs to be tried, one that credits it with the complexity and levels of meaning we are accustomed to read in sophisticated religious programmes.

Since we also know that Canterbury was far from being a peaceful religious community in the decades after the Conquest, often agitated as it was by hostile relations between Norman church leaders, on the one hand, and English monks and townspeople, on the other, as well as by on-going battles between Lanfranc and Odo over land and authority, should we not consider whether some of these bitter feelings found expression in the Tapestry? In other words, although it was almost certainly commissioned by a worldly Norman bishop as a triumphal monument to justify and glorify the invaders, and the patron's role in particular, does not the present state of our thinking about the genesis of the Tapestry – that it was designed by an Anglo-Saxon artist in Canterbury and made by English embroiderers – raise the distinct possibility that Bishop Odo got more than he bargained for?

PART TWO

Iconography: Mixed Messages

*An inquiry into how the unusual circumstances
of the conquered telling the story of their own
defeat at the command of the victors affected
the selection of what to include and what to
leave out, the ordering of events, and the creation
of the Tapestry's iconography*

CHAPTER VIII

The Politics of Art

It has long been recognized that the Tapestry's portrayal of events is not an objective record of what 'really happened' at the Norman Conquest, but that like all historical narration it tells a story which has been shaped by a purpose. In the Tapestry's case the aim is political and personal: to demonstrate William's power and legitimate claim to the throne of England, while at the same time giving special prominence to Bishop Odo and the relics of his cathedral church in Bayeux.

Yet, it has also become increasingly apparent in recent years that the Tapestry's imagery does not fit neatly beside the Norman versions known to us in the two prose narratives that were composed within eight years of the Conquest, one the very brief account by William of Jumièges and the other the minutely detailed biography of the Conqueror by William of Poitiers. Both of these writers were semi-official historians, who, while not commissioned by William the Conqueror, none the less saw events from the royal point of view and eulogized their hero.[1]

What can be used for comparison from the English side? The earliest sources are the three extant versions of the *Anglo-Saxon Chronicle* and a life of Edward the Confessor, neither of which, alas, aims at the fullness contained in the biography of the Conqueror. When discussing developments prior to 1066, none of the three versions of the *Chronicle* even mentions Edward's alleged designation of William as his successor and Harold's journey to Normandy. None mentions anything about an oath. About the events of 1066 there are brief but very important entries from the English point of view. Then, after the Conquest one version ends abruptly and another carries on only until 1080, while the third continues down to 1155. For William's reign, this third or 'E' version of the *Chronicle* is our chief source written from the English perspective.[2] It is a remarkable document in many ways, not least for the even-handed obituary on William that stresses his bad as well as his good qualities.[3]

Also sympathetic to the English side is a contemporary *Life of King Edward*, composed by an anonymous foreigner, which although written by someone who knew people in high places is of mixed usefulness.[4] Of special significance for reading the Tapestry is its uniquely detailed description of what happened around Edward's death-bed when the childless king spoke his last words regarding the succession; otherwise the *Life* is of limited value. It sets out to tell the life of a saint rather than a ruler and ends abruptly before the Battle of Hastings.

Fortunately the deficiencies of these few contemporary English versions of the controversial events of 1066 are offset, at least in part, by a valuable history written between 1095 and 1115 by an English monk living in Canterbury named Eadmer.[5] Since Eadmer's purpose in his *History of Recent Events in England* was to write a

biography of Archbishop Anselm (1093-1109) which dealt with the public acts in Anselm's life, particularly those involving church-state relations, he needed to establish historical background by going back briefly to the political history of England from the late 10th century onward through the Conquest. An Englishman by birth, brought up from infancy in the monastic community at Christ Church, Canterbury, Eadmer was young in 1066. As an adult he cherished his memories of the old days and resented the Norman invaders. Although later than the Norman accounts, his history is especially valuable for revealing what a Canterbury monk of native stock thought of the same events described by William of Jumièges and William of Poitiers and depicted in the Bayeux Tapestry.

The natural starting-point, then, for an inquiry into puzzling features of the politically important scenes of the Bayeux Tapestry is the relationship between the Tapestry's version of events and those contained in these contemporary or near contemporary accounts from both sides of the Channel.

HAROLD'S JOURNEY TO NORMANDY AND THE OATH TO WILLIAM

The scenes of Harold's adventures in Normandy are among the most enigmatic in the Tapestry. Setting out from Bosham on England's south coast, he is captured in Ponthieu and held for ransom, only to be liberated through William's intercession. Then, on a campaign to Brittany to punish one of William's rebellious vassals Harold distinguishes himself by saving a number of Norman soldiers trapped in the shifting sands at the crossing near Mont-Saint-Michel. After the Breton rebel Conan admits defeat by handing over the keys to his castle, William 'gives arms' to Harold, the acceptance of which implies feudal dependency, and lastly has Harold swear an oath at or near Bayeux before his return to England. It all seems very clear and straightforward, yet, when one places the Tapestry's account against those mentioned above, there are hardly any details of this journey which have not been the subject of controversy.[6]

Why did Harold go to Normandy in the first place? Recall that according to the Norman accounts, Harold was sent by the aged and childless Edward to confirm a designation of William as his successor.[7] The earliest English sources, the *Anglo-Saxon Chronicle* and the *Life of King Edward*, make no mention of the journey.[8] The first English writer to describe it is Eadmer. Writing forty years after the events he put a very different interpretation upon many of the same 'facts' found in the Norman accounts.[9] According to Eadmer, the initiative for the journey lay not with Edward but with Harold when he came to court to request permission to travel to Normandy in a bold attempt to recover members of his family being held hostage by William for over a decade.[10] Then, Eadmer has King Edward make a short speech which, although certainly an invention of the author's, is none the less extremely interesting for its interpretation of the Norman journey and of William's character:

I will have no part in this: but, not to give the impression of wishing to hinder you, I give you leave to go where you will and see what you can do. But I have a presentiment that

you will succeed in bringing misfortune upon the whole kingdom and discredit upon yourself. For I know that the duke is not so simple as to be at all inclined to give them up to you unless he foresees that in doing so he will secure some great advantage to himself.[11]

Once Harold has left England, Eadmer agrees with the Norman authorities in saying that he was blown ashore in Ponthieu and released only because of William's peremptory messages to his captor. Also in agreement with William of Jumièges and William of Poitiers is Eadmer's emphasis on the fact that Harold took an oath promising to forward the duke's succession to the throne.

However, on the motives of William and Harold the Canterbury historian interprets the situation very differently indeed. In Eadmer's version, it is William, not Harold, who first mentions anything about an oath, saying that years before when the two men were young, Edward had pledged that if he ever became king he would make over his throne to William as his heir. In Eadmer's version, Harold reluctantly accepts only because 'he could not see any way of escape without agreeing to all that William wished'.[12] Having sworn on the relics of saints, Harold takes his nephew and returns home, whereupon Edward exclaims: 'Did I not tell you that I knew William and that your going might bring untold calamity upon this kingdom?'[13]

How does the Tapestry's account compare with these two wildly different versions of the motivation behind Harold's journey and oath? As there is every indication that the Tapestry was commissioned by a Norman, we naturally expect that it shares a Norman point of view, and indeed, on the first issue of why Harold went abroad, one can read the narrative as portraying Edward sending Harold on a mission. Yet, while it opens with the two of them in a discussion, the inscription reveals nothing about who said what.[14] Is Edward sending Harold? If so, the Tapestry does not go out of its way to make this point. Or, as Eadmer later contended, is the king trying to prevent him from going? While the Tapestry does not seem to contain anything about Harold's relatives being held hostage by William, could not the opening scenes allow for either a Norman or a dissenting reading of the events?[15]

Then, if we skip over such enigmatic scenes as the one with the mysterious Lady Ælfgyva,[16] or the many episodes in the Breton expedition which hardly ever tally with the only contemporary written source,[17] to the climax of the journey (Plate 66, page 118) and ask whether the Tapestry follows the Norman sources in depicting Harold as willingly taking an oath to William or whether it suggests something close to Eadmer's interpretation, Harold being under constraint to do so in order to escape alive, we note some curious things. On the surface it certainly appears that William brings neither guile nor force to bear on Harold. William has saved Harold from his imprisonment, extended hospitality to the English earl, and the two have gone riding together amicably on the expedition to Normandy.

Yet, regarding the crucial matter of the oath, on which turns the whole Norman interpretation of the political significance of these events, certain details suggest that the artist is not willing to accept the straightforward Norman version. First, note that whereas William of Poitiers places the oath immediately after Harold's

arrival in William's court, the Tapestry places the oath after Harold has been with William some time on an adventure in Brittany.[18] Does not the Norman historian's version implicitly stress the theme of Harold being sent to Normandy in order to confirm the duke as Edward's heir, while the Tapestry's quite different ordering of events implies at least a close link between the oath and Harold's safe departure from Normandy?

Such a hypothesis about the Tapestry is indeed confirmed if we look more carefully at its way of depicting the oath ceremony and Harold's departure (Plate 66). Far from being two separate incidents, first the oath and then the departure, the two episodes are actually joined by the disposition of figures and the position of the inscription. While one soldier on the right is fully engaged in observing Harold swear his oath, the other is clearly meant to be read as a 'visual conjunction' by the way he moves towards the ship while looking back towards the oath ceremony, one foot on dry land, the other at the water's edge.

If that last figure in the oath scene is already half-way 'out the door', as it were, it is also noticeable that a critical part of the departure scene overlaps considerably with the oath ceremony. The first words of the inscription *Hic Harold dux reversus est ad Anglicam terram* [Here Duke Harold returned to English soil] are placed not over the ship or even above the shoreline, but above Harold's hand as it appears to hover over the reliquary on the right.[19] It is hard to imagine how the Tapestry could better imply that the oath was somehow linked with Harold's immediate and safe departure for home.[20]

Thus, the scenes in the Tapestry which depict Harold's departure for Normandy, as well as those dealing with his oath and return to Edward's court, are fraught with ambiguities. Some interpreters find in the Tapestry a visual parallel with the Norman insistence on how Harold was sent by Edward to confirm the duke as his successor and the way he dutifully, though with understandable reluctance, carried out his mission.[21] Others, including this observer, find so much studied ambiguity in the images and the inscriptions that it is also possible to read a version closer to Eadmer's attempt to place doubt on whether Edward sent Harold and whether the oath was taken voluntarily.[22] Perhaps the most judicious solution to date is that in these scenes of Harold's fateful Norman journey the Tapestry provides a set of images that 'seems to have one message for its Norman audience, but also to hint at a version known to the Canterbury writer, Eadmer'.[23]

EDWARD BEQUEATHS A KINGDOM

Another set of politically significant, yet puzzling, scenes follows immediately upon Harold's return. These portray the death of Edward the Confessor and the accession of Harold (Plates XXIX-XXXI). The main political question is: according to the Tapestry, did Harold have a right to the throne or did he seize it unlawfully?

Though these are clearly among the most important episodes in the historical drama with which the artist is dealing, his decision to employ an unconventional narrative method has not made it easy to grasp the meaning of the scenes. The apparent illogicality of the Tapestry's first showing Kind Edward carried for burial

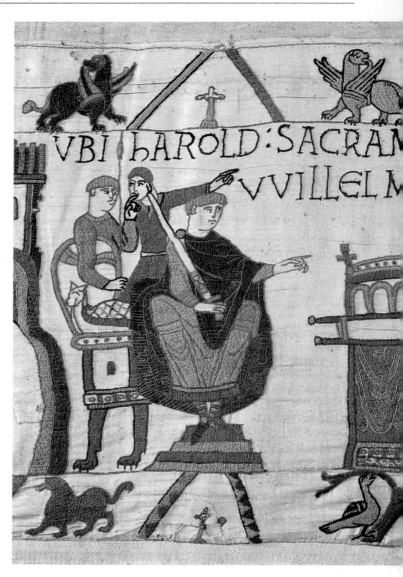

66 Oath scene. From the Bayeux Tapestry, Plates XXV and XXVI.

to Westminster Abbey and then addressing a group of loyal followers gathered around his death-bed has clearly disturbed some observers.[24] If we are to understand why the artist reversed the order of events we must first try to discover what a contemporary might have understood about that death-bed scene which has been so unnaturally dislocated.

What is happening on the day that the king is both alive and dead? While the inscription in the margin above the scene merely states in a not very informative manner 'Here King Edward in bed speaks to his faithful servants,'[25] contemporary texts fortunately agree on the substance of his last words. The fullest account is found at the end of the *Life of King Edward* written by a contemporary living in England who had as his aim to honour Edward, the queen, and her family, the

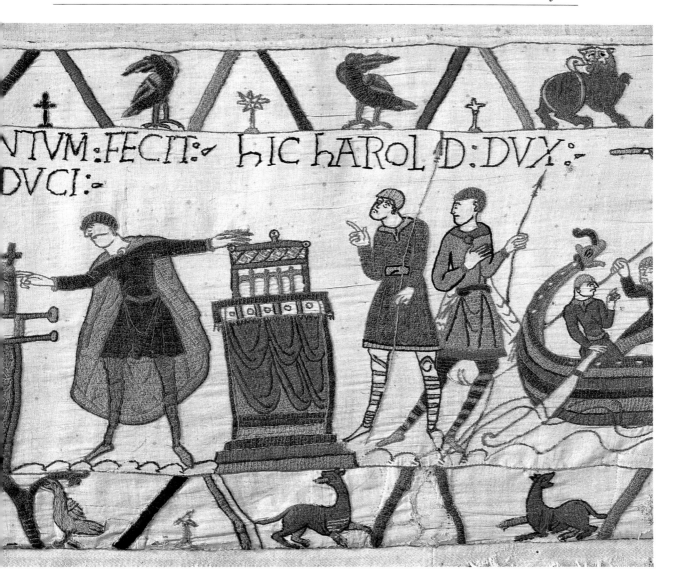

Godwins. Since this biographer's description of the king's death includes details that are remarkably consistent with the scene as depicted in the Tapestry, it is possibly of some importance that he is thought to have had Canterbury connections.[26] According to the *Life*: 'When Edward was sick unto death, his men stood and wept bitterly. . . . Then he addressed his last words to *the queen who was sitting at his feet*, "May God be gracious to this my wife. . . . ," and *stretching forth his hand to his governor, her brother Harold*, he said, "I commend this woman and all the kingdom to your protection."'[27] Correspondence of details – the position of the queen at the king's feet and Edward's gesture of touching the fingertips of the figure in front of the bed, who, although unidentified, is almost certainly Harold – is so close that one must assume some connection between the Tapestry

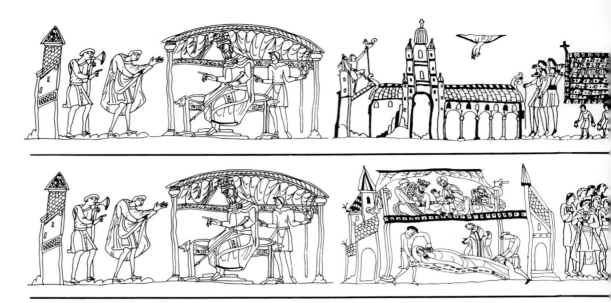

and the biography, and that therefore the Tapestry is depicting the moment when Edward reached forth his hand to consign the kingdom to the protection of Harold.[28]

If the biographer uses the ambiguous expression 'protector' of the kingdom, the more straightforward formulation in the *Anglo-Saxon Chronicle* clearly states that Harold was designated by Edward as his successor on the throne. According to the *Chronicle* this choice was also confirmed by the leading men of the kingdom; in the words of the version which has been associated with St Augustine's Abbey, Canterbury: 'Earl Harold succeeded to the realm of England, just as the king had *granted* it to him and as he had been *chosen* [by the leading men of the kingdom] to the position.'[29] The key words are 'granted' and 'chosen' because in the 11th century the English throne, even when there were eligible male heirs, was not passed on in any such strict order as primogeniture. The reigning king would designate his successor, usually the most suitable from the royal family, and the nominee would be 'elected' or 'recognized' by the leading nobles in the land.

On the Norman side, William of Poitiers knows of the bequest to the English earl but does not mention it when describing Edward's death. On the contrary, in his treatment of January 1066 the Conqueror's biographer follows William of Jumièges in stressing that Harold 'seized the kingdom' at the Confessor's demise.[30] Later in his work William of Poitiers does mention Edward's death-bed bequest, but treats it with ironic contempt, either by not having his hero dignify the claim with a refutation when Harold refers to it before the battle, or by himself reproaching the slain Harold with these words: 'Your end proves how justly you were raised to the throne by Edward's grant on his death-bed.'[31]

Clearly, on the vital question of Edward's last-minute nomination of Harold as successor, both English and Norman writings agree that it took place, but each

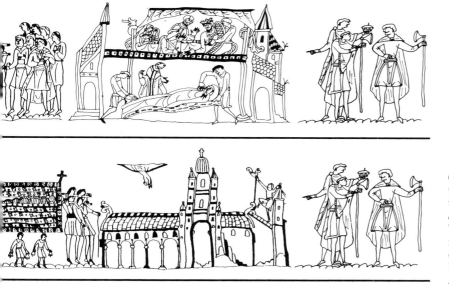

67 and 68 Experiment: the death of Edward and the accession of Harold, *above* as they are in the Tapestry, and *below* rearranged in chronological order. From M. Parisse, *The Bayeux Tapestry*, 1983.

places it in a different light, the English stressing the legitimacy and procedural regularity of the transmission of power (the kingdom being 'granted' and Harold being 'chosen' by magnates), whereas the Norman writer treats the whole matter with contempt.

With this sense of how contemporaries thought about Edward's last days and the accession of Harold in mind, we can return to the Tapestry's apparently illogical ordering of events (Plates XXIX-XXXI). The reason the artist has gone to the trouble of rearranging the chronological, and logical, sequence of events becomes apparent. The death scene forms the central axis of a larger composition from which two events result: not just the burial of one king but the assumption of the throne by the next. The causal connection between Edward's death-bed wishes and Harold's acceptance of the crown, hinted at in a rearrangement of episodes that allows the two scenes to be adjacent, is made manifest by the way the man handing the crown to Harold points backward to when the king was both alive and dead, as if to say, 'As Edward instructed in his last days, we hereby offer you his crown.'

To test the validity of this interpretation of why the artist has rearranged the episodes in an apparently illogical order, let us perform an experiment and imagine them 'in order' (Plates 67, 68).[32] Were events in chronological sequence and we first saw Edward speaking to his vassals and then being carried to Westminster Abbey, the courtier handing the crown to Harold would be pointing back not to Edward on the day he was alive and dead but to Edward resting peacefully in his coffin, in which case the meaning would be very different indeed: 'Now that King Edward is dead we hand you the crown.' In the artist's version the ordering of events suggests a causal connection between what contemporaries understood Edward to have said on his death-bed and the handing of the crown to Harold.

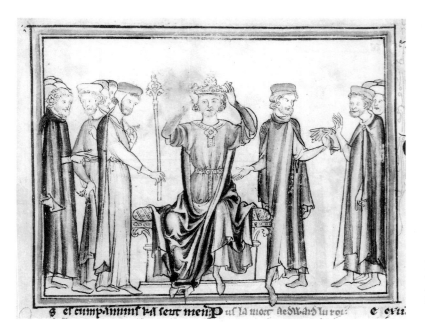

69 Harold placing the crown on his head. From *La Estoire de Seint Aedward le Rei*, St Albans, *c.* 1245; in Cambridge, the University Library, MS Ee. 3. 59, p.56.

Then, too, the artist has avoided allowing a straightforward Norman interpretation to dominate his portrayal of these events by crucial details. If the Norman writers emphasized that Harold 'seized' the crown, the Tapestry shows him receiving it, a point underscored by the choice of words in the inscription ('Here they gave Harold the king's crown'). In constitutional terms, the Tapestry includes both the elements of 'designation' by the reigning king and 'election' by the nobles that are essential for legitimate kingmaking in Anglo-Saxon England.[33]

To measure how far the Tapestry is from portraying Harold as a usurper who seized the crown, we have but to compare its version of the accession with a different artistic rendering of the same event. In the illustration to a 13th-century biography of Edward the Confessor, a book violently opposed to Harold and the whole Godwin family, Harold truly 'seizes' the crown and places it on his own head, acting without regard either for the wishes of Edward, who in this version never swerves from his designation of William as his successor, or the majority of powerful men at court (Plate 69).[34]

One final element was required to make a legitimate Anglo-Saxon monarch. Without the ceremony of coronation and anointment a man is not a king. According to William of Poitiers Harold was crowned by Stigand, the excommunicated and uncanonical archbishop of Canterbury, a point which gave the Normans grounds for questioning the validity of the ceremony.[35] According to the first English source that gives details of the ceremony, an early 12th-century chronicler who used earlier sources now lost, the cleric was not Stigand, but Ealdred, archbishop of York.[36] And the Tapestry? It is interesting that the Tapestry does not actually show the coronation. Instead the artist presents Harold's acclamation by the three orders of society (Plates XXXI-XXXII). Harold has been accepted by those who fight, those who pray and those who work. Is the man they acclaim a legitimate king or a usurper? In this scene of a crowned Harold enthroned with orb and sceptre he is clearly designated HAROLD REX in the

inscription. Certainly the new king's position appears compromised in the Tapestry by his association with Stigand (for why else would he be included at this moment in so prominent a role?), but does Harold's relationship with an uncanonical archbishop actually go so far as to undermine the validity of his claim to the throne? Unlike William of Poitiers or the Domesday Book, the Tapestry never refers to Harold as usurper or tyrant.[37]

In comparing the Tapestry's version of Harold's accession with those in the Norman writings a number of points can be made. First, for a Norman-sponsored triumphal monument it is intriguing how much is left out of the Norman case against Harold. Nowhere in the Tapestry is there a mention of William being Edward's cousin. Nowhere is there an explicit reference to Edward's bequest of the crown to William.[38] When we also consider that the Tapestry omits the coronation of Harold by Stigand, as alleged by William of Poitiers, we discover once again, as we did with regard to the purpose of Harold's mission to Normandy and the circumstances of his taking the oath, that by his silences the artist avoids a straightforward Norman version of events.

Second, it is interesting to note not only what is left out of the Norman case but what is included of the English. The stress in the English texts on a death-bed commendation of Harold as Edward's lawful successor and Harold being granted the crown by the nobles finds clear expression in the Tapestry once we realize the purpose behind the reordering of events. By also emphasizing in three ways that he did not seize authority but was given it by others – Edward reaching out to touch his fingers, the courtiers handing him the crown, the nobles presenting him with the sword of state – the Tapestry underscores that Harold acted with due regard for English constitutional procedures.

Thus, by avoiding any suggestion that he violently or surreptitiously usurped the crown, or that he was a tyrant ruling without popular support, the Tapestry artist makes Harold a tragic figure rather than a contemptible one. Consistent with the earlier depictions of Harold as a brave soldier who saved men's lives, the Harold of the Tapestry is a man to be admired and pitied, not one to be despised. In accepting the crown he made a choice between two valid obligations. Should he have kept his fealty to William and his oath made on the relics of Bayeux and not have accepted the crown as the designated and legitimate heir to his saintly predecessor? The future held the answer, but in January 1066 the right course of action was not clear.

As in a tragic drama, the end is foretold. Immediately after he sits in state receiving the acclamation of his countrymen, the heavens shine forth with a portent of great events to come (Plate XXXII). In the final scene of what we have termed the Tapestry's first act, Harold sits on the throne as both legitimate king and perjurer, a tragic figure whose fate will be settled only on the field of battle.

CHAPTER IX

Visual Polyphony: Animals in the Borders

The hundreds of animals who border the Tapestry's narrative, so endlessly intriguing in their variety and disposition, and so much a part of what makes the Tapestry unique, deserve a more systematic analysis than the scope of this work can possibly provide. At some point in the near future, let us hope that an attempt will be made to try to identify all the birds and beasts, count them, and ask if they appear in any patterns. Such a study might make use of the symbolic meanings attached to these creatures in works like the medieval *Bestiary*.[1] It might also attempt to relate the fables systematically to the iconography of the main narrative.[2] Since other marginal subjects add to our understanding of the whole work, such analysis might prove useful indeed. For now let us look briefly at a few prominent features which indicate that some of the delightfully enigmatic animal imagery is iconographically deliberate in selection and positioning.

ANIMALS AND DECORATIVE PATTERNS ASSOCIATED WITH PARTICULAR FIGURES

The hunter and the quarry

As it is only by a pattern of association that we can perceive a link between a particular animal and a human character, we naturally look first to the main field for heraldic emblems on the shields men carry. Unfortunately, when we see the same emblem, a dragon, on the shield of five different soldiers it is evident that a codified system of heraldry had not yet been developed.[3]

A different kind of association between animals and a character in the main field does, however, appear to be established at the outset of the Tapestry. Recall that we see Harold riding from court towards Bosham with a hawk perched on his hand and hounds running before his party (Plate II). Later, as Harold and his companions wade out to their boats, a hawk and dogs are carried (Plate IV), and in Normandy Harold is depicted twice more with a hawk on his hand (Plates IX, XIV). Why are there hunting animals at these particular phases of the story? One likely explanation is that Harold is carrying a desirable present for William as part of his diplomatic mission, be this mission for King Edward's purposes or his own. When Harold finally arrives at William's palace a large hawk, the last in the Tapestry's main field, is shown perched on William's hand, but Harold's wrist is bare (Plate XVI).

However, it is possible that narrative technique is at play here as well, for by first showing Harold setting forth from England equipped for hunting and then immediately on his arrival in France depicting the 'hunter' himself being captured,

the artist has used animal imagery as a metaphor for Harold's plight. Hunt and captivity images may also be serving as ironic commentaries on the main story. Look at the fettered birds above Harold setting forth on his journey with his hawk on his hand (Plate II). Then, when Harold is seized for ransom by Count Guy and his men at the Channel shore and led off to Guy's palace, unable to spur or guide his own horse, the Tapestry's bottom register echoes this predatory theme by showing the fable of the lion's share wherein a goat, a lamb, an ox and a lion chase and capture a deer (Plates VII-VIII).

Hunting metaphors fit Harold's captivity by Count Guy perfectly and need hardly surprise us. But what are we to make of the reappearance of the hunting motif beneath the scene where William orders his men to liberate Harold from his imprisonment, with the hunters in the lower registers this time unmistakably identified as Norman, as evident from their hair-style (Plates XII-XIII)? When we note that this time the deer (perhaps Harold) is trapped from two sides, the dogs and hunters closing in on their prey from right as well as left, in a manner not dissimilar to what we see above when William comes to free Harold from his captor, one may legitimately wonder if the creators of the Tapestry would agree that 'liberate' is the right word to describe Harold's imminent transferral from Guy to William.[4]

Zigzag pattern

If hunting appears to be associated with Harold and his role, or even his fate, what, if anything, seems to be distinctly associated with William's cause? First, there is a decorative pattern, found both in the main field and in the border, that appears to be linked only with the conquerors. This is the zigzag design much beloved by the Normans in the decoration of their churches and, according to the Tapestry, their clothing as well.[5] In the main field it appears first in the rows of triangles on a tunic worn by William when riding past Mont-Saint-Michel and later on a similar garment worn by Odo at Hastings (Plates XVII-XIX, LXVII). Most intriguingly, this series of triangles arranged in a manner resembling projecting teeth appears as well in the margins. First it is directly beneath William while he sits observing Harold take his oath (Plate XXV). Later it accompanies the Normans to England, forming a transitional decorative device between the feast celebrating their safe arrival and the war council attended by Odo, William and Robert (Plate XLVII).

Almost as distinctive a Norman motif as their bizarre haircut, this zigzag pattern is most ingeniously included as a framing device beside episodes involving Harold's relationship with William even when no Norman is physically present. The first such usage is above Harold as he visits King Edward on his return to England (Plate XXVIII). Given its association with Normandy, the placing of the zigzag design at this point in the story strikes an ominous chord, not unlike an orchestral motif in opera which reminds the audience of an offstage presence.

But surely the most extraordinary use of this Norman-linked design occurs beneath Harold accepting the crown in violation of his oath (Plate 70). The same jagged pattern we had seen beneath William as he received Harold's oath now

125

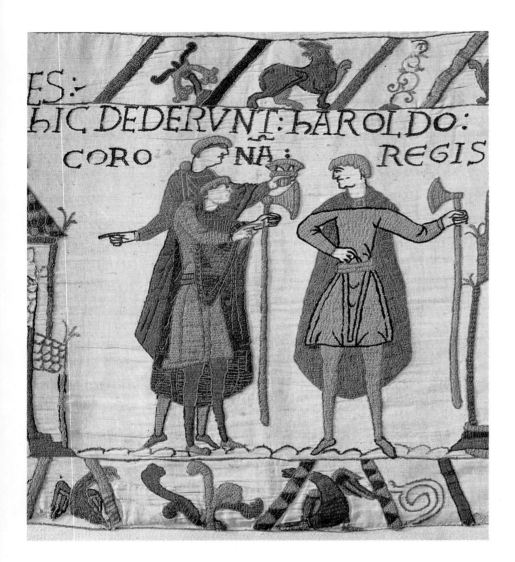

ES:
HIC DEDERVNT:HAROLDO:
CORO ̃NA: REGIS

70 Harold being offered the crown. From the Bayeux Tapestry, Plate XXXI.

reappears, but this time a bird (perhaps a symbol of Harold) strains, apparently in vain, to escape the confines of its compartment.[6] Both Harold's good fortune and a reminder of his involvement with William appear one above the other in this ingenious juxtaposition of primary and marginal forms. As in music, the images here are able to communicate two ideas – legitimate king and perjured vassal – almost simultaneously, one in a 'major key', the other in 'minor'.[7]

Lions with wings

In addition to this decorative pattern, is there any beast which appears to be associated with William's cause? Here one thinks naturally enough of what might be appropriate within a triumphal monument for a hero who conquers a kingdom: perhaps the king of beasts, or the ruler of the skies, or better yet, a mythical creature who combines the attributes of both lion and eagle.

In a monument depicting royalty and military conflict, it is natural that we encounter many winged lions and griffins, as well as the more mundane, though still very noble, lion. Are any of these linked to a particular side in the struggle?

126

The lion does not appear to be, since it can be found in association with both Saxons and Normans.[8] Indeed the lion is so ubiquitous a marginal decoration that apart from instances where royalty or ferocity are being depicted in the main scene, there seems to be no discernible reason for its inclusion at many points in the narrative.

Deliberate manipulation is suggested, however, by the placement of the winged lion and the griffin. Both make an appearance only when Harold has arrived in Normandy and both are usually associated with a Norman triumph: Count Guy capturing Harold as he lands on the Norman coast, William gaining a victory over first Guy and then Conan, William receiving Harold's oath, etc.[9] But the griffin and the winged lion, the two clearly differentiated by the latter's having paws and a muzzle instead of a griffin's talons and beak, do not appear to be interchangeable equivalents. The winged lion appears twice as often as the griffin, and is shown in places and postures that are unique to it.[10]

Thus, whereas the griffin makes its appearance when Guy captures Harold on the Norman shore (Plates VII-VIII), the winged lion enters the Tapestry only later in association with William, above the celebrated Turold scene where William's messengers intimidate Count Guy into handing Harold over to the duke (Plate XI). During the remainder of Harold's stay in Normandy the winged lion also appears only in connection with triumphs for William: the defeat of Conan at Dinan and Harold's oath at Bayeux (Plates XXIII, XXV). Further along in the narrative, we encounter the winged lion when William (and Odo) issue the command to build an armada (Plates XXXIV-XXXV), as well as above the feast held at Pevensey (Plate XLVIII). It appears that the winged lion has a special significance reserved only to it.[11]

Beyond appearing in many key episodes where the griffin is absent, the winged lion is also characterized in a distinctive way. Above the two towering messengers commanding that Guy hand over Harold to William, and also directly over William himself ordering Harold to make an oath to him, the winged lions appear to be preening themselves (Plate 71).[12] In complete contrast to many of the marginal birds and beasts who are attacking or being attacked, or who are so volubly agitated about what is going on around them that their screechings and howlings make this a very 'noisy' work of art, the 'preening' winged lions are the very model of composure and self-satisfaction.[13]

71 Preening winged lion. From the Bayeux Tapestry: see Plate 66.

A final point about the placement of the winged lion in the Tapestry. Just as we encountered the Norman zigzag design as a marginal reminder of William's stake in the succession drama being played out at Westminster in the opening days of January 1066, so we find the winged lion there as well. First there is an agitated pair above the funeral procession; then we find one alone above Edward's death-bed (Plates XXIX-XXX). Since the latter is adjacent to the inscription telling us that 'Edward was here speaking to his faithful ones,' even perhaps pointing at it as if to say 'note this well', one cannot help but wonder if the Tapestry is engaging in a delicious bit of irony by showing an animal associated with the Norman side drawing attention to the way Edward at the very last bequeathed the kingdom to Harold rather than to William.[14]

Why might the lion with wings have been chosen as a symbol for William and his cause? In the context of decorative animal imagery in a medieval work of art there is certainly nothing startling about seeing a winged lion or its close relative, the griffin. At every turn in the manuscripts and sculptures of the period we meet such composite beasts, so strange and so ancient. Deriving ultimately from Chaldea and from the Persia of the Sassanids, these symbols of ferocious power from the ancient Near East were kept alive by Christian artisans in Constantinople and in Muslim workshops of Baghdad, Alexandria and Palermo, whence they were transmitted to the West in textiles, ivories and manuscripts.[15] Perhaps the answer is obvious: if the lion was the king of beasts and the eagle the most regal of birds, then a creature that combined the former's awesome strength and brutality with the eagle's powerful soaring ability and acute vision was the perfect choice for a monument celebrating the triumph of the greatest military figure in Christendom. The possibility that there is another reason as well, one rather less straightforward, is something we shall shortly have to confront.

ANIMALS WHO SPEAK

Amid the hundreds of birds and beasts who inhabit the borders of the Tapestry are a few who have a special privilege: they can speak in a language understood by humans. These, of course, are the characters who have amused and edified the western world since they were created by a Greek genius and satirist named Aesop.[16] In the Middle Ages collections of fables were extremely popular and individual fables appear in political writings, literature and numerous works of art. On the pages of bibles and the walls of monastic dining rooms, on Romanesque sculptured capitals and even over the entrances to churches, the fables of Aesop and his Latin successors, Babrius and Phaedrus, spoke to the people of medieval Europe (Plate 72).[17] With its mixture of *naïveté* and mystery the fable is the perfect complement to the story of the Norman Conquest told in the Bayeux Tapestry.

Framing the central panel we find numerous fables, many of which can be identified with certainty.[18] Curiously, although at least two authors have written extensively on which fables seem to be illustrated in the Tapestry, there is yet to be a full and systematic analysis of what connections, if any, these fables might have with the main narrative. Such a full-scale study will have to await a different

72 Tympanum with fables and hunting scene, over the door of the church of St-Ursin, Bourges (Cher), Jardin de la Préfecture.

context, but if we look at three of those fables that have been securely identified we will be able to assess prevailing opinions and perhaps suggest some new approaches.

What is the dominant view today on their purpose in the margins of the Tapestry? Judging by the virtual silence of most commentators, even those who have studied these marginal figures carefully, there appears to be tacit acceptance of the view that has been advanced by two eminent art historians: 'the fables are an ornamental accompaniment on the upper and lower border, and have no relationship to the historical narrative'.[19]

To date only two scholars have dissented in print, and then only very briefly. One sees the Tapestry's fables as a pro-Norman 'commentary' because when we read the collection as a whole he feels 'that they have all been selected to point the same kind of moral. It is indeed the very moral of the main narrative – the moral of treachery and betrayal. . . . Particular parallels with the Harold story are not far to seek – animals who, like Harold break their word and their faith, animals who, like Harold, seek what does not belong to them, animals who, like Harold, at Hastings, will ultimately offer brute resistance.'[20]

According to another scholar, however, the role of the same fables is quite the opposite. Instead of underscoring the Norman view, they satirize it. This student of medieval art feels that their evident purpose, expressed in the most varied ways, is to comment on the cleverness which permits one to seize the goods of another. On this reading, the fables echo the counsel of prudence known to us from Eadmer's *History*. There Edward supposedly told Harold to beware the mixture of guile and force which would in fact, according to Eadmer's view, enable William to extract the oath from Harold.[21]

73 Detail: the pregnant bitch. From the Bayeux Tapestry, Plate IV: compare Plate LVII.

Which of these three views is the most credible: that the fables are purely ornamental without any connection with the main narrative; that they are anti-Harold in a thematic and moralistic fashion, underscoring his perjury and betrayal; or that they are subtly ironic about William's claim to hold the English crown legitimately?

The following fables first appear in a group at the beginning of Harold's journey to Normandy (Plates IV-VIII): (1) The fox and the crow; (2) The wolf and the lamb; (3) The pregnant bitch; (4) The wolf and the crane; (5) The wolf or the lion reigning (an uncertain identification); (6) The mouse, the frog and the kite; (7) The wolf and the goat; (8) The lion's share. Let us look at three of these fables, not necessarily in the order in which they occur, and listen to what these animals appear to be saying.

The pregnant bitch

In this fable by the Latin fabulist Phaedrus, a bitch about to have puppies asks another bitch to let her deposit her litter in the other's kennel. Permission is granted, but later on when the owner asks for her home back, the 'tenant' requests a little more time until the puppies are strong enough to go with her. When more time has passed the owner begins to insist more forcefully on the return of her home. 'If,' says the tenant, 'you can prove yourself a match for me and my brood I'll move out.' Phaedrus' moral: the fair-seeming words of evil persons conceal a trap.[22]

Why might the makers of the Tapestry have chosen this fable from the hundreds available for depiction around the main narrative? Let us note two themes in the tale of the pregnant bitch:

1. Broken faith and ingratitude towards another creature who had done a favour when assistance was needed.

2. Verbal and physical conflict over territory that turns on questions of ownership and possession, with a hint of the proverbial truth: possession is nine-tenths of the law.

Did the makers of the Tapestry see connections between the fable of the pregnant bitch and their story of the Norman Conquest? While certainty in such matters is never possible, it is noteworthy that the fable is included twice, first among all the others as Harold sails toward Normandy (Plate 73), while the second time it is singled out to be placed beneath William exhorting the Norman knights

74 and **75** Details: the wolf and
the crane. From the Bayeux
Tapestry, Plates V and XXVII.

to fight valiantly against a man whom he claims is an ungrateful perjurer in illegal possession of his land. It is also noteworthy that this fable, perhaps more than most, has narrative progression over considerable time – first there is the use of guile, followed by a period of delay while the promise-breaker consolidates a position, and finally an arrogant defiance: the only way to get me out is to throw me out. Given the thematic and narrative parallels between this fable and the main narrative it is hard to believe that it is merely decorative. Since the pregnant bitch's actions seem to fit comfortably as a metaphor for Harold's ingratitude and guile when making promises, and then for his use of force to retain his possession, this first fable would appear to be anti-Harold.

The wolf and the crane

A wolf having a meal got a bone stuck in his throat. When he promised a reward to any creature who would remove it, a crane accepted the offer on the strength of a solemn oath. Into the wolf's mouth the crane plunged her neck full length. When she got the bone out and asked for her reward, the wolf said, 'Reward! You ungrateful thing. Your head was in my mouth and you got it out intact, and now you say I should pay you a bonus.' Phaedrus' moral: he who wants to serve rascals and be duly paid for it makes two mistakes: first he helps the undeserving, and secondly, he enters into a deal from which he is lucky to emerge without injury to himself.[23]

Is this celebrated tale of the wolf and the crane merely decorative? As with the pregnant bitch, this fable was of sufficient interest to the Tapestry's creators to be included twice, first when Harold is sailing for Normandy and again above his return to the English coast, thereby effectively 'framing' the Normandy expedition (Plates 74, 75). Not just repetition and position but a thematic emphasis upon ingratitude and oath breaking suggest that this fable was chosen because of its bearing on the main narrative.

Was it designed to point up the immorality of Harold's behaviour towards William? If one concentrates only on the themes of ingratitude and betrayal it

76 Detail: the fox and the crow. From the Bayeux Tapestry, Plate IV. The crow drops the cheese.

would appear that Harold is like the wolf in not being thankful to William after the duke had saved him from captivity, an ingratitude that even involved breaking an oath.

Yet, if one moves from generalized thematic considerations to a comparison between the fable as it actually appears in the Tapestry's borders and images of Harold and William in the main story, matters are not so simple. When we first see the fable the crane is on the left and the wolf on the right, a relationship parallel to that of Harold and William at the beginning of the Norman journey. When at the second occurrence the crane and wolf have reversed positions, so have Harold and William, and if the bird still has his bill in the wolf's mouth, it appears somewhat safer now that it, like Harold, is separated from its adversary by a physical barrier. Also, in this tale about a bird who foolishly sticks its neck out to save a creature who is by nature a cunning predator, might there not be a connection between the crane and Harold, a man who in the Tapestry sticks his neck out, literally, to save Norman soldiers from the sands at the mouth of the river Couesnon (Plates XIX-XX)?[24] Finally, in considering whether this fable is intended to reinforce a Norman interpretation, recall that whereas the Norman writers stressed Harold's ingratitude, the Canterbury historian Eadmer emphasized his folly for placing himself in William's clutches.

What do such different possibilities imply? Unlike the fable of the pregnant bitch, which appears to be clearly anti-Harold in intent, one could endlessly debate whether Harold might be meant to be the foolish crane lucky to get back to England alive, or the ingrate wolf who does not honour his oath to pay up after William saved him. There being different and conflicting possibilities, the motives behind the choice of this particular fable can be read as didactic or sceptical, bluntly assertive or cleverly ironic. The possibility that this fable, so intimately related to the Normandy expedition in placement and themes, is open to such different readings would, of course, be consistent with what has been perceived as a studied ambiguity in the main narrative's treatment of why Harold went to Normandy and there took an oath to William.

77 (*right*) Detail: the fox and the crow. From the Bayeux Tapestry, Plate XVIII. The fox has the cheese.

78 (*below*) Detail: the fox and the crow. From the Bayeux Tapestry, Plates XXVII and XXVIII. The fox and the crow are now separated and the cheese is once more in the crow's mouth.

The fox and the crow

Another equally famous fable must also have had a special appeal for the creators of the Tapestry, for no other was so favoured as to be included three times. Recall the words and deeds of the crafty fox and the foolish crow. When a crow, perched on a high tree, was about to eat a piece of cheese which he had carried off from a window, a wily fox who hankered for the tasty morsel spoke up in this way: 'Oh Mr Crow, what a lustre your plumes have, how graceful your face and your figure! If only you had a voice, no bird would rate higher.' Anxious to show that he did have a voice, the foolish crow opened his mouth, letting fall the cheese which the fox immediately snapped up. Betrayed by his own folly, the crow bemoaned his loss. Alas, it was too late.[25]

What are we to make of the fact that the Tapestry's creators thrice repeated this tale of a foolish creature who lost a prize by opening its mouth within one narrative unit – the Normandy expedition – and moreover flagged its importance by placing it as the first and the last of the fables around that part of the story?[26] Surely such repetition and placement, as well as the fact that each appearance is clearly different, suggest that we should look beyond the merely decorative. How might the fox and crow fit the Tapestry's story?

On the one hand, if we look at it from William of Poitiers' perspective, we might see here another tale, like that of the pregnant bitch, which illustrates how a wily creature (Harold) obtains what it wants by lying and guile. On the other hand, if we look at the same fable from the perspective of Eadmer's version of what happened in Normandy and his characterization of Harold and William, we can

read it very differently. As we have seen, in Eadmer's history Harold was portrayed as foolish for not listening to King Edward's warning of the possible dire consequences should he place himself in the power of a man as clever as William. Then, too, in Eadmer's history, William was presented as cunning as a fox, fully capable of sizing up a situation and turning matters immediately to his advantage. In Eadmer's account, Harold, like the crow, is his own worst enemy. Finally, it is this Canterbury historian who first suggested that William coaxed the oath out of Harold's mouth involuntarily.[27]

Are there any visual clues to what the master artist of the Tapestry might have had in mind? Again we must look carefully at the ways in which the fable is actually depicted in the Tapestry. How, for instance, is it altered in its three appearances? In the first version (A), the crow is perched high up on the left, the direction from which Harold is coming, and the cheese, which is of remarkably similar shape to the food in front of Harold and his companions, has already fallen half-way down to the open-mouthed fox in a diagonal line that echoes the direction of the descending figures above (Plate 76). If one connects Harold with the crow, then the narrative link is surely a foretelling of how, by opening his mouth, Harold will let slip his prize when he falls under William's sway. In the second rendering (B), located at the beginning of a Breton campaign, the cheese is already in the fox's mouth (Plate 77). Again, one might see an instance of foreshadowing as Harold gallops off with William on an adventure which will be completed by Harold receiving arms and swearing the oath: Harold's prize is as good as gone. In the last occurrence (C), above the scene of Harold riding towards Edward to report what happened on his Normandy expedition, we find that an extraordinary thing has occurred: the cheese is back in the crow's mouth (Plate 78). But this is no mere echoing of version A. The fox and the crow, no longer in the same compartment, are separated by a panel, a spatial composition similar to that of William and Harold below, even to the reversal of positions. Does not the juxtaposition of this version of the fable precisely at this point where the English earl is safely separated by the Channel from his foe and the prize is again in his grasp invite us to see the characters in the terms of Eadmer, with William as a trickster and Harold as a foolish, but for the moment, fortunate aspirant to the throne?[28]

The fables and the Englishness of the Tapestry

So naïve and so mysterious, so transparent and so sophisticated, so universal and so particular: such is the impression made upon us by these ancient fables in the margins of the Bayeux Tapestry. As such they express much of the unique genius of a work which, as we have suggested, is classically inspired yet very contemporary, educated yet popular.

But what of their purpose? Clearly the view that they are 'merely decorative' and without bearing on the main narrative cannot be sustained. But can we say that they are pro-Norman, in the vein of William of Jumièges and William of Poitiers, as one contemporary critic has suggested, or alternatively that in the manner of Eadmer they are critical of the Norman case, as has been suggested by another 20th-century observer?[29] In testing these two interpretations we have

seen that the fables do not all fit so easily into one category or the other. If the fable of the pregnant bitch appears to support the Norman version of events, the two others can be read either as pro-Norman or as pro-English, depending on one's vantage point. Close attention to artistic choices also seems to reveal which way the artist was leaning.

Such variety and ambiguity is consistent with the extraordinary circumstances surrounding the creation of the Bayeux Tapestry. How often in world art has a subject people been called upon to make a monument depicting the events that led to their own enslavement, and, in the eyes of their victorious patrons, legitimized that victory? An English artist commissioned to make such a work for a Norman lord must continually have had to face the contradictions of his historical circumstance. When dealing with such controversial matters as why Harold went to Normandy and there swore an oath to William it is understandable that he selected some fables that lean towards an 'official' Norman view, while others permit a dissenting view for those who wish to find it.

The Tapestry artist was not unique in using the borders as a realm of freedom. In the margins of manuscript pages and the frames of sculptured doorways medieval artists found an outlet for their satires, their fantasies, their aggressions.[30] Nor was the Tapestry artist alone in using fables as a means of subverting an official point of view. Fables have long been associated with dissent. Aesop was supposedly a slave from Samos who used his animal tales for political purposes. Here is how Phaedrus, the Roman fabulist whose works formed the core of medieval collections, accounted for the origin of the fable: 'Now I will briefly explain why the type of thing called fable was invented. The slave, being liable to punishment for any offence, since he dared not say outright what he wished to say, projected his personal sentiments into fables and eluded censure under the guise of jesting with made-up stories.'[31]

Lastly, in contemplating the possibility that some of the fables were not used to support a Norman version of events but rather to subvert that view by providing an elusive ironic commentary on the main narrative, recall the kinds of characters who succeed in these animal stories. Unlike the clear-cut moral world of William of Poitiers' biography where his subject is always just and heroic, success in the fables is typically awarded to a disreputable character, a fox or a wolf. Most of those who succeed get their selfish way by using guile, flattery, treachery and, when necessary, physical force. Those who suffer are either innocent or foolish.[32] Violence and fraud reign; tricksters and bullies get the prize in the end.[33] Such is the path to power for the heroes, or rather the anti-heroes of the fables. A Reynard emerges triumphant by deliberately doing the opposite of what a Roland would have done.[34]

CHAPTER X

Centre Stage: King or Bishop?

In the opening of what we have termed the Tapestry's second Act a new character enters the drama. This is Odo, bishop of Bayeux, the man who, as we have seen, almost certainly commissioned this extraordinary monument. But in having Odo as his patron the artist faced a delicate problem. As had been the case with the political background in Act One, now, in the second Act's depiction of the actual conquest, he needed to satisfy differing and conflicting interests but this time it was not a matter of English versus Norman views of what had happened, but rather of satisfying two strong Norman personalities. His dilemma was how to depict Odo in ways that would flatter his enormous ego, while not giving offence to the sensibilities of the royal brother who shares the stage with Odo in each of his appearances. So ingenious are the varied solutions to this problem that only close examination of the four scenes in which Odo appears can reveal the artist's considerable diplomatic skill.

The decision to build an armada

At the opening of Act Two Odo first appears in the scene where a messenger brings news to William that Harold has seized the English throne (Plate 79, page 138). According to the inscription, William reacted immediately and decisively with a command that would alter the destinies of England and Normandy: 'Here Duke William ordered them to build ships.' William and the messenger are not alone. To the right a carpenter, conveniently present with an axe in hand, turns his head to hear the order while pointing to the adajcent scene of trees being felled in the first phase of the armada's construction. Between the carpenter and William sits a tonsured cleric, who, while unidentified by name, must certainly be Odo. His unique role in the Tapestry as the only identified Norman prelate makes it highly implausible that the artist would have seated any other ecclesiastic next to William at this critical moment.

Although apparently quite straightforward, the scene juxtaposes Odo and William in subtle ways that betray both the artist's dilemma and his ingenuity in reconciling conflicting demands. If the inscription unambiguously states that William gave the command for the ships to be constructed, the picture does not illustrate what the words say. In fact, by having William point towards the messenger while Odo directs attention to the scene of trees being felled, it looks as if William is merely an intermediary who receives the news from Westminster while Odo is actually the decisive figure giving the command to build the fleet. The artist creates further ambiguity with the placement of the two brothers. William is situated in the mathematical centre of the royal chamber, yet the

misalignment of the central tower overhead, to the right towards Odo, counteracts the duke's central position. Odo's expansive, assertive gestures, his more strongly defined face, shown almost frontal, his more boldly coloured attire and his slightly higher elevation are in marked contrast to the depiction of William.[1] Of course, William has not been completely 'upstaged' by Odo. He sits in front of the bishop; we see more of his lion throne; and his much broader cloak, sloping expansively like the roof line of his palace, overlaps part of Odo's lower body. None the less, our main impression of this scene is a playful and ironic interplay between what we expect and what we see, between what is written and what is pictured.

To further augment Odo's role at this momentous event, the artist has simplified history by leaving out a critical detail: according to William of Poitiers, Duke William took counsel with many men. Some apparently tried to dissuade him with arguments that an invasion of England was too difficult or beyond the resources of Normandy. In William of Poitiers' description of the event it was the assembled laymen, not the bishops and abbots, who spoke much more forcefully in favour of invasion. Many 'brilliant and splendid lights of counsel' were present: Robert, count of Mortain; Robert, count of Eu; Richard, count of Evreux and son of Archbishop Robert; Roger of Beaumont; Roger of Montgomery; and William fitz Osbern. While William of Poitiers does not record what they said, in a typically fulsome comparison of his Normans with the Romans of old, he comments that they were so eloquent and wise that 'the Roman republic, if sustained by such as these, might now be as distinguished as of yore, and might not have to regret the loss of its 200 senators'.[2]

Odo as cleric

The next scene in which Odo appears is also delightfully inventive in showing Odo to advantage in the company of his royal brother. This is the famous portrayal of the Normans holding a feast to celebrate their successful landing at Pevensey (Plate 80, page 139). A servant summons the diners with the blast of a horn, while the cooks and waiters are assembling the spit-roasted meats and chickens on to trays which appear to be kite-shaped shields. As the meal is about to begin Odo raises his right hand in blessing over the wine. At first glance this feast, with its table set for six diners served by a waiter holding a napkin and bowl in a courtly manner, seems to be just another of those scenes of everyday life whose naturalism fascinates us in the Tapestry and which Anglo-Saxon artists, much before their Continental counterparts, were particularly fond of making.[3]

But is this just a carefully observed meal filled with picturesque details devised to record life as it was in 1066? Also is it, as has been claimed, a purely secular episode without any religious overtones? Using this scene as an example, one historian has characterized the nature of Odo's patronage and, indeed, the meaning of the whole Tapestry in this manner: 'When the army reaches England, the chronicles preface Hastings with prayers but the tapestry offers instead a feast. And this is, indeed, the whole spirit of the tapestry. Everything is read in feudal and secular terms.'[4] Let us look more closely.

First, observe that although William is apparently seated at the table, it is Bishop

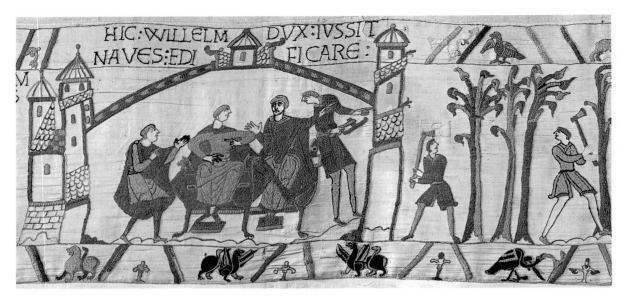

79 Odo counselling William to build an armada. From the Bayeux Tapestry, Plates XXXIV and XXXV.

Odo who dominates the scene. Looking directly at the viewer while all the diners, with one exception, turn towards him, Odo commands our attention and theirs. Where is William? As he is generally thought to be the round-faced man seated below and to Odo's right it is noteworthy that he is literally and figuratively 'upstaged' by both the bishop and the unidentifiable bearded diner who even seems to be elbowing his way in front of the duke. Odo's pictorial centrality is reinforced by the fact that he is the only person mentioned in the inscription: *Et hic episcopus cibum et potum benedicit* [And here the bishop blesses the food and drink], and by the deliberate manipulation of these words and adjacent images. His tonsured head rises above the others until it touches EPISCOPUS in the top line, while at the same time it is conspicuously being framed below by BENEDICIT, the word informing us of the bishop's actual role in this scene. Moreover, by spreading

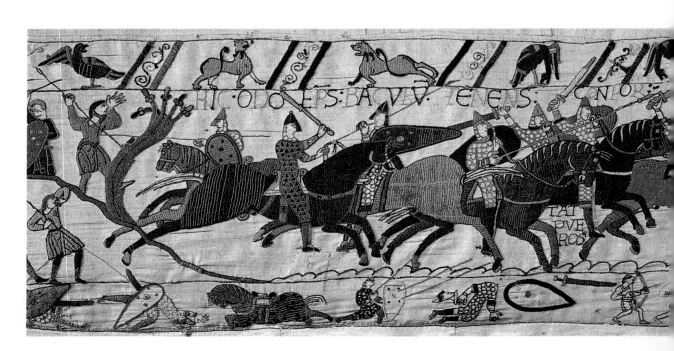

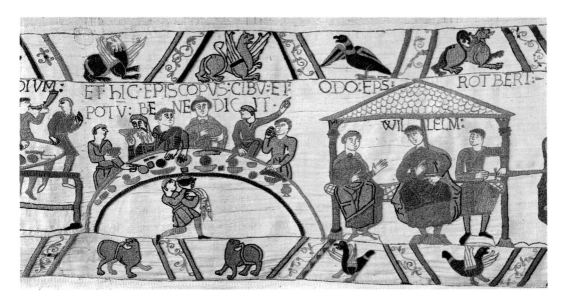

80 Odo blessing wine and food at the Norman feast then counselling William on military strategy. From the Bayeux Tapestry, Plate XLVIII.

out the word for 'blessing' so broadly, and by conspicuously punctuating its divisions with the heads of William, Odo and the unidentified diner to Odo's right, the artist slows down our reading, almost allowing us to hear the solemn, chantlike intonation of the Latin BE·NE·DIC·IT.

In so favouring Odo at the expense of the king, the artist was no doubt flattering his patron, much as he did in the scene where the command was given to construct the armada, but here the ironic interplay between words and images appears to be avoided, at least at first glance. Every feature – including the arc-shape of the table, the arrangement of the food, the gestures and placement of the diners, the central alignment of the servant and Odo, and the carefully devised inscription – combine to focus attention on the bishop making a blessing over the wine and the food.

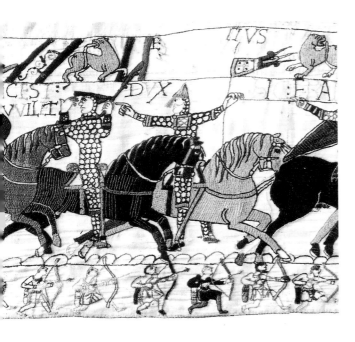

81 and **82** The tide is turning: in the midst of the Battle of Hastings, Odo is urging on the young knights while William lifts the visor of his helmet to show he is still alive. From the Bayeux Tapestry, Plates LXVII and LXVIII.

Second, recall that for the creation of this seemingly secular scene the artist has almost certainly used a religious pictorial model, a Last Supper illustration in the celebrated 6th-century Italian manuscript known as St Augustine's Gospels (Plate 18, page 49).[5] While visual similarities almost certainly link the Tapestry with this celebrated book, or a now lost copy, from the library of St Augustine's Abbey, Canterbury, it remains to be asked why the artist of the Bayeux Tapestry, a man so keenly interested in the details of life around him, chose an ancient model for his depiction of a Norman feast – moreover, not just any model from the many available in illustrated bibles, psalters and calendar illustrations, but a depiction of Christ instituting the mass at the Last Supper.[6]

Surely the intent of selecting a well-known biblical prototype for Odo's blessing at the Norman feast is to establish a close association in the minds of knowledgeable observers between Odo and Jesus. Propaganda by visual association, even the assimilation of prominent ecclesiastics to Christ, is not uncommon in the Middle Ages; the seal of Etienne de Bâgé, bishop of Autun and patron of the building of the cathedral of St Lazarus, shows the bishop in a position, with knees unnaturally splayed, similar to that of Christ in the Last Judgement sculpture over the cathedral's main doorway.[7] If Odo was aware that the Tapestry artist had selected an image of Christ at the Last Supper as his model for the portrayal of him blessing wine and food at the Norman feast, the allusion would no doubt have been as flattering to the bishop of Bayeux as was the design of the bishop of Autun's seal to Etienne de Bâgé.[8]

While many features of this feast scene can be explained by a dependence on a particular early Christian model, some cannot. Note the servant in the foreground, the inattentiveness of the diners drinking and talking during the blessing, and especially the mysterious diner who points towards the next scene while turning his head back to look at the bishop. As one student of the Tapestry has remarked, this seems 'an inappropriate gesture to make in the middle of grace'.[9]

Should this pointing figure be read as one of the Tapestry's many visual conjunctions, leading us on to the next episode in a manner similar to that of the axe carrying carpenter in the scene where the command is given to build the fleet, or is he gesturing to the other participants, perhaps calling them to the adjacent council, in much the way the gesturing servant informs feasters at Bosham that the boats in the Channel are ready for embarkation (Plates III-IV)?[10] While he is clearly pointing at the adjacent council scene where Odo, William and Robert are holding a meeting, it seems unlikely that he is calling Odo and William away while the bishop is saying grace.

What would justify the pointing figure disrupting the religious aura of the scene? Note that our mysterious diner is not pointing at the council scene in general, but at only one part of it, the inscription.[11] As in the scene of William ordering the armada to be built, the artist has again employed an unusual relationship between words and images to highlight Odo's role in the Tapestry, but this time the two do not appear to contradict each other. What might his purpose have been? Since contemporaries would have been aware that Odo was not the only ecclesiastic

accompanying the expedition, the bishop of Coutances being another mentioned in the written sources but conspicuous in the Tapestry by his absence, the artist may be taking into consideration our presence as slightly puzzled viewers wondering if the unnamed bishop blessing the food and wine was indeed Bishop Odo. Thus, by having the diner point at the adjacent scene's inscriptions, particularly its first words – ODO:EPS (ODO:EPISCOPUS) – the artist has made unmistakably clear that the bishop saying grace in a Christ-like manner is none other than the bishop of Bayeux.[12]

Odo as counsellor

About Odo's presence in the council scene, the third in which he is depicted, much less can be said. It appears to have been motivated by three aims: one, to have his name in the inscription; second, to place him together with his two brothers in a family portrait; and, third, to show Odo once again contributing to the Norman cause as a counsellor. This time he offers advice on military strategy now that the successful landing has left the invaders exposed to attack, and perhaps it is implied that the decision to erect a castle at Hastings was his. Again, as in his first appearance, Odo shapes history by the power of his words, though this time he stands out as William's 'right-hand man'.

Odo as warrior

Odo's last appearance is in an episode that naturally elicits a smile from the modern viewer. It is the climax of the Battle of Hastings (Plates 81, 82). From the outset the English had the advantages of higher ground and massive battle-axes that easily maimed man and beast. After a fierce struggle some of the Normans were in disarray, with horses somersaulting over one another and panic gripping the troops when they lost sight of their leader. But a general rout was checked. According to William of Poitiers, it was the appearance of William in the midst of the disordered ranks that gave a new turn to the battle. 'Staying their retreat, he took off his helmet, and standing before them bareheaded he cried: "Look at me well. I am still alive and by the grace of God I shall yet prove victor. What is this madness that makes you fly . . . ? You are throwing away victory and lasting glory, rushing into ruin and incurring abiding disgrace."'[13] The Tapestry wittily and imaginatively captures the moment William dispels the rumour that he had been killed by having Eustace of Boulogne point at the duke lifting his visor.

The Tapestry differs, however, from William of Poitiers' account of this Norman crisis in two critical details. If the Tapestry depicts Eustace as a hero, William's biographer portrays him as a counsellor of despair and retreat in the midst of battle, a characterization that no doubt reflects Eustace's loss of royal favour in the decade after 1066. Most significantly, the Tapestry also differs from William of Poitiers' account in allowing a secondary figure, Bishop Odo, to share the stage with William at this turning-point in the battle. For according to William's biographer, it was the duke and only the duke who 'thrust himself in front of those in flight'. It was only the duke who 'restored their courage' and 'inflamed their ardour'. Yet in the Tapestry it is William and Odo who turn the tide of battle.[14]

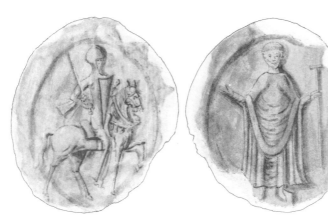

83 Odo's seal. From Sir Christopher Hatton, *Book of Seals*, 1640-41. The seal is attached to a copy of a charter which records, in Latin and Anglo-Saxon, a grant by Odo to Christ Church, Canterbury.

Distinguished by his baton and a richly coloured tunic that was tailored to fit over his hauberk, the cuffs and neck of which are visible, Odo stands out so well that he need not have anyone pointing to him.[15] To make certain that the viewer knows who is so richly adorned, and that, even in the thick of battle, Odo did not overstep the canonical prohibition against shedding blood, the inscription informs us that 'Here Bishop Odo, holding a baton, cheers on the young men.'[16] How important it was to the artist to stress Odo's oratorical abilities at this critical juncture is clear from the fact that only in this instance does he allow the inscription to migrate down from the upper zone to the lower part of the scene, even to between the horses' legs where we must search to find the completion of Odo's inscription.

More than anywhere else in the Tapestry, Odo here appears as a survivor of the warrior bishop of earlier days, a man who might have served as the model for Archbishop Turpin in the *Song of Roland*. Did Bishop Odo in fact want to be perceived as a warrior? According to William of Poitiers he merely assisted at the Battle of Hastings by his prayers, never took up arms and never wanted to, but was none the less feared by enemies because he 'gave aid in battle through his most excellent advice.'[17] Yet there is the evidence of the Tapestry and another most remarkable statement of Odo's delight in a martial reputation from his bishop's seal (Plate 83). On one side Odo appears as a cleric, but on the other he is fitted out in armour and shown on horseback, a depiction of a bishop as an equestrian in arms that is apparently unique in medieval European seals.[18] Judging by his Tapestry and his seal, Odo was untroubled by the tensions involved in combining the life of a cleric with that of a warrior prince. In this worldliness his views are reflective less of his own time than of an earlier day. Because of the writings and activities of papal reformers the contradictions of such a life were becoming more and more obvious to people in the 1070s and '80s. Indeed, how much the world had changed during Odo's lifetime is dizzyingly apparent when we stop and consider him succeeding in his alleged attempt to buy the papal chair occupied by Hildebrand or to take it by force of arms. One can hardly imagine a more incongruous successor to the prophet-reformer Gregory VII than Bishop Odo of Bayeux.

Such are Odo's four appearances in the Tapestry, but we might note a fifth scene in which he obviously has a vested interest even though he is not physically

present. This is the celebrated depiction of Harold's oath to forward William's claim to the English throne. Alone of contemporary historians, the Tapestry artist seems to place Harold's oath to William at Bayeux, rather than at Bonneville or at Rouen.[19] While Odo is not shown as present, and no church is visible, the cathedral of Bayeux and its store of relics achieve a distinction that could not have failed to advance the prestige of its episcopal overseer. As in the four episodes where Odo does appear, artistic choices and historical veracity are apparently not unaffected by considerations of patronage.

In conclusion, our analysis of how Odo is portrayed in the Tapestry suggests a number of points. It has confirmed the observations made since the mid-19th century that the bishop of Bayeux, not William or Matilda, was the patron of the Bayeux Tapestry. Yet, while earlier students have noted that his role in the Tapestry is of far greater significance than in any written account, permitting him to appear in more scenes than any other figure apart from Harold and William, those writers mainly contented themselves with observing the fact of his presence but did not explore *how* he was portrayed. Contemporaries would not only have noticed Odo at critical moments, but, more importantly, they would have seen him in multiple roles, as a wise and forceful counsellor, perhaps even the mastermind behind the expedition who gave the order to construct an enormous fleet and the key adviser on military strategy after the landing at Pevensey; as the cleric who brought God's presence into the Norman ranks, both as mediator with the divine and as custodian of the relics on which the all-important oath had been sworn; and, finally, as a brave fighter and eloquent leader, who, despite his priest's cassock, helped turn the tide of battle at Hastings when the Norman cause appeared lost.

Moreover, as counsellor, fighter and priest Odo would have appeared to rival, if not upstage, his more powerful brother in each of the scenes where he appears. In creating this impression and in his varied, ingenious solutions to the problem of having Odo and William in the same scenes, the artist has once again shown himself fully able to handle conflicting demands; indeed, he seems so adept at conveying multiple meanings that, while it is hard to imagine William accusing him of *lèse-majesté*, Bishop Odo would have undoubtedly found much in the Tapestry to flatter his not inconsiderable ego.

CHAPTER XI

Victory at Hastings and the death of Harold

No episode in the Tapestry has aroused more controversy than the death of King Harold at the climax of the Battle of Hastings. Why is this so? First, what we see is not easily read. It is not clear from the inscription which figure is Harold, or indeed whether the Anglo-Saxon king appears only once in his last scene or twice. Second, the earliest datable texts – the *Anglo-Saxon Chronicle*, William of Jumièges and William of Poitiers – are of little help since they are silent on the details which matter in the Tapestry's iconography: precisely what wounds Harold received. Lastly, adding to our difficulties is the fact that the end scenes, including the death of Harold, are no longer in their original state. Having suffered loss of many threads over time, these scenes were extensively restored in the mid-19th century, but without a critical evaluation of the Tapestry that analyses which threads are original and which are restored, and whether the restored sections appear true to the original design, we cannot always be certain that we are viewing the artist's work. While the author has had the opportunity to examine the area in question at close hand, the full scientific information gathered in 1982-83 by the Monuments Historiques has not yet been published.

Despite these obstacles I hope to show that a close analysis of the death of Harold scene discloses some new information on what the artist depicted and his methods of highlighting what is central to his story. This in turn will permit us to approach the iconography of the Tapestry's climactic scene in a new way. In particular, I hope to demonstrate that the artist chose a specific iconography to give symbolic meaning to his drama, not to illustrate how in fact Harold was killed – for to that question no contemporary seemed to have an answer. If the Tapestry designer seems to have invented his iconography in the manner of other medieval artists confronted with the problem of depicting a scene for which there were no known details, the interesting question then becomes why he chose the unusual imagery he did. To solve that enigma we will not only compare the Tapestry's details with those in contemporary historical accounts of the Battle of Hastings, but also place the work in its original cultural and political context, attempting to grasp Anglo-Saxon and Norman attitudes towards perjury, retribution, conquest and the mysterious patterns of history.[1]

HAROLD'S DEATH IN THE TAPESTRY

The Tapestry portrays the king's death under the inscription *Hic Harold rex interfectus est* at the end of the battle. The Normans have regrouped after William and Odo, rallied the troops, and with a combined archery and cavalry attack break

through the English lines (Plates LXVIII-LXXI). As we approach the climax we pass an Englishman about to be struck with a sword. Why is he unarmed and why is the Norman knight on foot when every one of his knightly peers at the battle is depicted on horseback? It is a puzzling episode to which we shall return.

Next, a mounted knight with lance and shield is advancing at a gallop, his horse's left foreleg about to crush the head of the dragon which served as Harold's battle standard. Crushing the enemy or his symbol underfoot is, of course, a part of traditional battle imagery starting with ancient Near Eastern royal art, and later adapted from Roman imperial monuments by medieval artists.[2] The Norman knight is advancing on a group of three Englishmen, each girt with a sword and each carrying in his left hand a shield bristling with arrows shot from the bows of the diminutive marginal archers. The first Anglo-Saxon holds a javelin above his head, the second a dragon standard and the third has transferred his javelin to his left hand while with his other he tries to pull an arrow from the right side of his head. Then comes another Norman knight armed only with a sword. He leans forward to slash the thigh of an Englishman who, before falling to the ground, had been armed with a sword and the characteristically Anglo-Saxon battle-axe. There are no visible arrows.

Artistic conventions

Which figure or figures is Harold? What is the manner of his death? Until 1957 most observers held that the standing figure pulling the arrow out of his head was the king and every schoolboy knew the story of how King Harold was shot by an arrow in the eye. In the notes to the 1957 volume on the Tapestry edited by Sir Frank Stenton the popular view that the Tapestry depicts Harold receiving an arrow in the eye was vigorously challenged by Charles Gibbs-Smith, who went on to elaborate his opinions in subsequent publications.[3] Because of the authority of the Stenton volume and the seeming plausibility of Gibbs-Smith's views, his revisionist interpretation enjoyed such wide acceptance that it was common to see it stated in popular and scholarly publications that Harold was not the arrow-in-the-eye figure but rather the one about to have his leg cut by a mounted Norman knight.[4]

More recently Gibbs-Smith's arguments have been subjected to a searching critique, and, as often happens in historical studies, his views have prompted a closer and more cogent analysis of the historical sources and artistic evidence.[5] For example, in response to Gibbs-Smith's view that artistic conventions would permit only one figure to be the king, it has been demonstrated by statements from 12th-century writers who may have seen the Tapestry that contemporaries read the scene as showing Harold first struck by an arrow in the eye (or the brain) and then being cut down.[6] It has also been shown that the Tapestry designer shared a predilection for duplicating important figures within a single scene with other late Anglo-Saxon artists, for example, the creator of the Ælfric Hexateuch and the artist of the so-called Caedmon manuscript (see Plates 53, 54).[7] In the Tapestry the English scout running towards Harold (Plate LVI) is probably the same as the one who is looking for the approaching Norman army, and the bearer of the dragon

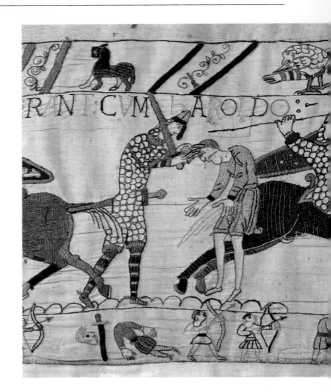

84 and 85 Experiment with the death of Harold scene: in Plate 85 (*below opposite*) the inscription is rearranged to fit solely over Harold B, unlike the arrangement in the original Tapestry (*right*).

standard, the old bearded man, is almost certainly shown twice in the scene depicting the death of Harold (Plate LXXI). Indeed, duplication is most conspicuously used by the artist in rendering the demise of important men, that day when they were 'both alive and dead': the passing of King Edward the Confessor (Plate XXX), the violent death of Harold's brother Gyrth (Plate LXIV), the deaths of the standard bearer (and the dragon), and King Harold as well.[8] Placing the Tapestry in the context of the artistic conventions of the time allows us to accept more readily the apparent unnaturalness of Harold being shown twice within the length of a horse, wearing different stockings and having changed weapons.[9]

Another medieval artistic convention – the integration of text and image – was also used by the Tapestry artist to let the viewer know not only that both figures are meant to be read as Harold but also how the king was killed. In the death of Harold scene, if it were assumed that the king had to be one or the other figure, the inscription's position would make it difficult to determine which figure it should be – the one whose head is framed by the name or the one above whose body the words *interfectus est* [is killed] are written. Let us call the first one Harold A and the second Harold B. Note that the inscription of this scene is so carefully placed that any attempt to alter it disturbs the meaning. Had the artist wished, for example, to indicate that only the second figure was Harold, this could have been done merely by relocating the words. Let us perform an experiment and rearrange the inscription so that it is clear that only the prostrate figure is Harold (Plate 85). If one compares the new version with the original (Plate 84), it is obvious that

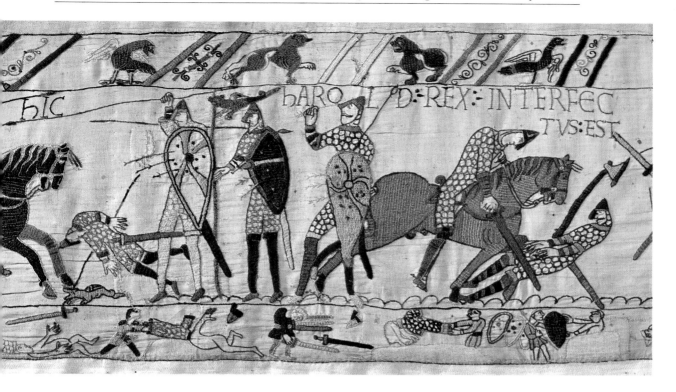

without having to delete any letters it was possible for the artist to make emphatic that the second and only the second figure was Harold. But the way the artist designed the inscription so that crucial words are situated above both Harold A and Harold B permits the viewer to read both figures as the king, first alive, then dead.

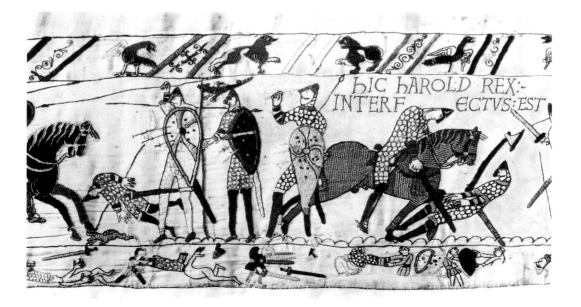

Blinding as leit-motif

If we look more closely at the inscription we will see that the artist not only chose to depict Harold twice but had selected a particular motif to associate with Harold's death. Observe that in the original version Harold's name is divided in such a way that a slightly diminished 'O' is situated closest to his brow and nose-piece, with the arrow almost touching it. Why does the Tapestry interrelate a person, a name and a weapon in this fashion? And not just once but twice.[10] A striking parallel with the death of Harold scene occurs in the animated episode of the English scout running towards Harold with the news of the approaching Norman army (Plate LVI). Harold, on his hog-maned horse and sporting a long moustache, points in the direction of the approaching danger, while his left hand holds a shield and spear. Note details that parallel those in the scene of Harold's death. As in that composition, the king's name frames the figure's head and in both cases attention is drawn to one letter, the 'O'. By appearing significantly smaller than its neighbours, the 'O' seems to have moved aside to make room for an intruder into its space, which, again, is a weapon that rests against the letter 'O'. That such relationships between inscriptions and images were consciously being adjusted by the artist and his embroiderers is suggested by the way the scout's spear is aimed downward, directly at William's name. Since all the embroidery in this scene seems to be original, it appears that the embroiderers did not simply work the figures and then fit in the text, but that there was a more complicated process of interplay between words and images.

But why would the artist have so tampered with the letter 'O' in Harold's name and grazed it with a weapon? In the context of this particular version of how King Harold was wounded at Hastings with an arrow in the eye, the letter 'O' has an obvious association with the shape of an eye, and is the first letter of the word 'eye' in Latin and French.[11] Since the battle is about to begin, Harold's own lance grazing the ocular-shaped letter is perhaps to be understood as a foreshadowing of what will occur at the end of the battle, and possibly an indication that he is either fated to be blinded or that he is not without responsibility for his own destiny.[12] By foreshadowing with inscriptions here and with Aesopic fables in other places, our artist uses techniques not dissimilar to those of medieval epic poets, even in the employment of rather heavy irony.[13] But in doing so, he activates his visual medium so that what are usually marginal zones become charged with a vitality and purposefulness that breaks down the usual boundaries between main figures and peripheral ones. By allowing the 'O' to serve as both a letter and an ideograph, the integration of text and image could hardly go further.[14]

Enigmatic stitch marks

Related to the questions of whether Harold is shown twice in this scene and how much importance was attached by the artist to the arrow which blinded him is a detail which has gone unnoticed in the literature. I bring it to the reader's attention, not because it conclusively proves anything about the death of Harold. Quite the opposite. At the moment it is new data that cannot be satisfactorily explained, but, by entering the laboratory, as it were, the reader can see some startling new evidence for himself. This is a line of several small holes in the linen

ground adjacent to the head of the figure we have labelled Harold B (Plate 86, page 150).[15] To the left of the axe handle are three large holes due to wear and tear with which we are not concerned, but to the right of the handle is a series of six holes, surrounded by discoloration of the linen, forming a diagonal with Harold B's brow.

Why are there stitch marks in a line leading to the fallen figure's forehead at this critical moment in the narrative? Two possibilities present themselves:

1. The holes are traces of an 11th-century embroiderer's stitching. If so, the only plausible explanation for a straight line at this point is an arrow lodged in Harold B's forehead directly above his eye.

2. The holes are traces of an arrow, but one sewn in later by an 'inspired' restorer who perhaps thought that there should be one there. After putting it in, presumably he or someone else removed the offending improvement.[16]

To determine the meaning of these puzzling holes, two types of evidence need to be considered, that contained in the Tapestry itself and that found in relevant documents. In January of 1983 the author was kindly permitted to examine the back of the Tapestry in the company of a team of textile experts who were completing a three-month scientific survey of the monument.[17] Studying the scene in question from the back, an important detail not visible in photographs taken from the front became apparent. Whereas six holes are visible from the front, from the rear it is possible, with the help of magnification, to make out seventeen holes. These form a straight line ending to the left of the axe handle in a pattern suggestive of one feather, though the significance of the pattern is uncertain due to compression of the linen ground at that spot (Plate 88, page 151). While not conclusive, the physical evidence of the Tapestry itself strongly suggests to this observer that original embroidery could account for these enigmatic stitch marks. First, the size and spacing of the holes appear consistent with those made in the 11th century. Second, the seventeen holes make a line approximately the same length as arrows in the Tapestry. Third, while no traces of yarn have been found, the discoloration around the holes indicates that thread had been in place for a considerable time.

Moreover, the possibility of an original arrow is consistent with the Tapestry's artistic conventions. As we have noted in connection with the interplay of letters and figures, the blinding motif was central to the artist's presentation of King Harold. Also, when the artist duplicated a figure in a single scene he usually repeated a distinctive motif, no doubt to allow ease of identification. Hence, an arrow lodged in the head of Harold B as well as Harold A would be a repetition of a motif similar to that found earlier in the portrayal of the death of Harold's brother Gyrth. He was depicted first alive and then dead with an identical facial wound, a lance in the mouth (Plate 87, page 150).

Finally, the possibility that the stitch marks are original is in accord with the testimony of the 12th-century poetical historian of the Norman Conquest, Master Wace. As a canon of the cathedral of Bayeux, he would naturally have had occasion to study the Tapestry if it had been located in Bayeux during his lifetime. While there is no conclusive evidence that he had seen the Tapestry, recent observers think it most likely, and certain details of the death of Harold scene appear to

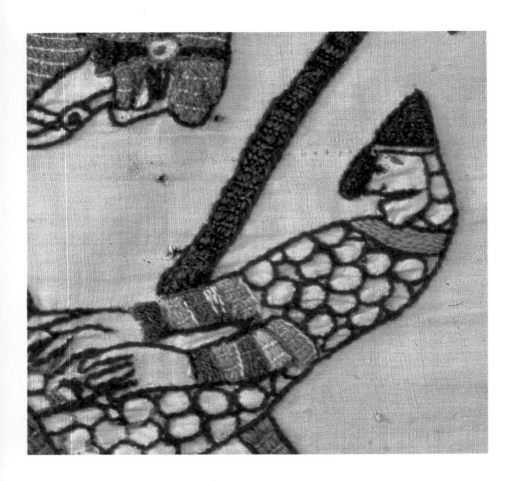

86 (*left*) Detail: enigmatic stitch marks by the brow of Harold B. From the Bayeux Tapestry, Plate LXXI.

88 (*right*) View from the back of the Tapestry with the stitch holes, some microscopic, indicated. The front of this figure has faded because of its exposure to light, while the harsh colours of the back show the quality of materials used by the restorers of the 19th century.

87 Detail: death of Harold's brother Gyrth, shown twice, in the main scene and in the lower border. From the Bayeux Tapestry, Plate LXIV.

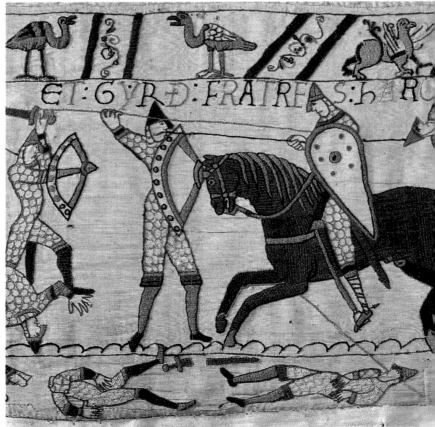

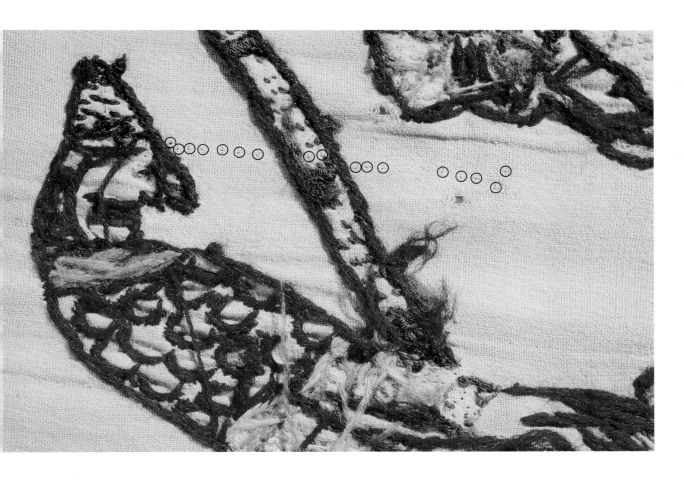

confirm his knowledge of the Tapestry.[18] In the *Roman de Rou*, written about a century after the Conquest, Wace describes Harold being hit by an arrow above the right eye, then reaching up to pluck it out. In attempting to dislodge it, he breaks the shaft.[19] Note that if we assume that there had been an original arrow in Harold B's brow, Wace's account would agree with the Tapestry in four unusual details: the arrow's entry above the eye; the blinding of the right eye; Harold reaching up to pull it out; and the incompleteness of the arrow in Harold B's brow, there apparently having been only one feather, if indeed any at all. It is difficult to account for so many correspondences except on the assumption that Wace saw the Tapestry when there was a line of stitching forming a diagonal with Harold B's head.

Unresolved puzzles about the stitch marks

If these stitches are not original we have to assume that a restorer embroidered a new arrow for Harold B which was subsequently taken out. To do so, this embroiderer would naturally have studied the stylistic features of the original and perhaps used Wace's *Roman de Rou* as a guide. While this is certainly a possible explanation for these enigmatic stitch marks, one is still left with the puzzle why no one recorded the deed or noticed the new stitches. Also, if this restorer put in an arrow and quickly took it out again before anyone noticed, why is the linen ground around the holes discoloured?[20]

On the other hand, if the holes are original, as archaeological data, artistic techniques and a medieval text seem to suggest, the most perplexing question is why they have not been noticed before. No drawings made in the 18th and 19th centuries record the existence of these holes. While those made for Montfaucon are notoriously inexact about details, Charles Stothard was much more careful and had a great interest in this scene.[21] It is certainly unfortunate that his original drawings cannot be located; perhaps they would reveal details missing in the lithographs printed by the Society of Antiquaries. At this point, we are left with a puzzle.

Thus, despite some unresolved, and perhaps unresolvable, problems, much of the data is explicable if we assume that the enigmatic stitch marks are traces of an original arrow to the brow of Harold B. However, even if after further study it should turn out that these holes have another explanation, it is none the less our conviction that both Harold A and Harold B are intended as the English king, and that the artist invented two motifs for showing the death of King Harold, an arrow blinding his right eye and a sword cutting his thigh.

THE BLINDING OF HAROLD AS SYMBOL

Why did the artist emphasize, through his manipulation of letters and images, the arrow to Harold's right eye when not one of the six accounts written in the 11th century mentions this extraordinary detail?[22] It has been suggested that by the arrow the artist found a means of rendering those facial blows which made Harold so unrecognizable that he had to be identified by certain marks on his body said to be known only by an intimate, Edith Swan-neck.[23] But, had the artist wished to show Harold receiving a disfiguring facial wound there were other means of doing so, as in the earlier episode when Harold's brother dies from a lance thrust into his face (Plate 87), or in the powerfully rendered scene of the Normans breaking through the English lines (Plates LXIX-LXX). One Saxon is depicted at the moment a sword strikes his face with such impact that the knight appears to be losing his grip on the hilt, and another Englishman is hit by an arrow near his mouth. It is thus unlikely that the arrow is intended to be documentary in the sense of a disfiguring facial wound.

Blinding as an invented motif

Artists and writers have a different problem when portraying a story in which a critical detail is missing. Whereas a person telling the story of Genesis is not required to specify which forbidden fruit grew on the Tree of Knowledge or how Cain actually committed the first murder, a visual artist cannot be so vague. Thus, an important theme in the history of art, especially in the Middle Ages when certain texts were invested with a canonical authority, is the artist's invention of details not found in received texts. Why certain visual motifs are selected and then become traditional – such as Adam and Eve's apple (or pomegranate or lemon), Cain's rod (or jaw-bone, or scythe), the *three* Magi and Moses' horns (five centuries before Michelangelo) – can be given plausible explanation by reconstructing the patterns of thought and association of an age.[24]

I believe the blinding of Harold is just such an invented iconography and that it was chosen by the artist because it had historical and cultural associations in the minds of Englishmen and Normans that could be related by them to the main theme of the Tapestry: the perjury of Harold in first making an oath on relics to assist William to the English throne and then breaking that oath by accepting the crown on Edward the Confessor's death.[25] It is likely that the artist also had to solve a problem in his narrative of events: how to show a connection between a crime committed at the end of the first Act and the death of Harold some forty scenes later.

In addition, since his was not a secular age he had to make sure that his audience understood that Harold's defeat was not just due to Norman superiority on the field of battle gained by combining archers with cavalry, but that it was ultimately caused by divine displeasure. Here is a theme repeated by all writers, Norman and English. Note the words of Eadmer, the Canterbury monk whose history is our best source for Kentish traditions (English and Norman) about the Battle of Hastings:

A furious battle was joined; Harold fell in the thick of the fray and William as conqueror possessed himself of the Kingdom. Of that battle the French who took part in it to this day declare that, although fortune swayed now on this side and now on that, yet of the Normans so many were slain or put to flight that *the victory which they had gained is truly and without doubt to be attributed to nothing else than the miraculous intervention of God, who by so punishing Harold's wicked perjury shewed that He is not a God that hath any pleasure in wickedness.*[26] [my italics]

Had the Tapestry artist included the hand of God in the battle episodes as he did in his portrayal of Edward the Confessor's newly completed Westminster Abbey, divine involvement in history would be obvious. But since he did not, let us consider what an arrow in the eye meant in medieval symbolism and whether blinding would have been considered by contemporaries an appropriate divine retribution for Harold's perjury.

Blindness as divine punishment

If light and the power to see clearly were attributes of saintliness and divinity in medieval thought, darkness and blindness were associated with sinful humanity.[27] Loss of sight was not just a physical handicap but a moral attribute as well. It placed one on the wrong side of the moral universe. In the words of a medieval writer, blindness 'connotes to us only something negative and never positive, and by the blind man we understand the sinner'.[28]

The association between loss of sight and avarice was manifest in one of the most popular books in the Middle Ages, the *Psychomachia* of Prudentius, an allegorical description of conflicts between virtues and vices personified as women. Often copied and illustrated, the *Psychomachia* influenced all the visual arts. In representations of the victory of the virtues over vices, the personifications are often treading upon their vanquished counterparts in the evil world (e.g., Humility on Pride, Faith on Idolatry), plunging a lance into one of the foe's eyes.

153

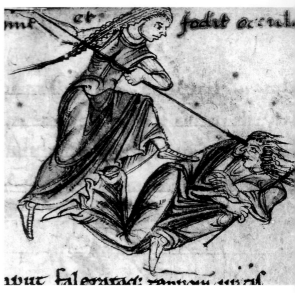

89 (*left*) King blinded by an arrow after ordering the execution of Saint Christopher. From an altar frontal by Maestro de Soriguerola, of the 13th century; in Barcelona, the Museu d'Art de Catalunya. 90 (*right*) Faith blinding Worship-of-the-Old-Gods. From Prudentius, *Psychomachia* (English), *c.* 1120; in the British Library, Cotton MS Titus D.XVI, f. 6r.

Thus, on the side of a 12th-century English reliquary now in Troyes Cathedral, a figure of Magnanimity holds Avarice by the ankle while stepping on her breast and most ungenerously blinding her in one eye, and in an early 12th-century English *Psychomachia*, the figure of Faith blinds her opponent in one eye (Plate 90).[29]

In medieval lore there were also famous tales about how rulers were miraculously blinded in one eye by an arrow because they had offended the divine order. According to a legend about Saint Christopher popular all over Europe, including Anglo-Saxon England, when a king ordered the saint to be bound to a post and transfixed with arrows the shafts just hung in the air. For a whole day they stayed there until the king approached Christopher asking, 'Where is thy god? Let him come now and deliver thee from these arrows.' Instantly one of the arrows leapt away and struck the king in his eye, blinding him (Plate 89).[30]

In Anglo-Saxon art we note another example of a king being hit by an arrow in the eye that appears germane to the question why the artist of the Bayeux Tapestry selected this iconography as the appropriate punishment for King Harold at the Battle of Hastings. This is a pictorial precedent, already discussed in connection with the Tapestry's Canterbury provenance, from the celebrated Utrecht Psalter and its first Canterbury copy, the Harley 603 in the British Library (Plate 91; see also Plates 13, 14). Psalm 2 is a royal psalm, probably composed for the coronation of a king, and has as its theme God's designation of an anointed monarch against whom rebellion by subject peoples is futile. The opening line sets the theme: 'Why do the nations conspire and the people plot in vain?' Standing on a hill, no doubt Zion, a king holds a rod with which he will dash the rebels in 'pieces like a potter's vessel'. Below him is a group of 'rulers' plotting against the Lord and his anointed, while to the left, the artist has placed the fallen or wounded rebels who have been attacked from above by God's agents. The psalm ends with

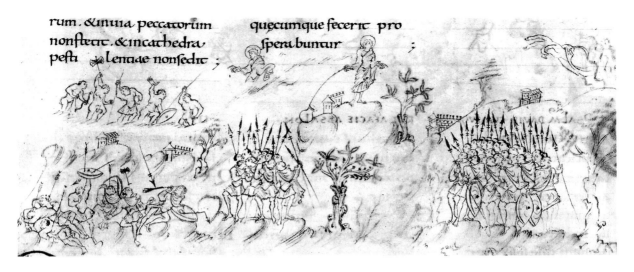

91 Rebel struck by an arrow in the head. From the Harley Psalter, Canterbury, *c.* 1000; in the British Library, Harley MS 603, Psalm 2, f. 2.

a warning to rebellious rulers to submit: 'Now, therefore, O Kings be wise, be warned, O rulers of the earth... lest He be angry and you perish in the way, for His wrath is quickly kindled.' Of special interest to us, of course, is the rebel pulling an arrow out of his head while bracing himself against a rocky outcrop. While the figure wounded by an arrow set loose by the heavenly host does not appear to illustrate a particular verse of Psalm 2, he is evidently being punished for rebelling against God's appointed ruler.[31]

These examples of blinding as an iconographic motif in medieval art lead us to conclude that the portrayal of Harold blinded by an arrow in the Tapestry is neither a documentary version of what happened to Harold late in the afternoon on Saturday 14 October 1066, nor a curious anecdotal detail that would have been devoid of symbolic meaning for the artist's contemporaries. Evidently an iconographic motif charged with significance, an arrow in the eye usually designated a punishment for sin, as in the *Psychomachia's* battle of virtues and vices, the legend of St Christopher's martyrdom, or the Utrecht Psalter's illustration of Psalm 2. Since many of those so punished were rulers, the blinding of Harold must have seemed an especially appropriate punishment for a king who perjured himself before God as well as the saints of Bayeux by swearing on reliquaries.

In art, as in life, there is seldom one simple reason why we act as we do. Many factors converge, and to assign an arbitrary distinction to one as *the* cause is closer to legendary than to historical thinking. Thus, while we have a reasonable explanation why the artist chose a particular symbolic motif, we wonder if it is sufficient, because in the Anglo-Norman world blinding had other, more immediate, associations as well.

An eye for an eye

Perjury was not the only crime lodged against Harold by the Norman propagandists. Harold and his countrymen were also said to have died as punishment for the sins of their fathers, Harold's father in particular.

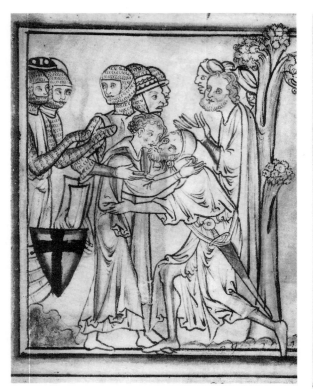
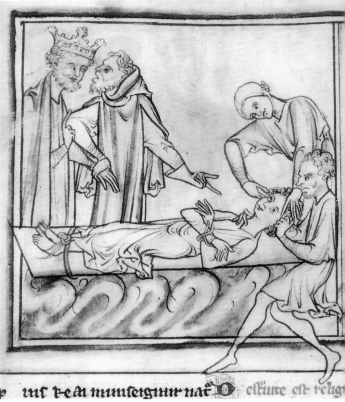

p̄ ınıſ b̄eaı munſeıgınır nar̄ O eſſıure eſſ relıg

92 (*left*) Earl Godwin welcoming Alfred and his Norman companions to England in 1036. From *La Estoire de Seint Aedward le Rei*, St Albans, *c.* 1245; in Cambridge, the University Library, MS Ee. 3. 59, p. 6.
93 (*right*) Blinding of Alfred in the presence of King Harold 'Harefoot'. From *La Estoire de Seint Aedward le Rei*, St Albans, *c.* 1245; in Cambridge, the University Library, MS Ee. 3. 59, p. 7.

Commenting on the thousands of Englishmen who had fallen in the battle, William of Jumièges, the first Norman historian to write about the Conquest, records that many people thought that God's hand could be seen in the outcome of the battle: 'They say... that Christ thus recompensed them [the English] for the foul and unjust murder of Alfred, brother of King Edward.'[32] Why did it seem that a murder committed thirty years in the past, when William was ten and Harold was fifteen, and involving none of the principals in the battle, was justly punished on Senlac Hill?

In 1036 Alfred the Aetheling, son of the Anglo-Saxon King Aethelred II and Emma, a Norman princess, arrived in England from Normandy where he and his brother Edward the Confessor had spent their youth in exile. Since he came accompanied by many Norman soldiers at a time of disputed succession, his visit was perceived by those in power as the first step in a claim for a contested throne.[33] Alfred was arrested by Earl Godwin, who, it will be recalled, was the father of Harold, king of England in 1066. Many of Alfred's Norman troops were put to death. The *Anglo-Saxon Chronicle* recounts:

Some were sold for money, some were cruelly killed, some put in fetters, some were blinded, some were mutilated, some were scalped. No more horrible deed was done in this land since the Danes came.[34]

156

Alfred himself was taken on board ship, savagely blinded, and transported to Ely where he died of his injuries. Who was responsible? Although Prince Alfred was blinded outside Godwin's custody, the powerful earl was often accused of a crime that 'shocked the conscience of even that callous age'.[35] The murder of Alfred left a legacy of suspicion and animosity against Earl Godwin (Plates 92,93).

Edward the Confessor demanded that Godwin clear himself of culpability in the death of the king's brother by an oath that 'it was not by his advice, nor by his will, that [Alfred] had been blinded'.[36] How little Godwin's oath was regarded is suggested by a popular story known from 12th-century sources. The circumstance was a dinner with King Edward and Earl Godwin at the same table. Whenever the conversation turned to the subject of Alfred, Godwin remarked that the king's face showed anger. Affirming his innocence, Godwin announced, 'May the morsel which I have in my hand choke me to death if I am guilty.' It did.[37]

After the Conquest, Norman propaganda laid great, some might say exaggerated, emphasis on the death of this half-Norman prince and his Norman companions as justification for William's descent upon England. William of Jumièges spoke of how the Normans served as God's agent in punishing the English for the 'foul and unjust murder of Alfred, brother of King Edward'.[38] Not just Englishmen in general but one man in particular was singled out for blame, Earl Godwin. In William of Poitiers' account of the events of 1036 the accusing finger was pointed directly at King Harold's father Godwin. After recounting the blinding of Alfred, William of Poitiers turned from his audience, and with dark theatricality addressed Godwin in an apostrophe which ends with this 'prediction' of how the sins of the father would be visited upon his son at Hastings:

It is certainly lugubrious and sad to speak of such crimes: but our glorious Duke William, whose exploits we record for future generations, with divine aid and an avenging sword will strike the mortal blow to your offspring, Harold. Because of treason, you have spilled innocent Norman blood; by just recompense, Norman weapons will spill the blood of your children.[39]

Thus Godwin, who had not ordered the blinding but who had carried out the arrest of Alfred and without whose consent the prince could not have been given to his tormentors, was held responsible for the death by the principal Norman justifiers of the invasion.

Not all agreed, however, that Godwin was personally responsible. English writers in two versions of the *Anglo-Saxon Chronicle* seem anxious to avoid laying the crime on Earl Godwin, either by using ambiguous language so as to implicate the king reigning in 1036, Harold 'Harefoot', or by omitting any reference to the murder at all.[40]

This contrast between English and Norman interpretations of Godwin's role in the blinding and murder of Prince Alfred suggests two observations with regard to the blinding of Harold in the Tapestry. First, since both William of Jumièges and William of Poitiers wrote after the Conquest, we have an insight into how Norman propaganda, motivated by a desire to justify William the Conqueror's attack on England, seized upon an opportunity of making the invasion an act of

vengeance for the murder of a prince who by half of his blood was of the Norman race. We can thus imagine a Norman who shared this sense of divine vengeance for Alfred's murder viewing Harold's death scene in the Tapestry and exclaiming, 'Aha, justice was done! An eye for an eye!'

But did the artist intend the blinding of Harold to be understood as validating the Norman claim that a crime committed thirty years earlier helped justify the invasion of England? We look in vain for any reference to Alfred or Earl Godwin in the Tapestry. With only slight alteration in the inscriptions the artist could have labelled Harold as 'Harold Godwinson' rather than HAROLD DUX or HAROLD REX or simply Harold. Given the notoriety of the Alfred episode and the prominence of anti-Godwin feeling in Norman propaganda our artist must have been aware of it, yet it is interesting that he avoided an explicit link between Harold receiving an arrow in the eye and his father's alleged crimes.[41]

Blinding as a Norman punishment

So far we have spoken of how two of the main Norman claims to legitimacy – Harold's perjury and his father's alleged crime – form a central part of the intellectual environment in which the Tapestry was created and viewed. As such they help explain why such a motif as blinding would have been selected from the many divine punishments for sin popular in the Middle Ages as one of the two appropriate wounds for Harold at the *dénouement* of his drama. Norman propaganda is only part of the story, however; there was also the reality of Norman rule in post-Conquest England. The historical records speak often of the punishments inflicted by the new governors, and while physical brutality was hardly new to the Anglo-Saxons, blinding as a legal punishment apparently was. Only in the laws of Canute do we meet with it before 1066, and then only as one of many tortures; but in the so-called *Articles of William the Conqueror* it is dramatized and given wide application: 'I also forbid that anyone shall be slain or hanged for any fault, but let his eyes be put out and let him be castrated.'[42] Nor was this an idle threat, as the rebels who aided the traitor Ralph 'Gauder', the earl of Norfolk, learned. Then too, recall that citizens of Canterbury were blinded for siding with the monks of St Augustine's in their rebellion against an alien Norman abbot.[43]

In speaking about blinding as a punishment in post-Conquest England it is understandable that English or pro-English authors speak with a particular bitterness not found in Norman writings. The following authors, both profoundly pro-English in sentiment, would probably have reacted to the Tapestry's inconography differently from their Norman contemporaries. About 1080, Goscelin of St-Bertin, a foreigner who had lived for twenty years in Wiltshire, wrote to an old friend at Angers these bitter words about the new masters of his adopted country:

How many thousands of the human race have fallen on evil days! The sons of kings and dukes and nobles and proud ones of the land are fettered with manacles and irons.... How many have lost their limbs by the sword or disease, have been deprived of their eyes, so

that when released from prison the common light of the world is a prison for them! They are the living dead for whom the sun – mankind's greatest pleasure – now has set.[44]

The second English voice is that of an Anglo-Saxon Chronicler. In his obituary on William, the author of a version of the *Chronicle* thought to have been associated with St Augustine's Abbey, Canterbury, indicates a link between this particularly brutal and demeaning punishment and a quintessentially Norman action, the infamous extension of the king's forests way beyond their historic boundaries. In a bit of ironic verse the Chronicler vents his indignation on a king who loved the stags so much that

> He made great protection for the game
> And imposed laws for the same
> That those who slew hart or hind
> Should be made blind.[45]

It would seem that from the perspective of the native English and those who identified with their experiences since 1066, blinding was almost synonymous with Norman law enforcement. As with the question of whether a contemporary would have necessarily perceived a link between the death of Harold Godwinson and the deeds of his father Godwin, so any implicit allusion to Norman punishments after the Conquest would not necessarily elicit the same response from English and Normans. One thus suspects that the blinding of Harold had a special resonance for an English artist and English embroiderers called upon to make a triumphal monument for the conquerors of their homeland.

To a remarkable extent, the artist's choice of the blinding of Harold as the central symbol of Norman victory and English defeat completes the pattern of mixed messages we have noted throughout the earlier part of the Tapestry: the treatment of Harold's fateful journey to Normandy and his accession to the throne on Edward's death, the selection and position of fables in the marginal zones, and the ingenious juggling act involved in portraying Odo's role in the Conquest. To an uncanny degree the artist has allowed his Norman patron and his fellow countrymen each to read the Tapestry in his own way, every viewer being permitted to complete a work kept deliberately 'open' to multiple interpretations.

Also if the Tapestry appears now as a more intellectually complex work than hitherto suspected, this complexity should not really surprise us, for the symbolical associations we have noted are in fact what one expects in a work of art created within a medieval monastic setting. Major programmes of medieval art were never satisfied with a purely literal portrayal of life.

LIES HAVE SHORT LEGS

Harold's death in the Tapestry is completed by the episode of a Norman knight slashing his thigh with a broad sword while the king is either falling to the ground or lying prostrate and defenceless, his characteristically Saxon axe beside him. Why did the artist choose this thigh-cutting motif? Again none of the six sources which can be securely dated to the 11th century mentions this detail. However, a

seventh source – a lengthy poem entitled the *Carmen de Hastingae Proelio* [Song of the Battle of Hastings] dated by some in the 1060s but by others in the 1130s – gives very precise details about how Harold supposedly met his death. The *Carmen* says that four knights were involved in the killing of Harold. One cleaved his breast, another cut off his head, the third pierced his belly, while the fourth 'hewed off his thigh and bore away the severed limb.'[46] As the relationship, if any, between the *Carmen* and the Tapestry is uncertain the question before us is not whether one borrowed the thigh motif from the other or whether both are independently reflecting another tradition, but rather why the artist of the Tapestry chose this particular type of wound for the last image we have of Harold.

The answer, I would suggest, lies in symbolism. The thigh is often used as a euphemism for the male genitals. Recall that in the Hebrew Scriptures a man's descendants are spoken of as proceeding from his thigh and that in classical mythology Dionysus springs from Zeus' thigh.[47] In medieval art the Tree of Jesse, that symbolic genealogical tree of Christ's lineage that was designed to give visual form to the prophecy in Isaiah, 'there shall come forth a rod out of the root of Jesse', was often shown as emerging from Jesse's thigh, the seat of procreative powers.[48]

With respect to the Tapestry, a phallic interpretation would clearly not be out of character. Phallic imagery as evidence of strength and vitality, even of death and impotence is found throughout the work. Men and horses often display their virility; it is also noticeable that in the portrayal of naked soldiers being stripped of their armour beneath the death of Harold scene one sign of death is the absence of a virile member. Thus, the cutting of Harold's thigh – a symbolic castration – would be a most appropriate way to show that with the death of Harold a royal line comes to an end.[49]

Another symbolic association that might have a bearing on the Tapestry's iconography is the mysterious link in biblical thought between the thigh and oaths. Abraham made his servant Eliezer swear a solemn oath not to allow Isaac to take a wife from among the Canaanites but only to choose one from Abraham's kindred back in Mesopotamia. The promise was accompanied by a ritual placing of Eliezer's hand under Abraham's thigh. Further in Genesis, Jacob required his son Joseph to place his hand under the father's thigh when swearing to bury him 'in the old country' with his ancestors, not in Egypt.[50] The precise symbolism of this action is unclear, but it has traditionally been interpreted as a way of solemnizing a pledge: since sons were said to issue from the thigh, touching that vital part might entail the threat of sterility for the breaker of the oath or extinction of his offspring.[51] In Christian art the placing of the hand under the thigh might be rendered symbolically, as in the Vienna Genesis, where Eliezer touches the genital area, or literally, as in the Ælfric Hexateuch (Plate 94).[52]

In many European cultures there is also a curious proverb which links one organ of the body – the leg – with telling, or rather not telling the truth. The proverb is that 'lies have short legs,' an expression which presumably means that the liar, like the cripple, will soon be caught. A variation is that liars have one leg.[53] In the Renaissance the notion behind these proverbs was given pictorial form in Ripa's

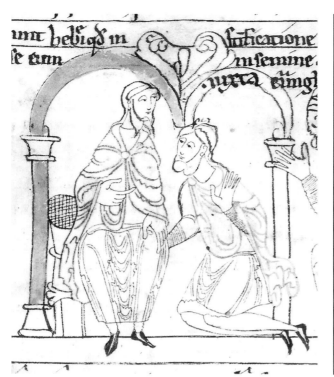

94 (*left*) Eliezer swearing an oath by placing his hand under the thigh of Abraham. From the Ælfric Hexateuch, St Augustine's Abbey, Canterbury, mid-11th century; in the British Library, Cotton MS Claudius B.IV, f. 39r. 95 (*right*) Bugia [Lie]. From Cesare Ripa, *Iconologia*, 1611.

Iconologia (Plate 95). It would be interesting if this proverb was known in 11th-century Canterbury.[54]

There are thus many ways in which the cutting of Harold's thigh might be perceived by contemporaries as having a symbolic link with the story of Harold and William as told by the creators of the Bayeux Tapestry. As a symbol of castration, as an allusion to the biblical link between a solemn oath and the thigh, and possibly as a reference to a proverbial truism, the slashing of Harold's thigh might have been perceived as more than just a violent act.

On another level, it is worth noting that since blinding by an arrow and thigh-cutting by a mounted warrior are combined in one episode the Tapestry permits the viewer to see both divine and human reasons for the Normans' victory at Hastings. God had 'no pleasure in wickedness,' but it was by a combined effort of lowly archers and knightly mounted warriors that victory was achieved. Neither archers nor mounted warriors were on the English side; nor, apparently, was God.[55]

CHAPTER XII

Conclusion to Part Two

How does our reading of the Tapestry's political iconography affect the way in which we understand the work as a whole, particularly its relationship to the historical setting described in Part One of this book, and the question as to who was its directing force, the patron or the artist?

Origin

With respect to the genesis of the Tapestry, if its iconography is much richer and more complicated than previously thought, are not the many ambiguous currents and counter-currents we have encountered a faithful reflection of the extraordinary historical circumstances in which it was created?

The first complicating factor was that the artist apparently worked in a monastic rather than a secular courtly setting. Anything approaching a simple, unmediated documentary of events would not have been possible in any post-Conquest milieu, but least of all in a community where the artist had at hand the rich artistic and intellectual traditions of patristic, Carolingian and early English culture. The compelling models found in books of the Utrecht and Winchester traditions, with their imaginative interplay of images, words and borders, and their invention of motifs for symbolic purposes, could not have been ignored, nor could the historical assumption which demanded seeing historical events as shaped by the workings of divine action. In this regard, no scene more fully illustrates the influence of the monastic setting than the death of Harold.

Secondly, had the Tapestry been commissioned by William, or made for him by Matilda at the Norman court, we can be certain that its imagery would have been much more straightforward, but by having Odo as its patron a complicating feature was introduced at the outset. Odo's sponsorship entailed a delicate problem for the artist. As we saw, his varied solutions to the matter of how to magnify the role of his patron while not overtly compromising William's stature and dignity can only elicit one's admiration. Whether we look at the inscription which says William commanded the fleet to be constructed while the images communicate something different, or whether we observe Odo subtly displacing his brother from the centre of attention at the feast, the adjacent council, and even at the climax of the battle, we note that the artist manages to insinuate that without Bishop Odo the Norman invasion of England might not have been launched, or, once launched, successful.

A third factor complicating the Tapestry's story was the volatile mixture of peoples involved in its manufacture. In this regard, one naturally wonders about the wisdom of a Norman bishop commissioning an English artist and English

embroiderers to make a triumphal monument celebrating the Norman victory at Hastings, and, by implication, the loss of English freedom, English land and English dignity. If Odo assumed, along with many of his fellow Norman churchmen, that the English were ignorant boors, or if he believed them to be sycophants, ready and willing to tell the story of the Conquest from the Norman point of view, he appears to have been woefully obtuse about the subtlety of their thinking.[1] English monks at Christ Church and St Augustine's Abbey might not have been in touch with the latest currents of Continental thought, but they were hardly unlearned and unsophisticated. They certainly were not uncaring about their national traditions. Recall the tenacity with which they tried to hold on to some of their ancient customs, their language and script, their artistic styles, their saints, and, in the case of St Augustine's, let us not forget the tragic violence which attended the attempt to maintain their freedom of self-government against Lanfranc.

One can only wonder whether Odo, when commissioning a triumphal monument to be made by newly-conquered Anglo-Saxons, had any inkling of the potentially 'subversive' weapon he was placing in English hands, subversive not in the sense of a call to rebellion but rather calling into question aspects of the Norman ideology of conquest, and doing so in a work of art whose purpose was to celebrate Norman deeds. After all, images unaccompanied by a detailed text are inherently imprecise, suggestive of much more than they say, and open to varied, even contradictory, interpretations.[2] When many different views were held as to what happened at the Conquest, and why, as we saw from comparing English and Norman writers, the opportunity to insinuate meaning is a special challenge. The artist apparently accepted that challenge with delight. Thus, on the controversial questions of why Harold made a journey to Normandy and why he took an oath there to William, or on the matter of William's sincere, magnanimous behaviour towards Harold, or on the disputed question of whom Edward designated as his lawful successor, or on whether Harold's death at Hastings was just retribution for the foul blinding of Alfred, we have seen that the artist created images which can be read as supporting the Norman claims, as found, for instance, in William of Poitiers' eulogistic writings, or as consistent with dissenting views recorded by the English Canterbury historian Eadmer. Ambiguity and insinuation also seem to be at play in the selection and placement of some of the marginal fables, as well as in some most perplexing iconography to be discussed in the last part of this work.

The directing force

If our reading of the Tapestry's iconography as politically ambiguous and subtly irreverent is correct, what might be deduced about the relationship between artist and patron? The first and most important inference is that such astonishing paradoxes are only explicable by assuming that the master designer, not a Norman patron, was the inventor of much of the Tapestry's iconography. While the general ideas for the programme – the decision, for example, to start with Harold's journey rather than the construction of the armada, or the emphasis on the bishop

of Bayeux's exalted role, and that of the relics of his ecclesiastic see – may well have been dictated by a Norman patron, nothing in the Tapestry's actual composition of what is in fact an enormous and extremely complicated work of art suggests that the patron exercised a close control over its creation. Both style and meaning point to the Englishness of the Bayeux Tapestry.

Secondly, although the patron may not have been involved in the details of composition, would he not have noticed how the main narrative and the fables could be read as casting doubt on Norman propaganda about William's claim to the throne? He may have, of course, but is it not more likely that he, like most observers, would have been swept along by the flow of the narrative and never studied the work closely enough to work out its multiple levels of meaning? Then too, most of the artist's deviations from the Norman version of events are cleverly disguised, allowing for an innocent interpretation as well as one that was not. While we can deduce that the Tapestry designer was a consummate master of double meaning, there is no evidence as to whether his patron was up to the challenge. In this regard, it is curious that the one contemporary anecdote in which Odo figures reveals him as rather naïve and literal minded. It was said that in his zeal to acquire the relics of Saint Exupèry, Odo bribed their custodian at Corbeil to sell them for the enormous sum of 100 *livres*. Alas, when the 'spiritual merchandise' arrived it turned out not to be the saint's body, for the custodian had supplied Odo with a corpse of a peasant of the same name and a highly ambiguous guarantee, which apparently satisfied the bishop while leaving Corbeil in possession of the genuine relic.[3]

Thirdly, one might well ask why an artist would go to such trouble to express a dissenting point of view when his labours were presumably destined to go to Normandy. Again, we can only speculate since we know nothing about when and how the Tapestry got to Bayeux. But even if immediately on completion it was to be shipped to Normandy, we can imagine the artist wanting to set the record straight, and perhaps prove that he and his people, though labelled provincial boors by the Normans, were cleverer than their new masters. We can also imagine the artist hoping, naïvely as it turned out, that foreign domination would soon end and a work made for the conquerors would never leave England. After all, with certainty of hindsight we know that the Normans had arrived for good, but no one in the 1070s and '80s could be so sure.

A final general thought on this delightfully inventive artistry. The Tapestry is often called a unique work because it is the only remaining monumental narrative of contemporary secular events to have survived from the early Middle Ages, and because it contains the most vivid, most lively portrayal of medieval people and their ways of life to last into the modern period. Certainly this survival is a most remarkable feat since it is made of such perishable materials as wool and linen. But the Bayeux Tapestry may be unique in another way. If the Tapestry artist is so much a master of the art of politics that he is able to undermine Norman certainties, is it not possible that the Tapestry may be the only subversive triumphal monument known in western art?

PART THREE

'By the Waters of Babylon'

*The case for suggesting that there is a previously
unsuspected source for the iconography of the
Bayeux Tapestry*

CHAPTER XIII

The Bayeux Tapestry and the Hebrew Scriptures

To account for some of the iconographic features of the Tapestry that have proved most puzzling to modern observers we have proposed that it cannot be read simply as a naïve tale of the Norman Conquest as seen from the Norman point of view. Rather, it appears that the master artist consciously used divergent traditions, as found, for example, in Eadmer, or that he invented symbolic motifs in order to create a narrative that is open to Anglo-Saxon readings while being broadly consistent with the Norman outlook epitomized by the writings of William of Jumièges and William of Poitiers. One can thus imagine both Odo and William, as well as English monks and Norman abbots, each finding much to delight them in the Tapestry.

Yet, not all of the Tapestry's enigmas can be satisfactorily solved by positing an English historical tradition, known to us primarily from writings by a monk in Canterbury, and a fertile symbolical imagination on the part of the artist. A number of puzzling features in the narrative remain, including the identity of the mysterious Ælfgyva, for which no satisfactory solution has been found, and which must remain problematic. Still, let us recall six mysterious features that might be explicable in an entirely different way:

1. PERJURY: Why does the Tapestry dwell exclusively on one point in the Norman propaganda – Harold's perjury – and omit William's other two arguments substantiating his claim to the throne: kinship with Edward and that king's supposed direct bequest of the throne to him, a gift allegedly confirmed by the English council of nobles?

2. THE PORTABLE RELIQUARY: Within the carefully contrived oath scene, why does Harold swear on two reliquaries, one of which is singled out as being portable, and what are we to make of the fact that this object is unlike virtually any known portable shrine from the Middle Ages?

3. LIONS WITH WINGS: Why are the Normans, and William in particular, linked in the marginal imagery with winged lions?

4. THE BRETON EXPEDITION: Why does the narrative make a triumph out of what appears in William of Poitiers to have been a set-back, and why does the artist use the motifs of Conan slipping away down a rope and then handing over the keys to his castle?

5. THE UNARMED ENGLISHMAN: Why is there one English soldier embroidered without armour and weapon and about to be decapitated directly before the scene of Harold's death?

6. BLINDING FOR PERJURY: With respect to the death of Harold, is there perhaps

some archetypal story of blinding, similar to that of Samson or Oedipus, wherein a protagonist was blinded for perjury?

To account for these puzzling features let us try an approach to the Tapestry's iconography different from any found in the literature. Let us hypothesize that like people everywhere who are confused by the swirl of events around them the creators of the Tapestry turned for guidance to the past in order to understand the present. In doing so, let us consider the possibility that they found a paradigm, a great conquest comparable to the events of their own time, that enabled them to grasp more fully its historical significance. Recall that William of Poitiers had done something similar in devoting many pages of his panegyric on the Conqueror to a point by point comparison between William's conquest and Julius Caesar's famous invasion of England in 55 BC.[1] Since it does not appear that the artist and his patron followed William of Poitiers' lead to classical history, perhaps they went instead to biblical times and a great military conquest that does indeed have an uncanny similarity to the events of 1066.

THE BABYLONIAN CONQUEST OF JUDAH

In the Scriptural account of the Babylonian Conquest of Judah, the southern portion of the once united kingdom of David and Solomon, the Hebrew king Zedekiah was captured and brought before Nebuchadnezzar. There judgement was passed on him for having rebelled against the mighty king of Babylon. The charge against the Hebrew king was straightforward: he rebelled against his Babylonian overlord by violating a sacred oath of fealty. The overriding importance of Zedekiah's perjury as *the* justification for why he was attacked by Nebuchadnezzar is brought out in the words of the prophet Ezekiel. After recounting how the Hebrew king broke his oath, the prophet spoke the words of the Lord:

Can a man escape who does such things? Can he break the covenant and yet escape? . . . Because he despised the oath and broke the covenant, because he gave his hand and yet did all these things, he shall not escape. Therefore thus says the Lord God: As I live, surely my oath which he despised, and my covenant which he broke, I will requite upon his head. . . . And all the pick of his troops shall fall by the sword, and the survivors shall be scattered to every wind; and you shall know that I, the Lord, have spoken.[2]

Nebuchadnezzar, in passing judgement on his faithless vassal, ordered a cruel punishment. Zedekiah's sons were slain before his eyes; then Zedekiah himself was blinded and taken in chains to Babylon.[3]

The blinding of Zedekiah and the execution of his sons were not just obscure events in the lives of an insignificant Hebrew royal family. Zedekiah's defeat in 586 BC marked the pivotal moment in the history of the entire Jewish kingdom. The Babylonians reduced Judah to the status of a colony. There followed the execution or exile of her royal officials, warriors and intellectuals. The Temple and the houses of Jerusalem were burned to the ground. All the Temple vessels were carried to Babylon as booty. Thus began the famous Babylonian Captivity of the Jews.

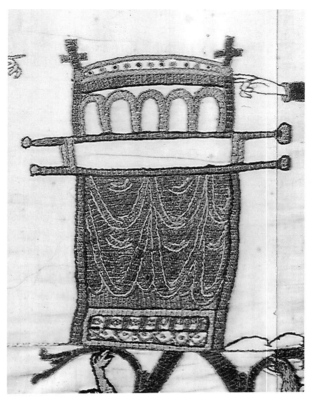

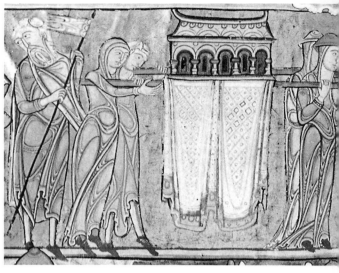

96 (*left*) Detail: portable shrine on which Harold swears his oath. From the Bayeux Tapestry, Plates XXV and XXVI.

97 (*above*) Israelites carrying the Ark of the Covenant. From the Book of Numbers, Lambeth Bible, perhaps St Augustine's Abbey, Canterbury, *c.* 1150; in the Lambeth Palace Library, MS 3, f. 66v.

After 1066, the intertwined history of Normandy and England would have looked very similar. Harold's perjury and infidelity had been used by William as principal elements in his claim to a legitimate conquest of England. With Harold's death, the independent English kingdom was no more. The aristocracy was killed or exiled; English abbots and bishops were replaced by foreigners; the precious vessels from her churches taken abroad. Just as the Babylonian Conquest had been the most cataclysmic event in the history of the Hebrew kingdom, so the Norman Conquest was by far the greatest single crisis in the history of the English nation.[4] Given the singular correspondences between these two conquests it behooves us to look once again at the Tapestry and ask if this paradigmatic conquest from biblical days might not hold the key to many of its iconographical puzzles.

VISUAL CLUES

Oath scene: portable reliquary

One of the most prominent features of the oath scene is that Harold swears on two shrines containing relics, the left one of which, as indicated by its two poles, had apparently been brought to this place from afar (Plate 96). Why is the Tapestry so concerned to show that this holy object was portable? Also, while portable reliquaries were very popular in the Middle Ages and many have survived, why is it that virtually no portable shrine or reliquary from the medieval period can be connected, so far, with the shape depicted in the Tapestry?[5]

In medieval art there is, however, a holy object carried on poles that has striking visual analogies with the Tapestry's portable shrine. This is the Ark of the Covenant described in Exodus 37 that had been made to carry the stone tablets inscribed with the Ten Commandments. While it is true that many medieval renderings of the Ark are true to the biblical text in showing cherubim and the poles passed through rings fixed to either side of the Ark, this is not always the case. Thus, in the Utrecht Psalter one finds an Ark with poles but without cherubim, and in the Ælfric Hexateuch the Ark has neither cherubim nor rings.[6] Most intriguingly, from 12th-century England we note an Ark in the Lambeth Bible with five arches, poles without rings and a draped hanging cloth that are all quite similar to features in the Tapestry's shrine (Plate 97).[7]

Given these visual similarities, what then are we to make of the portable shrine in the Tapestry? Quite obviously it is not meant to be a literal rendering of the Ark; indeed, the two crosses on top clearly indicate its Christian origin and purpose. Rather, for the moment let us hypothesize that the Tapestry's portable shrine is meant to evoke the Ark, perhaps as an archetypal portable shrine.[8] After all, in connection with the Tapestry's story it is noteworthy that the Ark was not only carried on poles but contained within it the tablet on which was written God's commandment against perjury: 'You shall not take the name of the Lord your God in vain; for the Lord will not hold him guiltless who takes his name in vain.' But let us also keep in mind that by means of such a pictorial allusion the artist might have been pointing as well to a particular biblical story concerned with an oath sworn on a holy object.[9]

Oath scene: winged lions

Is there any further evidence in the oath scene that the Tapestry artist was indeed alluding to the Hebrew Bible's story of the Babylonian Conquest? Note that flanking William and directly above the portable altar are two of the winged lions who appear to have a special relationship with the Conqueror in the Tapestry.[10] As noted before there is a question as to whether winged lions were chosen to be associated with William's triumphs merely because the terrible force of the lion joined to an awesome soaring ability would connote victory and majesty, or whether there might not have been a more concrete reference in the minds of the people who created the Tapestry.[11] We have only to turn to the Book of Daniel, that most famous of biblical books set in Babylon, to learn that winged lions can indeed have a special iconographic significance in connection with military-political events. In the seventh chapter of Daniel the author recounts one of his own most famous dreams. He says that he saw 'four great beasts come out of the sea, different from one another. The first was like a lion and had eagle's wings'.[12] There followed in quick succession a bear, a four-headed winged leopard and a dragon-like beast with ten horns, all of whom, as explained to Daniel by an angel, are 'great kings who shall arise out of the earth'.[13]

Starting with Josephus in the first century of our era, this dream of the four beasts was universally interpreted as standing for the succession of four worldly empires, each having to make way for the next, and all ultimately being judged

98 Daniel's vision of the Four Beasts (the winged lion is on the left opposite the bear). From the Beatus Apocalypse of St-Sever, 11th century; in Paris, the Bibliothèque Nationale, MS lat. 8878, f. 235.

99 (*right*) Scene from the conquest of Judah, Nebuchadnezzar ordering the killing of the sons of Zedekiah and the Hebrew king's blinding. From the Urgell Beatus, 10th century; in Urgell, the Archivum Capitulare, f. 208v.

100 (*far right*) Scene from the conquest of Judah, the Babylonian attack on Jerusalem. From the Urgell Beatus, 10th century; in Urgell, the Archivum Capitulare, 209r.

by God from a fiery throne while surrounded by his court. Which was represented by the winged lion? According to Josephus, Hippolytus, Jerome and their medieval successors, the winged lion, or lioness, represented only one kingdom, that of the Babylonians.[14]

In the Middle Ages the identification of the four beasts with these specific world empires was widely known and often illustrated; for example, in illuminated copies of Jerome's *Commentary on Daniel* the symbolic meaning of each of the mythical beasts was made clear by labels adjacent to each animal. Thus, next to the winged lioness were the words: *leena alas aquile habens regnum babilonium* [a lioness having wings of an eagle is the Babylonian kingdom] (Plate 98).[15]

Taking the oath scene as a whole, then, it appears that the combination of a most unusual portable reliquary that is evocative of some medieval depictions of the Ark of the Covenant, and the placing of the lions with wings above both that portable shrine and William suggest the possibility that ·the creators of the Tapestry took the Babylonian Conquest of Judah as a paradigm for the events of their own time. Are there more clues in other scenes?

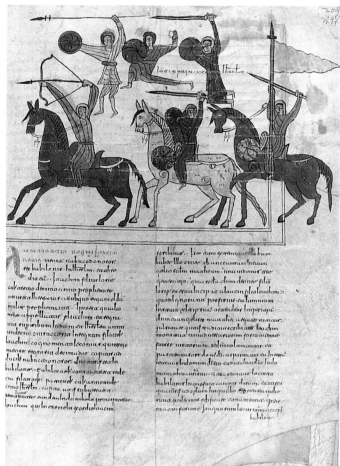

The death of Harold scene and the execution of the unarmed Englishman

How was Zedekiah's defeat and punishment for perjury against his overlord depicted in the early Middle Ages? Are there any connections between such renderings and the scene in the Tapestry of Harold's punishment for his perjury?

Alas, the most relevant pictorial tradition, the Anglo-Saxon, lets us down at this point, there being no portrayals of the Babylonian Conquest in any extant early English work of art. We must perforce turn to the only early medieval works that do have images of Nebuchadnezzar and Zedekiah, abundantly illustrated Bibles made in 9th and 10th-century Spain and the extraordinary Beatus manuscripts also made in the Iberian peninsula during that same period.

The earliest extant biblical illustration of the fate of Zedekiah, from the León Bible of 960, introduces a prominent theme that will reappear in all early renderings of the subject: a decapitation scene. Indeed, rather than depicting the blinding of Zedekiah it concentrates solely on the horrific episode where, in his last moments of sight, he had to witness the execution of his own sons (Plate 101),

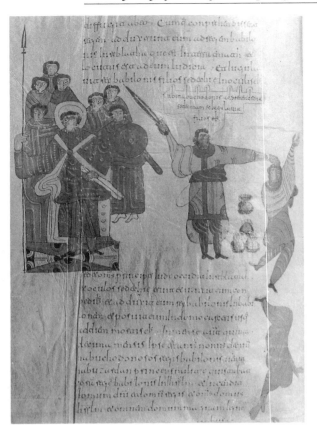

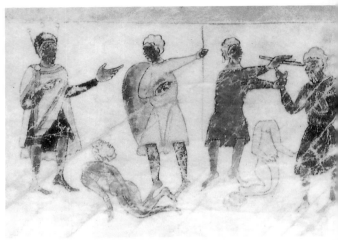

101 (*left*) 'The king of Babylon slew the sons of Zedekiah before his eyes', column illustration for Jeremiah 39: 5-7. From the León Bible of 960; in León, the Colegiata S. Isidoro, Cod. 2, f. 289v.

102 (*above*) Blinding of Zedekiah beside his already slain children. From the Ripoll Bible, Catalonia, early 11th century; in Rome, Vatican City, the Biblioteca Apostolica Vaticana, Vat. Lat. 5729, f. 161.

and when the blinding of Zedekiah is added in the Ripoll Bible of the mid-11th century it shares the scene with the execution of his sons (Plate 102).[16]

By far the most elaborate early medieval illustrations of Zedekiah's punishment are those in the Beatus manuscripts, so-called because they contain the commentary on the Apocalypse of St John written by the Spanish priest Beatus (d.798). Following the text of Beatus' commentary on Revelations in more than half of these manuscripts was an illustrated version of a comparable apocalyptic book from the Hebrew Bible, the Book of Daniel, as it had been commented on around AD400 by St Jerome.[17] As the Book of Daniel purports to tell of the prophet's experiences under Nebuchadnezzar, there are illustrations of Jerusalem falling under Babylonian control.

A fine example of the conquest of Jerusalem and the punishment of Zedekiah in the Beatus manuscript tradition is the 10th-century version in the cathedral library in Urgell, Spain (Plates 99, 100). On facing pages the artist has illustrated the siege of Jerusalem. Seated at the left is the prophet Jeremiah, head in hand, lamenting the fate of his besieged city, while defenders on Jerusalem's walls and towers are preparing to repel the approaching Babylonian·cavalry and infantry placed at the top of the second page. Beneath the besieged city is the judgement on Zedekiah. An elaborately crowned Nebuchadnezzar sits in the centre on a

throne, holding a lance. King Zedekiah, hands and feet fettered, is being blinded by a soldier. Note that as in the Spanish illuminated Bibles there is a prominent decapitation: a second soldier cuts off the head of one of Zedekiah's sons while the dismembered head and body of the other lies on the ground. Above the scene is an inscription, *Ubi Nabuchodonosor Sedeciam orbat et filios eius jugulat* [Where Nebuchadnezzar is blinding Zedekiah and slits the throat of his sons].[18]

Keeping this iconography of decapitation and blinding in mind let us return to the Tapestry's depiction of the climax of the Battle of Hastings. A possible clue to the artist's linking of contemporary events with the story of Nebuchadnezzar and Zedekiah is the inclusion in the death of Harold scene of a prominent decapitation that seems out of place in the overall composition (Plate 103, page 174).[19] We remarked earlier on the puzzling nature of this episode where an English soldier, having neither armour nor weapon, is about to be dispatched by a Norman knight, the only one on foot in the battle.

Why might one unarmed Englishman be shown about to be killed in precisely this way during the Battle of Hastings?[20] Anomalous details, suggestive of the possibility that this composition is not just part of traditional battle imagery but might have been borrowed from a scene of execution, make the episode stand out and cause one to think of the execution episodes in the Spanish manuscripts that portray the fate of Zedekiah's family.[21] Compare the scene of the unarmed Englishman about to be executed (Plate 103) with the execution of Zedekiah's sons in the León Bible (Plate 101), or the Ripoll Bible (Plate 102), or the Urgell Beatus (Plate 99) or the version in Valladolid (Plate 104, page 175). One of the Hebrew king's sons and the unidentified Englishman are in similar predicaments: both are being seized by the forelock and are about to be decapitated by an executioner wielding a very large sword. The Babylonian soldier and the Norman face right, grasp the victim's hair with their left hand while preparing to strike a blow with the right. Below, and slightly to the left of each group of executioner and victim is an already dispatched figure. Note also that were the Tapestry's episode anywhere else in the narrative it would not call for comment, but here one is confronted with not only a similar iconography but a comparable ordering of events. The placing of this unique scene where a Norman knight is about to dispatch an unarmed Englishman directly before the blinding of Harold conforms to the ordering in the Spanish manuscripts and to the biblical text: 'They slew the sons of Zedekiah before his eyes' (see Plate 84 for whole view).[22]

A last point about the decapitation of the Englishman directly in front of Harold receiving the arrow in his eye is that although these Spanish Bibles and Beatus manuscripts would presumably not have been known to an English artist, it should be kept in mind that much of this particular imagery is not considered to be indigenous to Spanish art in the early Middle Ages, but rather is thought to derive from an earlier, pre-Visigothic tradition of biblical illustration.[23] Such Babylonian Conquest imagery may have also come to England, in the company of such early Christian books as St Augustine's Gospels. A common descent of Babylonian imagery in both Spain and England from a single early Christian tradition has not been proven, but an early Christian exemplar, either an illustrated Bible or an

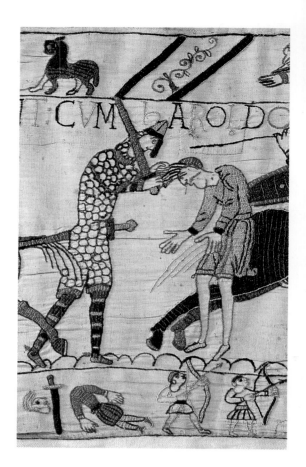

103 Detail: execution of an unarmed
Englishman, a puzzling scene located
immediately before the death of Harold. From
the Bayeux Tapestry, Plate LXX.

illustrated Book of Daniel, common to both Spain and England cannot be ruled out.[24]

Breton expedition: the escape by rope and the handing over of the keys

In addition to such singular details in the depictions of the oath and the death of Harold, yet another puzzling sequence in the Tapestry also appears to have parallels in stories that recount Nebuchadnezzar's attack on the kingdom of Judah. Recall that the Tapestry's depiction of William's expedition against his troublesome vassal Count Conan of Brittany diverges dramatically from what is recorded in a contemporary written account. According to the Tapestry, when William arrived Conan was defending himself inside the castle at Dol and only managed to escape by sliding down a rope (Plate XXI). Our principal written source, William of Poitiers' laudatory biography of the Conqueror, relates, however, that Conan was not within the castle at all, but outside laying siege to it. In the following episode, the Tapestry shows William pursuing Conan to the castle at Dinan, besieging it successfully, and, in another memorable image, receiving the keys to the castle on the end of an extended lance (Plates XXII-XXIII). Again the artist's version of history diverges completely from that of William of Poitiers; the latter tells the reader that rather than pursuing Conan, his hero retreated back into Normandy, for magnanimous reasons of course, allowing Conan to slip away.[25]

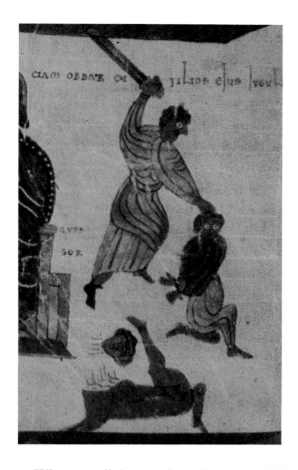

104 Execution of Zedekiah's sons at the command of Nebuchadnezzar. From the Valladolid Beatus, *c.* 970; in Valladolid, the Biblioteca Universitaria, f. 193v.

What parallels are there between Nebuchadnezzar's expeditions against the Hebrew kingdom of Judah and the Tapestry's depiction of Conan escaping from inside Dol, then being pursued and defeated by William? As we shall see, there are striking ones, but a word of caution is in order because the parallels to the Tapestry are found in early rabbinical legends not in the Bible itself. Although these embellishments on Scripture had appeared by the 11th century, there is no evidence as yet that the particular ones in question were known in Christian circles of the time. Therefore, while they cannot be ignored, the following parallels need to be treated with great caution.

What do we find in the Bible and in legendary material? Before attacking Zedekiah, Nebuchadnezzar had led successful campaigns against two previous kings of Judah, a father and son with very similar sounding names: Jehoiakim and Jehoiachin. When we investigate the history and lore of Nebuchadnezzar's triumphs over these two kings we find some remarkable details. First, in Jeremiah we read that the immediate predecessor of Zedekiah, King Jehoiachin, was commonly called by the nickname Coniah, a name uncannily close to that of the Breton lord who caused so much trouble for Duke William.[26] Second, when we turn to later Hebrew legends about the Babylonian Captivity we find some remarkable details about the actual campaigns against Zedekiah's predecessors. For example, we read that when Nebuchadnezzar advanced on Judah, he encountered the father, Jehoiakim, 'gliding down from the city walls of Jerusalem

by a chain'.[27] We also discover that when his son 'Coniah' was subsequently attacked by Nebuchadnezzar, the young man mounted the roof of the Temple to hand over its keys to God, hoping that he could thus prevent Nebuchadnezzar from entering. It was in vain, for Nebuchadnezzar took possession of the city and its king.[28]

Could the artist of the Bayeux Tapestry have had access to these Jewish tales with their motifs of attempted escape from the top of a building by a chain and a subsequent handing over of keys? Although they have not been located in Christian writings, the fact that Jewish motifs are being found with increasing frequency in Christian art and literature means that it is not impossible that the artist might have known them. In late antiquity, Jewish art has been shown to be of considerable importance in the development of Christian iconography, and, indeed, Jewish influences on Christian thought are now recognized as potent and fruitful throughout the Middle Ages, while the influence of Jewish folklore on medieval Christian art and lore, including that of early Ireland and England, has also been demonstrated by a number of scholars.[29] 'The possibility of the transmission of a large repertoire of ideas, stories and themes that have previously seemed too exotic, too oriental, too proscribed by official church lists to have survived the journey, has recently come more and more to be regarded as credible.'[30]

Whether future research will indicate that the correspondences we have discovered between Jewish lore and the iconography of the Tapestry's Breton expedition is fortuitous, or due to influences from the pseudepigrapha and later rabbinical texts, either indirectly through art or writings, or directly from Jewish scholars in Normandy or England, remains to be seen. Also a direct influence, a Hebrew scholar having discussions with the artist and members of his circle, cannot be ruled out, for in these years before the First Crusade (1095), relations between Jews and Christians in Northern France and England were extraordinarily cordial and open. That intellectual interchange in the 11th century could show a tolerance and appreciation of Jewish points of view so strikingly different from the bitterness of later polemics is indicated by the amicable debate in the late 11th century on matters of faith between a Jew who had studied in the famous Talmudic academy in Mainz and Gilbert Crispin, abbot of Westminster.[31] Also, Rouen, the important city in Normandy where Odo was long imprisoned, was a centre of Norman Jewry, and England would receive the beginning of a migration of Jews during the Conqueror's reign, some presumably settling in Canterbury.[32]

Coincidences?

It thus appears that many of the vivid and unusual details in the episodes which have been most puzzling to students of the Tapestry – the Breton Expedition, the Oath and the Death of Harold – can be accounted for by assuming, strange as it may seem at first glance, that the artist was using biblical history as a source for telling the history of the Norman Conquest of England. While it is possible that each of the anomalies discussed so far can be accounted for in other ways, there

are, in my opinion, two very strong reasons for believing that the artist of the Bayeux Tapestry was indeed using the Bible as a source for his depiction of the Norman Conquest.[33]

First, leaving aside the motifs in the problematic Breton expedition that are paralleled only in Jewish legendary material, while *each* of the above iconographic motifs and divergences from the texts could be given a reasonable explanation without recourse to the Bible, surely it is stretching the limits of credulity to accept that *all* of them just happen to be found in both biblical iconography and in the Tapestry: (1) the Ark-like portable reliquary on which a sacred oath is sworn, (2) the decapitation of the unarmed man directly in front of Harold (with the already executed figure in the lower margin), (3) the blinding of the defeated king whose crime was perjury, and (4) the link between the Normans and the winged lion in the Tapestry's borders. Finally, we should add a general correspondence: the fact that the Tapestry departs from the Norman written sources in isolating only Harold's perjury and infidelity as justification for William's invasion reminds one that in the biblical account Zedekiah's chief sins were perjury and infidelity.

In addition to having to accept an extraordinarily high level of coincidence, there is a more specifically historical reason for regarding the Hebrew Bible as a likely source for the Bayeux Tapestry. Medieval attitudes towards history took as their starting-point the Hebrew and Christian Bibles. Scripture provided both the general conceptual framework for organizing one's thoughts about history, as well as innumerable detailed allusions and analogies that could be interspersed in a narrative of events having nothing to do with the biblical period.

In both the general schema and in the minute details, the Babylonian Captivity played important roles. Prior to our modern view, originating with *trecento* Renaissance humanists, that world history is divided into ancient, medieval and modern periods, it was common for Christian historians to visualize history quite differently. To the medieval mind, man's collective life was conceived in terms of the 'six ages of the world,' as foretold in the six days of creation and consonant with the six ages in the life of everyman. The period from Adam to Noah represented infancy, Abraham to David youth, David to the Babylonian Captivity of the Jews manhood, the Babylonian Captivity to St John the Baptist middle age, and the time between the first and second coming of Christ senility; the end was imminent.[34] The Babylonian Captivity was thus the pivotal event bringing to a conclusion one age of world history and inaugurating another.[35]

Fortunately, medieval writers often rose above the gloomy notion that they were living in the old age of the world, facing an inexorable decline into death, and took an avid interest in the past and the world around them. Their principal historical source was the Bible, the most studied book in the Middle Ages.[36] For men educated in the monasteries, the only centres of learning before the rise of the more worldly cathedral schools and universities of the 12th-century renaissance, literary training was usually carried out 'through the patient assimilation of the Bible and works of devotion'.[37] A programme of study composed by an anonymous monk reveals how often and how thoroughly the Hebrew Scriptures were read. The monks began with the historical books of the Hebrew Bible, reading through

them three or four times with attention to the literal meaning; for help in understanding, the histories of Josephus and Hegessipus would be added, and difficult problems might be explained by Jerome's commentaries and Isidore of Seville's *Etymologies*. The prophetic and wisdom books would follow; next would come the Christian Bible and St Augustine.[38] Specific deeds and actors in Scripture became real characters. Abraham and Isaac, David and Saul, Isaiah and Jeremiah were so vivid to the monastic imagination that the Rule of St Benedict forbade the reading of the Heptateuch and the Books of Kings after dinner lest the monks became over-excited in the evening.[39]

One of our greatest historians of the Bible in the Middle Ages reminds us that 'medieval writings on history make little sense to a reader who does not know his Bible. A medieval writer will normally quote from the Scriptures; he will also refer and allude.'[40] Often the allusion to a well known event notes how a biblical pattern is repeated in later history, as in this passage from the Anglo-Norman historian Orderic Vitalis:

In the town of Rochester a plague like one of the plagues of Egypt broke out. *In this way God, who always directs and justly disposes human affairs, repeated old miracles in modern times.* Just as lice molested the Egyptians, biting them without a moment's respite from their persecution, so flies incessantly plagued the besieged.[41][my italics]

An interplay between present and past can be found in virtually every medieval work of history, from the lofty and subtle speculations of a Joachim of Fiore to the more commonplace annals of anonymous chroniclers. Nor was such knowledge and familiarity confined to monks and theologians. Epics and chronicles have biblical reminiscences. Beowulf's monstrous opponent Grendel is a descendant of Cain. In the *Song of Roland* the fact that Charlemagne is surrounded by his twelve peers, one of whom is a traitor, inevitably recalls Jesus and His twelve. Ganelon is indeed a veritable Judas, who sells his master for money.[42] Fascination with the Bible gave shape to the content of history and epic. 'The Frisians, comparing themselves to the chosen people, inverted the order of events in their history so as to get a closer correspondence with the Old Testament.'[43]

If the artist of the Bayeux Tapestry was as familiar with the religious art of the early Middle Ages as he appears to have been, and if he worked in Canterbury, the intellectual centre of Anglo-Norman England, then it is not difficult to imagine him participating in discussions, perhaps with his patron, perhaps with the monks of St Augustine's Abbey or their rivals nearby in the cathedral close, about the meaning of the events which shaped their lives. Searching the Bible for clues to God's purpose, 11th-century clerics may well have contemplated what such extraordinary parallels between the Babylonian and Norman Conquests signified.[44]

CHAPTER XIV

A Story Fraught with Meaning

Thus far we have seen that there are reasonable grounds for thinking that the Tapestry is not solely composed of images depicting contemporary events. Not only is there a miscellany of images apparently derived from a variety of pre-Conquest Canterbury manuscripts, but important aspects of the Tapestry's narrative also appear to be based on a particular biblical story. Yet, the most important question has still to be faced: if the makers of the Tapestry thought in terms of analogies and allusions, why did they select the Babylonian Conquest of Judah from the many possible paradigms of military conquest available in biblical and classical history? The answer to this question is by no means self-evident; to gain a sense of why that is so, let us begin with our principal source, the Bible.

To glorify and legitimize

The main theme of the historical and prophetic writings which describe the conquest of Judah (2 Kings, 2 Chronicles, Jeremiah and Ezekiel) is that, although a catastrophe, the Babylonian Captivity was part of God's plan, a punishment of the people of Israel and its kings for their repeated lapses into sin and idolatry, despite the efforts of prophets calling for reform. Hence, the pagan Babylonians (also referred to as Assyrians and Chaldeans) were God's instrument to chastise 'His chosen people'. The annihilation of the previously independent Hebrew kingdom, the enslavement of its population, even the destruction of the Temple and the looting of its holy vessels, were commanded by God. Listen to the words of the Hebrew historians:

Zedekiah did what was evil in the sight of the Lord his God. . . . He rebelled against King Nebuchadnezzar, who had made him swear by God. . . . All the leading priests and the people likewise were exceedingly unfaithful, following all the abominations of the nations. . . . Therefore he brought up against them the king of the Chaldeans, who slew their young men with the sword in the house of their sanctuary, and had no compassion on young men or virgin, old man or aged; he gave them all into his hand. And all the vessels of the house of the Lord, and the treasures of the king and of his princes, all these he brought to Babylon. . . . He took into exile in Babylon those who escaped from the sword and they became servants to him and his sons.[1]

Since the Bible consistently interprets Nebuchadnezzar as acting with just cause in his campaign against Zedekiah, as well as being God's instrument for punishing the perjured Hebrew king and his sinful people, it is reasonable to assume that the artist, alone or in consultation with his patron, chose the Babylonian Conquest as a paradigm because the biblical narrative contained themes peculiarly appropriate to glorifying and legitimizing what the Normans accomplished in

1066. With its emphasis on feudal obligations, sanctity of oaths, and the divine wrath that descends upon a perjurer, the biblical narrative would have seemed almost contemporary.

The fact that the prophets denounced the sins of Hebrew priests would also have had a charged meaning to a world awakened to clerical corruption by the uncompromising denunciations, themselves modelled on biblical rhetoric, of such religious reformers as Peter Damian and Archdeacon Hildebrand. Just as the prophets excoriated the high priests of Jerusalem for 'following the abominations of the nations,' so Norman propagandists lashed out against English clerical abuses and particularly at Archbishop Stigand, whose uncanonical position as head of the Anglo-Saxon church and unsavoury character, winked at in more easygoing times, now appeared unacceptable. Such heightened awareness of Anglo-Saxon clerical improprieties no doubt helps explain the prominence accorded to the papally condemned Stigand in Harold's acclamation ceremony (Plate XXXI).[2]

Another important reason why the creators of the Tapestry may have selected the Babylonian Conquest as a paradigm for the events of their own day would have been the opportunity to make a personal comparison between the two great conquerors at the centre of the parallel histories. Granted William was enormously successful in his time, the West's greatest military hero since Charlemagne, but was he also a world historical figure to be spoken of in the same breath as heroes of old: an Achilles, a Julius Caesar, a Nebuchadnezzar, fabled king of Babylon? All the Norman eulogists certainly thought so.[3] William of Jumièges called William the wisest and most gracious king, as strong as Samson and as just as Solomon.[4] As we have seen, William of Poitiers continually compared William with individual heroes of ancient history or epic: Agamemnon for skill in launching an armada, Achilles for his warlike valour, Theodosius the Great for piety, Augustus for the affection he inspired in his countrymen, and, of course, Caesar for success in conquering England.[5] Recall also that in the learned poem written for the Conqueror's daughter Adèle, the poet Baudri de Bourgueil placed an imaginary Tapestry depicting William's conquest in the company of hangings portraying Joshua, David, Agamemnon and Caesar.[6]

Implicit comparisons to great military heroes were also made by the Norman writers. There was even one obituary composed by an anonymous author, perhaps a monk at the abbey of Caen which William had founded, in which a comparison with Charlemagne is implied by the fact that his portrayal of William the Conqueror is in reality conflated (plagiarized may be the more appropriate word) with a description from Einhard's *Life of Charlemagne*. This is what we are told by the Norman monk about William, with the borrowings from Einhard's portrait of Charlemagne in italics:

He was great in body and strong, tall in stature but not ungainly. He was also temperate in eating and drinking. Especially was he moderate in drinking, for he abhorred drunkenness in all men, and disdained it more particularly in himself and at his court. He was so sparing in his use of wine and other drink that after his meal he rarely drank more than thrice. In speech, he was fluent and persuasive, being skilled at all times in making known his will. If his voice was harsh, what he said was always suited to the occasion. *He followed the Christian discipline in which he*

had been brought up as a child, and whenever his health permitted he regularly and with great piety attended Christian worship each morning and evening, and at the celebration of mass.[7]

Clearly, a comparison between William and Nebuchadnezzar in the Tapestry, even a conflation of ancient model and contemporary portrayal which did not call attention to its source, would have been thoroughly in keeping with the efforts of Norman literary propagandists to place the duke of Normandy in the company of great world conquerors, and consistent with the common medieval practice of referring to a famous figure of the past when praising a hero.[8]

However, before we accept the apparently plausible notion that the Bayeux Tapestry was making biblical allusions *solely* in order to glorify and legitimize the Conqueror, while showing God's hand in history, let us note two features of the Tapestry's historical parallels which are different from any we have so far observed in the Norman texts. First, the allusions to Nebuchadnezzar's triumphs are so well embedded in the Tapestry's contemporary historical images that one can easily miss them. Was the artist deliberately concealing his biblical references as best he could? Did he perhaps have two audiences in mind, the masses who would be satisfied with the surface meaning, and the élite, for whom a clever set of hidden references to biblical antetypes would provide the kind of intellectual pleasure one gets from pitting oneself against those learned Anglo-Saxon riddles that perplex us to this day?

Then, there is a second feature of the biblical allusions that gives pause for thought. If our interpretation of the Tapestry's iconography is correct, of all the contemporary accounts of 1066 only the Tapestry alludes to the Babylonian Conquest of Judah as a paradigm for contemporary events. Although William of Jumièges, William of Poitiers and Baudri de Bourgueil refer to many famous pagan and biblical military conquerors, not once do they mention Nebuchadnezzar.[9] What reasons might there have been for those Norman propagandists to avoid any reference to the Babylonian Conquest or to Nebuchadnezzar? To grasp the intentions of the Tapestry's master artist *vis-à-vis* those of the Norman literary propagandists, we need to look briefly, first, at early medieval images of Nebuchadnezzar and, second, at the symbolic meaning which the Babylonian Conquest of Judah had for future generations.

NEBUCHADNEZZAR IN EARLY MEDIEVAL THOUGHT AND ART

For the Middle Ages, as for the Bible, Nebuchadnezzar was a highly ambivalent figure, a God-sent conqueror as well as a cruel despot. Repeatedly punished by God for his overweening pride, he was a king who also regained God's grace.[10] Since the Book of Daniel is by far the most important source for the ambivalent image of Nebuchadnezzar in medieval culture let us recall two of Daniel's tales.[11]

The golden idol

Among the young men whom Nebuchadnezzar ordered be brought from all parts of his empire to serve in the royal palace there were four Hebrews – Daniel and his assistants, Shadrach, Meshach and Abednego. When they refused to bow

105 (*above*) Praying to the idol.

106 (*right*) Three boys in the fiery furnace.

From the Roda Bible, 10th century; in Paris, the Bibliothèque Nationale, MS lat. 6, III, fs. 64v and 65r.

down in worship before a golden image Nebuchadnezzar had built, the king, wild with rage, ordered a fiery furnace to be heated. After the three boys were cast into the furnace, preferring martyrdom to apostasy, the king looked with amazement into the oven to see them walking unhurt amidst the flames (Plates 105, 106).[12].

But the Babylonian king is not merely a tyrant and persecutor of God's faithful. Looking into the oven he saw next to the boys a fourth figure, one with the appearance of 'a son of the gods,' according to Daniel.[13] Thereupon, Nebuchadnezzar acknowledged the God of the three youths as the one God of the universe. For medieval Christians, this mysterious fourth figure was Christ, as indicated in our illustration from the Roda Bible by his distinctive cruciform halo. Thus, if the Nebuchadnezzar of the Hebrew Scriptures was already a complex figure who appeared in three guises, first as God's servant to punish sinful Judah, then as tyrant and blasphemer, and third as a pagan who acknowledged the one God, in the medieval view his image became even more involved by the special role he played in Christian history as one who had foreknowledge of Christ.[14]

'Let his lot be with the wild beasts'

Pride and repentance, sin and redemption – this is a pattern that recurs in all the Daniel stories about the Babylonian king. However, the final tale about Nebuchadnezzar added a very unusual punishment: the most powerful king on earth would be compelled to live with wild beasts. Nebuchadnezzar told of a dream wherein he saw a tree so tall that it could be viewed from anywhere on earth. A celestial messenger gave instructions for the tree to be cut down, adding 'let his lot be with the beasts in the grass of the earth; let his mind be changed from a

107 Nebuchadnezzar beneath a tree eating grass like an animal. From the Morgan Beatus, mid-10th century; in New York, the Pierpont Morgan Library, MS 644, f. 252.

man's and let a beast's mind be given to him, and let seven times pass over him.'[15] Daniel interpreted the tree reaching to heaven and covering the earth as symbolizing Nebuchadnezzar, and the image of a heavenly being ordering the tree to be cut down as an omen that the king would lose his kingship, driven from among men for seven years, his dwelling made to be with animals, his food the grass of the fields. Then Nebuchadnezzar would 'know that the Most High rules the kingdom of men, and gives it to whom he will.'[16]

A year later, at the very moment he began to brag of his greatness, Nebuchadnezzar became insane, and in fulfilment of the prophecy, 'he was driven from among men, and ate grass like an ox, and his body was wet with the dew of heaven till his hair grew as long as eagle's feathers, and his nails were like bird's claws.'[17] When the stipulated seven years' punishment had passed, Nebuchadnezzar was restored to sanity, and, after acknowledging the sovereignty of the true God, had the splendour of his kingship returned to him.

Quite popular in early medieval art, the story of Nebuchadnezzar's fall can be found in a number of illuminations, including the commentaries on Daniel attached to the Beatus manuscripts. There one sees a naked man squatting under a large tree holding some grass in one hand while with the other he brings a bunch to his mouth (Plate 107).[18] Perhaps the most haunting version of the story is in the Roda Bible (Plate 108),[19] below Nebuchadnezzar's vision of a tree that reaches to heaven. The naked king, his hair unnaturally long and his nails like talons, walks on all fours over the undulating ground, an ox and a lion on either side.[20]

108 Nebuchadnezzar as a wild beast; from the Roda Bible, 10th century; in Paris, the Bibliothèque Nationale, MS lat. 6, III, f. 65v.

How was Nebuchadnezzar's fall into bestiality interpreted in the Middle Ages? To the medieval Christian the main point of the story was that Nebuchadnezzar fell because of his pride.[21] While this interpretation emphasized that Nebuchadnezzar's fall into madness and bestiality was followed by the grace of the knowledge of God, another considerably more damning notion was the association between Nebuchadnezzar's fall and that of the devil. In the most popular biblical commentary of the early Middle Ages, the *Glossa Ordinaria*, references to Lucifer in biblical writings on the Babylonian Exile were often glossed as *Nabugodonosor vel Diabolus* [Nebuchadnezzar or the Devil], and in early 11th-century England, the homilist Ælfric commented:

The Babylonian king, Nebuchadnezzar, who of the sinful people slew some and led others captive to his kingdom, betokened the devil, who in divers ways fordoes the sinful, and leads them captive to his city, that is to hell, to confusion. Babylon, the Chaldean city, is interpreted *confusion*. It betokens hell.[22]

The inherently problematic image of Nebuchadnezzar in medieval culture can be seen in Ælfric speaking in one sermon of Nebuchadnezzar both as signifying the devil and as God's agent to punish the Hebrews.

THE BABYLONIAN CAPTIVITY AND THE IDEA OF RESISTANCE

The Babylonian Conquest is clearly not just about a sinful people punished by God for their iniquities. Other meanings, some positive, some negative, overflow the biblical texts and those that comment on them by later writers. Then, too, the Babylonian Captivity, like the story of enslavement in Egypt, has a triumphal ending. After seventy years the Babylonian kingdom was destroyed and the Jews permitted to return to Jerusalem. Because the release from Babylon is as inextricably bound up with the Babylonian Conquest as the Exodus is with the enslavement in Egypt, it too became a metaphor for liberation. Even more, it became in some circles a metaphor for resistance, for if the Jews in Egypt only groaned under their burdens, heroes like Daniel and Judith took action against their oppressors. To say this is not to read the Babylonian Captivity literature in an idiosyncratic way. This is how it was read and used in antiquity and the early Middle Ages. Thus, even if there is nothing overt in the Tapestry's iconography about Hebrew resistance to the Babylonian victory, the very existence of that conquest as paradigm suggests the very strong likelihood that there were people in the artist's circle who were contemplating what such an extraordinary repetition of a pattern of history entailed. If the relationship between Zedekiah and Nebuchadnezzar prefigured the feudal ties and sacred covenant between Harold and William, perhaps the future of the English nation would resemble that of the Hebrew kingdom after seventy years by the rivers of Babylon. In concrete terms, what in the biblical literature might have spoken to Anglo-Saxons in post-Conquest Canterbury? Also, since the Babylonian Captivity was often employed by subject people as a way of understanding their plight, what meaning did these same stories have for earlier writers and artists in somewhat analogous historical situations? Let us explore the most important occurrences in chronological sequence.

'Our captors required of us songs, and our tormentors, mirth'

To begin, we should not lose sight of a distinctive feature of the Scriptural texts that would have an enduring impact on later generations. Biblical writing on the Babylonian Conquest is virtually unique in ancient literature in that it recounts a traumatic conquest from the victim's point of view. As medieval Europe knew no Babylonian court histories, the perjury of Zedekiah, the destruction of Jerusalem and the Temple, the forced march to Babylon, and the seventy years of captivity were perceived only as they had been viewed by the Hebrew authors. While these Jewish writers certainly saw Nebuchadnezzar as God's agent in punishing the Israelites, they none the less gave unforgettable expression to the torment and despair of a people losing their homeland and their freedom. Would not these words of the Hebrew psalmist have spoken directly to the anguish of a defeated people commanded to create a triumphal monument narrating their own humiliation?

> By the waters of Babylon, there we sat down and wept, when we remembered Zion.
> On the willows there we hung up our lyres.
> For there our captors required of us songs, and our tormentors, mirth, saying,
> 'Sing us one of the songs of Zion.'

And lament over being forced to sing mirthful songs turned to an embittered cry for vengeance:

> O daughter of Babylon, you devastator! Happy shall be he who requites you
> with what you have done to us!
> Happy shall he be who takes your little ones and dashes them against the rock![23]

Given the rich variety of these biblical texts, certainly one of the most extensive and powerful bodies of writing on the agony of military defeat within the Western tradition, it is hard to conceive of Anglo-Saxons thinking that the Babylonian Conquest had relevance to them only in terms of glorifying and legitimizing the Norman Conquest. Once the biblical metaphor is established the mind naturally moves beyond what is signified about Harold's crime and punishment being like that of Zedekiah's to that which is left unstated: the suffering of the Hebrews, Nebuchadnezzar's pride and megalomania, the defeat of the Babylonians by the Persians, and, ultimately, the Hebrew re-entry into Jerusalem in 539 BC to build their Temple anew.

Sharpen the arrows! Take up the shields! The Lord has stirred up the spirit of the kings of the Medes, because his purpose concerning Babylon is to destroy it, for that is the vengeance of the Lord, the vengeance for his temple.[24]

The Maccabee revolt

When the descendants of the Jews who returned to Jerusalem faced persecution and the profanation of their rebuilt house of worship at the hands of the Syrian king Antiochus Epiphanes in 167 BC, many looked back to the first attack on the Temple by Nebuchadnezzar for guidance and consolation. Interestingly, one of

these men, a contemporary of Judas the Maccabee, picked up the pen as his means of giving hope to his fellow Jews while attacking the enemy. This was the author of the Book of Daniel. As often occurs when writing under the threat of persecution, he concealed his true intention by ostensibly telling of the experiences of a Daniel living in Nebuchadnezzar's Babylon, when, in fact, if we were to understand the true message in the Book of Daniel, we should read Antiochus for Nebuchadnezzar and Syrians for Babylonians.[25]

Black underneath but white outside

Later, after the second Temple had been destroyed in AD70 by Roman soldiers under the command of the Emperor Titus and the Jews began their second and longest Diaspora, writings about the Babylonian Captivity took on a sense of immediacy once more. One vehicle for criticizing the Roman tyrants were the commentaries on biblical texts set in the time of the Babylonian Captivity.[26] An historically significant *midrash*, or embellishment of a biblical text that draws out its meaning and perhaps makes the past relevant to the conditions of the present, comes to us from this period after the destruction of the second Temple. It 'reports' that when some exiles accompanying Zedekiah were brought to Babylonia by Nebuchadnezzar they were met by earlier deportees hailing Nebuchadnezzar as 'conqueror of the Barbarians.' These captive Hebrews who joyously welcomed the Babylonian king were, however, described as wearing 'black underneath but white outside'. There is little doubt that this story actually alludes to the mass of Jews of the Roman Diaspora, as well as to individuals such as Josephus, who had to conceal their mourning for Jerusalem and proclaim their loyalty to the Roman conquerors.[27]

'Babylon the great, mother of harlots'

Christians as well as Jews turned back to the writings on the Babylonian Captivity during their persecutions by the Romans. Through mystery-filled visions filled with strange beasts and obscure symbols, the Revelation to John, that greatest of books produced by early Christians facing human, and, it was thought, demonic foes, interprets present events and predicts the coming consummation of history when the 'saints' will have ultimate victory. In one of the most famous passages whereby John tells of ways in which God's wrath will be manifest on earth before God's final victory he describes how an angel said to him:

'Come, I will show you the judgement of the great harlot who is seated upon many waters, with whom the kings of the earth have committed fornication. . . .' And he carried me away in the Spirit into a wilderness, and I saw a woman sitting on a scarlet beast which was full of blasphemous names and it had seven heads and ten horns. The woman was arrayed in purple and scarlet, and bedecked with gold and jewels and pearls, holding in her hand a golden cup full of abominations and the impurities of her fornication; and on her forehead was written a name of mystery: '*Babylon the great, mother of harlots and of earth's abominations.*'[28]

As in the Book of Daniel, Babylon is a code name, this time standing for Rome,

the arch-persecutor of the saints in the time of Nero, when the book was presumably composed.

Heretics, schismatics and the infidel

The identification of Babylon with the enemies of the church persisted, taking on a new and special meaning in the Christian kingdoms of northern Spain, where a susceptibility to endemic heresy and a fear of Islam directly to the south contributed to a spirit of fierce fanaticism. It is in this milieu of obsession with doctrinal differences on the nature of Christ and revived resistance to the Muslims that John's Apocalypse and its Hebrew predecessor, the Book of Daniel, had their first major impact on medieval culture, primarily through a very scholarly yet popular commentary on John written by Beatus of Liébana in the 8th century.[29] Copied and recopied with remarkable enthusiasm, twenty lavishly illustrated copies exist to this day.

Why was Beatus' rather dry, erudite treatise so popular? The most plausible explanation is that the Spanish monks found a consonance between the message of the Apocalypse and the frightening religious situation in Spain. The monks found a cosmic explanation in the Book of the Apocalypse: before the Day of Judgement and the ultimate triumph of the faithful, the world would be ruled by Antichrist and there would be turmoil and tribulation. Muhammad and his followers were ministers of Antichrist and followers of Satan.[30]

In this atmosphere of heroic resistance to Muslim rule, it is not surprising to find that the wonderfully illustrated Beatus manuscripts also contain illustrations of the Book of Daniel, for Daniel carried a similar message, a prophetic incitement of faith and will in a time of struggle. Already, Isidore of Seville had written that the Book of Daniel is to be interpreted in terms of the relationship between the true church and the kingdom of heretics, the former symbolized by Jerusalem and the latter by Babylon.[31]

Two illustrations from these extraordinary books, one from Beatus' Commentary on John and one from Jerome's Commentary on Daniel, are of special interest to us as they use imagery derived from the Babylonian Captivity for contemporary ideological and political purposes. In the 10th-century Morgan Beatus, the painter Magius deviated from the usual depiction of the whore of Babylon, based on the text from Revelations quoted above which described an enthroned woman seated on the waters, to identify her in specific cultural terms (Plate 109, page 188).[32] She sits on a cushioned divan of Islamic type, while the decorations on her crown include the famous Islamic crescent associated with regality or divinity; thereby an iconography is created that is clearly anti-Muslim.

Also in the Morgan Beatus, as well as in four other illustrated Beatus manuscripts, one finds a most unusual depiction of the Feast of Balshazzar (Plate 111, page 189). The general iconography is of the early Christian type, the diners reclining around a semicircular table. But the setting is remarkable. The feast takes place under a distinctly contemporary horseshoe arch.[33] The horseshoe arch is in itself not unusual, since Visigothic builders had used it even before the Muslims had arrived in the peninsula, and Spanish Christians even placed

horseshoe arches within depictions of the Heavenly Jerusalem, but this specific arch, with its alternating red and white archivolts, carries a special meaning.[34] In the 10th century, it would have referred to only one building, the mosque of the Muslim capital of Cordoba (Plate 110).

ANGLO-SAXON ATTITUDES

If we turn from Spain to Anglo-Saxon England we find a wonderfully rich vernacular literature, religious, epic and lyrical, that attests to an intense popular fascination among the Anglo-Saxons with ancient Hebrew history.[35] For our purposes two vernacular poems stand out in importance – 'Daniel' and 'Judith' – because both suggest that English poets and their audiences felt an emotional identification with the Hebrews in their time of Babylonian captivity that is unique in early medieval culture.

'Daniel'
An incomplete poem of 765 lines, 'Daniel' is an 11th-century vernacular work that follows the Vulgate text of chapters 1-5 quite closely, except for a few revealing additions. The introductory lines tell of the prosperity of the Jews in Jerusalem and their resultant arrogance and disobedience. There follows the capture of the city by Nebuchadnezzar, the selection of the three youths, their refusal to prostrate themselves before the golden idol and their miraculous fate in the fiery furnace. Afterwards there is the king's dream of the tree reaching to heaven which will be cut down, a foretelling of the fall of Nebuchadnezzar, his seven years among the wild beasts and subsequent return to sanity and power; lastly, there is the partial account, due to the fact that the manuscript breaks off, of Balshazzar's Feast.[36]

A number of aspects of this poem interest us. Nebuchadnezzar, in keeping with the ambiguous image we have observed in other texts, is described as both 'great and glorious over all the earth', and as one who 'lived in insolence and heeded not the law'. In addition, he is 'not wise but redeless, reckless, heeding not the right', and the author continually refers to Nebuchadnezzar as fierce, savage, ruthless, haughty and heathen.[37]

Most interestingly, the Hebrews, although said to be justly deserving of the Lord's anger, are consistently dealt with in a sympathetic manner by the poet.[38]

109 The whore of Babylon as a Muslim. From the Morgan Beatus, mid-10th century; in New York, the Pierpont Morgan Library, MS 644, f. 194v.

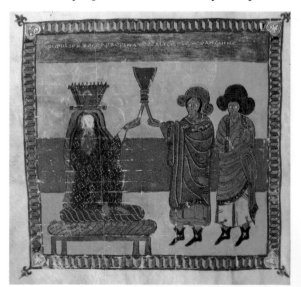

110 (*above*) Mosque at Cordoba, with horseshoe arches composed of alternating red and white archivolts.
111 (*right*) Balshazzar's feast as a Muslim feast. From the Morgan Beatus, mid-10th century; in New York, the Pierpont Morgan Library, MS 644, f. 255v.

Involvement with their plight is most evident in the two short poems interpolated into the biblical story that express the thoughts of the boys miraculously saved from the flames. As expected, they praise God's strength and glory while praying for salvation, but they also utter thoughts about their abject state, political and religious, that are implied but not articulated in the biblical source: 'Wrapped in flame, we pray Thee for Thy mercy on our woe, our *thraldom* and *humiliation*. . . . In many lands and under many peoples our life is infamous and vile, and *we are subject to the worst of earthly kings*.'[39] Such political and 'national' sentiments go beyond the traditional emphasis on only the plight of three youths facing martyrdom for refusing to bow down before a heathen idol.

An additional tantalizing aspect of this Old English text of 'Daniel' needs to be mentioned. When it was copied in the second quarter of the 11th century, probably at Christ Church, Canterbury, it was clearly intended that the text would be illustrated. Alas, all we can know about these illustrations is their intended location, as indicated by blank spaces in the text.[40] Would that the illustrations had been inserted! Even without them we can still learn a great deal from the text of the poem about three important matters: the Anglo-Saxon fascination with the story of Daniel, the ambivalent, but predominantly negative image of Nebuchadnezzar in the Anglo-Saxon imagination, and the tendency of the English poet to identify completely with the political and religious predicament of the Hebrews in their period of Captivity.

'Judith'

Nor is 'Daniel' an isolated instance of an empathetic involvement with the Jews during their Captivity. A second Old English work dealing with that period in biblical history is 'Judith', a stirring poetic version, apparently composed in the 10th century, of the apocryphal book of that name.[41] A masterpiece of fiction written probably in the 2nd century BC, the biblical story on which it is based is situated, like Daniel, in the period of the Babylonian Exile and narrates with unforgettable horror Judith's slaying of Holofernes, the leader of the Babylonian army in Judah. It is a remarkably effective piece of historical fiction designed with a propagandistic purpose: to encourage the Jewish reader that in a time of trial or persecution piety can be expressed as patriotism and God helps those who help themselves.

The Anglo-Saxon poem ignores the first part of the book, a tedious account of how Nebuchadnezzar ordered Holofernes to invade Judah and lay siege to the Jewish town of Bethulia, to concentrate on the ways in which Judith, a beautiful and pious widow, cunningly beguiled Holofernes into entertaining her in his tent, where, when he became thoroughly drunk, she decapitated him.[42] It opens with an elaborate description of Holofernes at a banquet, a quintessentially Anglo-Saxon feast set in a mead hall with the Assyrian general surrounded by his thanes. Drunk with wine, the general calls for Judith to be brought to his bed, but when they are left alone Holofernes falls back in a stupor. Judith draws his sword and utters a prayer. Unaided, she drags him by his hair to get the best position for attack and then strikes two blows at his neck. The head rolls on the floor and Holofernes' soul departs to hell 'for endless time into eternity'.

The second part of the poem (ll. 122-200) describes Judith's triumphant return to her people in Bethulia, the enemy's head secreted in a leather bag, and the joyful reception of the news of her astonishing feat. This part is not unlike the biblical source, but the ensuing battle scene (ll. 200-349) has no counterpart in the Apocrypha. As might be expected in a heroic society, the Old English poet gives special emphasis to the account of the battle between the pursuing Hebrews and the terrified Assyrians. The battle occupies the remainder of the poem, concluding with a description of the war booty stripped from the felled soldiers, and the treasures given to Judith by her victorious Israelite army.

Some interpreters have regarded the elaborate emphasis on combat, which is much greater than in the biblical source, as a reflection of the author's absorption in a warrior society. While no doubt true, let us not ignore that the essential character of the biblical book is its fervent patriotism and practical example of what to do when confronted by overwhelming odds. Judith's courage and cunning is a model of heroism, but not of the egotistical sort, since she braves disaster for her people. As the 10th century was a period of invasion in England, it would seem reasonable that in retelling the triumph of Judith and her people over the pagan Babylonians the poet was thinking of the very real threat to England posed by the Danish invaders.

This view of the poem's political context is consistent with the fact that the poet is not just interested in creating the portrait of a Christian female hero, chaste in

her widowhood, wise in her faith. These Christian motifs are in the work, but unlike earlier religious interpretations by Jerome, Ambrose, Prudentius and Aldhelm, which showed no interest in the Book of Judith as a work of Hebrew patriotism, and indeed so allegorized the heroine that she became an antetype of the church, the Anglo-Saxon poet is sensitive to the patriotic tenor of the original. Listen to the language employed in the battle scene: 'the heroes were enraged, the native people against the nation of their enemies. . .'; 'the retainers in the morning-time pursued the foreigners unceasingly. . .'; 'the owners of the land destroyed by swords their former enemies, those who alive had been most hateful to all living people'.[43] It would appear that the poet hoped that his listeners would apply the lessons of the story to their own struggles against the Danes. It has even been speculated that the poet may have been inspired in his characterization of Judith by a real Anglo-Saxon patriotic heroine, Æthelflaed, 'Lady of the Mercians,' who led the Mercian hosts in person on expeditions which she herself had planned.[44]

Finally, direct evidence that the biblical story of Judith was used in late Anglo-Saxon England for patriotic purposes during the Danish invasions comes to us from Ælfric's *Treatise on the Old and New Testaments*. In this preface to his Scriptural translations Ælfric declared that he had specifically chosen Judith because it could be an example of heroism against an invader: 'Judith was written in English in our manner as an example to you men, that you defend your country with weapons against the attacking army here.'[45]

With regard to the Bayeux Tapestry, this vernacular literature has a special relevance in two ways: as proof of the popularity in pre-Conquest England, and perhaps Canterbury in the case of the Daniel manuscript, of stories connected with the Babylonian Captivity, and as examples of a particular way of looking at the Babylonian period in biblical history that has no parallel in Norman culture. A general interest on the part of Old English writers in the historical events recounted in Hebrew Scriptures grew out of shared tribal customs, but fascination with the writings on the Babylonian Conquest of Judah was enlivened by the long ordeal of invasions by the Northmen. In turning to this rich body of biblical material the preachers and poets of 10th and 11th-century England naturally identified themselves with the Hebrews under attack. Just as the Jews had merited God's vengeance, so did the English, a theme common in such sermons as Wulfstan's *Sermo ad Anglios*.[46] But while they deserved their punishment and had to reform, the literature did not dwell only on themes of sinfulness or instill passivity by emphasizing that all events are in God's hands. The heroism of Daniel, of the three boys in the fiery furnace and of Judith were vivid examples of how one might act in the midst of defeat. And if the Jewish heroes were seen as models for English men and women, Nebuchadnezzar, Balshazzar and Holofernes were associated with the enemy. Clearly, the Babylonian Captivity is a story fraught with meanings not found in any contemporary Norman text.

CHAPTER XV

Conclusion to Part Three

If our analysis of the Tapestry's iconography is correct and the artist was blending past and present, sacred and secular history, it is evident that yet another mystery has been added to an already formidable list: did the artist intend Odo and his fellow Normans to grasp the allusions to Nebuchadnezzar and Zedekiah, to the winged lion and Babylon? The interpretation of motive is certainly the most difficult task confronting an historian, for if works of art in our own time often leave us baffled as to an artist's intentions, consider how much more delicate the problem is when an anonymous artist, working nine hundred years ago, has left only a few ambiguous clues.

We can only surmise. While it is conceivable that the 'Babylonian' imagery was designed as a secret code, with the artist playing a very dangerous game, it is more likely that he was engaged in the same kind of visual and intellectual acrobatics he displayed elsewhere in the Tapestry. Recall that in narrating William's claim to the throne there is enough of the Norman argument to make one forget that the Tapestry left out important elements of the Norman case – Edward's purported bequest of the throne to the duke or their slender blood-ties. Recall the open-ended treatment of Harold's journey to Normandy. Numerous clues in the main scenes and the inscriptions playfully suggest that the artist was allowing a viewer to understand the oath either as Harold discharging his obligation to Edward, or as the fulfilment of Edward's warning to Harold not to go to Normandy. Recall also that while some of the marginal images, especially the fables, seem to mirror the view that Harold was a betrayer of William and an unlawful occupant of the throne, others cast doubt on Norman propaganda by mischievously suggesting that Harold had acted foolishly when he placed himself in the clutches of a more cunning, more powerful opponent. Lastly, remember the consummate juggling of conflicting interests in the various depictions of Bishop Odo alongside the king.

In the choice of the Babylonian Conquest as model, and in the selection of which biblical images to use and which to avoid, it is possible to see the same political mastery at play. If, on the one hand, the Tapestry's specific allusions to Nebuchadnezzar and Zedekiah would have served the primary purposes of Norman propaganda, legitimizing and glorifying the victory at Hastings, on the other, these allusions open the way to another body of thought that would have been more congenial to the Anglo-Saxons. Note that the artist does not take that sinister road himself: there is apparently nothing in the Tapestry's biblical

references explicitly critical of the victorious king – no marginal figure with a Norman haircut is down on the ground eating grass.[1] Still, it is undeniable that Nebuchadnezzar's later career as a cruel megalomaniac lurks in the wings. On this point, we can only say that, unless the artist was making a secret code, he apparently thought the biblical allusions, with their multiple unexpressed nuances, would have been acceptable in his patron's circle. Since the Tapestry was made well into the Conqueror's reign, perhaps an implicit comparison between William, a ruler infamous for his avarice and brutality, and Nebuchadnezzar would not have seemed inappropriate.[2] Then too, there was one Norman for whom a suggestive link between William and a great conqueror who subsequently went mad with delusions of power might have had a special appeal: the king's half-brother Odo. Certainly this would have been the case after William had cast Odo into prison, and might have been a factor even earlier if there had been a simmering fraternal rivalry and subtle threats to Odo's enormous power. Alas, without firm dates for the creation of the Tapestry, and any definite information on why William thrust his brother into prison, we can only note the possibility of malice on Odo's part.

Even the winged lion as a symbol of the passing of the Babylonian empire from the stage of history need not, in the 11th century, have been taken as politically subversive. No other epoch laid so much stress on the transience of all earthly accomplishments as did the Middle Ages. A recurrent call of *momento mori* resounds throughout the literature, where we often meet the question, 'where are now all those who once filled the world with their splendour?' In such melancholy reflections on the frailty of man's creations, the fate of the Babylonians was considered almost as resonant as that of the Romans. One instance is the 12th-century erudite poem by Bernard of Morlaix, also known as Bernard of Cluny, entitled 'De Contemptu Mundi,' particularly the verse that concludes with a line made famous again in our time by the author of a popular historical novel, a scholarly detective story set in a Franciscan monastery:

Est ubi gloria nunc Babylonia? nunc ubi dirus Nabugodonosor, et Darii vigor, illeque Cyrus? . . . Nunc ubi Regulus? aut ubi Romulus, aut ubi Remus? Stat rosa pristina nomine, nomina nuda tenemus.

[Where is now your glory, Babylon, where is now the terrible Nebuchadnezzar, and strong Darius, and the famous Cyrus? Where now is Regulus, or where Romulus, or where Remus? The rose of yesterday is but a name, mere names are left to us.][3]

On the Anglo-Saxon side one suspects that the same Babylonian imagery might have had a very different political and psychological meaning. Think of how differently the Norman Conquest looks when the historical allusion so favoured by the Norman eulogists, Caesar's conquest of Britain, is replaced by that of the Babylonian Conquest of Judah. Instead of a binary opposition between civilized and backward (Roman and Celt), we have a Babylonian-Hebrew polarity which suggests something quite different. On one side there is a great power that was first an instrument of God's wrath but which would subsequently be destroyed, while on the other there are God's people who were punished by invasion for falling into error and who would regain their homeland. Norman consciousness

about being successors of Rome, explicit in the literature and perhaps implicit in the Bayeux Tapestry, through its very format and narrative mode, and Norman certainties about the backwardness of the Saxons can be held with much less confidence if seen from this new vantage point.

Such doubts and ambiguities are not expressed in Norman texts. If, however, we turn to English or Anglo-Norman accounts we find more complex estimates of the Conqueror and his effect on England than those by William of Poitiers or the anonymous Norman monk of Caen.[4] Shortly after William's demise an English chronicler who knew the king, having 'looked upon him and once lived at his court', wrote a remarkably balanced assessment of his character and rule. He appears as 'a very wise man, and very powerful and more worshipful and stronger than any predecessor of his had been'. He was a great benefactor of the church and respected for maintaining law and order in a violent age. But he is also shown as a harsh and violent oppressor, avaricious and cruel, for 'certainly in his time people had much oppression and very many injuries':

> He had castles built
> And poor men hard oppressed.
> The king was so very stark
> And deprived his underlings of many a mark
> Of gold and more hundreds of pounds of silver,
> That he took by weight and with great injustice
> From his people with little need for such a deed.
> Into avarice did he fall
> And loved greediness above all.
> He made great protection for the game
> And imposed laws for the same.
> Those who slew hart or hind
> Should be made blind.[5]

To those who witnessed the creation of the New Forest and the savage penalties for men who killed royal game, to those who experienced the utter devastation of the north as a reprisal for rebellion, William must have seemed to be possessed of bestial cruelty. Domesday Book and the confiscation of English property gained him a reputation for unbounded avarice.

This more realistic and balanced assessment is found in the *Anglo-Saxon Chronicle*, but only afer the Conqueror had died. If our analysis of the Tapestry's political and biblical imagery is correct, its narrative, usually interpreted as an account seen only from the side of the Normans, emerges as an especially valuable witness to the Anglo-Saxon refusal to be uncritical recipients of a version of history which was defined and controlled by their new masters. In the immediate post-Conquest period, when so little from the English side is recorded, its double vision makes the Tapestry an important source not just for what happened in 1066, but for how people thought about those events. Given the precariousness and delicacy of the artist's position, it is not surprising that he speaks obliquely, using subtlety, ambiguity, wit and irony. By encouraging more than one interpretation of his

images he probably perplexed the Normans; he has certainly kept posterity guessing.

Nor is the balanced outlook we find in the narrative unique to the Tapestry and the *Anglo-Saxon Chronicle*. It will recur in the next century in much more explicit form in the writings of three English-born historians. In the accounts of these historians – William of Malmesbury, Henry of Huntingdon and Orderic Vitalis – we look at events from more than one vantage point. Like all 11th and 12th-century writers on the Conquest they feel that the phenomenal rise to power of William and his Normans is a clear indication of God's hand in history, and that the Norman Conquest is God's punishment on sinful men.[6] From this point of view, then, the Normans are God's chosen people, but from another, they are repressors of English liberty. Orderic says what one never finds, for example, in William of Poitiers: that under William's rule the 'native inhabitants were crushed, imprisoned, disinherited, banished and scattered beyond the limits of their own country'. He tells frequently of how 'the English deeply lamented the loss of their freedom', and 'sighing for their ancient liberties', were 'provoked to rebellion by every sort of repression on the part of the Normans', who 'had crushed the English and were overwhelming them with intolerable oppression'.[7]

If, as we have argued, a Canterbury artist designed the programme of the Bayeux Tapestry, we might imagine that he and his compatriots, perhaps English monks from Christ Church or from the nearby house of St Augustine's that proved so resistant to Normanization, had conflicting feelings similar to those so forcefully expressed by Anglo-Norman historians of the next generation. If so, biblical writings on the Babylonian Captivity that have the singular distinction of allowing the reader to experience a conquest from the perspective of the vanquished ('By the waters of Babylon, there we sat down and wept. . . . For there our captors required of us songs, and our tormentors, mirth') would have had a special resonance for these monks, much as it has had for subject people throughout history. For this archetypal story of conquest and liberation, which includes such resistance heroes as Daniel and Judith, has enabled victims of oppression everywhere – ancient Hebrews, early Christians in the Roman Empire, Calvinist Dutch under Spanish rule, black slaves in America, subject people in eastern Europe today – to preserve a measure of freedom and hope.[8] Perhaps the biblical writings gave hope to Anglo-Saxons in Canterbury that their captivity would soon end and their kingdom be restored.

APPENDIX

The 'Bull's Eye' and the Blinding of Harold

Amidst the strikingly unusual iconography of the oath scene are two reliquaries, the left one of which has been discussed above, but the other raises some interesting questions as well (Plate XXVI). William sits on an elaborate cushioned throne, holding his sword of authority and power. Harold, weaponless and looking rather vulnerable with his outstretched arms, stands between the two carefully distinguished altars, touching the left one with the two forefingers in a prescribed form of swearing in the Middle Ages, while the other hand appears to hover over a small box set on the altar with a stepped base.[1] Given the permanent appearance of this altar one expects the scene to be set in a church, yet it is held out of doors. Also unusual is the number of ocular-shaped objects in this scene – the brooch holding Harold's cloak together, the bosses or jewels at the upper corners of the portable reliquary on the right, and, most noticeably, the mushroom-shaped object on top of that reliquary (Plate XXVI).[2] Set on a short stem is what appears to be a single stone which by its design evokes an eye. What is this object and why is it there?

Contemporaries did not record any details about the relics on which Harold swore his oath to William, but in the next century it is noteworthy that two authors singled out one reliquary by name when describing the oath ceremony. It was called the 'bull's eye' (*oculus bovis* or the *oeil de boeuf*), because, according to one writer, it 'contained in its middle a stone as precious as it was large'.[3] Does the Tapestry depict this particular reliquary?[4] We cannot be certain, but it is not unlikely given the singular detail on top of the shrine on the right, and the later textual tradition.

Is the name significant for the Tapestry's particular version of the story? While it is naturally tempting to make a connection between the appellation 'bull's eye' and Harold's blinding of the right eye by an arrow, we must be cautious. To the modern mind a bull's-eye immediately connotes the centre of a target or a shot that hits the mark, but this usage apparently developed after the early Middle Ages. In pre-modern Europe the term was usually associated with glassmaking, a bubble or boss in a sheet of glass being called a bull's eye, and by extension a piece of convex glass inserted in a lantern or side of a ship.[5] Any association with archery or hitting the target being unlikely, we should probably recognize nothing more in the name than a term like cat's eye or tiger's eye, appellations for the numerous stones which by their colours, luminosity and design evoke the eye.

Although we rule out a link between the term 'bull's eye' and hitting the mark as anachronistic, a linguistic connection is still possible. A poetic association between words and deeds has often been observed in the formation of legends,

not least in those which explain details about violent acts which although famous are sketchily known. The Hebrew legend that Cain killed Abel with a rod is based on the resemblance of *Kain* with the Hebrew word for rod, *kaneh*.[6] It is also well documented in medieval culture that a particular saint's powers were often related not to any deed he or she performed but to a poetic association with the saint's name – hence Saint Vincent was called upon by wine growers to improve the harvest, Saint Genou by sufferers of knee ailments, Saint Expeditious by messengers, and Saint Clair, Santa Lucia and Saint Augustine by those who hoped for brighter eyes or clearer vision.[7] The popularity of Saint Clair in Normandy, and of Saint Augustine, the apostle to the Anglo-Saxons, in England, especially at St Augustine's Abbey, Canterbury, might have a bearing on the invention of the ocular motif.[8]

NOTES

ABBREVIATIONS

Anglo-Saxon Mss E. Temple, *Anglo-Saxon Manuscripts, 1000-1066* [A Survey of Manuscripts Illuminated in the British Isles, 2] (London, 1976)

ASC *Anglo-Saxon Chronicle* [cited by version and year]

Baudri *Les Œuvres Poétiques de Baudri de Bourgueil*, ed. P. Abrahams (Paris, 1926)

Brooks and Walker N.P. Brooks and the late H.E. Walker, 'The Authority and Interpretation of the Bayeux Tapestry,' *Proceedings of the Battle Conference on Anglo-Norman Studies*, I, 1978, ed. R. Allen Brown (Ipswich, 1979), 1-34, 191-99

BL British Library

BN Bibliothèque Nationale

BT *The Bayeux Tapestry*, ed. F.M. Stenton, 2nd ed. (London, 1965)

Carmen *The Carmen de Hastingae Proelio of Guy, bishop of Amiens*, ed. C. Morton and H. Munz (Oxford, 1972)

Eadmer *Eadmer's History of Recent Events in England (Historia novorum in Anglia)*, trans. G. Bosanquet (London, 1964)

EETS Early English Text Society

EHD *English Historical Documents*, I, ed. D. Whitelock (London, 1955); II, ed. D.C. Douglas (London, 1953)

English Romanesque *English Romanesque Art, 1066-1200* [Hayward Gallery exhibition catalogue, ed. G. Zarnecki] (London, 1984)

Golden Age *The Golden Age of Anglo-Saxon Art, 966-1066* [British Museum exhibition catalogue, ed. J. Backhouse, D.H. Turner, L. Webster] (London, 1984)

GR William of Malmesbury, *De gestis regum Anglorum*, ed. W. Stubbs, RS, 1887

OV *The Ecclesiastical History of Orderic Vitalis*, ed. and trans. M. Chibnall, 6 vols. (Oxford, 1969-80)

PL *Patrologiae cursus completus: series latina*, ed. J.-P. Migne (Paris, 1844-64)

Romanesque Mss C. M. Kauffmann, *Romanesque Manuscripts, 1066-1190* [A Survey of Manuscripts Illuminated in the British Isles, 3] (London, 1975)

RS Rolls Series

Vita Ædwardi *The Life of Edward the Confessor*, ed. and trans. F. Barlow (London, 1962)

WJ *Guillaume de Jumièges, Gesta Normannorum Ducum*, ed. J. Marx (Rouen and Paris, 1914)

WP *Guillaume de Poitiers: Histoire de Guillaume le Conquérant*, ed. Raymonde Foreville (Paris, 1952)

Preface. Pages 7-11

1. At least 150 articles and books devoted solely to the Tapestry have appeared since Dom Bernard de Montfaucon first brought the work to the world's attention in 1729 in his *Monuments de la Monarchie Française* (1729-30), vols. I and II. An inventory made in 1935 of all publications on the Tapestry has about 120 entries: M. Marquet de Vasselot, *Bibliographie de la Tapisserie*. Since then at least 40 studies devoted solely to the work have appeared, most of which are listed in O.K. Werckmeister, 'The Political Ideology of the Bayeux Tapestry,' *Studi Medievali*, 3rd series, 17 (1976), 535-95, with select bibliography on 589-95. More recent publications will be cited in the notes below, but two stand out for special notice, an important critical article, Brooks and Walker, and a lavish reproduction, especially fine for details: *The Bayeux Tapestry*, ed. D.M. Wilson (1985). Wilson's brief discussion, which in any case is mainly a synthesis drawn from earlier publications, appeared too late for more than occasional comment in the notes below. A complete bibliography has been promised by Shirley Ann Brown. In addition, it should be kept in mind that there are innumerable discussions of particular points about the Tapestry in works on such a variety of topics as medieval technology, coronation rituals, and the hand of God.

2. E.H. Carr, *What is History?* (New York, 1961), 26.

3. Otto Pächt, *The Rise of Pictorial Narrative in Twelfth-Century England* (Oxford, 1962), 9. Only Brooks and Walker, and R.D. Wissolik, 'The Saxon Statement: Code in the Bayeux Tapestry', *Annuale Medievale*, XIX (1979), 69-97, have raised the question.

4. *Feudal Society* (Chicago, 1961), I, 60.

5. Schapiro's wide-ranging, elegant articles on medieval subjects, a continual source of inspiration on how to link the visual arts to other features of medieval civilization, have been collected in two volumes, *Late Antique, Early Christian, and Medieval Art* (New York, 1979) and *Romanesque Art* (New York, 1977).

Introduction to the Bayeux Tapestry and the Norman conquest of England. Pages 14-26

1. In BT, 25, the measurements given are 70.34 m by 50 cm (230ft 10¼ in by 19¾ in). According to the most recent measurements, Wilson, *Bayeux Tapestry*, 10, citing data taken by the Monuments Historiques, it is 224¼ feet (68.38 m) long, and varying between 18 and 21 inches (45.7 and 53.6 cm) high.
2. Interestingly, a recent comparison of threads on the front with those on the back indicated that the exposed front colours were not dramatically less vibrant than those shielded for at least the last 200 years from light and dirt by a woollen backing.
3. For example, the horses carrying William's messengers in Plates XI and XII.
4. A single directive force seems evident from the uniform spirit and appearance of the whole, as well as from the point of view we find in the iconography, but certain differences in design suggest more than one artistic hand. Compare, for example, the rather crude horses and people in Plates XLV-XLVI with those in Plate XI. That different workshops were used for embroidering is suggested by the fact that the needlework in some scenes is considerably finer than in others, e.g., the death of Edward/accession of Harold scenes are much more skilfully done than other places, a point apparent from the back.
5. All references to embroiderers in Anglo-Saxon England collected by A.G.I. Christie, *English Medieval Embroidery* (Oxford, 1938), Appendix I, are to women.
6. According to S. Bertrand, *La Tapisserie de Bayeux* (La Pierre-qui-Vire, 1966), 24-25, the first two pieces are each over 44¼ feet (13.5 m) long, but each of the following five are shorter, varying from 21¾ to 27¼ feet (6.6 m to 8.35 m). Since the last piece, damaged and incomplete, now measures 17¼ feet (5.25 m) it appears likely that it originally would have been 4½ to 9¾ feet (1.35 to 3 m) longer, if it was ever completed.
7. Ibid., 24-25, the seven seams, difficult to discern in reproduction, are located in the following places: Plate XV, right; Plate XXX, between *Et* and *hic*; Plate XXXIX, left; Plate XLVII, after *ministri*; Plate LIII, before *ad prelium*; Plate LX between *Anglorum* and *exercitum*, Plate LXVIII between *Hic* and *Franci*.
8. When the Nazis occupied France they obviously delighted in the Tapestry's depiction of a successful invasion of England and may have studied it extensively. See René Dubosq, *La Tapisserie de Bayeux: dix années tragiques de sa longue histoire* (Caen, 1951).
9. The restorations of 1842 were severely critized as fraudulent in intent by C. Dawson, *The 'Restorations' of the Bayeux Tapestry* (London, 1907), but for a defence and comment on Dawson's own shaky reputation, ironically enough, as a perpetrator of frauds, see Brooks and Walker, 26. A recent critic of the 'death of

Harold' restorations is C. Gibbs-Smith, *The Bayeux Tapestry* (London, 1973), 15.
10. Figures cited in F. Fowke, *The Bayeux Tapestry* (London, 1913), 20, from J. Bruce, *The Bayeux Tapestry* (London, 1856), 13, n. a.
11. W. Hollister, *The Making of England* (Boston, 1966), 78.
12. F. Stenton, *Anglo-Saxon England* (Oxford, 1943), 564.
13. ASC, 'E' in EHD, II, 163.
14. This Norman princess was married first to King Ethelred II (reigned 979-1016), and then after his death to the Danish king, Canute (1016-35). By the first marriage she had Edward the Confessor (1042-66) and by the second, Harthacnut (1040-42).
15. See Chapter VIII.
16. Unlike the reversal of order in the death of Edward scenes, there appears to be no major point that the artist was trying to make. Perhaps he merely wished to dramatize the distance from William's court to Guy's. Perhaps the Tapestry was designed for a specific room where it would have been effective to have the narrative converge at a point, say a corner.
17. The Ælfgyva scene has remained one of the most puzzling in the Tapestry, in large part because Ælfgyva is a not uncommon name in the period. For a review of who it might be see E.A. Freeman, *The History of the Norman Conquest of England* (Oxford, 1869), 6 vols., III, 696-98. The most recent plausible solutions are those by J. Bard McNulty, 'The Lady Aelfgyva in the Bayeux Tapestry', *Speculum* (1980), 659-68, and M.W. Campbell, 'Aelfgyva: The Mysterious Lady of the Bayeux Tapestry', *Annales de Normandie*, 17 (1984), 127-45.
18. The delightful phrase is in Brooks and Walker, 3.
19. René Lepelley, 'Contribution à l'étude des inscriptions de la Tapisserie de Bayeux', *Annales de Normandie*, 14 (1964), 313-21.
20. O. Pächt, *The Rise of Pictorial Narrative*, 10.
21. According to the fullest early account, Harold swore of his own free will that he would be the duke's representative at Edward's court, that he would do everything possible to assure William the crown, and that he would hand over to William's knights a castle at Dover, as well as other castles when the duke wished them. WP, 104. Later writers speak of a betrothal by William of his daughter to Harold. See R. Allen Brown, *The Normans and the Norman Conquest* (New York, 1968), 129-31.
22. See below, Chapter VIII.
23. Other dramatic details of the crossing are also omitted in the Tapestry; for example, that while the fleet sailed through that memorable night William's ship got separated from his armada. Finding themselves alone in mid-Channel at dawn, the duke cast care aside and called for his breakfast which he proceeded to eat along with some wine, 'as if in his chamber back home'. WP, 164.
24. ASC, 'D' 1066 in EHD, II.
25. The description is William of Poitiers', WP, 194; also

quoted in Brown, *Normans and the Norman Conquest*, 173, n. 152.

26. See Bertrand in BT, 89ff for the history of the Tapestry, where, for example, we learn that it was used to cover a munitions cart during the French Revolution, and was kept on a drum. Also, Dubosq, *La Tapisserie de Bayeux: dix années tragiques de sa longue histoire*, op. cit., for an illustration of the contraption used by the Nazis for viewing it. If an end was lost, it must have happened before the drawings were done for Montfaucon in 1728.

27. WP, 208; Stenton, *Anglo-Saxon England* (3rd ed., 1971), 596.

28. Much of the preceding assessment of the impact of the Norman Conquest derives from the fine short article by R.H.C. Davis, 'The Norman Conquest', *History* (1966), 51, 279-86, especially the first paragraph. Many fuller summations have appeared over the years; this author has profited most from those by Sir Frank Stenton, *Anglo-Saxon England* and R. Allen Brown, *The Normans and the Norman Conquest*, each of which has a special slant indicated by the emphasis in their respective titles. Perhaps the best short discussion of the introduction of the castle in Norman times is R. Allen Brown, *English Castles* (London, 1954), chs. 1, 2.

CHAPTER I: *The Patron. Pages 28-36*

1. Simone Bertrand in BT, 88. The full document is reproduced in her *La Tapisserie de Bayeux*, op. cit., 16-19.
2. Montfaucon is the first to mention it: 'L'opinion commune à Bayeux est, que ce fut la Reine Mathilde femme de Guillaume le Conquérant, qui la fit faire (savoir, la Tapisserie). Cette opinion qui passe pour une tradition dans le payis, n'a rien qui de fort vraisemblable.' *Monuments de la Monarchie Française* (1730), II, 2.
3. The words are those of Sir Joseph Aylosse, vice-president of the Society of Antiquaries, *Archaeologia*, III, 186; quoted in B. Corney, *Researches and Conjectures on the Bayeux Tapestry* (London, 2nd rev. ed., 1838). Emphasis added. Note that there are six unsupportable assertions about the origin of the Tapestry in this one sentence.
4. The title of an early 20th-century book by A. Levé shows the uneasy relationship between the two: *La Tapisserie de la Reine Mathilde, dite la Tapisserie de Bayeux* (Paris, 1919).
5. Bertrand, in BT, 91-92.
6. The director of the Musée Napoléon, M. Denon, prepared a guide entitled *Notice Historique sur la Tapisserie brodée de la Reine Mathilde, Épouse de Guillaume-le-Conquérant* (Paris, 1803).
7. Bertrand in BT, 92.
8. Abbé G. de la Rue, 'Sur la tapisserie de Bayeux', *Rapport Général sur Travaux, Académie des Sciences, Arts, et Belles-Lettres de Caen*, II (1811), never doubting that

the tradition which ascribed the work to a Matilda must have had some basis, reasoned that if it had been done by the Conqueror's wife it would have been destroyed in the Bayeux Cathedral fire of 1106. Therefore, he suggested the Empress Matilda, though he was not the first; Lord Lyttleton, followed by Hume had done so.

9. In unpublished lectures read to the Mechanics Institute of Lewes, dated approximately 1860 and presently in the Mount Holyoke College Library, Mark Anthony Lower says that 'The Tapestry contains some indelicacies deemed incompatible with the idea that a virtuous and dignified lady like Queen Matilda was the originator of the work.'
10. H.F. Delauney, *Origine de la Tapisserie de Bayeux, Prouvée par Elle-Même* (Caen, 1824).
11. See interesting sources in M. de Boüard, *Documents de l'Histoire de la Normandie* (Toulouse, 1972), 134ff. In the words of an early 12th-century observer, 'They [the Normans] grow their hair long like girls, ... walking with delicate steps and mincing gait.' Eadmer, 48.
12. A. Carel, *Histoire de la Barbe et des Cheveux en Normandie* (Rouen, 1859), for which reference I am indebted to Connor Hartnett; also C.R. Dodwell, *Anglo-Saxon Art* (Ithaca, 1982), 325, n. 49.
13. William of Poitiers speaks of him briefly on the expedition, WP, 182. William of Jumièges, the *Carmen*, Baudri and Orderic Vitalis assign him no role of importance comparable with that in the Tapestry.
14. WP, 102-104; OV, II, 134-36.
15. Bolton Corney, *Researches and Conjectures on the Bayeux Tapestry*, op. cit., 20-21. Wadard held lands in various parts of Kent, Oxfordshire and Lincolnshire from Odo. Domesday Book (London, 1783), I, f. 1r, 6r, 77r, 155v, 156v, 342r, 342v, 343r, 343v. Vital got land from Odo in Kent, Domesday 7r, 10r, and was a witness to a charter for Odo in 1072. Another minor figure in the Tapestry, Turold, is mentioned as Odo's tenant in a document of 1078-79, BL, Cotton MS Aug. II 36 (D.C. Douglas, 'Odo, Lanfranc, and The Domesday Survey', in *Historical Essays in Honour of James Tait* (Manchester, 1933), ed. J.G. Edwards, V.H. Galbraith, E.F. Jacob, 47-57). For recent recapitulations of the evidence, see Brooks and Walker, 192-93, n. 22, and Werckmeister, 'Political Ideology', op. cit., 580, nn. 240-42. Because Corney's theories about the date of the Tapestry proved invalid, his keen observations have seldom been appreciated, Werckmeister being one of the few to acknowledge Corney's work.
16. Werckmeister, 'Political Ideology', 579-89. Brooks and Walker reject the hypothesis saying that, 'Nothing suggests that Turold, Wadard and Vital were such important lords that they could commission so magnificent and vast a work. Moreover to attribute to the imprisoned bishop such an exaggeratedly prominent role in the Norman conquest would but have added another to the list of Odo's crimes.' (Brooks and Walker, 18).

17. The fullest and most valuable study is David Bates, 'Odo, Bishop of Bayeux, 1049-1097', (Ph.D. diss., Exeter University, 1970; hereafter referred to as Bates, 'Odo', diss. Many results are summarized in D. Bates, 'The Character and Career of Odo, Bishop of Bayeux (1049/50-1097)', *Speculum*, L, no. 1 (1975), 1-20. Also S.E. Gleason, *An Ecclesiastical Barony of the Middle Ages: The Bishopric of Bayeux, 1066-1204* (Cambridge, 1036), 8-17; V. Bourrienne, *Odon de Conteville, Evêque de Bayeux* (Evreux, 1900).

18. Now see D. Bates, *Normandy before 1066* (London, 1982), ch. V.

19. D.C. Douglas, 'The Norman Episcopate before the Norman Conquest', *Cambridge Historical Journal*, XIII (1057), 101-15, esp. 103-104, on the youth of some appointments, on the purchase of bishoprics, and on the children of these bishops.

20. By 1066, however, such behaviour was frowned upon, as was keeping a mistress. Bates, *Normandy before 1066*, ch. V, esp. 226-28.

21. For Saint-Vigor, see OV, IV, 117 and n. 3.

22. *Le Roman de Rou de Wace*, ed. A.J. Holden (Paris, 1970-73), l. 6186; WP, 183.

23. ASC 'D' 1066, in EHD, II, 146.

24. Much of Odo's rule was naturally of a routine nature, 'setting judicial investigations in motion by use of the king's authority, confirming land transactions which needed the king's assent, and transmitting the king's commands, received from abroad.' Stenton, *Anglo-Saxon England* (3rd ed., 1971), 610. According to the Anglo-Saxon Chronicler and Goscelin of St-Bertin, Odo acted as the king's *alter ego*, ruling England whenever the king was in Normandy. ASC 'E' 1087, in EHD, II, 164; Bates, 'Odo', diss., ch. 3; Bates, 'The Character and Career of Odo', 7, n. 33.

25. ASC 'E' 1067, in EHD, II, 146.

26. Orderic Vitalis says that the viceregents were so swollen with pride that they would not hear the reasonable pleas of the English or give them impartial judgement, and abused any Saxon who tried to accuse a Norman of plunder and rape. OV, II, 203.

27. Bates, 'Odo,' diss., 73, citing the slightly later account of Simeon of Durham, *Symeonis Monachi Opera Omnia*, ed., T. Arnold, RS, 1882, I, 116-18.

28. Bates, 'The Character and Career of Odo', 10; *Camb. Med. Hist.*, V, 507-11.

29. F.R.H. Du Boulay, *The Lordship of Canterbury: An Essay on Medieval Society* (New York, 1966), 106-107. Bates, 'Odo', diss., 33, thinks that 184 is too low a number. Also *Victoria County History, Kent*, III, 188.

30. For some of their holdings see Du Boulay, *Lordship*, 54, 60, 357, 380, 381, 384, 388; Bates, 'Character and Career of Odo', 11; W. Urry, 'Normans in Canterbury', *Annales de Normandie*, II (1958), 119-38; and above n. 15.

31. Turold had seized Preston from Christ Church, held it as a fief of Odo's until it was returned at Penenden Heath. Du Boulay, *Lordship*, 37-39; Brooks and Walker, 193, n. 22.

32. EHD, II, 449-51; J. Le Patourel, 'The Reports of the Trial on Penenden Heath', in *Studies in Medieval History Presented to Frederick Maurice Powicke*, ed. R.W. Hunt, W.A. Pantin, R.W. Southern (Oxford, 1948), 15-26; for some interesting contrasts between the lawyer-monk Lanfranc and the prince-bishop Odo, see M. Gibson, *Lanfranc of Bec* (Oxford, 1978).

33. Report of the trial in EHD, II, 449-51, also literature cited there. Included were claims of the cathedral church to Delting and Preston, and those of the church of Rochester to Stoke and Denton, near Rochester, all from Odo. Some of Odo's tenants also had to return spoils in their possession. Bates, 'Character and Career of Odo', 9. According to Du Boulay, if not all the land was retrieved, in following years 'the matter did not rest there, for the documents make it clear that the claim was pursued throughout the Conqueror's reign against the resistance of Odo and others, and was only slowly brought to its more or less successful end'. Du Boulay, *Lordship*, 37-41.

34. OV, IV, 117. A poem by Serlo, a canon of the cathedral of Bayeux in the early 12th century, speaks of the splendid buildings he erected in the city. T.H. Wright, ed., *Minor Anglo-Latin Satirical Poets and Epigrammatists of the Twelfth Century*, RS, 1872, II, 242-43.

35. WP, 224-26; also quoted in Dodwell, *Anglo-Saxon Art*, 217 and 320, along with other evidence.

36. EHD, II, 160.

37. OV, IV, 40-44; William of Malmesbury, GR, II, 360-61; *Liber Monasterii de Hyda*, ed. E. Edwards (RS, 1866), 296. Chibnall has a valuable discussion of the problems in her introd. to vol. IV of OV, xxvii-xxx.

38. William of Malmesbury, GR, II, 334. Similar stories are in the Hyde Chronicle, *Liber Monasterii de Hyda*, ed. E. Edwards (RS, 1886), 296, and OV, IV, 39-41.

39. Stenton, *Anglo-Saxon England*, 616, n. 3; Lanfranc would later make the same distinction at the trial of William of St Carileff, bishop of Durham; cf. Gibson, *Lanfranc of Bec*, 160-61.

40. Gregory's true feelings are open to interpretation, since he sent only a sorrowful rebuke to Lanfranc, 'You have acted unworthily, putting worldly considerations before the law of God and having insufficient regard for the honour due to a priest.' As Lanfranc's recent biographer says, 'Gregory could do better than that.' Gibson, *Lanfranc of Bec*, 136, where the pope's letter is quoted; also Chibnall, OV, IV, xxvii-xxx.

41. WP, 240-42, cf. 262-66, 134-36, 182. Here I follow R.H.C. Davis, 'William of Poitiers and his History of William the Conqueror', *The Writing of History in the Middle Ages: Essays Presented to Richard William Southern*, ed. R.H.C. Davis and J.M. Wallace-Hadrill (Oxford, 1981), 71-100, esp. 90-93, who makes an interesting suggestion that William of Poitiers, often identified as the Conqueror's chaplain, was possibly a protégé of the bishop of Bayeux.

42. ASC, 'D' 1066, in EHD, II, 146.

43. OV, IV, 116, n. 2.
44. OV, IV, 114-19.
45. OV, IV, 264-66.
46. Bates, 'Character and Career of Odo', 12-13.
47. Ibid., 12.
48. A visitor to the cathedral, Ralph Tortaire, was impressed by the splendour of its furnishings, and like many others, marvelled at the great candelabrum (*corona*) which hung at the crossing of the nave and transept. Made of silver, with the upper part gold, it was so huge that it almost touched the walls of the cathedral. Bates, 'Odo', diss., 155; also Bates, 'Character and Career', 12.
49. Bates, 'Character and Career', 19.

CHAPTER II: *Provenance: Normandy or England? Pages 37-50*

1. My thanks to Prof. Charles T. Wood for bringing this cartoon to my attention.
2. Brooks and Walker, 9. Review of this historiographical tradition can be found in Shirley Ann Brown, *The Bayeux Tapestry: Its Purpose and Dating*, Ph.D. diss., Cornell University, 1977, 4ff, and in F.R. Fowke, *The Bayeux Tapestry, a History and Decription* (London, 1875), Appendix II.
3. William of Poitiers gives a poor account of him, WP, 202. See introd. to *Carmen*, xxiiff for Eustace and the writers on the Conquest.
4. See below, Chapter VI.
5. M. Rickert, *Painting in Britain: The Middle Ages* (2nd ed., Harmondsworth, 1965), 136-39.
6. On remaining works see A.G.I. Christie, *English Medieval Embroidery*.
7. Many records attest to Edith, Harold's sister and the Confessor's queen, being an expert embroideress; the garments worn by her husband at great feasts were 'interwoven with gold which the queen had most sumptuously embellished'. Quoted from William of Malmesbury in Dodwell, *Anglo-Saxon Art*, 70. It is intriguing that within an embroidered work such as the Tapestry we see depictions of embroidered cloth: e.g., the Confessor's garment at the opening and the richly decorated covering on his bier. The Anglo-Saxon proverb that 'a woman's place is at her embroidery' indicates that most households practised the ordinary skills of needlework. Quoted ibid., 72. On Goscelin and William of Poitiers see Dodwell, *Anglo-Saxon Art*, 44-45. The whole of ch. III, 'Artists and Craftsmen in Anglo-Saxon England', is filled with illuminating information.
8. One work sent abroad by Matilda was a chasuble and cope for Saint Evroul. Ibid., 75, 78; 182, 227 and n. 100.
9. Killed fighting the Vikings in 991, Brythnoth was an earl who embodied the Germanic heroic ethic of absolute and overriding loyalty to one's lord and to fame, even in the face of defeat, as well as being a martyr in the then almost continual battles against pagan invaders. For the Battle of Maldon see the ASC 991, EHD, II, 213; for the poem, Michael Alexander, *Earliest English Poems* (Harmondsworth, 1966), 111-23. For the hanging see *Liber Eliensis*, ed. E.O. Blake (London, 1962), also O. Lehmann-Brockhaus, *Lateinische Schriftquellen zur Kunst in England, Wales, und Schottland vom Jahre 901 bus zum Jahre 1307* (Munich, 1935), I, 415, no. 1534, and the recent critical discussion in Dodwell, *Anglo-Saxon Art*, 134-36.
10. R.S. Loomis, 'The Origin and Date of the Bayeux Tapestry', *Art Bulletin*, VI (1937), 3-7; M. Förster, 'Zur Geschichte des Reliquienkultus in Altengland', *Sitzungsberichte der Bayerischen Akademie der Wissenschatften* (Philosophisch-historische Abteilung, Jarhgang 1943, Hft. 8), 16-19, especially the material in n. 6.
11. Regarding the question of whether this spelling is original, the author's examination of the back of the Tapestry revealed that the barred D is stitched in original wool. It is not clear whether Gyrth was originally spelt with a V or a Y, the tail of the letter now appearing in later wool.
12. Eadwardus is found in Plates XXIX, XXX, and Willelm, or variations such as Wilelm (2 times), Willem (3 times) in Plates X-XI, XII, XVIII, XXII, XXIV, XXIV-XXV, XXXIV, XXXIX, XLVIII, L, LVI, LVII, LXVIII, while Wilgelm appears in Plates XIV, XVI. More recently, R. Lepelley has noted other insular characteristics in the spelling, for example in the unique rendering of BAGIAS for Bayeux, 'Contribution à l'Etude des Inscriptions de la Tapisserie de Bayeux', *Annales de Normandie*, 14 (1964), 313-21.
13. Wormald in BT, 32; for this manuscript and its context *Anglo-Saxon Mss*, no. 49; R. Stettiner, *Die illustrierten Prudentius-Handschriften* (Berlin, 1895-1905); H. Woodruff, 'The Illustrated Manuscripts of Prudentius', *Art Studies*, 1929, 33ff.
14. BT, 32, figs. 16-17, and Wormald's chapter in BT for additional examples.
15. The artists of the Ælfric Hexateuch were evidently quite fond of this leg-crossing pattern. C.R. Dodwell, P. Clemoes, *The Old English Illustrated Hexateuch*, Early English Manuscripts in Facsimile, XVIII (1974), fs. 9v, 10r, 31r, and 34r. For more on patterning and the Ælfric Hexateuch see below Chapter IV, 'The Englishness of the Tapestry'.
16. The servants and other similarities were noted by C.R. Dodwell, 'L'Originalité Iconographique de Plusieurs Illustrations Anglo-Saxonnes de l'Ancien Testament', *Cahiers de Civilization Médiévale*, XIV(1971), 319-28. Note, however, that Dodwell believes, 325ff, that these correspondences suggest that both artists were keenly observant of the world around them rather than that the Tapestry artist was indebted to an earlier Canterbury manuscript tradition. In many cases this is undoubtedly true, but in this instance, as well as the cases of the bird slinger and the escape artist, the

similarities appear much too close to be independent representations of 11th-century life.

17. This, the following, and other less certain connections between the Tapestry and the English tradition were made by Vivian Mann, 'Architectural Conventions in the Bayeux Tapestry', *Marsyas*, 17 (1975), 59-65.

18. What may be a clue to the fact that the Tapestry artist was familiar with an English tradition of handling (or mishandling) this distinctively classical form is indicated by the anomalous placing of roof tiles within the pediment. This same misunderstanding of an antique form is found in the so-called Caedmon Genesis, Oxford, Bodleian Library, MS Junius 11, p. 53, as pointed out by Vivian Mann, op. cit. However, the connection she makes, p. 62 and fig. 12, between Psalm 57 from the Anglo-Saxon copy of the Utrecht Psalter (BL, Harley MS 603, f. 31) and the Tapestry's scene cannot stand since that particular portion of the manuscript post-dates the Tapestry.

19. I am grateful to Miss Jennifer Kiff for bringing this psalter figure to my attention. Its significance will be discussed later in Chapter XI, on the death of Harold.

20. St Augustine's Gospels, Corpus Christi College, MS 286. L.H. Loomis, 'The Table of the Last Supper in Religious and Secular Iconography', *Art Studies* (*American Journal of Archaeology*), V (1927), 71-90: 'As for the round table of Bishop Odo's feast it seems clear that art and not military actuality provided its model' (p.77). Also Brooks and Walker, 15-16.

21. Brooks and Walker, 15-16, are the first to make the important linkage between St Augustine's Gospels residing at this monastic house and the provenance of the Tapestry, though they do not note the similarity of the servant to the figure in the Ælfric Hexateuch. Instead, they suggest that the servant is an adaptation of a Judas figure from other Last Supper compositions.

22. D. Wilson, *The Bayeux Tapestry*, 212, has recently questioned the association with Canterbury, while proposing Winchester as an alternative. Note that in stating the case for Canterbury he neglects to mention the links between Canterbury and Turold, Wadard and Vital, and that, as has been pointed out by others, and as we shall see later in Chapter VIII, there are connections between the Tapestry's version of events and chronicles connected with Canterbury. The case for Winchester rests essentially on certain stylistic similarities between the Tapestry and one fragment of a Winchester sculptured frieze of uncertain date and significance.

23. Important texts arrived with the conquerors. The first canon law collection in Canterbury came from Normandy, and at the end is a note: 'I Lanfranc the archbishop purchased this book from the monastery of Bec, had it brought to England and gave it to Christ Church.' Gibson, *Lanfranc*, 179-80.

24. Many contain no decoration of significance. Thus, of the ten or eleven books surviving from Bec and Caen, only one contains illustrations and was written twenty or thirty years after the Conquest. C.R. Dodwell, *The Canterbury School of Illumination* (Cambridge, 1957), 16. Other houses produced more fully illustrated bibles, for example, see the manuscripts treated by J.J.G. Alexander, *Norman Illumination at Mont St Michel, 966-1100* (Oxford, 1970).

25. For how Norman pre-Conquest art shows signs of English influence see Dodwell, *Canterbury School*, 8ff. One importance of this phenomenon is that when the Normans came to England they brought, in addition to their own novel ideas, an already formed taste for insular art, thereby helping to ensure its continuity after 1066, as first observed by Wormald.

26. This is a book containing the same patristic text as the one embellished at Christ Church noted above, Plate 15, with the letter B containing David and the entertainers.

27. See J.J.G. Alexander, *The Decorated Letter* (New York, 1978).

28. O. Pächt, *Rise of Pictorial Narrative*, 12-13. For attitudes towards space see Pächt, 'The pre-Carolingian Roots of Early Romanesque Art', *Studies in Western Art. Romanesque and Gothic Art. Acts of the 20th International Congress of the History of Art*, ed. M. Meiss *et al*, (Princeton, 1963), I, 67-75. In addition, Alexander, *The Decorated Letter*, 15-16, where one should also compare an Anglo-Saxon historiated letter, David slaying Goliath in the Arundel Psalter, ibid., pl. 16. Also, C.R. Dodwell, *Painting in Europe*, 800-1200 (Harmondsworth, 1971), 85-89.

29. C.M. Kauffmann, *Romanesque Mss*, 1066-1190 (1975), 13.

30. For references to the evidence see Brooks and Walker, 192, n. 22.

CHAPTER III: *Canterbury: from Anglo-Saxon to Norman. Pages 51-59*

1. For example, the Prudentius MS, BL, Cotton MS Cleopatra C.VIII, with the man carrying a coil of rope, was attributed to St Augustine's by Brooks and Walker, p. 13, but its provenance may be Christ Church. *Anglo-Saxon Mss*, no. 49, and *Golden Age*, no. 45.

2. On more general stylistic grounds, it would seem that the greater continuity of Anglo-Saxon art at St Augustine's would argue in favour of the master designer's being associated with that house, but, again, we must keep in mind that the old style did not die at Christ Church with the coming of the Normans.

3. Dodwell, *Canterbury School*, 6-8, 26; N. Ker, *English Manuscripts in the Century after the Norman Conquest* (Oxford, 1960), 22, 26, 29.

4. Several of the abbey's manuscripts, such as the important Ælfric Hexateuch that was written and illustrated there in the mid-11th century, show English

glosses written in the next century when the native language was becoming unintelligible elsewhere to learned men.

5. Since we do not have other examples of narrative manuscript art in the fifty years after the Conquest, a gap which may be caused by the loss of books that contained such narrative pictures or may be due to the fact that they were not then being made, this manuscript is particularly valuable.

6. Note that in the Tapestry lances and a mace are also depicted realistically as they are hurled through the air, Plate LXI.

7. Discussion of this important example of post-Conquest narration is found in Dodwell, *Canterbury School*, 31-32, pl. 19b; *English Romanesque*, cat. no. 14, illustrated; Rickert, *Painting in Britain*, 50-51, pl. 46a, was the first to note connections with the Tapestry. Other examples of Anglo-Saxon figure style continuing at St Augustine's after the Conquest are given in Dodwell, *Canterbury School*, 26-31.

8. Brooks and Walker, 192, n. 22, give the references. It should be noted, however, that Vital was also a tenant of the archbishop.

9. For example, in 1074 Odo gave up his claim to Plumstede: 'I, Odo, bishop of Bayeux and Earl of Kent, make donation to SS. Peter and Paul and also to St. Augustine the apostle of the English of this property which has been been subject to me.' *William Thorne's Chronicle of Saint Augustine's Abbey*, trans. A.H. Davis (Oxford, 1934), 52.

10. The arguments in favour of St Augustine's over Christ Church were first advanced by Brooks and Walker, 17, to which this discussion is greatly indebted.

11. N. Brooks, *The Early History of the Church of Canterbury: Christ Church from 597 to 1066* (Leicester, 1984). This is not the place to recount the extension of Canterbury's control over English church life, which was not always uncontested, its growing reputation as an intellectual centre, and its formation as a great medieval lordship, for which now see Brooks.

12. Not all church leaders in 1066 were English born. For the foreign bishops – Herman, Giso, Leofric, etc. – appointed by Edward the Confessor, see F. Barlow, *The English Church*, 1000-1066 (2nd ed., London, 1979), 81-85.

13. D. Knowles, *The Monastic Order in England* (Cambridge, 1950), 111.

14. *The Letters of Lanfranc, Archbishop of Canterbury*, ed. H. Clover and M. Gibson (Oxford, 1979); Gibson, *Lanfranc*.

15. GR, II, 306 (Book III).

16. R. Willis, *The Architectural History of Canterbury Cathedral* (1845); R. Southern, *Saint Anselm and his Biographer* (Cambridge, 1966), 260-67. Willis was the first to note that the dimensions are the same at Canterbury and St Etienne to within a foot: the nave 187 feet (56.99 m) long and 72 feet (21.94 m) wide, the transept 127 feet (38.71 m) across. It is important to recall that Lanfranc's example of providing more spacious and more regularly ordered monastic buildings, including a wall around the whole complex, was followed elsewhere in England, at St Albans, Bury, Rochester, Gloucester, Evesham, Ely and St Augustine's Abbey, Canterbury. A.W. Clapham, *English Romanesque Architecture after the Conquest* (Oxford, 1934); R. Gem, 'The Significance of the 11th-century Rebuilding of Christ Church and St Augustine's, Canterbury, in the Development of Romanesque Architecture', *British Archaeological Association Conference Transactions*, V (1979): 'Medieval Art and Architecture at Canterbury before 1220', 1-19.

17. 'At no house was the break with the past so complete as at Christ Church, and the organizing genius of Lanfranc, together with his desire that the metropolitan church should set a standard of life and luxury, prompted him to draw up constitutions. . .' for all of England. Knowles, *Monastic Order*, 122-24. See also Gibson, *Lanfranc*, ch. VII.

18. *Memorials of St Dunstan*, ed. W. Stubbs (RS, 1874), 237-38, quoted and discussed in Southern, *Saint Anselm and his Biographer*, 247.

19. In this section I follow the precise and stimulating discussion in Southern, *Saint Anselm and his Biographer*, 241-46. See also, Gibson, *Lanfranc*, 177-82. Note that while the Anglo-Saxon collection is indicative of being out of touch with the newest currents of thought, there are features which mark English monastic life as unique in European culture of the time. There is the astonishing extent to which the vernacular had penetrated an intellectual life carried on elsewhere only in Latin: sixteen of the thirty-seven volumes attributable to pre-Conquest Christ Church are either in Old English or have Old English glosses, i.e., translations or commentaries, to a Latin text.

20. Southern, *St Anselm and his Biographer*, 267-68. Also see A. Lawrence, 'Manuscripts of Early Anglo-Norman Canterbury', in *Brit. Archaeol. Assoc. Conf. Trans.*, V (1979), 101-11, plus plates; Dodwell, *The Canterbury School of Illumination*, 14ff. To remedy some of the glaring gaps in English collections and provide accurate, up-to-date texts, Lanfranc only gradually established a scriptorium in Canterbury equipped to make books to Norman standards. At first he brought manuscripts with him or requested that they be sent. The most important addition made by the Normans to the content of English libraries was to fill in the many gaps in the collection of patristic writings: Augustine, Ambrose, Jerome, Gregory the Great.

21. Southern, *St Anselm and his Biographer*, 246-47. During Lanfranc's years in Canterbury the number of inmates rose to 60 and then to about 100, not all of the newcomers being Norman. Ibid., 255 and Cecily Clark, 'Peoples and Languages in post-Conquest Canterbury', *Journal of Medieval History*, II (1976), 5.

22. *Memorials of St Dunstan*, 149-51, 234-38; Southern, *St*

Anselm and his Biographer, 248; Clark, 'Peoples and Languages in post-Conquest Canterbury', op. cit., 4. Apparently after this traumatic event, things went more smoothly between the two factions.

23. Knowles, *Monastic Order*, 116-17; the notes provide some evidence, for example, a phrase from a letter of Lanfranc's to Pope Alexander II: '*excusatio incognitae linguae gentiumque barbarum*'.

24. Knowles, *Monastic Order*, 118-19.

25. Ibid; Barlow, *English Church*, 1066-1154, 191.

26. Also written Elphege. ASC, 1012 and 1023, EHD, I, 222, 229-30; also *Chronicle of Thietmar of Merseburg*, EHD, I, 318-21.

27. Ælfheah appears among those of the second rank. Writers were also commissioned to fill the gaps in Canterbury hagiography by writing Latin lives of pre-Conquest English saints. Ultimate recognition of the English past and a greater measure of reconciliation between the two peoples had to wait, however, until the next century, when, in an extraordinarily symbolic action, the altars of two Anglo-Saxon saints, Dunstan and Ælfheah, were placed on either side of the high altar in Canterbury Cathedral and their effigies stationed on either side of a statue of Christ in glory. Southern, *St Anselm and his Biographer*, 248-52; also 260-67, 274-86.

28. Although it has been demolished, the building campaign was described by Goscelin, a Fleming who came to reside at St Augustine's, 'therefore, when everything had been removed from the old church. . . abbot Scotland pulled down the church itself which now constituted a danger and appeared to be on the point of falling down and erected new buildings right up to the porch and the site of the translation of the most excellent Augustine and his companions.' Text and translation in Humphrey Woods, 'The Completion of the Abbey Church of Saint Peter, Saint Paul and Saint Augustine, by Abbots Wido and Hugh of Fleury', *Brit. Archaeol. Assoc. Conf. Trans.*, V (1979), 120. Note that the abbot's name sometimes appears as Scolland.

29. In addition to the usual patristic works, they reveal that Scotland seemed to have an interest in historical and medical subjects. J. Alexander identified some books as ones which Scotland appears to have brought with him, a *Historia Langobardorum*, a chronicle of the dukes of Normandy and various other chronicles. Alexander, *Norman Illumination at Mont St Michel*, 28; Lawrence, 'Manuscripts of Early Anglo-Norman Canterbury', *Brit. Archaeol. Assoc. Conf. Trans.*, V (1979), 101.

30. Gibson, *Lanfranc*, 167-68.

31. Knowles, *Monastic Order*, 102 and Appendix VI for a tabulation of the wealth recorded in Domesday of all monasteries and nunneries.

32. *William Thorne's Chronicle of St Augustine's Abbey*, 47-50. Unfortunately Thorne, our only source for his activities, is late and sometimes incorrect, but the author, a monk of St Augustine's, was active around 1400 and used earlier sources now lost. There are variant spellings of the rebellious abbot's name: Elsin, Aelfsige, Æthelsige. There is uncertainty about his later career, but he may have gone to Denmark. Other abbots who resisted were Aelfwig, abbot of the New Minster in Winchester, who was in the field at Hastings and died there, and Leofric of Peterborough who was also with Harold. Knowles, *Monastic Order*, 103-104; F. Barlow, *The English Church*, 1066-1154 (London, 1979), 195.

33. BL, Cotton MS Vitellius C.XII(i), quoted in *Golden Age*, 198. For the importance of this manuscript as evidence for the continuity of Anglo-Saxon art after the Conquest see F. Wormald, *English Drawings of the Tenth and Eleventh Centuries* (London, 1952), 55-56, pl. 37, and Rickert, *Painting in Britain*, 49-50, pl. 46c.

34. Our main source for the whole affair is the *Acts of Lanfranc*, a record in Latin appended to the 'A' version of the *Anglo-Saxon Chronicle*, and printed by J. Earle and C. Plumner, *Two of the Saxon Chronicles Parallel*, 2 vols. (Oxford, 1892, 1899), I, 287-92, and also in EHD, II, 631-35.

35. Knowles, *Monastic Order*, 115, thinks it was 'racial feeling'; Gervase of Canterbury, a 12th-century chronicler, thinks it a wish to hold a free abbatial election. *The Historical Works of Gervaise of Canterbury*, ed. W. Stubbs (London, 1879), I, 71, cited in C. Clark, 'Peoples and Languages in post-Conquest Canterbury', op. cit., 8.

CHAPTER IV: *The Englishness of the Tapestry: Style. Pages 60-81*

1. The expression 'Golden Age of Anglo-Saxon Art' is borrowed from the title of an exhibition held at the British Museum in 1984-85, the catalogue for which, *Golden Age*, contains valuable information and illustrations. As no English embroidery remains from this period, we are perforce required to understand the Tapestry's place in the English tradition by relating its pictorial style to the related arts of painting and drawing.

2. On the role of the psalter in medieval devotion see 'The Rule of St Benedict', ed. E.F. Henderson, *Select Historical Documents of the Middle Ages* (London, 1892), 274-309, and the *Cambridge History of the Bible* (Cambridge, 1969) II, 246.

3. For instructive comparison, see M.W. Evans, *Medieval Drawings* (London, 1969), pls. 18, 19, 20. Also A. Heimann, 'The Last Copy of the Utrecht Psalter', *The Year 1200*, III, *A Symposium*, Metropolitan Museum of Art (New York, 1975), 313-38.

4. Carl Nordenfalk, *Early Medieval Painting* (New York, 1975), 145.

5. Owing to the fact that the Latin text of the Utrecht Psalter follows the Vulgate version of Jerome, and that

the King James version is based on the Hebrew text, the numeration of psalms and verses is sometimes at variance. Hence, the psalm in question is 103 in the Vulgate, and 104 in English and Hebrew versions. All verses will be referred to in the English translation numeration.

6. On the Utrecht Psalter see F. Wormald, *The Utrecht Psalter* (Utrecht, 1953); E.T. DeWald, *The Illustrations of the Utrecht Psalter* (Princeton, 1933); Nordenfalk, *Early Medieval Painting*, 144-45; Dimitri Tselos, *The Sources of the Utrecht Psalter Illustrations* (Minneapolis, 1960).

7. Wormald, *English Drawings*, 29ff, pls. 10, 11, 12, 35a; Rickert, *Painting*, 39ff, pls. 32, 33, 48b; *Anglo-Saxon Mss*, no. 64, ills. 200-207, fig. 1, and full bibliography.

8. It is interesting that in the Harley MS 603, as in the Tapestry, the choice of colours is purely arbitrary, depending solely on the artist's whim. Another correspondence is that in the Tapestry (from Plate XLVIII onwards), text and pictures are chromatically linked by the colouring of the letters, with the same colours used in the inscriptions also used in the pictures.

9. Another instructive change is in the text. In the copy the English scribes continue the old-fashioned tradition of using the 'Roman' version of the psalms whereas Continental monastic houses had already adapted the Gallican version used in the Utrecht Psalter. See the discussion, with references, of pre-Conquest liturgical practices, as they relate to the psalters in N. Brooks, *The Early History of the Church of Canterbury*, 261ff.

10. *Anglo-Saxon Mss*, no. 84, discussion with full references. Most of the iconography derives from the Utrecht Psalter and the Harley MS 603, contracted and adapted to a marginal space; seven drawings correspond to those in another psalter, the Otbert Psalter (Boulogne MS 20); some is original, and some reflects original Anglo-Saxon conceptions of biblical subjects, for example, the novel method of representing the ascension with a 'disappearing Christ' (f. 73v, reproduced ibid., pl. 264). This manuscript deserves more attention than it has so far received from scholars.

11. *Anglo-Saxon Mss*, p. 23, no. 84, fig. 27, ills. 263-64; M. Schapiro, 'The Image of the Disappearing Christ: The Ascension in English Art around the Year 1000,' reprinted in his *Late Antique, Early Christian, and Medieval Art* (New York, 1979), 266-87. Some other Anglo-Saxon inhabited frames are found in the Kederminster Gospels, Kederminster Library, 267 (on indefinite loan to the British Library, Loan 11); another gospel in the British Library, Royal MS I.D. IX; and a third at Cambridge, Pembroke College, MS 301, all three of which are illustrated in *Golden Age*, nos. 51, 52, 53.

12. Wormald, *English Drawings*, 54, 67, pl. 34a. Wormald dates the drawings to approximately 1073.

13. The choice of subject, Saint Pachomius receiving instructions for the exact date of Easter, is revealing in itself, as it relates to a problem one would have thought had been safely settled more than 300 years earlier after the heated controversies between Celtic and Roman-oriented monks, which the reader may recall was recounted in seemingly endless detail by Bede. Iconographically and intellectually, as well as stylistically, Canterbury art in the years around the Conquest has a distinctly backward-looking character. Other examples of the continuity of the English pictorial style in manuscripts, first observed by Wormald in his essay, 'The Survival of Anglo-Saxon Illumination after the Norman Conquest', *Proceedings of the British Academy*, XXX (1944), can be found in Wormald, *English Drawings*, 54ff; Dodwell, *Canterbury School*; and summarized in Rickert, *Painting*, 47ff.

14. BL, MS Add. 49598, made between 971-84 at Winchester. *Anglo-Saxon Mss*, no. 23 with full bibliography. See especially F. Wormald, *The Benedictional of St Æthelwold* (London, 1959); Rickert, *Painting*, 36-38, figs. 26, 27; Nordenfalk, *Early Medieval*, 182, pl. 180.

15. Although many iconographic and stylistic elements derive from Carolingian models, the overall effect of these pages is quite new and distinctly English. See *Anglo-Saxon Mss* for brief discussion and references, and Nordenfalk, *Early Medieval*, 182-83.

16. Although called the Winchester style, not all of these were made at that cathedral and government centre, for it is now thought that such a splendid work as the so-called Missal of Robert of Jumièges is from Ely, while the Trinity Gospels and the Grimbald Gospels are of Canterbury origin. Rickert, *Painting*, 38ff and pls. 31, 28a, and 36a, 36b; in colour, *Golden Age*, pls. XIII, XIV, and XVI. Works in other media are illustrated in J. Beckwith, *Ivory Carving in Early Medieval England* (London, 1972), and *Golden Age*, nos. 122, 123, 124. Compare the iconography and treatment of the nativity in the Missal of Robert of Jumièges, *Golden Age*, colour pl. XIV, with the opening page of St Matthew's Gospel in the Boulogne Gospels, ibid., 63, and in turn with the exquisite ivory carving of the same scene, ibid., colour pl. XXIV (b). An important point is that since books were brought to Normandy before the Conquest, elements of a common iconography became disseminated among English and Normans before 1066, and that a taste for English art and some grounding in its practice predates the Conquest: compare Rickert, *Painting*, pls. 29b and 27. Because such books would influence Norman artists and patrons before 1066, one can appreciate why Wormald maintained that stylistic grounds alone could not allow one to prove the English origin of the Tapestry. The clues from inscriptions and correspondences with specific manuscripts residing only in Canterbury was the evidence that clinched the case.

17. For the Grimbald Gospels, see *Anglo-Saxon Mss*, no. 68, ill. 215 (colour), 218; Rickert, *Painting*, 41-42, pls.

36a and 36b; Nordenfalk, *Early Medieval*, 185, pl. 181; E. Kitzinger, *Early Medieval Art in the British Museum* (London, 1940), 62, pl. 28. See *Golden Age*, colour pl.55 for double page illustration of evangelist portrait and facing text.

18. Compare these wings with acanthus leaves framing the portrait of St Luke in the same book, Grimbald Gospels, f. 73v, reproduced alongside the portrait of John in Rickert, *Painting*, pl. 36a.

19. The Angers illustration is discussed briefly in G. Henderson, *Gothic* (Harmondsworth, 1967), 43 and fig.14.

20. Ibid.

21. Wilson, *Bayeux Tapestry*, 213-26, on buildings, dress and objects; also essays in BT.

22. The 'modern' one, apparently unknown to the Romans but often depicted in medieval works of art from the 11th century onward, consists of a padded collar resting on the shoulders of the horse that permits free breathing and circulation of blood, thereby enabling the animal to pull four to five times more weight than horses with the older yoke harness.

23. L. White, Jr, 'The Discovery of Horse Power', in his *Medieval Technology and Social Change* (New York, 1966), 57-69. A good short discussion of the kind of horses bred for battle and the joy of the Tapestry in depicting them is in R.H. C. Davis, *The Normans and their Myth* (London, 1976), 32.

24. The Cotton MS Julius A. VI in the British Library. See *Anglo-Saxon Mss*, no. 62, and ills. 197-99; *Golden Age*, no. 60; Wormald, *English Drawings*, 36, 39, 68, no.30, pl. 17b; Rickert, *Painting*, 40-41, 59, 224 n. 58, pl. 34a. Full references in *Anglo-Saxon Mss*, no. 62.

25. Schapiro, 'The Image of the Disappearing Christ,' op. cit., 280.

26. On ploughs and other fascinating innovations in agricultural life see L. White, Jr, *Medieval Technology*, ch. 2. See as well f. 54v in the Harley manuscript, conveniently reproduced in J. Campbell, ed., *The Anglo-Saxons* (Ithaca, 1962), 170, for another ploughman and two men working in the midst of vines.

27. The BL MS Cotton Tiberius B.V contains, in addition to a calendar with painted labours of the months, a series of 27 drawings accompanying Cicero's translation of the Greek astronomical poem *Aratea* and a copy of the famed *Marvels of the East*, with 38 framed drawings illustrating fabulous people, monsters and wonders. *Anglo-Saxon Mss*, no.87, ills. 273-76, and full bibliography.

28. Olga Koseleff, in *Gazette des Beaux-Arts* (Nov. 1942), 77-88, referred to in Schapiro, 'Image of the Disappearing Christ', op. cit., 280.

29. Tunics are in Plates 33, XIX, 81 respectively.

30. That decoration was not without interest to the artist of the drawings is shown by the decorative arrangement of such natural objects as trees, vines and the columnar frames at either side of each scene. No two pairs of capitals are identical.

31. George Wingfield Digby, in BT, 40, distinguishes in this way from the closely related stem and outline stitches: 'Outline stitch is a variety of stem stitch in which the needle comes out each time on the right of the thread, thus forming a thin continuous line, instead of the slight overlapping of consecutive stem stitches.'

32. The author is much indebted here to the chapter on 'Technique and Production' by Digby in BT, esp. 40-41.

33. Or note how the light blue-green thread used in the helmet's laid and couched work becomes a contour around the shield, and then again re-enters Harold's body contour to become the thread used for the circular armour pattern.

34. Janet Backhouse, catalogue entry *Golden Age*, no. 57, and colour pl. XVIII. Eadui, the artist, has apparently inserted himself as the crouching figure at Benedict's feet; he holds a psalter and wears a girdle inscribed with the words '*zona humilitatis*'. Note that the combination of frontality and profile, or three-quarter view, might also be compared to the acclamation of King Harold scene in the Tapestry (Plate XXXI).

CHAPTER V: *The Englishness of the Tapestry: the Borders. Pages 82-88*

1. I wish to express my gratitude to Linda Seidel for bringing this *New Yorker* cover to my attention.

2. The pioneer in analysis of frame-field relationships in medieval art is Meyer Schapiro. Unfortunately many of his observations remain unpublished, but for now see his brief essay, 'On Some Problems in the Semiotics of Visual Art: Field and Vehicle in Image-Signs', *Semiotica*, 1 (1969), 223-42, esp. 226-29. A student of Schapiro's, Herbert R. Broderick, has published the best piece to date on Anglo-Saxon frames, 'Some Attitudes toward the Frame in Anglo-Saxon Manuscripts of the Tenth and Eleventh Centuries', *Artibus et Historiae* (rivista internazionale di arti visive e cinema), V (1982), 31-42. In this illumination, and in innumerable medieval works of art, the frame, as Meyer Schapiro has expressed it, very often appears 'not as an enclosure but as a pictorial milieu of the image'. Schapiro, op. cit., 228.

3. Rickert, *Painting*, 36; *Golden Age*, no.26. It would be incorrect, however, to credit the Winchester artist with a completely novel use of the frame. Recall that the earliest Christian artists in Britain made similar use of the frame as a physical milieu for the figures within, as seen, for example, in the Lindisfarne Gospels, created around AD700. There, St Matthew's bench rests on a floor made up of the lower frame while the curtain hangs from a ceiling that is in fact the frame above. The Lindisfarne Matthew is conveniently reprinted and discussed in many places, including Rickert, *Painting*, pl. 7; Carl Nordenfalk, *Celtic and Anglo-Saxon Painting* (London, 1977), pl. 17;

J.J.G. Alexander, *Insular Manuscripts* (London, 1978), no. 9, and most thoroughly, in T.D. Kendrick, *et al.*, *Evangeliorum Quattuor Codex Lindisfarnensis*, 2 vols. (Olten-Lausanne, 1956-60). To see at a glance the difference between the classical idea of the frame and the medieval, compare this Matthew portrait in the Lindisfarne Gospels with its model, or close relative, in the Codex Amiatinus, which was ultimately inspired by the Mediterranean world, Ricket, pl. 7b or Nordenfalk, Introd, fig. X.

4. Broderick, 'Some Attitudes toward the Frame,' op. cit., discussion and figs. 1, 2. Illustrations are also in *Anglo-Saxon Mss*, pls. 32, 265.

5. This example was first brought to my attention by Meyer Schapiro. It is published and commented on wittily by Broderick, 'Some Attitudes toward the Frame', op. cit., fig.3. The Cotton MS Tiberius B.V, the same manuscript containing painted labours of the months, is also discussed above, Chapter IV.

6. On the few occasions when the lances and swords of mounted warriors overlap the border, it does not appear accidental, for they occur almost exclusively in scenes of actual warfare, when violent, unconstrained action is taking place, and seldom in messenger scenes or those depicting preparations for battle. Compare, for instance, the warfare as depicted in Plates XXI, XXIII, LXVI, and LXVII with the capture of Harold (Plates VII-VIII), or the march past Mont-Saint-Michel (Plate XIX) before the attack on Conan.

7. Also see some of the important palace structures, those in England that witness the death of Edward and the acclamation of Harold, and the Norman palace where Odo and William give the command to construct the armada (Plates XVI-XVII, XXVIII, XXXI, XXXII, XXXIV-XXXV). But not those at Dol and Rennes.

8. The often-made comparisons between the Anglo-Saxon warrior's shoulder clasp found at Sutton Hoo and the formal arrangement of a carpet page from the Book of Durrow point clearly to a barbarian source for the entangled and biting figures who inhabit the borders of that page and many others in Hiberno-Saxon manuscripts. Rickert, *Painting*, pls. 2 and 3, for example. For more thorough analysis see F. Henry, *Irish Art in the Early Christian Period* (London, 1965), and the fundamental contributions by Sir Rupert Bruce-Mitford in T.D. Kendrick, *et al.*, *Evangeliorum Quattuor Codex Lindisfarnensis*. One of the earliest Mediterranean models is the celebrated Gospels of St Augustine, the manuscript thought to have been sent from Rome with the apostle to England in 597, which we have had occasion to notice already in connection with the Norman feast scene. Surrounding the portrait of the Evangelist Luke in St Augustine's Gospels is a series of twelve scenes of the Passion in small compartments arranged in a manner similar to that in an earlier pagan stele to Mithras. Nordenfalk, *Early Medieval Painting*, 98-101, with ills. from *St Augustine's Gospels*; Wormald, *The Miniatures in the Gospels of St Augustine*, 6-7, with ill. of Mithras Stele, XIIa, and references to other late classical reliefs and ivories. See Otto Homburger, 'L'Art Carolingien de Metz et l'Ecole de Winchester', *Gazette des Beaux-Arts*, 62, 1963; Broderick, 'Some Attitudes towards the Frame', op. cit.

9. Rickert, *Painting*, 45. Two other features are remarkable: (1) this is one of the first attempts to make the story (not just the death and destruction) vitally alive to the viewer, as exemplified by the choice of a contemporary-design ship, the first known instance of the ark being depicted as a ship rather than the usual box, and in the treatment of Noah's wife as reluctant to enter the ship; (2) the handling of narrative time is extremely ingenious, for the unfolding of time is conveyed in a single scene. In this rendering of the beginning of the voyage we are kept mindful of its providential end. God is about to close the door, Noah is at the rudder, but at the top of the ship, a fifth young man, necessarily one of Noah's three sons at a later stage in the journey, is setting loose the raven.

10. Augustine, *City of God*, Book 15, ch. 26.

11. A wonderfully spirited depiction of an angel crossing the frame on its way from heaven to earth is found in a Gospels of about 1020 now in Cambridge, Pembroke College, MS 301, f. 10b, illustrated in *Golden Age*, 71, no. 53. There are many interesting features to this St Matthew page, including a little-noted inhabited frame, and a more complex set of receding and overlapping planes than one usually finds in these evangelist portraits. Also, note the bookstand.

12. See, for example, animals under Plate LIX, and those over LXII, LXVII, LXX with *Elene*, ll. 27-30, 52-53, 110-13; *Beowulf*, ll. 3024-27; *Battle of Maldon*, ll. 106-107; *Brunnanburh*, ll. 60-65; *Judith*, ll. 205-12. F.P. Magoun, Jr., 'The Oral-Formulaic Character of Anglo-Saxon Poetry', *Speculum*, 28 (1953), 446-67; Adrien Bonjour, 'Beowulf and the Beasts of Battle', *Proc. Mod. Lang. Assoc.*, LXXII, 4, Sept. 1957, 563ff. Animal imagery is part of almost all descriptions of war, for instance, whether in the Bible or Homer, or the *Song of Roland*, 'As even the hart flies before the hounds, so flee the heathen from before Roland.'

13. Rupert Taylor, *The Political Prophecy in England* (New York, 1911), a book brought to my attention by Meyer Schapiro. Taylor notes, p.4, that the 'most distinctive feature of the English method [of political prophecy] is the use of animals and birds instead of men and women'.

14. Wormald in BT, 27; cf. below, Chapter IX.

15. Rickert, *Painting*, pls. 26 and 27.

16. Perhaps the author, Reginald of Durham, had access to the tomb and saw the remains himself. The text is printed and discussed by Meyer Schapiro, 'On the Aesthetic Attitude in Romanesque Art', reprinted in a volume of the author's selected papers entitled *Romanesque Art* (New York, 1977), 1-27, esp. 11-13. Latin text is in *Reginaldi monachi Dunelmensis Libellus de*

admirandis beati Cuthberti virtutibus, ed. James Raine: Surtees Society, I, London, 1835, cap. xlii, 87ff. Also, see Charles Eyre, *The History of St Cuthbert*, 3rd ed., London, 1887, 173ff.; Stevenson, *Church Historians of England*, vol. III, part II, 782-84; C.F. Battiscombe, ed., *The Relics of St Cuthbert* (Oxford, 1956). Some of the fabrics post-date Cuthbert's death, being presented by King Æthelstan around 934 to St Cuthbert's shrine at Chester-le-Street, where the saint's body found temporary shelter after its removal from Lindisfarne to escape Viking invaders. Its ultimate location was, of course, to be Durham.

17. See the marvellous discussion in E. Mâle, *Religious Art in France: The Twelfth Century* (Princeton, 1978), 340-63, with references, on the influence of eastern textiles on Romanesque art. For Anglo-Saxon art and eastern textiles see the valuable discussion by Dodwell, *Anglo-Saxon Art*, ch. V, and his *Canterbury School of Illumination* for a treatment of the influence of such eastern textile imagery on manuscripts made in Canterbury.

CHAPTER VI: *Continuous Narrative, Distinctive Format and the Idea of Triumph. Pages 89-107*

1. Because there are no vertical boundaries at predetermined intervals, as occurs when an artist must adjust his narrative to the dimensions of a page, scenes vary markedly in their length, from short episodes made up of only two persons (e.g., Plate XXIV, William bestowing arms on Harold) to vast successions of uninterrupted episodes (e.g., Plates XL-XLVIII, the armada sailing across the Channel, the disembarking and foraging for food, and the celebratory feast are all conceived as a continuous, unfolding story). The story generally unfolds from left to right, though in two instances the whole narrative is reversed, with the beginning of an action originating to the right and the actors moving to the left (Plates X-XIII, XXIX-XXX). In only one scene are two distinctly 'framed' episodes combined into a single picture space, the death and preparation for burial of Edward the Confessor (Plate XXX).

2. For works which deal with how artists tell tales with images and no (or very few) words, see H.A. Groenewegen-Frankfort, *Arrest and Movement* (London, 1951); 'Narration in Ancient Art', a symposium conducted by the Archaeological Institute of America in 1955 and published in the *American Journal of Archaeology* (1957), vol. 67; Meyer Schapiro, *Words and Pictures* (The Hague, 1973), and, most recently, R. Brilliant, *Visual Narratives: Storytelling in Etruscan and Roman Art* (Ithaca, 1984). Unfortunately nothing comparable to these theoretical and detailed writings on ancient narrative art exists for the medieval period. For now see the brief but thought-provoking

remarks in Pächt, *The Rise of Pictorial Narrative in Twelfth-Century England*.

3. Digby in BT, 45-46.

4. E. Maclagan, *The Bayeux Tapestry*, (rev. ed., Harmondsworth, 1945), 17-18, and Digby, BT, 46. For a comprehensive survey see Betty Kurth, *Deutsche Bildteppische des Mittelalters* (Vienna, 1926).

5. Digby thinks yes, BT, 47; Maclagan, *Bayeux Tapestry*, 18, thinks it probable that he saw the Bayeux Tapestry or at least heard of it; Abrahams, the editor of Baudri, thinks it unlikely (247).

6. O.K. Werckmeister, 'The Political Ideology of the Bayeux Tapestry', *Studi Medievali*, 3rd series, XVII (1976), 535-95, plus plates, esp. 554-63, has an informative discussion of the problems.

7. One object which is not discussed below should be mentioned. This is a fragment discovered in 1965 at Winchester of a sculptural frieze depicting parts of two scenes: walking to the left is a soldier clad in mail similar to that worn by warriors in the Tapestry; to the right a dog or a wolf touches the head of another man, bound around the neck and wrist, lying on his back. M. Biddle, who excavated the work, also proposed an ingenious solution to its iconography, suggesting that it depicts an episode in the exploits of Sigmund, a hero from the Volsunga Saga. Yet, much is uncertain about this unusual fragment, its date, the size of the whole, its subject matter and purpose. Since no other sculptural frieze is known from 11th-century England, any connections between sculpture and the format of the Tapestry remain very tenuous. For a photograph of the Winchester slab, a short discussion, and an up-to-date bibliography, see *Golden Age*, no. 140. For its bearing on the Tapestry see also now Wilson, *Bayeux Tapestry*, 206-208.

8. For the varying lengths of the eight sections see above, Introduction, n.6, and Bertrand, *La Tapisserie de Bayeux*, 23-26.

9. Digby, BT, 51. His whole discussion on pages 37-52 provides excellent material and analysis, which has been summarized all too briefly here. While very inclusive he does omit a fragment of an English textile now in the Museo di S. Ambrogio in Milan, illustrated in Wilson, *Bayeux Tapestry*, fig. 2. However, note that Digby sticks to the northern textile tradition in accounting for the form of the Tapestry, as might be expected from an expert in that field, and neither looks outside his media and northern Europe, nor considers that problems of form and narrative style might be related.

10. Ælfric (d. about 1020) was abbot of Eynsham and a major figure in English pre-Conquest culture. A facsimile of the manuscript with important introductory material is *The Old English Illustrated Hexateuch*, ed. by Dodwell and Clemoes. For full bibliography see *Anglo-Saxon Mss*, no. 86.

11. This page is discussed briefly in W. Cahn, *Romanesque Bible Illustration* (Ithaca, 1982), 88.

12. See analysis with illustration from the Ælfric manuscript in Henderson, *Early Medieval*, 173-77. Also found in the Ælfric illustrations are the more common narrative devices of separating episodes by vegetation or by a building and the duplication of a figure within one scene.

13. This work, a metrical paraphrase of Genesis in Old English that was illustrated by two artists around the year 1000, has been noted above in connection with frame-field relationships in its rendering of Mrs Noah and the ark. Pächt, *Rise of Pictorial Narrative*, 6-8; cf. Schapiro, 'The Image of the Disappearing Christ', *Late Antique*, op. cit. With respect to our questions, Pächt notes, 8, n.1, that 'it is the very essence of continuous narration to render changes visible by means of comparing the same person in different moments or states. Thus, disappearing is made apparent by showing Enoch as a complete and an incomplete figure within the same picture.'

14. Brooks and Walker, 29-33, and below in Chapter XI. Duplication is of course found in many English manuscripts of the period, including the Ælfric Hexateuch and the post-Conquest *Passionale* from St Augustine's with the Life of Saint Caesarius illustrated above, Chapter III, Plate 22.

15. It is also extraordinary that not one of the authors of the splendid volume edited by Stenton, BT, even discusses the place of continuous narration in medieval art.

16. Werckmeister, 'The Political Ideology of the Bayeux Tapestry', (see above, n. 6), 535-48. As Werckmeister indicates, the obvious formal connection between the Tapestry and ancient monuments was noted by Montfaucon, who introduced the Tapestry to the world in 1729, writing, 'Cette première partie de l'Histoire est séparée de la suivante par de grandes branches qui s'élèvent du bas jusqu'en haut, & qui marquent qu'une autre action va commencer. Cela s'observe aussi dans les colonnes Trajane & Antonine, & dans d'autres bas-reliefs,' Montfaucon, *Monuments de la Monarchie Française*, 1729, I, 735, quoted in Werckmeister, 537, n.9.

17. The basic works on the columns are C. Cichorius, *Die Reliefs der Trajanssäule* (Berlin, 1896-1900); K. Lehmann-Hartleben, *Die Trajanssäule* (Berlin and Leipzig, 1926); L. Rossi, *Trajan's Column and the Dacian Wars* (London, 1970); W. Gauer, *Untersuchungen zur Trajanssäule* (Berlin, 1977); C. Caprino, et al., *La Colonna di Marco Aurelio* (Rome, 1955); G. Becatti, *La Colonna di Marco Aurelio* (Milan, 1957).

18. Werckmeister, 'Political Ideology', 540.

19. Another 'quotation' adduced by Werckmeister (pls. 1a and 1b) is that of the horse falling forward while crossing near Mont-Saint-Michel and a horse stumbling in a column scene of soldiers making a river crossing. In both cases the rider falls over the neck. Again, however, the Tapestry artist presumably could have observed just such a mishap; a falling horse with rider thrown forward over the neck is also a subject found later in the Tapestry, during the Battle of Hastings, Plate LXVI.

20. Some linkage is hard to deny, and we are all in Prof. Werckmeister's debt for noting a possible Roman imperial source for this imagery. Perhaps one might consider a link via Roman sarcophagi containing battle iconography. I wish to thank Prof. Richard Brilliant for his observations on this puzzle.

21. Dodwell, *Anglo-Saxon Art*, 152.

22. Ibid., 153; *Victoria County History, Kent*, II, 128 for Abbot Wulfric. Bates, *Normandy before 1066*, 201, for Bishop Geoffrey of Coutances. Every archbishop was supposed to go to Rome to receive his *pallium*. About Lanfranc, Gibson, *Lanfranc of Bec*, 118; for Abbot Scotland, *Thorne's Chronicle*, 53. Also see the interesting record of Archbishop Sigeric's journey (991) to collect his archepiscopal *pallium*, wherein is noted his visit to all of the churches in the holy city, his meal with the pope, and the eighty stages of his journey home, involving an absence of probably at least six months. BL, Cotton MS Tiberius B.V, part 1, described in *Golden Age*, no.164, and article by F.P. Magoun, *Harvard Theological Review* xxxiii (1940). From this account, however, he was interested only in Christian sites. In the 11th and 12th centuries, pagan Rome would exercise an increasing fascination, as is evident in G.B. Parks, *The English Traveller in Italy*, vol. I, 'The Middle Ages' (Rome, 1954); J.B. Ross, 'A Study of the Twelfth-Century Interest in the Antiquities of Rome', in *Medieval and Historiographical Essays in Honor of James Westfall Thompson* (Chicago, 1938), 302-21.

23. Dodwell, *Anglo-Saxon Art*, 153, interesting details and references. Starting in the 8th century there was a permanent Anglo-Saxon settlement which the Italians called the *schola Saxonum*, but which the settlers themselves called their own 'borough'. Here resided those who wished to end their days near the relics of the holy martyrs. Also see W.J. Moore, *The Saxon Pilgrims to Rome and the Schola Saxonum* (Freiburg, 1937). Recall also that papal legates often visited the north on business for the *curia*.

24. Located in the south-eastern corner of the country on the main road from Dover, Canterbury would also have been a stopping place for travellers returning from the Continent, thereby giving residents the opportunity to hear accounts of the marvels of ancient Rome without ever leaving the city's walls. Such a regular staging post was Canterbury that royal messengers had their own pasture there for their horses. *Victoria County History, Kent*, 206, cited in C. Clark, 'People and Languages in post-Conquest Canterbury', op. cit., 3. .

25. The Column of Trajan had an even more important appeal to medieval Christians because it commemorated one of the 'good' Roman emperors.

Even though he was a pagan, Trajan was so admired for his virtues that Pope Gregory the Great (590-604) was said to have prayed for his soul, and according to medieval legend, even secured his release from Purgatory and entrance into Heaven. The legend of Trajan, including his supposed act of justice to a poor widow and Gregory's prayers, is translated by B.W. Henderson, *Five Roman Emperors* (Cambridge, 1927), 179-80; the way in which a misreading of a work of classical art helped create the legend is treated in M. Hammond, 'A Statue of Trajan', *Memoirs of the Academy in Rome*, 21 (1953), 127ff; for the image of Trajan in the Christian era see Arturo Graf, *Roma nella Memorie e nella Immaginazioni del Medioevo*, 3rd rev. ed. (Turin, 1923), 374-402. Dante, *Paradiso* (XX, 44-46, 100-17), has Trajan as the ideal emperor, his soul, delivered by Gregory's prayers, forming the eye of the imperial eagle at the centre of Paradise. I am extremely grateful to my colleague Joseph Forte for bringing this material to my attention. It is also interesting that both Gregorovius and Lanciani believed that the columns were visited by pilgrims and travellers to secure a view of the city from its lofty point, making them a medieval equivalent of the Eiffel Tower or Post Office Tower, Ross. op. cit., 311.

26. P. Lasko, *Ars Sacra, 800-1200* (Harmondsworth, 1972), 111-23, esp. 120-23, and F.J. Tschan, *St Bernward of Hildesheim* (Notre Dame, 1951), II, 251ff.

27. E. Panofsky, *Renaissance and Renascences* (New York, 1969), 53-54, with references on Bernward and the art which he had created. A replica of the famous candlestick can be seen at the Busch-Reisinger Museum, Harvard University.

28. K. Weitzmann, *The Joshua Roll* (Princeton, 1948), 113-14. M. Schapiro, 'The Joshua Roll in Byzantine History' (1949), reprinted in Schapiro, *Late Antique, Early Christian, and Medieval Art*, 49-66. Schapiro's paper is of fundamental importance in its grasp of connections between biblical subjects and contemporary political and military history.

29. A Greek army conquered Asia Minor between 922-44; Antioch was gained in 969; and in 975 John Tzimisces advanced through Syria and northern Palestine up to Jerusalem. Schapiro, op. cit., 57.

30. The interrelationships of past and present, art and politics, as well as biblical and pagan culture have been summarized in this manner by Meyer Schapiro: 'It is the political situation of Byzantium in the 10th century that perhaps accounts for this art and the pseudo-classical culture of the Byzantine court in this period. The military campaigns for the lost provinces which had belonged to Byzantium at its classic height, the wars against "barbarian" peoples, the Russians, Bulgars and Arabs, the new concern with the imperial heritage . . . helped to stimulate in the Byzantine court the consciousness of its own "Hellenism".' Ibid., 63-64.

31. For the recently discovered fragment of a sculptural

frieze at Winchester, see above, n. 7.

32. WP, 162-63; cf. E.R. Curtius, *European Literature in the Latin Middle Ages*, (New York, 1953), 162-65, on what Curtius calls the panegyrical topos of 'outdoing'.

33. William was also compared with Theodosius the Great for his piety, with Augustus for the affection he inspired in his countrymen, and with Achilles for warlike valour. WP, 129, 199, 229. See T.A. Dorey, 'William of Poitiers: *Gesta Guillelm Ducis*', in a book he edited, *Latin Biography* (New York, 1967), 139-55, esp. 152-53.

34. WP, 249-55; Werckmeister, 'Political Ideology,' 550-51.

35. WP, 252. Another delightful example is that the strength of his case for claiming the crown could not have been shaken by Cicero himself (WP, 179, also EHD, II, 224). William of Poitiers was not alone, for the duke's triumph is again compared with the great Roman's conquest of Britain in both the pro-Norman *Carmen de Hastingae Proelio* and the poem by Baudri de Bourgueil describing the fictional bedroom tapestries of Adèle, the Conqueror's daughter. In the *Carmen*: 'Hail, blessed king, supporter of justice, peace of the homeland, a foe to foemen, protector of the church! . . . You have changed the name of count [i.e., duke] for the royal style which birth and merit have conferred upon you; another Caesar, indeed, in renewing whose triumphs you force a headstrong race to love the yoke.' *Carmen*, pp. 4-5; William is again compared with Caesar on pp. 22-25. In Baudri, William will be comparable with his predecessor: 'Soon, outside the line of dukes, he will be Caesar.' *Baudri*, ed. Abrahams, v. 241.

36. R.H.C. Davis, 'William of Poitiers and the History of William the Conqueror', in *The Writing of History in the Middle Ages*, ed. R.H.C. Davis and J.M. Wallace-Hadrill (Oxford, 1981), 71-100, esp. 71-72. It is intriguing that Davis speculates that William of Poitiers might have been a protégé of Odo's. Also, Baudri's editor makes clear that his poem is modelled on an established classical literary genre, of which it is the most elaborate medieval version until the 12th-century renaissance; this is in the classical tradition of *ekphrasis*, 'a descriptive kind of poetry about works of art and architecture'. See Abrahams, *Les Oeuvres Poétiques de Baudri*, 233 with references, and Werckmeister, 'Political Ideology', 554-63 with references.

37. The list is from R.H.C. Davis, *The Normans and their Myth* (London, 1976), 114. It may be that the grandeur of the imperial past would have also had a special resonance for monks in post-Conquest Canterbury since at the centre of the city the still-standing remains of an imposing Roman theatre were then receiving a great deal of attention. One of the largest structures from Roman Britain, this theatre, rebuilt in the 3rd century to seat an audience of about 7,000, was apparently still impressive enough a feature in Norman Canterbury to merit wholesale robbing of its

stonework for use elsewhere, probably in the rebuilding of Canterbury Cathedral after the disastrous fire of 1067, and in the construction campaign at St Augustine's. Brooks, *Early History of the Church of Canterbury*, 24-25.

38. This is not to say that the Norman and Saxon builders copied Roman structures point by point, but that they were inevitably inspired by the examples of their illustrious predecessors.

39. WP, 155; also EHD, II, 219. William's appeal to the papacy and his relations with the popes are treated in Douglas, *William the Conqueror*, 187-88, 192-98, 260-62, 336-43. Only William of Poitiers reports that the invaders carried a papal banner. It is striking that the Tapestry does not appear to show this famous banner. See Carl Erdmann, *The Origin of the Idea of Crusade* (Princeton, 1977), 197-200, originally published in German in 1935.

40. For a pioneering essay analysing the cultural meanings a specific form might have had for an age, in this case architectural, see R. Krautheimer, 'The Carolingian Revival of Early Christian Architecture' (1942), reprinted in a collection of the author's papers, *Studies in Early Christian, Medieval, and Renaissance Art*, ed. J. Ackerman, (New York, 1969). Krautheimer helped establish a field within art history known as the 'iconography of architecture'.

41. For example, see BT, 33-34.

42. 'The Bayeux Tapestry and the French Secular Epic', *The Burlington Magazine*, CVIII (Nov. 1966), 549-60.

43. Ibid., 549-50.

44. Although much of Odo's cathedral was destroyed in the early 12th-century fire, the eight bays of the nave are substantially the same as the original, despite later restoration and decoration. For example, the round Norman arches have survived, although resting on piers that were later decorated in the Gothic manner. See J. Vallery-Radot, *La Cathédrale de Bayeux* (2nd ed., Paris, 1958).

45. Height of columns in Sant'Appolinare Nuovo was approximately 16⅓ feet (5 m) and in Bayeux the nave piers measured 20 feet (6 m 10) from base to springer; also, the mosaics are considerably higher.

46. The only building dating from the 1070s and '80s still extant from either side of the Channel that gives us an indication of a Norman great hall is Chepstow Castle, built by William fitz Osbern on the Welsh side of the Wye. It is interesting that the 11th-century Great Tower measures 30 by 12 metres (100 by 40 feet) externally, making the interior easily large enough to accommodate the Tapestry's 70 metre (232 foot) present length. It is also interesting that William fitz Osbern was the other viceregent appointed by William to rule along with Odo in the king's absence. The present condition of the castle does not allow for reconstruction of the interior space, but if we look at two halls of slightly later date, certain general observations about a bishop's hall of the Conquest period can be made. J.C. Perks, *Chepstow Castle* (London, HMSO, 2nd ed. 1967). I am indebted to George Zarnecki for bringing Chepstow to my attention.

47. H.M. Colvin, ed., *The History of the King's Works* (London, 1963), I, 42-48; W.R. Lethaby, 'The Palace of Westminster in the Eleventh and Twelfth Centuries', *Archaeologia* lx (1906).

48. The windows are set within a continuous arcaded gallery. Such continuous arcading at an elevated level, a favourite form of Norman architectural decoration, can also be found in the depiction of William's great hall at Rouen in the Tapestry (BT, pl. 18). R. Allen Brown, 'The Architecture,' in BT (2nd ed. only), 81.

49. T.H. Turner, *Some Account of Domestic Architecture in England from the Conquest to the End of the Thirteenth Century* (Oxford, 1851), I, 43-45.

50. How much is missing is anyone's guess. If only a small part has been lost, then we can speculate that about 2 metres more would have completed the Tapestry, since five of the linen panels used as ground for the embroidery are slightly over 23 feet (7 m), and the last incomplete panel is 17¼ feet (5.25 m). The probable remaining 6½ feet (2 m) on this panel would have allowed for a representation of William seated as king (a coronation?), a fitting conclusion since the Tapestry opens with Edward the Confessor and the turning point of the drama occurs when Harold accepts the crown. For the lengths of the linen panels see Bertrand, *La Tapisserie de Bayeux*, 24.

51. Eric Fernie, *The Architecture of the Anglo-Saxons* (New York, 1983), ch. I, 'Halls, Houses and Palaces'. Also, A.W. Clapham, 'The Origins of the Domestic Hall', in A.W. Clapham and W.H. Godfrey, *Some Famous Buildings and Their Story* (Westminster, n. d.).

52. A suggestion of Prof. Richard Brilliant.

53. Joel Herschman, 'The Eleventh-Century Nave of the Cathedral of Coutances: A New Reconstruction', *Gesta* (1983), XXII/2, 121-34. The document on Bishop Montbray's hall is in an appendix on 133-34. A private chapel such as the one at Deerhurst in Gloucestershire built by Earl Odda not long before the Conquest is another example. H.M. Colvin, 'Domestic Architecture and Town Planning', in *Medieval England*, ed. A.L. Poole (Oxford, 1958), I, 38. For bringing this material to my attention, and for many keen observations on Norman architecture as it relates to the problem of displaying the Tapestry, I owe thanks to conversations with Prof. Herschman.

54. The capitals were discovered by Smirke and reported in *Archaeologia*, XXVII (1838), 136-37. Now see the catalogue *English Romanesque*, 154-55, with photographs and references. Some capitals are decorative (e.g., an animal encircled by foliage, a lion with a foliate tail facing an eagle preening its breast, etc.), while others are narrative. A decoration used in secular and religious dining halls was fables: Mâle, *Religious Art of France in the Twelfth Century*, 337-40.

55. This is the way it was moved from the old museum in Bayeux to the Orangerie for scientific analysis in 1982.

56. It has been aptly remarked that before the revival of a money economy a medieval ruler often had to ride around continuously, eating his taxes rather than collecting them.

57. See above, Chapter I, p.34. The flexibility of the Tapestry's material composition, in this regard so unlike that of a sculptured monument or a painted fresco, would have also allowed it to be unrolled in sections on a long table where a spectator could have read it like a book, in a manner similar to the way a Byzantine courtier would have read the Joshua Roll. The possibility that the Tapestry might have also on occasion been wrapped around a column, to simulate an antique monument, perhaps deserves some consideration.

CHAPTER VII: *Conclusion to Part One. Pages 108-12*

1. Urry, 'Normans in Canterbury', *Annales de Normandie* (1958), II, 119-38; Brooks, *The Early History of the Church of Canterbury*; Du Boulay, *The Lordship of Canterbury*.

2. Wormald, writing in 1957, in BT, 57. Brooks and Walker (1978), 78; and R. Wisolik, 'The Saxon Statement', *Annuale Medievale* 19 (1979), 77.

3. The major exceptions are Brooks and Walker, and Wisolik, op. cit., 67-97.

4. Nordenfalk, *Early Medieval Painting*, 186-87.

5. Brooks and Walker, 19-20.

6. Dodwell, 'The Bayeux Tapestry and the French Secular Epic', *Burlington Magazine* CVIII (1966), 549. Dodwell continues, 'The concern is with feasts rather than with prayers, warfare rather than piety, feudal equity rather than religious edification.' D. Wilson, in his recent *Bayeux Tapestry*, pp. 202-203, takes the secular argument a step further and even wonders whether the oath on relics is central to the Tapestry's story.

7. Dodwell, *Painting in Europe*, 86, emphasis added. Also see R.W. Southern, '1066', *New York Review of Books* (17 Nov., 1966). In reviewing the 2nd ed. of Stenton, BT, Southern says of the Tapestry, 'It testifies at once to the artistic skill of the conquered people and to the political views of the conquerors. It gives the truth distorted by propaganda and inflated by rhetoric; but at least it is the truth as one side saw it.'

8. See Brooks and Walker, 3, and below, Chapter XIII.

CHAPTER VIII: *The Politics of Art. Pages 114-23*

1. William of Jumièges, a Norman monk, composed the earliest account from the Norman point of view, finishing his *Gesta Normannorum Ducum* [Deeds of the Dukes of the Normans] soon after 1070 or 1072. The work is dedicated to William the Conqueror and Book VII narrates his rule in Normandy as well as his conquest and settlement of England. He praises the king and makes his seizure of the English throne legitimate. More fulsome as a panegyric is the biography of the Conqueror by William of Poitiers, who in his youth was a warrior for Duke William and then a cleric. He studied at Poitiers, absorbed a great interest in classical literature, apparently returned to Duke William's service as his chaplain, and subsequently became archdeacon of Lisieux. William of Poitiers apparently used and expanded upon the text of William of Jumièges in writing his *Gesta Guillelmi Ducis Normannorum et Regis Anglorum* [Deeds of William Duke of the Normans and King of the English] some time around 1074. A literary historian writing under the influence of Roman authors, Livy, Caesar, Sallust, etc., William of Poitiers was capable of graphic descriptions and interesting invented dialogue. Also from the Norman side is a poem, the *Carmen de Hastingae Proelio* [Song of the Battle of Hastings], which cannot be assigned with certainty to a specific author nor precisely dated, some saying it was done by 1070, others in the early 12th century. For an early attribution see Introd. to *Carmen*; for a later date see R.H.C. Davis, 'The *Carmen de Hastingae Proelio*,' *Eng. Hist. Rev.*, CCCLXVII (1978), 241-61. A very helpful survey of the historians of the Conquest is A. Gransden, *Historical Writing in England, c.550-c. 1307* (London, 1974), ch. 6.

2. For the Chronicles which treat the late Saxon and Norman periods see introd. and refs. in EHD, II, 107-9. Also *The Anglo-Saxon Chronicle*, ed. D. Whitelock, with D.C. Douglas and S.I. Tucker (London, 1961); *The Peterborough Chronicle, 1070-1154*, ed. C. Clark (2nd ed., Oxford, 1970).

3. See below, Chapter XV, 'Conclusion to Part Three.'

4. *Vita Ædwardi*, with valuable introd. by F. Barlow; also Gransden, *Historical Writing*, 60-66.

5. The complete text of the *Historia Novorum* is in *Eadmeri Historia Novurum in Anglia*, ed. M. Rule (R S, 1884). An English translation of Books I-IV by G. Bosanquet, *Eadmer's History of Recent Events in England*, cited herein as Eadmer, has a short Introd. by R.W. Southern. A penetrating account of this important Canterbury historian is found in R.W. Southern, *St Anselm and his Biographer*, esp. part II.

6. The problem is not just the divergence of the Tapestry from the sources but all accounts from one another. The matter is succinctly expressed by Douglas, *William the Conqueror*, 175: 'In 1064 (as it would seem) Earl Harold set sail from Bosham in Sussex on a mission to Europe. Almost every detail of his ensuing adventures, and their purpose, has been the subject of controversy and no finality can be claimed for any single interpretation which may be put upon them.'

7. WJ, 132-36; also EHD, II, 215. 'Edward, king of the

English, being, according to the dispensation of God, without an heir, sent Robert, archbishop of Canterbury, to the duke, with a message appointing the duke as heir to the kingdom which God entrusted to him. He also at a later time sent to the duke, Harold the greatest of all the counts in his kingdom alike in riches and honour and power. This he did in order that Harold might guarantee the crown to the duke by his fealty and confirm the same with an oath according to Christian usage.' The fuller account is given by WP, 101-105; see EHD, II, 217-18.

8. There might be an allusion to it in *Vita Ædwardi*, 53.

9. The three versions of the *Anglo-Saxon Chronicle* never mention Harold's journey or Edward's supposed delegation of William as his successor. A later writer who questioned the Norman version is the Anglo-Norman historian, William of Malmesbury, who around 1125 wrote that Harold's visit was not purposeful at all, but accidental, he being blown ashore in a storm while out fishing. According to this improbable tale, in order to get released Harold then sent a message from his prison in Ponthieu to William that he had come to confirm the succession. After his release he swore an oath of his own accord so as to further ingratiate himself with William. GR, I, 279-80. Given the diversity of the interpretations one can appreciate why every detail of Harold's adventures and their purposes are the subject of controversy among modern historians.

10. Ever since 1051, when, according to Eadmer, Harold's brother and nephew were sent to William as pledges of good behaviour on the part of the Godwin family on their return to England after a year's exile.

11. Eadmer, 6.

12. According to Eadmer, William had Harold swear that he would aid the duke gain the throne, make a stronghold at Dover for his use, send his sister to be married to one of William's nobles, and seal the bargain by marrying William's daughter. In return William promised to give over Harold's nephew, to bring with him to England Harold's brother, and to do anything which Harold might reasonably ask. Eadmer, 7-8.

13. Eadmer, 8.

14. Compare the studiously noncommittal nature of the inscription regarding the purpose of Harold's visit with the amount of information included about the Channel crossing: 'Here Harold sailed the sea and with the wind full in his sails arrived in the land of Count Guy' (Plates IV-V). The laconic inscription at this point has been noted by F. Barlow, *Edward the Confessor* (Berkeley, 1970), 222-23, in a useful discussion of the problems surrounding Edward's bequest of a kingdom.

15. For a discussion of the Tapestry's narrative in the context of other sources see S. Körner, *The Battle of Hastings, England, and Europe, 1035-1066* (Lund, 1964).

16. The most sensible discussion of this much discussed scene involving what must have been a well-known sexual scandal is J. Bard McNulty, 'The Lady Aelfgyva in the Bayeux Tapestry', *Speculum*, 55 (1980), 659-68, where he correctly emphasizes the importance of paying attention to gesture, medieval iconographic conventions and marginal zones for interpreting meaning in the Tapestry. While the article asks the right questions, its identification of the specific Ælfgyva is less certain. See references to two other recent discussions, Introduction, n.17, above.

17. For the discrepancies between the Tapestry and the version in William of Poitiers, along with a new proposal for solving the anomalies see Chapter XIII, 'The Bayeux Tapestry and the Hebrew Scriptures'.

18. WP, 102, and EHD, II, 217-18; see the Anglo-Norman historian Orderic Vitalis writing in the 12th century, who also places the oath before the Breton expedition, OV, II, 134-37.

19. Cf. Harold's departure in Plate IV.

20. The instability of both the soldier and the inscription at the joining of these two episodes is found as well in the posture and agitation of the marginal figures. Compare the settled disposition of the two winged lions above William and the birds below the portable altar with that of the birds and quadruped above and below the shrine and soldiers on our right. For another instance of a figure who participates in two scenes at the same time, see M. Schapiro, 'The Romanesque Sculpture of Moissac II,' reprinted in his *Romanesque Art*, 234. It has also been observed (Brooks and Walker, 10-11) that on his arrival at Edward's palace (Plate XXVIII), Harold's contorted posture does not appear to be that of a man coming to tell the king of how successfully he carried out his mission. Indeed, Harold's posture might be read as that of someone who felt rather foolish about what had transpired on his journey. The matter is complicated by the similarity between Harold's posture and that of the obedient monks in the Canterbury manuscript noted above, Chapter IV, Plate 26.

21. Brown, *Normans and the Norman Conquest*, 127.

22. Barlow, *Edward the Confessor*, 223-29.

23. Brooks and Walker, 10-11. E.A. Freeman, long ago, saw the possible connection between Eadmer's treatment in the *Historia Novorum* and the Tapestry, and has been supported more recently by C.N.L. Brooke, 'Historical Writing in England between 850 and 1150', *La Storiografia altomedievale*, Settimane di Studio del Centro Italiano di Studi Sull'alto Medioevo, XVII (Spoleto, 1970), I, 240-41. The Norman version is found in varying degrees in Douglas, *William the Conqueror*, 175-77; Brown, *The Normans and the Norman Conquest*, 127ff.

24. Stenton, in BT, 16, wrote, 'at the beginning of this section there occurs a curious dislocation of events for which a convincing explanation cannot easily be found.' About the death-bed scene itself, Stenton adds, 'it is not easy to see at once why an artist sensitive

to points of logical order should have relegated so momentous an episode to what is virtually a visual parenthesis'. BT, 17. Gibbs-Smith in BT, 180, also says, 'it is hard today to understand why the artist has decided upon the reversal'.

25. *Hic Eadwardus rex in lecto alloquitur fidelis.*
26. Barlow, Introd. to *Vita Ædwardi*, xli-xlix.
27. Brooks and Walker, 12; *Vita Ædwardi*, 79.
28. Precisely how one relates to the other is impossible to say, Brooks and Walker, 12.
29. ASC, 1066, 'E' version in EHD, II, 142, emphasis added. The 'C' and 'D' versions have a less precise formulation: 'Yet the wise ruler entrusted the realm/ To a man of high rank, to Harold himself/ A noble earl who all the time/ Had loyally followed his lord's commands.' EHD, II, 141. See also Florence of Worcester, a 12th-century annalist using the *Chronicle* materials, EHD, II, 212. Eadmer, in line with the *Chronicle*, says, 'as Edward had provided before his death, Harold succeeded him on the throne.' (8).
30. William of Jumièges, in EHD, II, 215; WP, 146-47, also in EHD, II, 218.
31. WP, 172-73; 266-68; Harold's speech is also in EHD, II, 223. An excellent discussion of the problems surrounding these matters is Barlow, *Edward the Confessor*, 251-53.
32. The author first tried this experiment in a lecture to the Robert Branner Medieval Art Forum at Columbia University in October 1981. It is encouraging that other observers, working independently of each other, also attempted a similar experiment, J. Bard McNulty in a talk at Kalamazoo, Michigan, in 1983, and M. Parisse in his *The Bayeux Tapestry* (Paris, 1983), 76-77.
33. *Hic dederunt Haroldo coronam regis.* By election one does not mean voting by a formal assembly but recognition by the magnates of the kingdom, which, by and large, Harold received. See Brown, *Normans and the Norman Conquest*, 133-37.
34. *La Estoire de Seint Aedward le Rei*, written about 1245 by Matthew Paris, at Cambridge Univ. Lib., MS Ee. 3. 59, has been reproduced in facsimile by M.R. James (London, 1920); also printed in H.R. Luard, ed., *Lives of Edward the Confessor* (RS, 1858), 1-178.
35. WP, 146.
36. Florence of Worcester, *Chronicon ex Chronicis*, ed. B. Thorpe, 2 vols. (London, 1848-49), I, 224, quoted and discussed in Brown, *Normans and the Norman Conquest*, 134, n.129, 135, n.133.
37. H. Ellis, *A General Introduction to Domesday Book*, London, 1833, 311ff gives examples of how Harold was described as a usurper, a tyrannical fraud, '*tirannica fraus*', and a man who forcibly seized property unjustly.
38. For William as Edward's kinsman, WP, 174-75. The bequest was allegedly made when Edward was a young man in exile enjoying the hospitality of the Norman court, and then again with the alleged ratification of the leading men in England, probably in 1051 while the Godwins were out of the kingdom. WJ, 132, also in

EHD, II, 215; WP, 31, 101, 173-77; also, less completely, EHD, II, 217, 223.

CHAPTER IX: *Visual Polyphony: Animals in the Borders. Pages 124-35*

1. The literature on animals in medieval art and thought is extensive. See, for example, T.H. White, *The Bestiary* (New York, 1960); F. McCulloch, *Medieval Latin and French Bestiaries* (Chapel Hill, 1960); F. Klingender, *Animals in Art and Thought* [to the end of the Middle Ages] (Cambridge, Mass., 1971); E. Mâle, *Religious Art of France in the Twelfth Century*, ch. IX; B. Rowland, *Blind Beasts* (Kent, Ohio, 1971).
2. The fables in the Tapestry have been identified in whole or in part by J. Abraham and A. Letienne, 'Les Bordures de la Tapisserie-Broderie de Bayeux,' *Normannia*, II (1929), 483-518; H. Chefneux, 'Les fables dans la Tapisserie de Bayeux,' *Romania*, LX (1934), 1-35, 153-94; L. Hermann, *Les Fables Antiques de la Broderie de Bayeux* (Brussels and Berchem, 1964); and more briefly, A. Goldschmidt, *An Early Manuscript of the Aesop Fables of Avianus* (Princeton, 1947), 47-50. None of these works relates them to the narrative.
3. J. Mann, 'Arms and Armour,' in BT, 56-69. For example, the dragon appears on the shields of Count Guy's retainers as well as on the shields of William's men (e.g., Plates VII-VIII, XII, XIII, XV).
4. In addition, note certain symbolic associations made about the hawk: e.g., since traits of a creature were associated with its name, *accipiter*, the hawk, got its name from '*a capiendo*' [from seizing], 'for it is an avid bird at seizing upon others'. White, *The Bestiary*, 138-39. Ambiguity about captivity and freedom is also found in the border beneath the messengers riding to 'free' Harold, in the scene of the Norman soldier confronting the chained bear (Plate XII).
5. In churches, see, for example, the pointed moulding, resembling jagged teeth, around the arches at Durham and many other buildings. A. Borg, 'The Development of the Chevron Ornament', *Journal of the British Archaeological Association*, XXIX-XXX (1966-67), 122-40; G. Zarnecki, 'Romanesque Sculpture in Normandy and England in the Eleventh Century', *Proc. of the Battle Conf.* I, 1978, ed. R. Allen Brown, 169-89, esp. 180-81, revises Borg by dating the appearance of the chevron twenty years before Durham and claiming that the chevron is 'a Norman importation' into post-Conquest England. It should be noted that the Tapestry uses a variant of the standard chevron form.
6. The juxtaposition of compositions and elements is most intriguing. Above, Harold stands at rest between two battle-axes symbolic of English power; battle-axes are usually shown in the Tapestry being used by the English soldiers, successfully as in Plate LXV, futilely in Plates LXIX-LXX, and again at the end, where one

lies on the ground, an emblem of the defeat and death of King Harold (Plate LXXI). Below Harold accepting the crown, a bird is hemmed in and perhaps figuratively decapitated by a symbol of Norman culture. Another instance of the zigzag pattern should also be noted, though it is less pronounced, in the scene where an English scout spies the approaching Norman army (Plate LVI).

7. Leonard Bernstein, *The Unanswered Question* (Cambridge, Mass., 1976), esp. 221ff. Recall also that the development of polyphony, a phenomenon unique to western culture, perhaps because of the inherent conflict of musical heritages, was taking place in the 11th and 12th centuries, and that England apparently took the lead. Paul Henry Láng, *Music in Western Civilization* (New York, 1941), 125ff, 'The Origins of Polyphony'.

8. For example, with Edward in the opening scene and Harold when he is acclaimed by the laity and clergy (Plates I, XXXI), and with Norman triumphs over Conan and Harold (Plates XXIII-XXIV, LXXI).

9. Harold's arrival and captivity (Plate VII); William's messengers to Guy (Plate XI); William's victory over Conan (Plates XXI-XXIII); William receiving Harold's oath (Plate XXV); William and Odo ordering the armada to be built (Plates XXXIV-XXXV); the slaying of Gyrth (Plate LXIV).

10. There are 14 griffins and 29 winged lions (14 pairs plus one). Griffins appear in Plates VII, VIII-IX, XVI, LIX, LXI, LXIV, LXIX. Winged lions appear in Plates XI, XIX, XXI, XXII, XXIII, XXIX, XXX (single), XXXV, XXXVI, XXXIX-XL, XLV, XLVIII, LI-LII, LVI.

11. The griffin is found in neither the Breton and oath episodes, nor the council and feast scenes. Note also the way the winged lion appears repeatedly beneath the arrival of the messenger on the Normandy shore, the ordering of the fleet's construction, the dragging of the ships to the beach and their sailing (Plates XXXV, XXXVI).

12. They might just be biting their wing tips, the way many beasts are shown biting their tails, but their attitude here looks more self-satisfied and calmer. Note that the one above William receiving the oath has its eye closed in a most affecting manner.

13. Compare such other noisy works as the French Romanesque tympanum at Autun. For excellent photographs see D. Grivot and G. Zarnecki, *Giselbertus: Sculptor of Autun* (New York, 1961).

14. See above, Chapter VIII for analysis of this scene and historical background.

15. Mâle, *Religious Art of France*, 341-63.

16. The ultimate source of medieval fable collections is the Greek fable which by the 5th century BC was associated with Aesop, though later Greek collections were also associated with a 2nd-century AD figure named Babrius. Medieval collections, however, derive primarily from the Latin books of Phaedrus (*c*.15 BC-AD 50), a freedman of Augustus who both used Aesop and

added much material. The most complete compilation is L. Hervieux, ed., *Les Fabulistes Latin depuis le Siècle d'Auguste jusqu'à la Fin du Moyen Âge*, 5 vols. (1893-99). An excellent edition is *Babrius and Phaedrus*, ed. and trans., with a useful Introd., by Ben Edwin Perry (Loeb Classical Library, Cambridge, Mass., 1965).

17. The literature on medieval fables is extensive: G.C. Keidel, *A Manual of Aesopic Fable Literature* (1896); J. Bastin, *Recueil Général des Isopets*, 2 vols. (1929-30); K. Warnke, *Die Fabeln der Marie de France* (1898); *The Fables of Odo of Cheriton*, trans. with Introd. by John C. Jacobs (Syracuse, 1985); Mâle, *Religious Art of France*, 338-40; J. Adhemar, *Influences Antiques dans l'Art du Moyen Age Français* (London, 1939), 223-30; on St-Ursin see E. Panofsky, *Renaissance and Renascences in Western Art* (New York, 1969), 90-91, n.2.

18. See above, n.2 for most important attempts to identify the fables.

19. A. Goldschmidt, *The Aesop Fables of Avianus*, 48, a view shared by Wormald, 'these fables serve a purely decorative purpose and cannot be related to the main scenes' (BT, 27).

20. C.R. Dodwell, 'The Bayeux Tapestry and the French Secular Epic', *Burlington Magazine* CVIII (1966), 549-60, esp. 559.

21. Adhemar, *Influences Antiques*, about the fables beneath Harold sailing to Normandy: '*La leçon, la morale évidente de toutes ces fables c'est, sous les formes les plus variées, la glorification de l'adresse qui permet de s'emparer du bien d'autrui. Le trouvère qui a inspiré l'oeuvre devait commenter et paraphraser de la sorte les conseils de prudence donnés par Edouard le Confesseur à Harold et rappelés par Augustin Thierry: "Je connais bien le duc Guillaume et son esprit astucieux: il ne t'accordera rien, à moins d'en avoir un grand profit." Les petites images de la frise soulignent ainsi, avec un esprit satirique qui est assez dans la tradition, la ruse du duc normand*' (230). Regrettably Adhemar did not follow this up with an analysis.

22. Adapted from Perry, *Babrius and Phaedrus*, 215. Cf. N.R. Shapiro, trans., *Fables from Old French* (Wesleyan, 1982), 58-59.

23. Adapted from *Babrius and Phaedrus*, 201, 115. Cf. Shapiro, *Fables from Old French*, 88-89.

24. Remember also that Harold is associated with birds three times in these Normandy scenes.

25. Adapted from *Babrius and Phaedrus*, 96-97, 206-209. Cf. *Fables from Old French*, 4-5.

26. In addition to framing the Normandy journey, it appears also mid-way in Harold's adventures (Plates IV, XVIII, XXIX).

27. Eadmer, 7-8. The famous embellishment of the story to include trickery, i.e., that Harold took an oath on relics concealed and unknown to him, first appears in Wace, *Roman de Rou*, ed. H Andresen (Heilbronn, 1877-79), II, 258.

28. I wish to thank Mme Simone Bertrand, former curator of the Bayeux Tapestry, for kindly pointing out some features of this scene in a private conversation as we

were examining the Tapestry. I am pleased to note that another scholar, J. Bard McNulty, who has examined the work very carefully, has apparently arrived at somewhat the same conclusions (unpublished paper, 'The Bayeux Tapestry: Text and Gloss', delivered at the 20th International Congress on Medieval Studies, Kalamazoo, Mich., 1985).

29. See above, page 129, for views of Dodwell and Adhemar.

30. Lilian M.C. Randall, *Images in the Margins of Gothic Manuscripts* (Berkeley, 1966), and review by Meyer Schapiro reprinted in his *Late Antique, Early Christian and Medieval Art*, 197-98.

31. Phaedrus, Prologue to Book III, Perry, *Babrius and Phaedrus*, 254-55. For some medieval instances of fables as social commentary, see Arnold C. Henderson, '"Of Heigh and Lough Estat": Medieval Fabulists as Social Critics', *Viator* IX (1978), 265-90. Goethe remarked that fables generally came from people who, having to obey, liked at least to grumble, whereas their rulers would reply with deeds. Goethe, *Werke*, 13, 217 (K. Heinemann, ed.), cited by Klingender, *Animals in Art and Thought*, 84.

32. Those who lose may also be less than honest. In the fable of the fox and crow, the crow (Harold?) got his cheese by stealing it from an open window.

33. See the fable of the wolf and the lamb and the one of the lion's share, clearly identifiable in the lower border beneath, Plates IV, VII-VIII. In both, the only justification for success is superior force; equity or justice is laughed out of court.

34. This interpretation of the moral and political world of the fables as one where success goes to anti-heroes is one reason why I cannot accept Dodwell's view that all the fables are meant to underscore Harold's perfidy and disloyalty (cf. his 'The Bayeux Tapestry and the French Secular Epic', *Burlington Magazine*, 559). It might also be recalled that the victors in these fables, the fox and the wolf, were types of the devil in medieval moralistic writings. See Panofsky, *Renaissance and Renascences*, 91, n.2.

CHAPTER X: *Centre Stage: King or Bishop? Pages 136-43*

1. The common artistic device of juxtaposing profile and frontal (or three-quarter) views to signify relative status can also be found at the opening of the Tapestry and in the oath scene, where William's authority over Harold is reinforced by the contrast between William's face in three-quarter view and Harold's in profile, directed toward the enthroned duke.

2. WP, 148-51; also in EHD, II, 218-19.

3. See Anglo-Saxon calendar illustrations above in Chapter IV, 'The Englishness of the Tapestry,' Plates 36, 37, 39.

4. C.R. Dodwell, 'The Bayeux Tapestry and the French

Secular Epic', *Burlington Magazine*, 549.

5. For this MS see above, Chapter II, 'Provenance'.

6. Cf. Utrecht Psalter, fs. 8v, 21r, 33r, 37v, in De Wald, *The Illustrations of the Utrecht Psalter*; and the feast from BL, Cotton Tiberius CVI, f. 5v, reproduced in Dodwell, *Anglo-Saxon Art*, pl. 34.

7. Grivot and Zarnecki, *Giselbertus*, pls. l and m; also see the Christ on the apse capital, pl. A5. Whether the seal was designed by Giselbertus cannot be determined, though it is a possibility, *Giselbertus*, Appendix 3, 178. The fact that Christ is shown engaged in a judicial role and that the bishop was also a judge is probably not unrelated to the similarity of portrayals, an interpretation suggested to the author by Bernice Thomas.

8. For the celebrated book at St Augustine's Abbey, see F. Wormald, *The Miniatures in the Gospels of St Augustine* (Cambridge, 1954).

9. Gibbs-Smith in BT, 183, note to pl. 49.

10. That servant at Bosham, and the diner next to him, also point to the next scene while looking back at the central character. While there is an apparent similarity between the men at Bosham looking back while pointing to the next scene and the gestures of our mysterious diner, there is a major difference in what they point at.

11. O. Werckmeister is apparently the first commentator to mention that the pointing figure was directing us to Odo's name; 'Political Ideology,' 579, n.237.

12. Note the calculations that went into this interplay of word and image. So that the diner would point to the name ODO in the adjacent inscription, both the seating order of the council scene and the placing of the inscription needed special arrangement.

13. WP, 190-93, also in EHD, II, 226.

14. On Eustace, WP 202-205, also in EHD, II, 228-29; for a different version, *Carmen*, 32-36, and introd. The importance of the differing portrayals of Eustace for dating the work is discussed in Chapter II above.

15. Note that he also wears a helmet that is unique among the hundreds in the Tapestry in having a decorative finial at its peak.

16. On Odo's *baculus* see Wilson, *Bayeux Tapestry*, 225. It is perhaps not accidental that the Tapestry designates Odo's weapon as a *baculus*, for in an ecclesiastical context this word meant an abbot's staff or a bishop's crozier, while in a military context it designated a mace or baton of office.

17. WP, 182, 242.

18. The original seal no longer exists, but a drawing was made of it in the 17th century for *Sir Christopher Hatton's Book of Seals*, conveniently published by D.M. Stenton and L.C. Loyd (Oxford, 1950), no. 431, pl. viii. For discussion of its authenticity see T.A. Heslop, 'English Seals from the Mid-Ninth Century to 1100', *Journal of the British Archaeological Association*, 133 (1980), 1-16, esp. 10-12. Despite anomalies possibly explained by some careless copying, Heslop feels that

the drawing is of an original seal not a later forgery. With regard to this unusual seal I am very grateful to Brigitte Bedos Rezak, of the Archives Nationales, Paris, and the Metropolitan Museum, for generously sharing her expertise in medieval sigillography.

19. WP, 102-104; OV, II, 134-36. Also, it is intriguing that the artist does not really state that the oath was taken at Bayeux. Note that in the inscriptions for these two scenes – HIC WILLELM VENIT : BAGIAS and UBI HAROLD : SACRAMENTUM : FECIT:/WILLELMO DUCI:/ – the UBI can either be read as, 'Here William came to Bayeux *where* Harold took an oath to Duke William', or as, 'Here William came to Bayeux;' [new scene] '*Here* (i.e., below, or herein) Harold made an oath to Duke William.' Note that in other scenes, UBI seems to mean 'Herein' or 'Below' (Plates X, XVII) thereby serving the same function as HIC.

CHAPTER XI: *Victory at Hastings and the Death of Harold. Pages 144-61*

1. Much of the following discussion has appeared in the author's 'The Blinding of Harold and the Meaning of the Bayeux Tapestry', *Proceedings of the Battle Conference on Anglo-Norman Studies*, V, 1982, ed. R. Allen Brown. For a fuller discussion of many points and fuller documentation see this article.
2. E.g., O. Demus, *Romanesque Wall Paintings* (New York, 1970), fig. 190.
3. BT, 188; C.H. Gibbs-Smith, 'The Death of Harold at the Battle of Hastings', *History Today*, X (1960), 188-91; Gibbs-Smith, *The Bayeux Tapestry* (1973), 15.
4. H. Loyn, *Harold, Son of Godwin* (London, 1966), 14-15; R. Allen Brown, *The Normans and the Norman Conquest*, 173, n. 154; D.J.A. Matthew, *The Norman Conquest* (London, 1966), 84; K. Spence, *Companion Guide to Kent and Sussex* (London, 1973), 286.
5. Brooks and Walker, 23-34.
6. William of Malmesbury (*c.*1125), GR, 303; Henry of Huntingdon (*c.*1130), *Historia Anglorum*, 203; Wace (*c.*1160), *Le Roman de Rou*, ed. A.J. Holden, II, 189. For discussion of this evidence and quotations from the sources, see G.H. White, 'The Death of Harold', in *The Complete Peerage* (London, 1953), XII, pl. I, Appendix L; Brooks and Walker, 27-28.
7. Much more evidence could be adduced for duplication in medieval art, but one example that should have special consideration, because of its time and place of origin, is the historiated initial in the *Passionale* produced in St Augustine's, Canterbury, around 1100, BL, MS Arundel 91, f. 188, ill. above, Chapter III, Plate 22. Note that not only is Saint Caesarius shown twice – first riding up the mountain and then hurtling head-first down the upright of the letter – but his leggings have changed from dark to light, and his helmet from light to dark. See Brooks and Walker, 29-34, for other examples.

8. The banner carrier and Harold are in Plate LXXI.
9. With regard to the different hose worn by both figures identified as Harold in the final scene, it should be noted that the lower part of the fallen figure has been extensively reworked in modern wool; whether the restorers preserved the original colours and design remains to be determined by textile analysis. In any case, change of colour and pattern is not uncommon in medieval duplication since naturalism is not the canon. When Gyrth is shown alive and dead the pattern and colour of his leggings are altered. The artist has varied the colour of the bearded banner carrier's leggings, the pattern of his wrist bands, and the colour of his sword; the dragon standard itself is shown in two different colours. Also see n.7 above regarding a contemporary depiction of St Caesarius twice in one episode, replete with a change in the colour of his hose.
10. If this were the only place in the Tapestry where there was a deliberate adjustment of the 'O' in Harold's name to an image, little emphasis should be given to it, but of the sixteen times Harold is identified in the Tapestry, in four instances the letter 'O' is distinguished by unusual placement and/or by being grazed by a weapon (Plates VI, XIV, LVI, LXXI). Not all diminution of letter size implies deeper meaning. In Plates XLIX, L the final 'A' of HESTENGA and the final 'O' of WILLELMO, both smaller and elevated, are ordinary adjustments of a final letter to fit the available space. The important point is that in Harold's case the letter is both within the name and grazed by a weapon.
11. Latin, *oculus*; French *oeil*.
12. One might also recall that among earlier peoples fate was often considered to be spun or woven, as when the Anglo-Saxons said fate was woven – *gewif*. In Germanic mythology the Norns spin and bind, their web hangs over every man, and the 'weird sisters' weave a 'woof of war'. R.B. Onians, *The Origins of European Thought* (Cambridge, 1951), ch. 5. See also *Beowulf*, ll.696-708.
13. Dodwell, 'The Bayeux Tapestry and the French Secular Epic', 558-60.
14. For other instances see J.J.G. Alexander, *The Decorated Letter* (New York, 1978) and refs. cited on 31-34.
15. Although visible without magnification these marks were first clearly recognizable to me as stitch holes in a much enlarged detail made available thanks to the generosity of the *National Geographic* which provided the author with a 5 x 7 inch internegative from their original of the same size.
16. A third possibility – that the original embroiderers put an arrow there and decided to remove it themselves – has been ruled out because of the discoloration around the holes.
17. I am greatly indebted to members of the team, mentioned in the Preface, for their gracious assistance.

18. Matthew Bennett, 'Poetry as History? The *Roman de Rou* of Wace as a source for the Norman conquest', *Anglo-Norman Studies*, V, 1982, ed. R. Allen Brown, 21-39.

19. Wace, *Le Roman de Rou*, ed. A.J. Holden, II, 189, ll. 8161-66: '*Issi avint qu'une saete,/ qui devers le ciel ert chaete,/ feri Heraut desus l'oil dreit;/ que l'un des oilz li a toleit;/ e Heraut l'a par air traite,/ getee l'a, mais ainz l'out fraite.*'

20. It is important to note that in addition to Harold, two other figures in the Tapestry have an arrow to the eye (Plates LXX, LXXIII). Both of those are embroidered in restored thread. The earliest drawings of the Tapestry, those by Benoit in the 18th century, do not indicate that either had an arrow then. Stothard does not note the first one, but does have dotted lines for the second.

21. B. de Montfaucon, *Les Monuments de la Monarchie Française*, I and II. C. Stothard, *Vetusta Monumenta* (1819), VI, pl. XVI (31), and essay in *Archaeologia*, XIX (1821), 184-91.

22. WJ, 135; WP, 204; Baudri, 209, ll.461-64; three anonymous Anglo-Saxon chroniclers, 'C', 'D', and 'E', EHD, II, 142-46. The passages in William of Jumièges and William of Poitiers are conveniently available in EHD, II, 216 and 229. There is also a seventh writer if we include the anonymous author of the *Carmen*, 34-36, thought by some to be the first written source but by others to be 12th century (see Chapter VIII, n.1).

23. Brooks and Walker, 33-34; WP, 204; *Dict. of Nat. Biog.*, VIII, 1303, 'Harold'.

24. Of the large literature see J. Snyder, 'Jan van Eyck and Adam's Apple,' *Art Bulletin*, 58 (1976), 511-15; Meyer Schapiro, 'Cain's Jaw-Bone That Did The First Murder,' in his *Late Antique, Early Christian, and Medieval Art*, 248-65; R. Mellinkoff, *The Horned Moses in Medieval Art* (Berkeley, 1970); and for the rich development of extra-textual details in the Jewish tradition see Louis Ginzberg, *The Legends of the Jews* (Philadelphia, 1925), 6 vols.

25. See above, Chapter VIII and BT, 15-16. Breaking the oath is the dominant note sounded by the Norman propagandists, William of Jumièges and William of Poitiers, EHD, II, 215 and 224.

26. Eadmer, 9. A fascinating text of the next century that highlights the importance of Harold's perjury is an imagined speech in the history by Orderic Vitalis. Harold's brother Gyrth is supposedly pleading with Harold on the eve of the battle: 'Take care that you do not commit perjury, and by this crime destroy the flower of our people with yourself and bring shame on all our posterity. I have taken no oath and owe nothing to count William; therefore I can boldly join combat with him on my native soil. But you, my brother, should wait peacefully wherever you like for the outcome of this war, lest the fair freedom of the English should perish through your destruction.' OV,

II, 170-71.

27. E.g., John, 3.19: 'And this is the judgement, that the light has come into the world, and men loved darkness rather than light, because their deeds were evil.' In post-Conquest England, one expression of this common set of ideas can be found inscribed on the famous Gloucester candlestick, commissioned *c*.1110 : + *Lucis on(us) virtutis opus doctrina refulgens predicat ut vincio non tenebretur homo* [This flood of light, this work of virtue, bright with holy doctrine instructs us, so that Man shall not be benighted in vice]. *English Romanesque*, cat. no. 247 for description, ill., and bibliog.

28. Petrus Berchorius, cited in E. Panofsky, 'Blind Cupid', *Studies in Iconology* (New York, 1962), 109. For blindness in medieval thought and art, consult this essay and W. Deonna, *Le Symbolisme de l'Oeil* (Paris, 1965), 223-45 ('La Cécité symbolique') and Deonna, 'La Cécité mentale', *Rev. Suisse d'Art et d'Arch.*, XVIII (1958), 68ff.

29. The Troyes Casket was probably made in the west of England around 1170, *English Romanesque*, cat. no. 283 for description, ill., and bibliog. For the English *Psychomachia* (*c*.1120 from St Albans Abbey, see A. Katzenellenbogen, *Allegories of Virtues and Vices in Medieval Art* (London, 1939, New York, 1964); R. Stettiner, *Die illustrierten Prudentius-Handschriften* (Berlin, 1895-1905); H. Woodruff, 'The Illustrated Manuscripts of Prudentius', *Art Studies* (1929), 33ff.

30. Saint Christopher's martyrdom as told in Old English is in the BL, Cotton MS Vitellius A.XV, one of three prose tests immediately preceding *Beowulf*. It has been edited by S. Rypins, *Three Old English Prose Texts* (London, 1924), EETS, v. 161, 68-76. For the texts of *Vita Sancti Christophori*, from the *Acta Sanctorum* (25 July) see Rypins, 108-10. Also Jacobus de Vorigane, *The Golden Legend* (London, 1941), for Saint Christopher, and Saint Savianus, of whom the same story is told. In some versions two arrows miraculously blind the king. Another story illustrative of how blinding by an arrow was associated in medieval thought with punishment for sin occurs in the 12th-century writings of Walter Map where he recounts a tale of a foolish young lad who made a pact with the devil. Near the end, after making false oaths ('thus perjured and worse than his former self he rose up against Christ and His elect'), the lad was deprived 'of an eye by means of a random arrow which a boy had chanced to shoot'. *Walter Map's 'De Nugis Curialium'*, trans. by M.R. James (London, 1923), 183. I owe this reference to the generosity of Prof. Giles Constable.

31. See also a mid-12th-century illustration in the Harley MS 603 of Psalm 58 (59) where God's angels shoot arrows against other sinners, hitting one in the back of the neck, three through the mouth and two in the eye.

32. EHD, II, 216.

33. In the England of 1036, just as in 1066, there was a disputed succession to the throne. Canute had

kingdom: 'I also forbid that anyone shall be slain or hanged for any fault, but let his eyes be put out and let him be castrated.' See above n.42. On the more general connections between the phallic and ocular in European culture see Deonna, *Le Symbolisme de l'Oeil*, 68ff; Onians, *Origins of European Thought*, 184ff. For distant but none the less intriguing visual connections between what happened to Harold and Graeco-Roman art, see the material on classical erotic images in Catherine Johns, *Sex or Symbol* (British Museum, 1982), ch. 3, 'The Phallus and the Evil Eye'.

CHAPTER XII: *Conclusion to Part Two. Pages 162-64*

1. As an example of the Norman clerical attitude towards their predecessors in high office take Abbot Paul of St Albans (1077-93), Lanfranc's nephew and rebuilder of the church there. His contempt for the former Anglo-Saxon abbots, whose tombs he disturbed in his works, is shown in his accustomed way of describing them as '*rudes et idiotas*'. Reference in C. Platt, *The Abbeys and Priories of Medieval England* (New York, 1984), 1.
2. E. Gombrich, 'The Visual Image: Its Place in Communication,' in his *The Image and the Eye* (Ithaca, 1982), 137-61, on equating art with communication.
3. Guibert of Nogent, *De Pignoribus Sanctorum*, PL, CLVI, col. 625; Bates, *Normandy before 1066*, 216.

CHAPTER XIII: *The Bayeux Tapestry and the Hebrew Scriptures. Pages 166-78*

1. See above, Chapter VI, pp. 102-103.
2. Ezek. 17:13-21 (all following refs are to the Revised Standard Version).
3. 2 Kings 25; Jer. 29:1-8 and 52.
4. For Hebrew history of the devastating effects of the Babylonian Conquest see 2 Chr. 36:17-21; 2 Kings 25:1-21; Jer. 41-42; compare these accounts with Norman looting of England and reprisals, for example in R. Allen Brown, *The Normans and the Norman Conquest*, ch. 5., esp. 183, 187-88, 193-98.
5. The author has found only one early medieval portable object that has a resemblance to what is shown in the Tapestry, St Cuthbert's coffin as depicted in the *Life of St Cuthbert*, Oxford, University College, MS 165, p.159. For portable shrines see Peter Lasko, *Ars Sacra*, 800-1200, pls.9, 10, 35, 51-54, 89-91, 98, 99, 136, 140, 150, 151, 160, 161, 163, and books listed in his bibliography. I am also indebted to Marie-Madeleine Gauthier and Walter Cahn for their views on the relationship of the Tapestry's portable shrine to other medieval objects.
6. In the Utrecht Psalter, Psalm 131 (132), f. 75r. In the Ælfric Hexateuch, BL, Cotton Claudius B. IV, f. 142v (compare 138v). Such simplification of the biblical text

apparently began quite early in Christian art as evidenced by the mosaic of Joshua taking Jericho in Santa Maria Maggiore, Rome (432-40), reproduced in Grabar and Nordenfalk, *Early Medieval Painting*, 39.

7. The Lambeth Bible has been attributed to St Augustine's Abbey, Canterbury by Dodwell, while more recent arguments suggest Bury or St Albans. See *English Romanesque*, 115, for brief discussion and bibliography. In an illuminated initial from a Romanesque Bible in Bourges one also finds an Ark being carried around the walls of Jericho that is quite similar to the object in the Tapestry both in the arches on the side and in the use of poles without rings, Bourges, Bibliothèque Municipale, MS 3, f. 61v.
8. Some portable reliquaries were described as arks, for instance the *arca Willibrordi* at Emmerich, though it does not in fact resemble the Ark. See H. Schnitzler, 'Die Willibrordarche,' in *Festschrift H. Lützeler* (Düsseldorf, 1962), 394ff.
9. In some Jewish legends Nebuchadnezzar forced Zedekiah to swear his oath on a scroll of the law; in others he made him take the oath of allegiance by the 'horns of the altar'. Ginzberg, *Legends of the Jews*, IV, 291; VI, 382, n.2.
10. See above, Chapter IX, pp. 126-28.
11. Note that the question of whether an animal has a particular symbolic value can only be determined with the aid of a text or a context; for instance, it is clear that a winged lion placed beside a winged calf, an eagle, and a winged man, would be a symbol for the evangelist Mark.
12. Dan. 7:3,4.
13. Dan. 7:17.
14. The bear meant the Persians, the winged leopard the Macedonian Greeks, while the dragon signified the last world conquerors, the Romans. Hippolytus, *Commentaire sur Daniel*, trans. M. Lefèvre (Paris, 1947), 23-24; *Jerome's Commentary on Daniel*, trans. Gleason L. Archer, Jr (Grand Rapids, 1958), ch. 7, esp. 72-73; the Latin text is in PL, XXV. Also, Louis Réau, *Iconographie de l'Art Chrétien*, 3 vols. (Paris, 1955-59), II, 1, 391-410, 'Daniel'; *Lexicon der christlichen Ikonographie*, ed. Engelbert Kirschbaum (Freiburg im Breisgau, 1971), 'Nabuchodonosor', vol. 3, 303-307. While the Bible speaks of a lion, note that Jerome comments that the mythical beast is a lioness: 'The kingdom of the Babylonians was not called a lion but a lioness, on account of its brutality and cruelty, or else because of its luxurious, lust-serving manner of life. For writers upon the natural history of beasts assert that lionesses are fiercer than lions, . . . and constantly in their desire for sexual relations.' (*Jerome's Commentary*, 72-73). Jerome's modern editor comments that 'actually Jerome errs in rendering 'aryeh' as lioness, for it is the regular masculine form for lion in Aramaic. . .' It is interesting that in the Tapestry most of the winged 'lions' are in fact lionesses, and that over the feast scene care has been

taken to differentiate between the very prominent male and female winged lion.

15. For instance in the St-Sever Apocalypse, Paris, BN, Lat. 8878, f. 235, reproduced in W.Neuss, *Die Apokalypse des Hl. Johannes in der altspanischen und altchristlichen Bibel-Illustration*, 2 vols. (Münster in Westfallen, 1931), 2, pl.205; for the inscription see Neuss, 229-30; also see Roda Bible, III, f. 66, W.Neuss, *Die katalanische Bibelillustration* (Bonn and Leipzig, 1922), fig. 101; and the now destroyed ceiling fresco of the 12th century in Regensburg, *Lexicon der christlichen Ikonographie*, 'Nabuchodonosor', vol. 3,307.

16. I wish to express gratitude to Prof. John Williams for a photocopy of relevant pages from the León Bible. Also see Roda Bible, Paris, BN, Lat. 6, III, f. 19v, and illustrations in Neuss, *Bibel*, figs.87, 88, 92. The incident is also described in 2 Kings 25:7.

17. Thus, side by side were two lavishly illustrated commentaries on some of the most evocative and mysterious imagery in the whole of Scripture. While John's text is set in pagan Roman times, Daniel's purports to be from the days of Nebuchadnezzar and the Babylonian Conquest of Judah. Neuss, *Die Apokalypse*, esp. I, ch. 4.

18. With minor modifications this conception of the blinding of Zedekiah remained stable in most of the twenty-two illustrated copies of the Beatus commentary, most dating from the 10th and 11th centuries, that have come down to us; for example, compare the Urgell version with one of approximately AD970 that is presently in Valladolid (Plate 104). Indeed, all nine Beatus manuscripts which still contain a depiction of this episode share a family resemblance. See the Morgan 644, fs. 240v-41r, reproduced in Bernstein, 'Blinding of Harold,' *Proceedings of the Battle Conference*, V, 1982, 61; the Madrid Beatus, Biblioteca Nacional B. 31 (*c.*1047), fs. 268v-269, illustrated in Neuss, *Die Apokalypse*, pl.198; Paris, BN, Lat. 8878 (11th century), f. 217; Gerona, Archivo de la Catedral (*c.*975), f. 253v; Turin, Biblioteca Nazionale Lat. 93 (11th-12th century), fs. 180v-181; Silos Beatus, BL, Add. MS 11695, f. 222v-223. For others and description see Neuss, *Die Apokalypse*, 224.

19. That decapitation is involved is suggested by the marginal figure beneath the scene whose head and body are separated by a large sword.

20. Decapitation scenes involving the victim's being held by the forelock while the victor raises a sword above his head are not unusual in medieval art, and are even sometimes found in the midst of battle. David killing Goliath is sometimes shown in this way, for example, fresco from Santa María de Tahull (*c.*1123), Barcelona, Museu d'Art de Catalunya, ill. in Demus, *Romanesque Wall Painting*, fig. 207; also J. Kiff, 'Images of War: Illustrations of Warfare in Early Eleventh-Century England,' *Anglo-Norman Studies VII, Proceedings of the Battle Conference*, 1984, ed. R. Allen Brown (Bury St Edmunds, 1985), 180, 190.

21. Note such details as the Englishman's being without both armour and weapon, and the fact that there is an already decapitated figure, also without armour, preceding him in the lower margin. Then too there is the puzzling anomaly of the victor wielding one sword while another is at his side, a detail first noted by J. Kiff, 'Images of War'.

22. Jer. 39:5-7; 2 Kings 25:7.

23. For the early Christian prototype behind the León Bible of 960 see John Williams, 'The Beatus Commentaries and Spanish Bible Illustration', *Actas del simposio para el estudio de los códices del "Comentario al Apocalipsis" de Beato de Liébana* (Madrid, 1980), I, 211-13. Also see Neuss, *Apokalypse*, I, 224; Walter Cahn, *Romanesque Bible Illumination* (Ithaca, 1982), 61-82. Moreover, as pointed out by students of Spanish art, the illustrations for the Daniel commentary were not compositions original to the Beatus manuscript tradition. Their source must have been an illustrated bible of a type reflected in the León Bible of 960. This is indicated, first, by a similarity of format, for the pictures accompanying Jerome's *Commentary on Daniel* are unframed and placed against clear parchment in the manner of pictures in Spanish bibles, whereas the miniatures which accompany the Beatus commentary on John are framed and given painted backgrounds. For illustrations from these two types of manuscripts see John Williams, *Early Spanish Manuscript Illumination* (New York, 1977).

24. It has been recently noted, for example, that the 12th-century English manuscript, known as the Lambeth Bible (1140-50), and perhaps from St Augustine's, Canterbury, contains iconography dealing with the prophets (Ezekiel and Daniel, for instance) which can only be paralleled in the Roda Bible. As pointed out by Michael Kauffmann, this is not to claim that the artist of the Lambeth Bible knew the Catalan manuscript but that a similar cycle of prophet illustrations would have been known in 12th-century England. *Romanesque Mss*, 99-100, and figs.30-35. Unfortunately, no prophet illustrations from Anglo-Saxon England survive.

25. WP, 107-11. It is interesting to note what Gibbs-Smith says about the attack on Dol in the notes to the Stenton edition of the Bayeux Tapestry: 'The designer has made a mistake here It is certainly hard to accept that simple mistakes or faulty information could be incorporated in such a work as the Tapestry, but this is certainly one example.' Note to pl.23, BT, 178-79. For an attempt to explain this discrepancy on the grounds that the artist misunderstood the William of Poitiers text see Brooks and Walker, 3.

26. Jehoiachin is referred to as Coniah in Jer. 22:24, 22:28 and 37:1. This nickname does not appear to have been used in the Vulgate, but, like other mysterious details discussed below, is found, so far at least, only in Jewish writings. Note that in the Tapestry Conan is spelled differently in the two attack scenes (Plates XXI, XXIII,

CONAN and CUNAN respectively), a slight alteration, which, by itself, might only be noteworthy as an example of an orthographic variation quite common in the Tapestry, but in the context of other details which point to a biblical source for the Tapestry, the shift from CONAN to CUNAN does recall the almost identical names of father and son, Jehoiakim and Jehoiachin.

27. In the Bible the stories of Nebuchadnezzar's attacks on Jehoiakim and Jehoiachin are found in 2 Kings 23 and 24, 2 Chr. 36, Jer. 22 and 36. The Hebrew legends or *midrashim* have been collected in the magnificent volumes by Louis Ginzberg, *The Legends of the Jews*, with the extra-biblical tales about these two predecessors of Zedekiah recounted in vol. IV, 284-87, and important notes in VI, 379. The quotation in the text is from Ginzberg, IV, 285. In these midrashic sources, Jehoiakim was caught by Nebuchadnezzar and made to suffer an ignominious death. For English translations of some of the sources see *Midrash Rabbah: Genesis*, 879, and *Midrash Rabbah: Leviticus*, ed. H. Freedman (London, 1939), 245-77.

28. The episode of giving over the keys to the Temple to a heavenly hand stretched forth to receive them is transmitted in several rabbinic texts, as well as in the *Apocalypse of Baruch* (X, 18), R.H. Charles, ed., *The Apocrypha and Pseudigrapha of the Old Testament in English* (Oxford, 1913), II, 486. The many texts and their relationships are carefully discussed in P. Bogaert, *Apocalypse de Baruch* (Paris, 1969), 234-41. See also *Encyc. Brit.*, 11th ed., article 'Apocalypse of Baruch', and Ginzberg, *Legends*, VI, 379, n.130 and 393, n.29. I am grateful to Rabbi James Perman and Prof. Shaye Cohen for assistance on these points.

29. K. Weitzmann, 'Die Illustration der Septuaginta', in *Münchner Jahrbuch der bildenden Kunst*, 3-4 (1952-53); also his *Zur Frage des Einfluss jüdischer Bildersquellen auf der Illustration des Alten Testaments* in *Mullus* (Jahrb. f. Antike u. Christ., Ergänzungsb. 1), 1964, 401ff. G. Kretschmar, 'Ein Beitrag zur Frage nach dem Verhältnis zwischen jüdischer und christlicher Kunst in der Antike', in *Abraham unser Vater: Festschrift für Otto Michel* (Leiden, 1963), 295 with bibliography. Both of these articles, the first in an English translation, others by leading scholars in the field are conveniently collected in the important anthology *No Graven Images: Studies in Art and the Hebrew Bible*, ed. J. Gutmann (New York, 1971). Herman Hailperin, *Rashi and the Christian Scholars* (Pittsburg, 1963); Beryl Smalley, *The Study of the Bible in the Middle Ages* (2nd ed., Notre Dame, 1964), esp. 149-95; L. Ginzberg, 'Jewish Folklore: East and West', *Harvard Tercentenary Publications; Independence, Convergence, and Borrowing* (Cambridge, Mass., 1937, 89-108. On medieval art see articles in Gutmann, op. cit. Also Carl-Otto Nordström, 'Rabbinic Features in Byzantine and Catalan Art,' *Cahiers Archéologiques*, 15 (1965), 179-205, and his *The Duke of Alba's Castilian Bible* (Uppsala, 1967). For insular lore and art see O.F. Emerson,

'Legends of Cain, especially in Old and Middle English', *Publ. Modern Language Assn*, XXI (1906); St J. Seymour, 'The Book of Adam and Eve in Ireland,' *Proc. Royal Irish Academy*, XXXVI (1922); R.J. Menner, 'The Poetical Dialogues of Solomon and Saturn,' *Modern Language Assn.* (1941), 21ff, 45ff, 59ff; A.S. Cook, 'Old English Literature and Jewish Learning', *Mod. Lang. Notes*, VI (1891), 142-53; *An Old English Martyrology*, ed. G. Herzfeld, EETS, o.s., 116 (London, 1900); D.N. Dumville, 'Biblical Apocrypha and the Early Irish: a Preliminary Investigation,' *Proc. Royal Irish Academy*, 73 (1973), 299-338; Meyer Schapiro, 'The Angel with the Ram in Abraham's Sacrifice,' *Ars Islamica*, X (1943), 134ff, reprinted in Schapiro, *Late Antique, Early Christian, and Medieval Art*.

30. Ruth Mellinkoff, 'Cain's Monstrous Progeny in "Beowulf": Part I,' *Anglo-Saxon England*, 8, ed. Peter Clemoes (Cambridge, 1979), 157ff.

31. B. Blumenkranz, ed., *Gilberti Crispini Disputatio Iudei et Christiani* (1956); J.A. Robinson, *Gilbert Crispin, Abbot of Westminster* (Cambridge, 1911), esp. 60-67; Southern, 'Gilbert Crispin and the Jews,' *St Anselm and his Biographer*, 88-91. Crispin was abbot from 1085-1117.

32. B. Blumenkranz, *Juifs et Chrétiens dans le Monde Occidental*, 430-1096 (Paris, 1960); R. Chazan, *Medieval Jewry in Northern France* (Baltimore, 1973); L. Rabinowitz, *The Social Life of Jews in Northern France in the XIIth-XIVth Centuries* (London, 1938), which argues that apart from religious life, 'the Jews lived in a state of complete social assimilation with their non-Jewish neighbours'; N. Golb, 'The Forgotten Jewish History of Medieval Rouen', *Archaeology*, 30, no.4-5 (July-Sept. 1977), 254ff. C. Roth, *History of the Jews in England* (Oxford, 1964), 3ff; M. Adler, 'The Jews in Canterbury', in *Jewish Hist. Soc. Trans.*, VII (1915), reprinted in his *The Jews of Medieval England* (1939).

33. As an example of other explanations recall the different reasons one might find for the choice of the blinding of Harold, discussed above; then, too, the key motif when surrendering a castle or town can be found in secular lore; see, for example, *Carmen*, 39 and 49. One point, however, that should not be neglected is the Tapestry's emphasis on the Breton expedition, which in itself has less bearing on the conquest of England than other episodes that the artist omitted, for instance, the campaign that Harold led against Tostig and Harold Hardrada at Stamford Bridge days before the Battle of Hastings.

34. Max Förster, 'Die Weltzeitalter bei den Angelsachsen,' *Die Neuren Sprachen*, beiheft 6 (1925), 183-203, for numerous Anglo-Saxon texts and their relationships to Continental models; also see Bede, 'Chronicle of the Six Ages of the World', in *Historical Works of Venerable Bede*, trans. J.A. Giles (London, 1845), II, 220-21.

35. Note that the schemas may vary: the Babylonian

Captivity can be the transitional point from the third to fourth ages, other times from fourth to fifth, or fifth to sixth. See Förster, op. cit.

36. Smalley, *Study of the Bible in the Middle Ages*, xi.
37. Chibnall, Introd. to OV, I, 15.
38. Ibid., for ref. to the curriculum; see J. Leclerq, *The Love of Learning and the Desire for God* (New York, 1961); also P. Delahaye, 'L'Organization Scolaire au XIIe Siècle,' *Traditio*, V (1947), 211-68.
39. Smalley, *Study*, 24.
40. B. Smalley, *Historians of the Middle Ages* (New York, 1975), 27.
41. OV, IV, 121, using 2 Sam. 16:5-11, in recounting a siege by William Rufus against rebels led by Odo in 1085. Sometimes the Babylonian Captivity played its role as a point of comparison and reference, as in a speech from Orderic Vitalis that was purportedly made by William the Conqueror's barons to express their concern over the division of Normandy and England between two of his sons after the Conqueror's death: 'We must take great care to avoid the kind of division under these princes [William Rufus and Robert Curthose] which befell the Israelites under Rehoboam and Jeroboam. Then one people was divided against itself under two princes, abandoned the law and the temple and worship of God, and lapsed into apostasy. Through this abominable division the Jews fell into the evils of civil war,' which so weakened them that they were easy prey for invasion. 'A part of them were carried away to Media by the Assyrians, never to return; and the other part endured the Babylonian captivity under the Chaldeans.' OV, IV, 122-23. The speech is an invention of the author in the Thucydidean manner; like the Tapestry, the histories of the period combine a classical style with biblical references in the telling of contemporary or recent history.
42. J. Crosland, *Old French Epic* (Oxford, 1951), 74.
43. Smalley, *Study*, xi, and notes; see also Gransden, *Historical Writing in England*, 283, 462.
44. In the next century, an invasion of Italy by the German emperor Henry VI that had many fewer parallels to the Babylonian Conquest than did the Norman Conquest of England was none the less understood by a contemporary, Joachim of Fiore, in terms of Nebuchadnezzar's campaign against Judah. He saw in the ferocious attack on south Italy in 1191 a fulfilment of a prophecy of doom pronounced by Ezekiel on Tyre, 'For thus saith the Lord God: Behold I will bring upon Tyre Nebuchadnezzar king of Babylon, a king of kings from the north, with horses, and with chariots, and with horsemen, and companies, and much people' (Ezek. 26:7). The Emperor Henry VI, like Nebuchadnezzar, took the new Tyre and devastated it. In this way, the study of the Bible gave 'the clue to the vast events on the threshold of which Joachim believed he stood'. Marjorie Reeves, *The Influence of Prophecy in the Later Middle Ages* (Oxford, 1969), 10-11.

CHAPTER XIV: *A Story Fraught with Meaning. Pages 179-91*

1. 2 Chr. 36:11-20; The sins of the priests and people are also developed in Jer. 7 and Ezek. 8, but in 2 Kings 25 the blame is laid chiefly on Zedekiah's own misdeeds. For other references to Nebuchadnezzar as God's 'servant' see Jer. 25:9; 27:6.
2. In an 8th-century biblical commentary, Bede explained the sack of Jerusalem in terms of God's punishing a people whose teachers fell into heresy or apostasy, no doubt with an eye on the spiritual negligence of his own day. Judith McClure, 'Bede's Old Testament Kings', in *Ideal and Reality in Frankish and Anglo-Saxon Society*, ed. P. Wormald (Oxford, 1983), 81.
3. For a brief survey of the field see Gransden, *Historical Writing in England*, ch. 6, 'Historians of the Norman Conquest'.
4. WJ, 1.
5. See Chapter VI, pp. 102-103, above. Also T.A. Dorey, 'William of Poitiers: *Gesta Guillelm Ducis*', in his *Latin Biography*, 139-55, esp. 152-53, and Werckmeister, 'Political Ideology', 550-51.
6. Baudri, ll. 93-572. The *Carmen* also compares him with Caesar and depicts him as surpassing heroes of old; he is 'wiser than Solomon, more valiant and more bountiful than Charlemagne'. *Carmen*, 4-5, 22-25, 46-47.
7. The only difference concerns the voice, Einhard saying Charlemagne had a clear tenor voice. This description of the Conqueror is contained in an addition to some manuscripts of William of Jumièges. It has been printed as a long footnote in T.D. Hardy, *Catalogue of Materials* (RS, 1865), 14-16 and in WJ, 145-49. Translation from EHD, II, 279-80. For the relationships between this Norman obituary and Einhard see L.J. Engels, 'De obitu Willelmi ducis Normannorum regisque Anglorum: Texte, modèles, valeur et origine,' *Mélanges Christine Morhrmann* (Utrecht, 1973), 209-55; Barlow, *William the Conqueror*, 173.
8. Recall that the Beowulf poet, shortly after his hero defeated Grendel, likened Beowulf to the legendary dragon-slayer Siegemund. *Beowulf*, ll. 893-900.
9. Only William of Poitiers mentions Babylon, and this in an inexplicable allusion to how the Normans were such great conquerors that they even attacked Babylon. WP, 228.
10. Recall all of the books in which Nebuchadnezzar figures: 2 Kings, 2 Chr., Jer., Lam., Ezek., Ps., Dan., Isa., Ezra, Neh., Tobias and Judith. This large body of writings, created over many centuries and in response to different problems, treats of much more than the actual conquest of Judah in 586 BC; indeed, much of the biblical literature is concerned with the seventy-year period of actual 'captivity' beside the rivers of Babylon.

224

11. Daniel is a work which falls into two parts, each with a different aim: the first (1-6), composed of six narratives regarding the reign of Nebuchadnezzar and his supposed son Belshazzar, is designed to illustrate how faithful Jews, loyally practising their religion, were enabled by divine help to triumph over their enemies; the latter section (7-9), consisting entirely of apocalyptic prophecies in the form of cryptic or symbolic utterances, is designed to encourage the faithful with predictions of a future of peace and triumph. It is the first work of apocalyptic imagery in the Bible, later examples being 1 Enoch, Syriac Baruch, and the Christian Bible's Book of Revelations, all of which follow Daniel in use of cryptic and symbolic expressions.

12. Neuss, *Bibel*, fig.99; cf. Neuss, *Apok.*, 225-26, pl. 201.

13. Dan. 3:25.

14. The translator of the Vulgate, for example, rendered the original text's description of the fourth figure, one who has the 'likeness of *a* son of the gods' as having the 'likeness of *the* son' of God. The popularity of this prophetic Christological interpretation was virtually insured by its being the subject of a sermon, attributed to Saint Augustine, that became part of the Christmas liturgy. K. Young, *Drama of the Medieval Church* (Oxford, 1933), 2, ch. 21. For Nebuchadnezzar as a prophet in the *Ordo Prophetarum* and on the façade of Nôtre-Dame la Grande in Poitiers, where he is placed with Moses, Isaiah, Jeremiah and Daniel as a prophet announcing the Messiah, see Mâle, *Religious Art of France in the Twelfth Century*, 144-47, fig.129. Perhaps there is also a suggestion of this Christological role in the cross-like insignia on Nebuchadnezzar's crown in the Urgell Beatus, Chapter XIII, Plate 100 above.

15. Dan. 4:15-16.

16. Dan. 4:25.

17. Dan. 4:33.

18. For the Silos Beatus, f. 232v, depicting Nebuchadnezzar as an oriental potentate having his dream interpreted, see Williams, *Early Spanish Manuscript Illumination*, 116 and pl. 39.

19. Neuss, *Bibel*, 91 and fig. 100.

20. Romanesque sculptors did not ignore this story in their decoration of monasteries and churches, the episode of Nebuchadnezzar as a wild beast appearing on a cloister capital at Moissac, in the transept at Saint-Benoit-sur-Loire, at Saint Gaudens, and on the west portal at Bourg-Argental. Mâle, *Religious Art*, 4-17, A.K. Porter, *Romanesque Sculpture of the Pilgrimage Roads*, 10 vols. (Boston, 1923), 8, pl.1152.

21. Thus, when the Anglo-Saxon preacher Ælfric composed a homily on pride he illustrated his message with historical examples: 'as we read everywhere in books, the Almighty Creator often humbles the proud against their will. One of these was Nebuchadnezzar, another was his son Balshazzar'. The stories were then made vivid to the audience by means of lengthy quotations from Daniel, translated into the vernacular, recounting Nebuchadnezzar's descent into bestiality and Belshazzar's infamous feast. *The Homilies of the Anglo-Saxon Church*, ed. and trans. Benjamin Thorpe, 2 vols. (London, 1844), 2, 433-37. For another example, Richard of St Victor saying that 'Nebuchadnezzar serves as an example that, whenever and wherever he pleases, God can humble those who walk in pride' (PL, v.196, 1348), see Penelope Doob, *Nebuchadnezzar's Children: Conventions of Madness in Middle English Literature* (New Haven, 1978), 75. This book and her more fully annotated doctoral dissertation, *'EGO NABUGODONOSOR': A Study of Conventions of Madness in Middle English Literature* (Stanford University, PhD diss., 1970), are fundamental for a study of the image of Nebuchadnezzar in the western Middle Ages. I am greatly indebted to Prof. Doob's research as the following notes will show.

22. *The Homilies of the Anglo-Saxon Church*, trans. Thorpe, 2, 65-67; the connection between Babylon and 'confusion' is found in Augustine, *City of God*, Book XVI, ch. 4, where the Tower of Babel and Babylon are interpreted. In the *Glossa* see, for example, the passage from Isaiah that was taken to apply to Nebuchadnezzar – 'Hell below was in an uproar to meet thee at thy coming. . . . How art thou fallen from heaven O Lucifer, who didst rise in the morning? how art thou fallen to the earth, that didst wound the nations?' – which was glossed 'Nabugodonosor vel Diabolus', *Glossa Ordinaria*, IV, 32-33; *Nebuchadnezzar's Children*, 62-63; Doob, *'EGO NABUGODONOSOR'*, 241; actually the passage refers to Belshazzar. See also Isidore of Seville where Nebuchadnezzar is identified as the devil: 'Nabuchodonosor rex (IV Reg. XXV) typus diaboli fuit, qui haereticorum plebem, erroris captivitate devictam, de Ierusalem, id est, de Ecclesia in Babyloniam, id est, in ignorantiae confusionem abduxit.' *Allegoriae quaedem sacrae scripturae*, PL, v.83, 116; quoted in Doob, *'EGO NABUGODONOSOR'*, 242; cf. also Rupert Tuitensis, *Commentarium in Danielem*, PL, v.167, 1500: 'Nabuchodonosor . . . typum gesserit diaboli inimici Ecclesiae Christi', Doob, *'EGO NABUGODONOSOR'*, 296, n.18. How did this extra-biblical idea become pervasive? Ironically, it was probably through a work that strenuously attacked the notion, Jerome's extremely popular *Commentary* on the Book of Daniel. A volume containing this commentary was apparently made in Canterbury sometime between 1070 and 1100: Cambridge, Trinity College, MS B 3 5; Dodwell, *Canterbury School*, Appendix 4.

23. Psalm 137:1-3, 8-9.

24. Jer. 51:11; see also Isa. 10 and 47. To the writers of Scripture, although the Babylonians were God's chosen instrument for punishing the Hebrews, arrogance prevented them from realizing that their successes were not due solely to their own might. For this and for their cruelty in committing atrocities that

exceeded the bounds of what is acceptable even in war they would be punished.

25. The opening verses of Daniel assert that the events described occurred in Babylon in the third year of the reign of King Jehoiakim, but it has become accepted that the pretence of composition during the Babylonian reign was actually a disguise of 2nd-century BC writers to conceal their hostility to the contemporary Syrian invaders. There is an extensive literature, but for a brief treatment see R.H. Charles, 'Daniel,' *Encyc. Brit.*, 11th ed., vol. 7.

26. Thus commentators described Nebuchadnezzar not as a great conqueror but as 'the wicked one' or 'hater and adversary of God'. Sometimes he was described more pointedly as the 'wicked slave,' an apparent reference to Titus and the notoriously humble origin of the Flavian dynasty. *Encyc. Jud.*, 'Nebuchadnezzar', and refs.; also *Jewish Encyc.*, 'Nebuchadnezzar'.

27. *Encyc. Jud.*, 'Nebuchadnezzar', reference to Lam. R.Proem 23. From early medieval times comes an example of how a Jew looked to the exilic period for consolation and hope. A Christian named Bodo-Eleazer who converted to Judaism in the 9th century wrote: 'It is not surprising that we are captives, and that far from Jerusalem, we have no king of our own. For thus we were captive in Babylon, but later returned to our homeland. This then is our hope: that the same thing will happen to us again, when God wills.' Quoted by B. Blumenkrantz in 'Roman Church and the Jews', *The World History of the Jewish People: The Dark Ages* (New Brunswick, 1966), ed. C. Roth, 93.

28. Revelations 17:1-5; cf. 14:8; 18:1ff; 18:21ff.

29. The commentary of this monk who lived in northern Spain in the 8th century enjoyed an extraordinary popularity, as attested by the well over twenty surviving illustrated copies, only a fraction of what must have once existed. No other book on the Bible was copied and recopied with such remarkable enthusiasm.

30. These frightened men also found in the Book of Daniel the evidence they needed that Antichrist was making his final appearance. R.W. Southern, *Western Views of Islam*, 19-25; Southern, 'Aspects of the European Historical Tradition of Historical Writing: 3. History as Prophecy', Presidential Address, *Transactions of the Royal Historical Society*, 5th series, XXII, 159-86, for use of biblical prophecies in the medieval historiographic tradition; Dodwell, *Painting*, 96-103. Beatus said that the mother of harlots in chapter 17 represents the infidels who attack the church from outside and the schismatics within, and that the fall of Babylon in chapter 18 symbolizes both the final damnation of all heretics and schismatics and the final triumph of God's people.

31. Cited by Dodwell, *Painting*, 102.

32. Williams, *Early Spanish Manuscript Illumination*, 77 and pl. 19a.

33. The Tabara, Valladolid, Gerona and Morgan manuscripts have horseshoe arches with red and white

archivolts; the Apocalypse of St-Sever has the alternating pattern but not the horseshoe shape.

34. Williams, *op. cit.*, 77 and pl. 19b; A.W. Clapham, *Romanesque Architecture in Western Europe* (Oxford, 1936). My thanks to George Zarnecki for assistance in this matter.

35. One thinks of Ælfric's translation into Old English of the Pentateuch, Joshua and Judges, and his homilies, virtual paraphrases, on Judges, Kings, Judith, Esther, Job and Maccabees. S.J. Crawford, ed., *The Old English Version of the Heptateuch, Aelfric's Treatise on the Old and New Testament and his Preface to Genesis* (EETS, o.s., no.160); for editions of the homilies see M.C. Morrell, *A Manual of Old English Biblical Materials* (Knoxville, 1965), 13-18.

36. Sir Israel Gollancz, *The Caedmon Manuscript* (Oxford, 1927). For translation and analysis, C.W. Kennedy, *The Caedmon Poems* (London, 1916), lx-lxiv, 121-45.

37. Kennedy, *Caedmon Poems*, 124, 126.

38. E.g., 'Nebuchadnezzar showed no pity on the tribe of Israel, but made them subject unto him to be his slaves, all such as had escaped the sword.' Ibid., 123.

39. This is from the short prayer entitled, 'The Prayer of Azariah', (ll. 279-361), Kennedy, *Caedmon Poems*, 130-31 (emphasis mine); for problems involved in these interpolated prayers, both this one and 'The Song of the Three Children', see Kennedy, *Caedmon Poems*, lxi-lxii, and the short discussion in W.L. Renwick and H. Orton, *The Beginnings of English Literature to Skelton 1509* (3rd rev. ed., London, 1966), 210-11, with refs. Both prayers are found in another famous codex of Old English verse, *The Exeter Book* (fs. 534-55v), for which see R.W. Chambers, Max Förster, R. Flower, *The Exeter Book of Old English Poetry* (London, 1933).

40. Gollancz, *The Caedmon Manuscript*, a complete facsimile; Wormald, *Drawings*, 76; for possible Christ Church provenance see *Golden Age*, 152. Peter J. Lucas, 'On the Blank Daniel Cycle in MS Junius 11,' *Journal of the Warburg and Courtauld Institutes*, 42 (1979), 207-13. My thanks to Herbert Broderick for his generous help in this matter.

41. A.S. Cook, *Judith, an Old English Epic Fragment* (Boston, 1904), with full discussion and a translation; Bernard F. Huppe, *The Web of Words* (Albany, 1970), a structural analysis, discussion and translation of four Old English poems, including 'Judith'; translation also found in R.K. Gordon, *Anglo-Saxon Poetry* (rev. ed., London, 1954), 320-26, and in Richard Hammer, *A Choice of Anglo-Saxon Verse* (London, 1970). That the biblical work is fictional is evident from the fact that, in complete disregard of historical accuracy, the author has Nebuchadnezzar giving orders to Holofernes in what purports to be the period after the Hebrews have returned from Babylon, hence after Nebuchadnezzar's death and the collapse of the Babylonian empire.

42. Only the concluding portion, totalling 350 lines, of this heroic epic has survived, though what portion that is

of the original entity is not clear. The considerable scholarly speculation on the extent of loss is summarized in Huppe, *Web of Words*, 136ff, with refs. The original is in BL, Cotton Vitellius A.XV, the famous Beowulf manuscript. The part containing 'Judith' belongs to the late 10th or early 11th century.

43. Huppe, *Web of Words*, ll. 225-26; 236-37; 321-23.

44. Stenton, *Anglo-Saxon England* (3rd. ed., Oxford, 1971), 324-29; J.G. Foster, *Judith* (Strassburg, 1892); Cook, *Judith*. As widow of Æthelred of Mercia, who led a notable resistance against the Danes in the early years of the 10th century, she ruled Mercia for eight years, carrying out year by year a deliberate plan of fortress building which gave a new solidity to the defences of Mercia, even allowing her at last to send troops into the enemies' territory. She was remembered in the 12th century by William of Malmesbury, and Henry of Huntington, who celebrated her in a poem; see Huppe, *Web of Words*, 146.

45. *The Old English Version of the Heptateuch, Aelfric's Treatise in the Old and New Testament and his Preface to Genesis*, Crawford, ed., 49. It should be pointed out that following this description, Ælfric discusses the other great book of Jewish patriotism, the book of Maccabees, saying, 'Let us also rely on Almighty God, and he will bring to naught the enemy that afflicteth us.' Ælfric turned both Judith and Maccabees into homilies, which are actually metrical paraphrases in Anglo-Saxon of the originals. B. Assmann, 'Abt Aelfric's angelsachsische Homilie uber das Buch Judith', *Anglia*, 10 (1887), 76-104. This work was composed, according to Assmann, between 997-1005, and is known in two 12th-century manuscripts. The long homily on the Maccabees is found in numerous manuscripts; see W.W. Skeat, *Aelfric's Lives of the Saints*, EETS, o.s., 94, 66-121.

46. EHD, I, 854-59; D. Whitelock, *Sermo Lupi ad Anglos* (3rd rev. ed., London, 1963).

CHAPTER XV: *Conclusion to Part Three. Pages 192-95*

1. This is not to say the artist does not express in other places the pathos of the invasion, as when he shows the woman leading her child away from the house being burnt by the Normans. That this may be a quotation from a Roman monument does not lessen its poignancy. After all since there are many scenes to quote from Roman monuments, why this one?

2. Douglas, *William the Conqueror*, 370-76.

3. K.P. Harrington, *Medieval Latin* (Chicago, 1972), 314-21; complete text in *The Anglo-Latin Satirical Poets and Epigrammatists of the Twelfth Century*, ed. Thomas Wright (London, 1872), II. This verse is used in a short discussion of the medieval vision of death by J. Huizinga, *The Waning of the Middle Ages* (London, 1924), ch. XI. Such lyrical, elegiac sentiments find their

counterpart in Anglo-Saxon literature, for example in the poetic fragment known as 'The Ruin', an elegy on a deserted ruined city taken by many to be the Roman city of Bath: 'Bright were the castle dwellings, many the bath houses, lofty the host of pinnacles, great the tumult of men, many a mead hall full of the bravery of men, till Fate the mighty overturned that.' Gordon, *Anglo-Saxon Poetry*, 84. Also, a remarkable text of the next century by the Anglo-Saxon born, Norman-educated monastic historian Orderic Vitalis uses the passing of the Babylonian empire as an example of how such transience should cause us to reflect on the health of our souls. In narrating the Norman Conquest Orderic invented many speeches for his protagonists, and in one invented for the occasion of a venerable Norman monk's refusal to cross the Channel with William and take up ecclesiastical duties in the new kingdom, Orderic has his character speak these words of admonition to the king:

Do not allow your victory over the English to be a cause of pride to you; but instead gird yourself for the harder and more dangerous battle against the evils of the spirit, for that is a fight you must continue to wage every day. There are frequent revolutions in earthly kingdoms, as we find them scattered over the fields of many books in which God has chosen to supply us with knowledge of the liberal arts. *Under King Nebuchadnezzar the Babylonians conquered Judea, Egypt and many other kingdoms: but seventy years later they and their king Balthasar were conquered and enslaved by the Medes and Persians under Darius and his kinsman Cyrus. . . .* (OV, II, 274-75, my italics.)

4. See Chapter XIV, pages 180-81, above.

5. ASC, 'E', 1087, in EHD, II, 163-64.

6. In this section I am indebted to Robert Hanning, *The Vision of History in Early England* (New York, 1966). William of Malmesbury, GR, Book III, sects. 238, 244; Orderic Vitalis, *Historia Ecclesia*, ed. A. Le Prévost and L. Delisle (Paris, 1838-55), Book III, sect. 8. Interestingly, Henry of Huntington feels God chose the Normans because he 'perceived that they were more fierce than any other people'. *Historia Anglorum*, ed. T. Arnold (RS, 1879), Book VI, sects. 27, 38, quoted in Hanning, *Vision*, 226, n.33. The punishment for sin theme is similar to the way Gildas interpreted the ruin of Britain at the hands of the Anglo-Saxons.

7. See Hanning, *Vision*, 226, n.36, citing *Hist. Eccl.*, ed. A. Le Prévost, IV, 3, 4, 8; VI, 2. Orderic also says about the Battle of Hastings: 'For the Normans became uncontrollable, and on that Saturday they massacred many thousands of English who long before had unjustly murdered the innocent Alfred with his servants, and only a week earlier had slaughtered without mercy King Harold [Hardrada], Earl Tostig, and many others. The same just judge avenged the English on the eve of Sunday, and plunged the fierce Normans into the abyss of destruction. For they had

been guilty of coveting the goods of other men, contrary to the precepts of the law.' OV, ed. Chibnall, II, 177-79. Henry of Huntingdon characterizes the Normans as a people who love to fight until they have 'so crushed their enemies that they can reduce them no lower', at which point they turn against each other. *Hist. Angl.*, VI, 38. Note that Hanning, 128-29, sees the two points of view found in these texts – justificatory and critical – as a reflection of 'two moral and rhetorical traditions', the biblical and the classical, respectively, whereas I find, in the case of the Tapestry, that the Bible would have provided a paradigm for resistance as well as acceptance. It is also interesting to note that certain images in the Tapestry fit the descriptions of these historians quite well. The Normans as predators might be seen in the looting for food that takes place on their arrival at Pevensey (Plates XLV-XLVI), their ferocity, which meant often turning on each other, in the enigmatic workers setting off to build the castle at Hastings who bash each other in the head with their shovels (Plate XLIX), and their cruel oppression in the mother and child being forced to flee the house set on fire (Plate L).

8. See above, Chapter XIV, for Jewish and early Christian uses of Babylonian captivity material, to which should be added the abundant use of the Daniel stories in catacomb paintings. A. Grabar, *The Beginnings of Christian Art, 200-395* (London, 1967). For the Dutch in the 16th century, see E.A. Sanders, *Old Testament Subjects in the Prints of Maarteen van Heemskerck* (PhD. diss., Yale University, 1978). My thanks to Prof. James Marrow for bringing this study to my attention. For the constant invocation of Daniel, as well as Jonah, and Moses, and Joshua, all of whom found salvation in *this* world, by American slaves in their songs, see L. Levine, *Black Culture and Black Consciousness: Afro-American Folk Thought from Slavery to Freedom* (Oxford, 1978), 23, 37, 50-51. My thanks to Amy Swerdlow for reference to this stimulating book.

APPENDIX *Pages 196-97*

1. In medieval oath-swearing ceremonies the sacredness of the oath was based on two things: touching an object with the idea that the object would bring destruction if one swore falsely, and using a formula invoking the Divine as witness: '*In illo Deo, pro quo sanctum hoc sanctifactum est*'; [By the Lord before whom this holy thing is holy] '*In omnipotenti Deo*'; '*On aelmihtiges Godes naman*' were three of the usual opening expressions in Anglo-Saxon oath-formulas. Liebermann, *Die Gesetze der Angelsachsen*, I, 396-99; also see 'Eid', 'Eidesformeln', and 'Meineid' in Lebermann, II. As with other Germanic peoples the swearing person in England continually touched something which in the case of deceit would bring destruction on the perjurer, Liebermann, II, 376. For perjury as a heinous crime,

counting along with murder, adultery and witchcraft as one of the most serious, see Liebermann, II, 580-81; R. Hirzel, *Der Eid* (Leipzig, 1902), chs. 19, 20; and James Tyler, *Oaths* (London, 1834). For the importance of relics in connection with oaths see Max Förster, 'Zur Geschichte des Reliquienkultus in Altengland,' *Sitzungberichte der Bayerischen Akademie der Wissenschaften* (Philosophisch-historische Abteilung, Jahrgang 1943, Hft. 8), 15-22. For using two fingers, Jacob Grimm, *Deutsche Rechtsaltertümer*, 4th ed. (1899), II, ch. VII ('Eid'), 555.

2. Note that in the death of Harold scene there are also ocular-shaped objects, two bosses which are unique in the Tapestry, on the harness of the horse ridden by the knight who slashes Harold's thigh.

3. First the anonymous author of the *Brevis Relatio*, known as the Hyde writer, and then Wace. *Brevis Relatio*, Edward Edwards, ed., *Liber Monasterii de Hyda* (RS, 45, 1866), 290: '*Ei, sicut multi dicunt, super filacterium quod vocabant oculum bovis quod ei fidem et promissionem quam ei faciebat bene custodiret.*' The Hyde writer then tells why it is called the 'bull's eye': *Infinitam sanctarum multitudinem reliquiarum deferri jussit, superque eas filacterium gloriosi martyris Pancratii, quod oculum bovis vocant, eo quod gemmam tam speciosam quam spatiosam in medio sui contineat, collocavit, certissime sciens tantum martyrem nulla temeritate posse deludi.*' The mention of St Pancras is tantalizing, as he was a protector of oaths, but probably apocryphal as there was no cult of Pancras in Bayeux. Wace, for example, does not mention him. Wace, *Roman de Rou*, II, 97-98, ll. 5691-96 '*desus out mis un filaterie, tot le meillor qu'il pout eslire e le plus chier qu'il pout trover, oil de boef l'ai oi nomer. Quant Heraut sus sa main tendi la main trembla.*' As there was, however, a special worship of St Pancras at St Augustine's Abbey, Canterbury, there might actually be some connection between the *oculus bovis* of the Hyde writer and a cult of St Pancras that can no longer be documented. H. Leclerq, 'Pancrace,' *Dictionaire d'Archéologie Chrétienne et de Liturgie*, ed. F. Cabrol and H. Leclerq, 15 vols. (Paris, 1907-54), XIII, part I; *Les Petitis Bollandists* (Paris, 1882), V, 'Saint Pancrace'; P.H. Blair, *An Introduction to Anglo-Saxon England* (Cambridge, 1977), 148-50.

4. Some observers see this object as the wafer for mass, EHD, II, 235, and Brooks and Walker, 5.

5. In architecture a round opening in a wall or the ceiling was also called an *oculus* or *oeil de boeuf*.

6. Ginzberg, *The Legends of the Jews*, V, 139, n.20. Samson's use of a jawbone in slaying the Philistines apparently owes its origin to a similar linguistic play: jawbone in Hebrew is *lechi*, which is also the name for the place where the author of Judges locates the battle. Judges 15:14. In medieval inventions the same process of linguistic transference may be operating in the Anglo-Saxon vernacular custom of specifying that Cain used not a rod, stone or hoe but a jawbone for his murder weapon, as suggested by Meyer Schapiro,

'Cain's Jaw-Bone That Did The First Murder,' in his *Late Antique, Early Christian, and Medieval Art*, 249-65, esp. 256. I am indebted to Schapiro's approach for much of the material in this section. For other explanations of Cain's jawbone, see the articles by G. Henderson in *Journal of the Warburg and Courtauld Institutes*, XXIV (1961), 108-14, and A.A. Barb in the same journal, XXV (1972), 386-89.

7. H. Delahaye, *Les Légendes Hagiographiques* (Brussels, 1927), 45ff (available also in English translation); K. Nyrop (and H. Gaidoz), 'L'Étymologie Populaire et le Folklore,' *Mélusine* (1899), IV, 504-24 (1980), V, 12-15, 148-52. C. Cahier, *Caractéristiques des Saints dans l'Art Populaire* (Paris, 1867), I, 'Aveugles', 104-106.

8. '*Auge*' is the German for 'eye'. Also, note that an 'eye' on a reliquary might be associated with divine observation of the proceedings between William and Harold, a consideration also suggested by an unusual feature of this scene, the placing of the oath ceremony out of doors. This was a designated locale in biblical, Roman and some medieval oath-swearing customs, so that no secret could be hidden from the Divine. Grimm, op. cit., II, 545, with references to laws and secular literature on swearing in the open. In Rome, according to historians of ancient legal customs, perhaps the majority of oaths were sworn out of doors so that no secret could be hidden from the sight of the Divine. In the Hebrew Scripture, to cement a covenant with David, Jonathan said to him, 'Come, let us go out into the field,' where Jonathan then added the words, 'The Lord, the God of Israel be witness' (I Samuel 20:11-12).

PLATES:
THE BAYEUX TAPESTRY

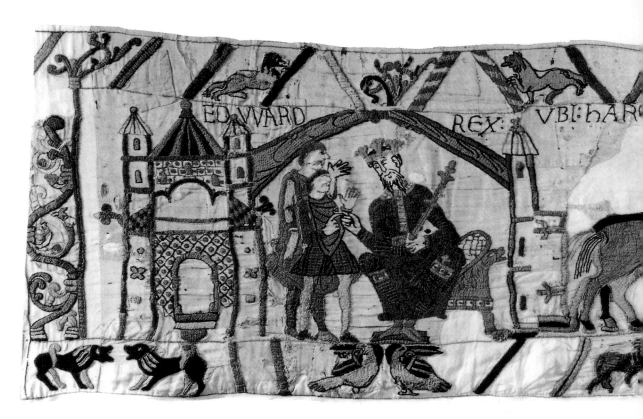

I KING EDWARD: In his palace Edward the Confessor speaks with Earl Harold and a companion.

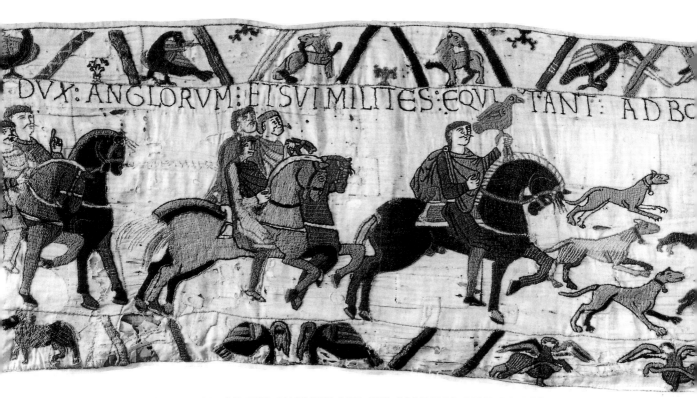

II WHERE HAROLD DUKE OF THE ENGLISH AND HIS SOLDIERS RIDE TO BOSHAM:
Harold Godwinson rides in front, hawk on wrist, his dogs before him.

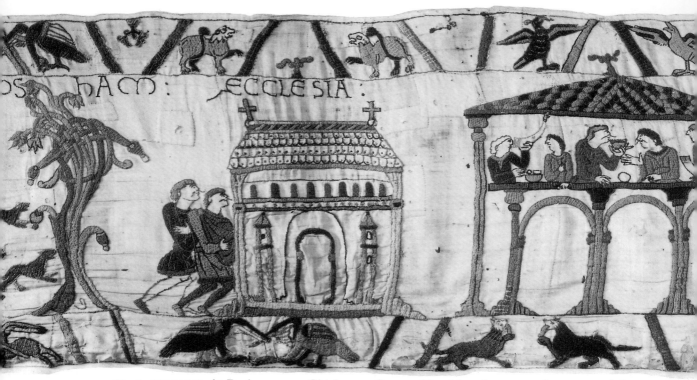

III A CHURCH: At Bosham, near Chichester, Sussex, Harold and a companion pray and then dine in the upstairs room of a seaside house.

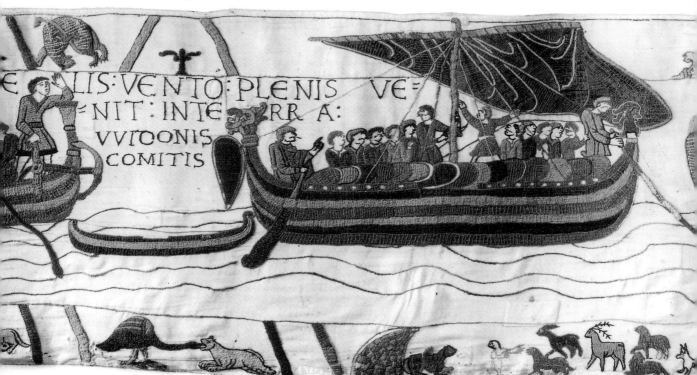

V AND WITH THE WIND FULL IN HIS SAILS ARRIVED IN THE LAND OF COUNT GUY: As they approach the French side of the Channel in the Viking-type ships, one man takes a sounding of the depth.

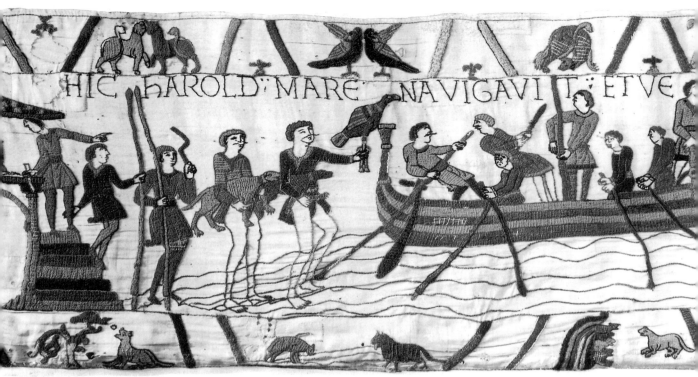

IV HERE HAROLD SAILED THE SEA: A messenger informs the diners it is time to start. Having removed their hose and tucked up their skirts, Harold and company wade out to the ships carrying hounds and a hawk.

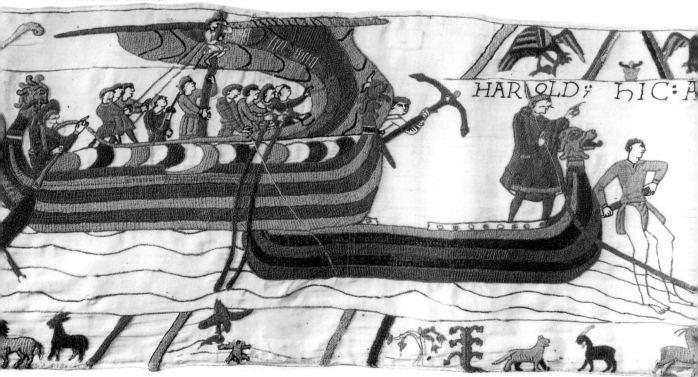

VI HAROLD: Land is sighted by a sailor who has shinnied to the top of the mast, the anchor is dropped and Harold approaches shore in a ship.

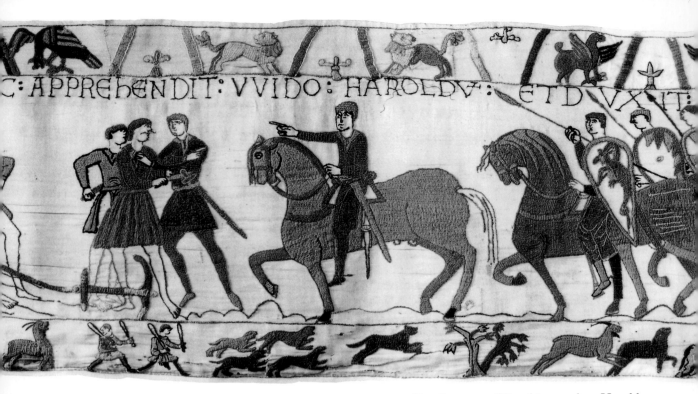

VII HERE GUY SEIZES HAROLD AND LED HIM: Guy I, count of Ponthieu, orders Harold seized and held for ransom.

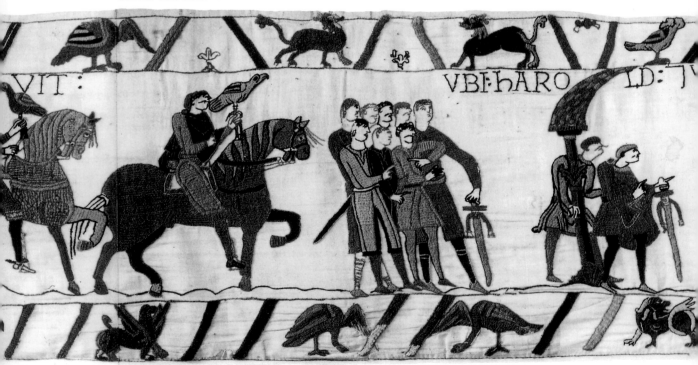

IX Harold rides as a captive at the head of the party without reins in his hand and without spurs. WHERE HAROLD AND GUY CONFER:

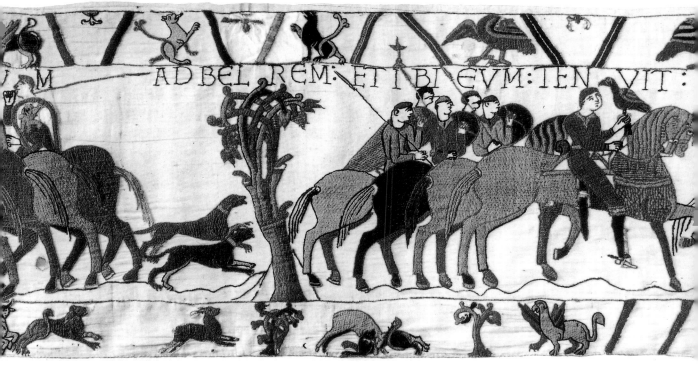

AM ADBEL REM:ET IBI EVM:TEN VIT:

VIII TO BEAURAIN AND HELD HIM THERE:

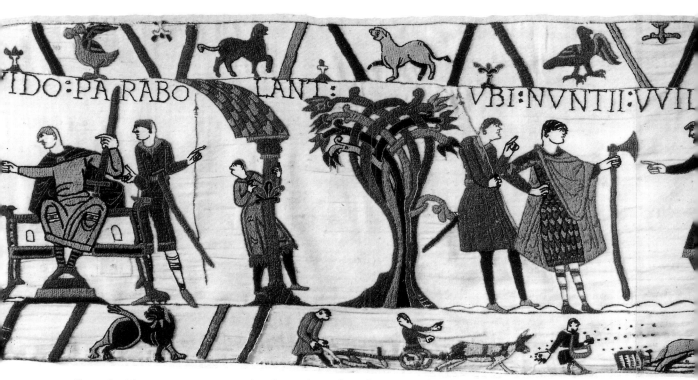

IDO:PA RABO LANT: VBI:NVNTII:WII

X Seated with an enormous sword in his palace, Guy dominates the discussion. WHERE MESSENGERS: An attendant touches Guy's elbow to inform him that messengers from Duke William have arrived. Holding an axe and wearing an elaborately patterned tunic, Guy greets them.

235

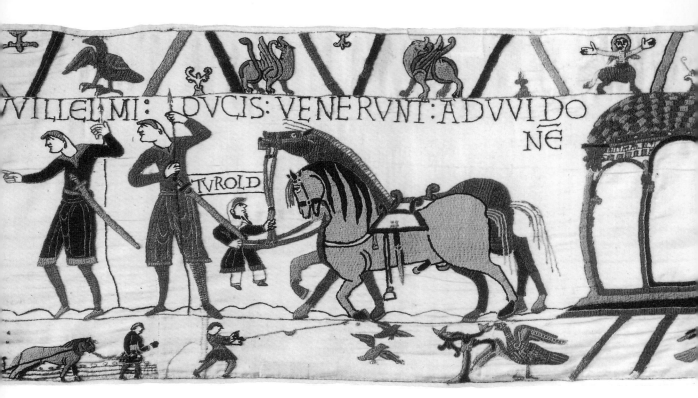

XI OF DUKE WILLIAM CAME TO GUY: A dwarf holds the reins of their spirited horses while the two messengers, one of whom is apparently named TUROLD, demand that Guy release Harold.

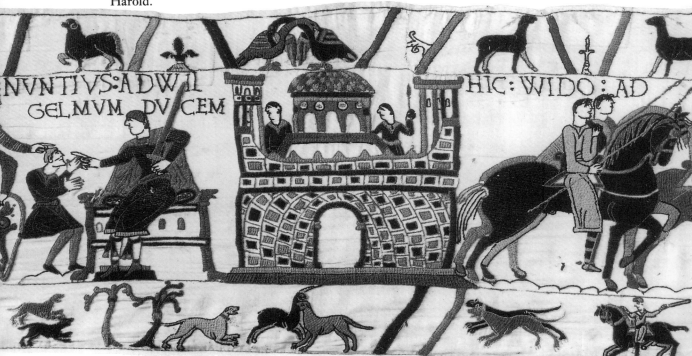

XIII HERE A MESSENGER CAME TO DUKE WILLIAM: Another scene in reverse order, with an Anglo-Saxon, as evident from his moustache, informing William that Harold has been captured. The duke orders the two knights to rescue Harold.

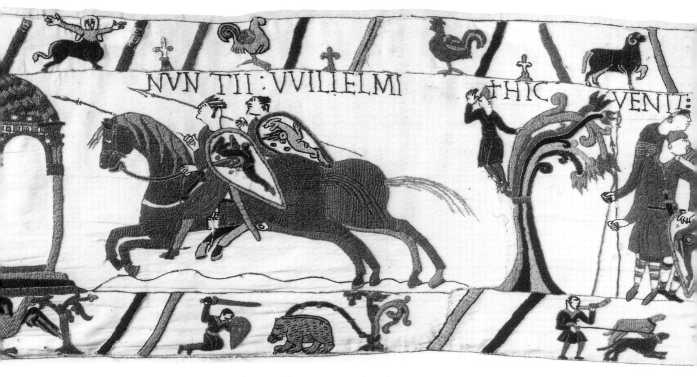

XII WILLIAM'S MESSENGERS: A scene in reverse order showing the messengers galloping from William's palace to Beaurain.

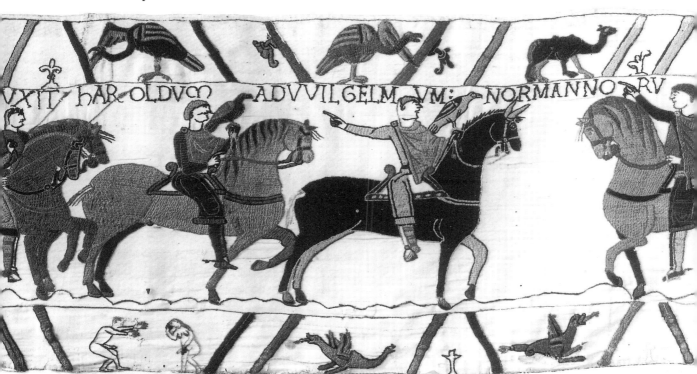

XIV HERE GUY BROUGHT HAROLD TO WILLIAM, DUKE OF THE NORMANS: Count Guy, riding in front, points back to Harold. The difference between Norman and English hair-styles and taste for moustaches is emphasized.

237

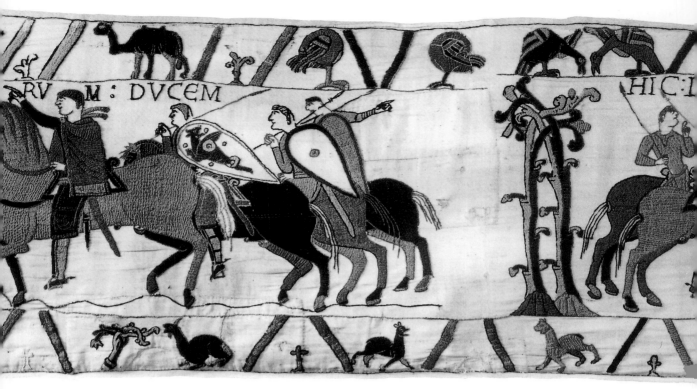

XV William, at the head of his party, greets Guy and Harold.

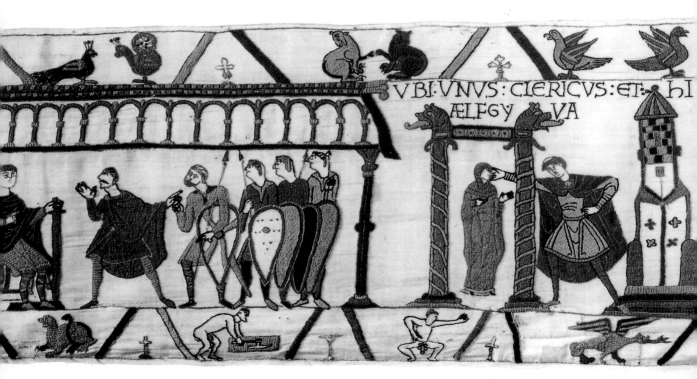

XVII William and Harold converse in the palace watched by William's knights. WHERE A CLERK AND ÆLFGYVA: A mysterious scene, probably alluding to a sexual scandal, but the identity of ÆLFGYVA and the cleric are uncertain. Note that there is no verb in the inscription.

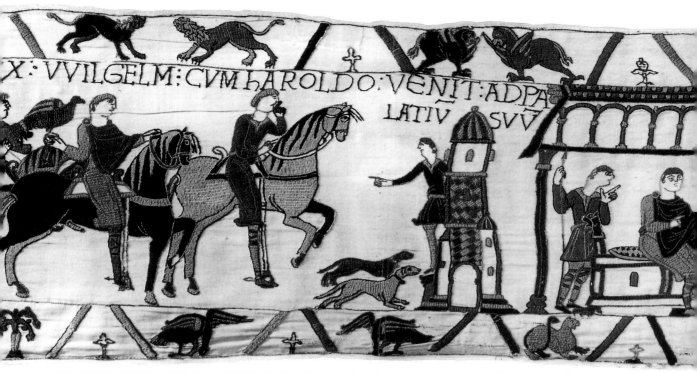

XVI HERE DUKE WILLIAM, WITH HAROLD, CAME TO HIS PALACE: A lookout greets the party as they arrive, perhaps at Rouen.

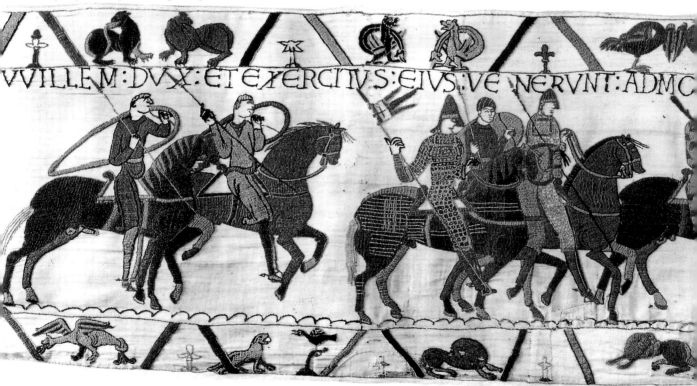

XVIII HERE DUKE WILLIAM AND HIS ARMY CAME TO: William, Harold and the duke's Norman knights set off on a campaign to punish one of William's vassals in Brittany.

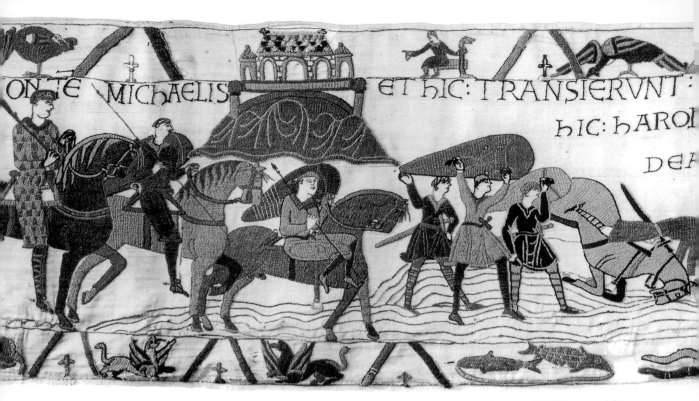

XIX ST MICHAEL'S MOUNT: With Mont-Saint-Michel in the background William and his troops travel from Normandy to Brittany. AND HERE THEY CROSSED THE RIVER COUESNON.

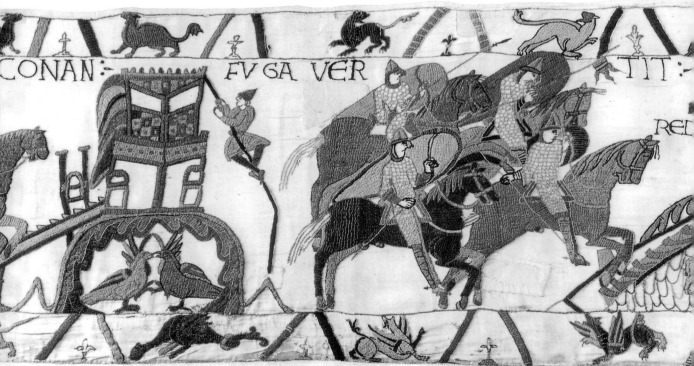

XXI AND CONAN TOOK TO FLIGHT: The Breton vassal escapes down a rope from a castle situated atop a mound. The soldiers give chase, passing RENNES.

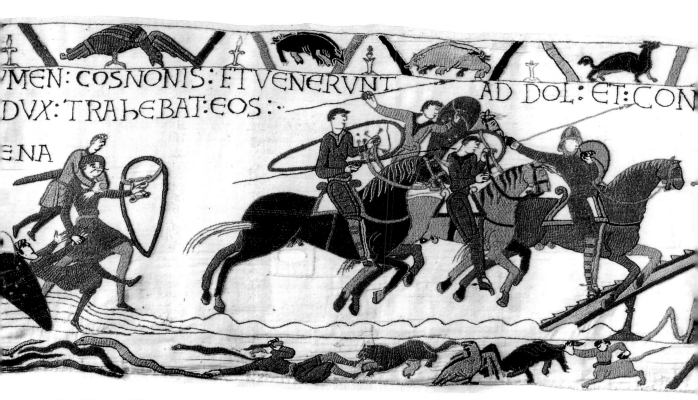

XX HERE DUKE HAROLD DRAGGED THEM OUT OF THE SAND: In crossing the treacherous quicksands of the river, some soldiers fall and Harold rescues two of them. AND THEY CAME TO DOL

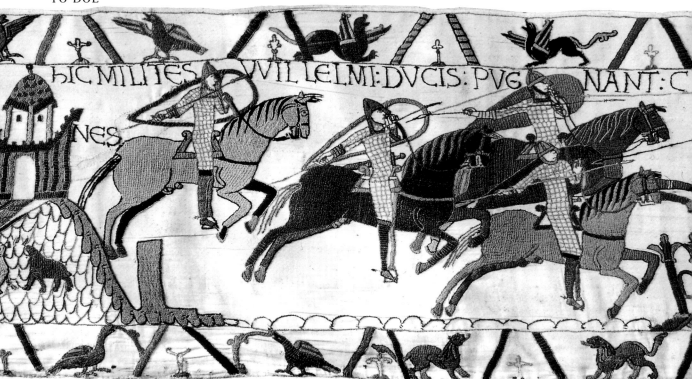

XXII Entering deeper into Brittany, HERE DUKE WILLIAM'S SOLDIERS FIGHT

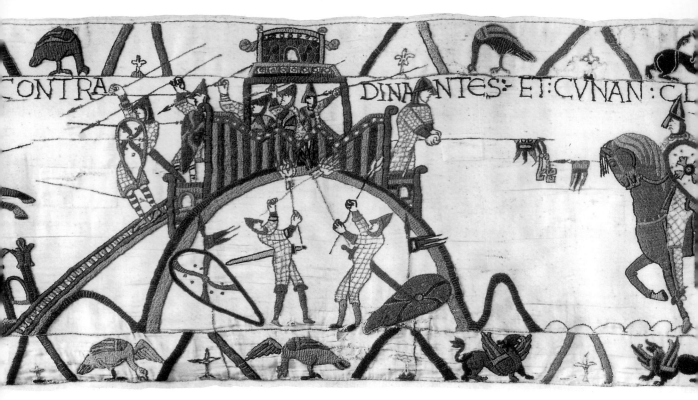

XXIII AGAINST THE MEN OF DINAN AND CONAN HANDED OVER THE KEYS: Having surrounded Conan at Dinan, two of William's soldiers set fire to the castle, forcing Conan to hand over the keys to the castle on the end of a lance.

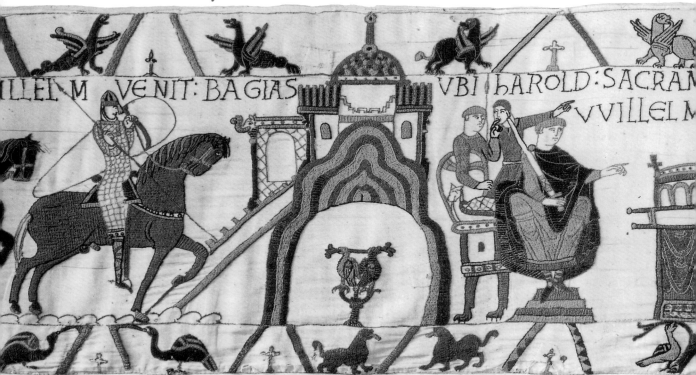

XXV HERE WILLIAM CAME TO BAYEUX: William and Harold return to Normandy and arrive at Bayeux, here spelt in a fashion not found in any other source.

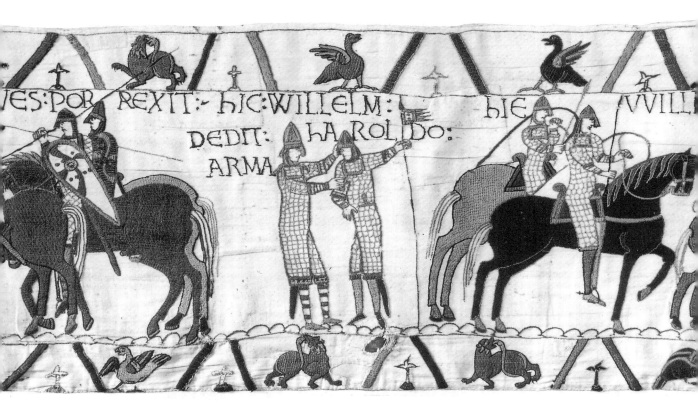

XXIV HERE WILLIAM GAVE ARMS TO HAROLD: Rewarding Harold for his valour in the Breton campaign, William bestows arms on Harold in a ceremony resonant with symbolism about feudal supremacy and loyalty.

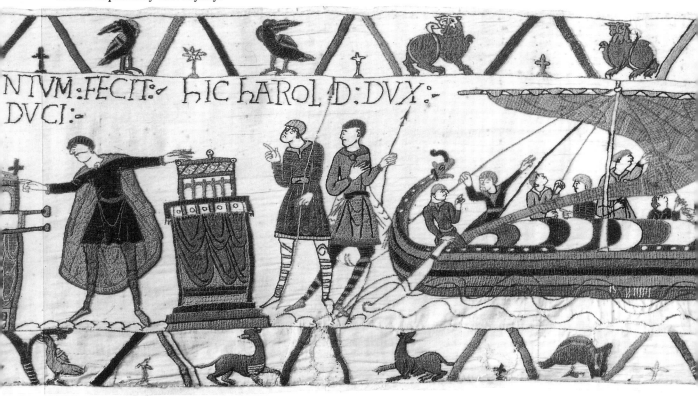

XXVI WHERE HAROLD TOOK AN OATH TO DUKE WILLIAM: The climax of the trip to Normandy. Harold, standing between two shrines, swears an oath to William to forward the duke's claim to the throne of England.

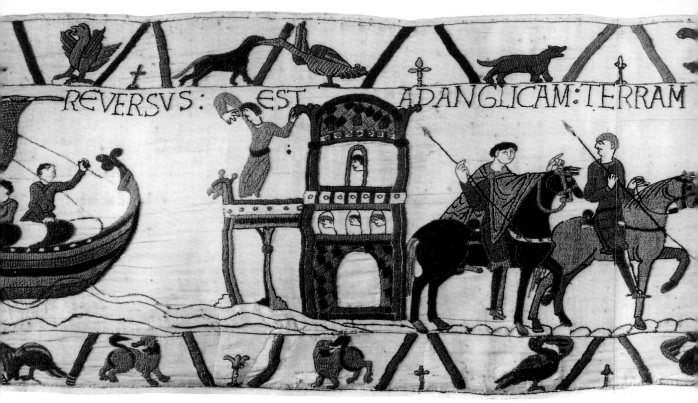

XXVII HERE DUKE HAROLD RETURNED TO ENGLISH SOIL: Immediately Harold and his men set sail for home. A watchman and people in the windows of the port structure anxiously await their return. Harold and a companion ride towards Westminster.

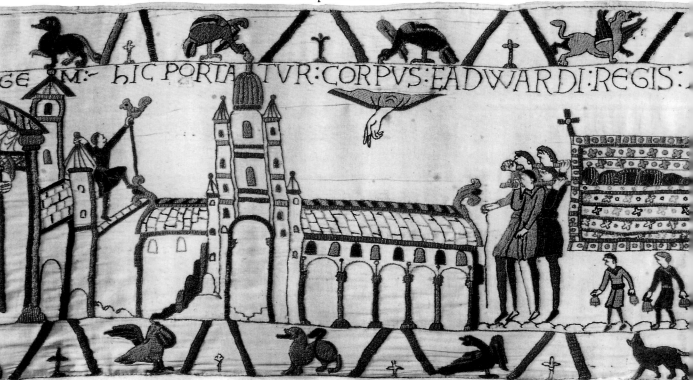

XXIX HERE THE BODY OF KING EDWARD IS CARRIED TO THE CHURCH OF ST PETER THE APOSTLE: The scenes of Edward's death (4 January 1066) and burial are in reverse order. The large church is Edward's new abbey at Westminster, its newness indicated by the man affixing the weathercock. God's favour is manifested by the hand in the sky.

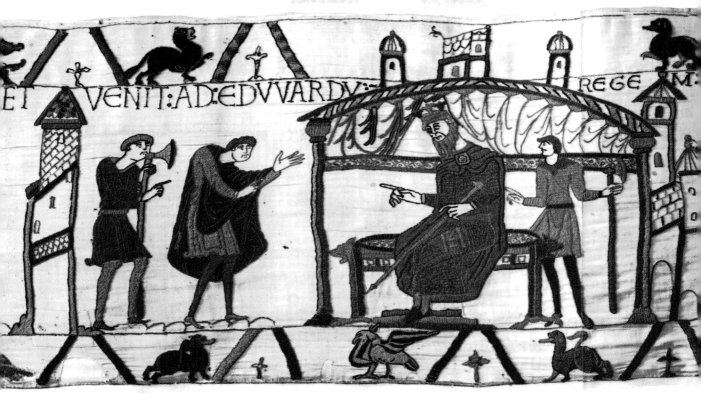

XXVIII AND HE CAME TO KING EDWARD: The aged king, who, judging by the stick he carries, is infirm, speaks with Harold about the journey. Whether Harold's posture is meant to be read as reverential or apologetic is unclear.

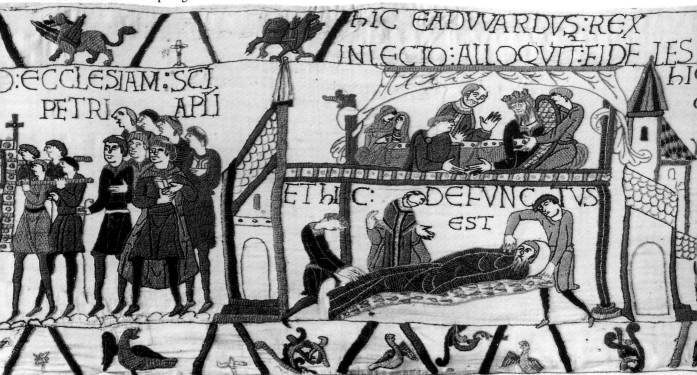

XXX HERE KING EDWARD ADDRESSES HIS FAITHFUL ONES: It is the day on which Edward is both alive and dead. In an upstairs room the king is surrounded by a cleric, his wife and Harold, to whom he extends his hand. Below (AND HERE HE DIED) the body is shrouded for burial.

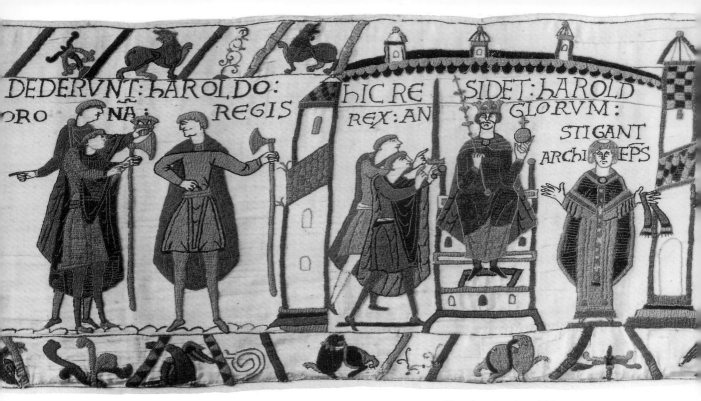

DEDERVNT:HAROLDO: ORO NA: REGIS HIC RE SIDET:HAROLD REX:AN GLORVM: STIGANT ARCHI EPS

XXXI HERE THEY GAVE HAROLD THE KING'S CROWN: Two knights hand Harold the crown while one points backwards. In the next scene (HERE SITS HAROLD, KING OF THE ENGLISH) Harold is acclaimed king by two nobles and ARCHBISHOP STIGAND. It is January 1066.

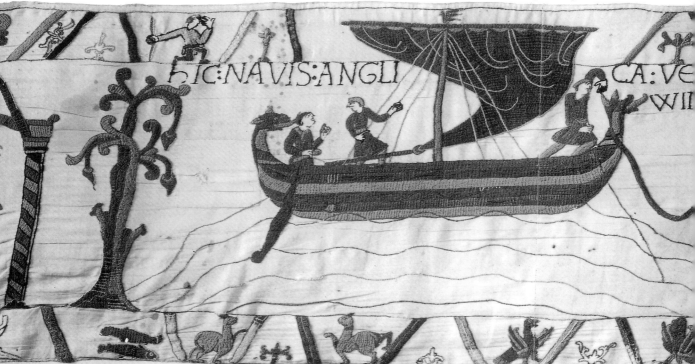

HIC:NAVIS:ANGLI CA:VE WII

XXXIII A ship departs from England.

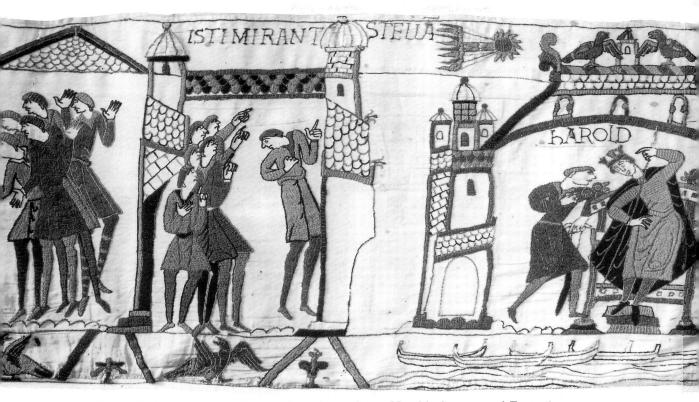

ISTI MIRANT STELLA

HAROLD

XXXII In an adjoining chamber the populace also acclaims Harold; then around Eastertime, Halley's comet appears in the heavens, and THESE MEN MARVEL AT THE STAR. HAROLD inclines his head to hear what the appearance of the comet portends.

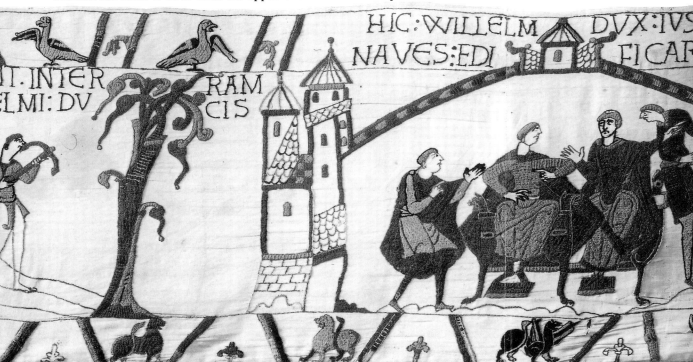

HIC: WILLELM DUX: IVS NAVES: EDI FICAR

IT. INTER ELMI: DV RAM CIS

XXXIV HERE AN ENGLISH SHIP CAME TO THE LAND OF DUKE WILLIAM: News arrives of what the duke would call Harold's treachery.

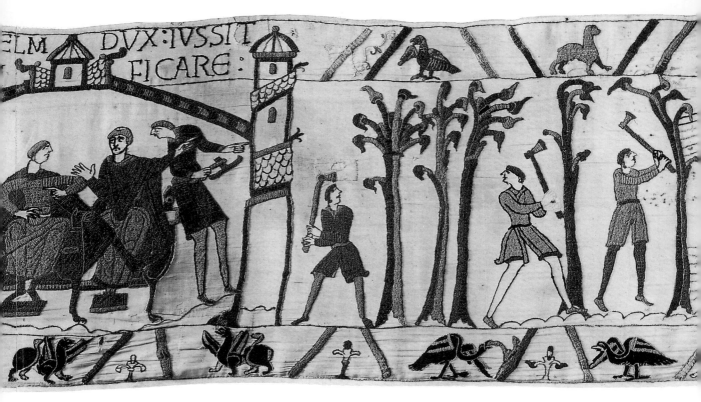

XXXV HERE DUKE WILLIAM ORDERED THEM TO BUILD SHIPS: In consultation with his brother Odo, the tonsured cleric seated beside him, the duke commands that an armada be built. A carpenter is conveniently present, and trees are felled.

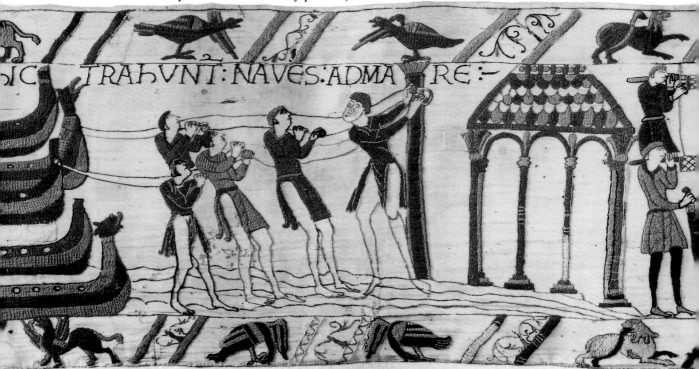

XXXVII HERE THEY DRAG THE SHIPS TO THE SEA by means of a pulley attached to a post.

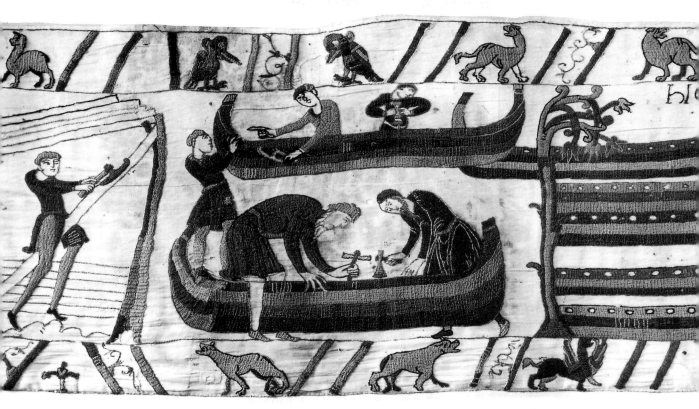

XXXVI Each stage of the preparations is shown. Planks are cut and planed, shipwrights are at work.

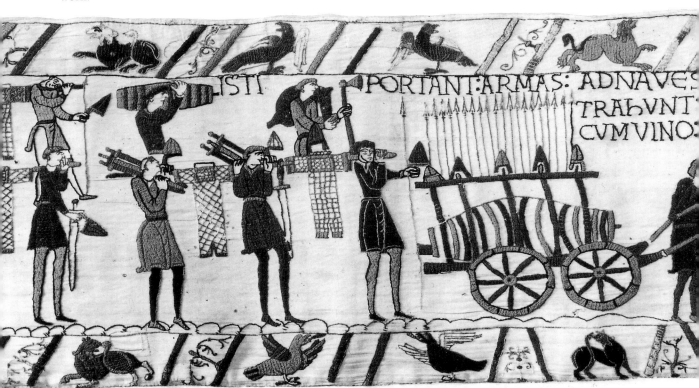

ISTI PORTANT:ARMAS: ADNAVES TRAhVNT CVMVINO.

XXXVIII THESE MEN CARRY ARMS TO THE SHIPS, AND HERE THEY DRAG A CART LADEN WITH WINE AND ARMS: Men carry hauberks on poles, while a multi-purpose cart transports lances, helmets and the apparently indispensable wine cask.

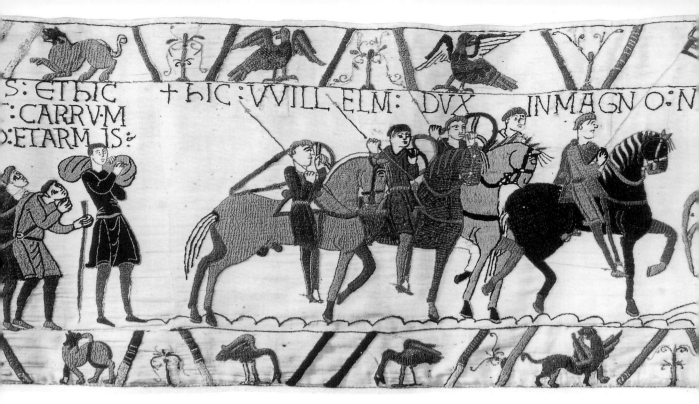

S: ETHIC +HIC : VVILLELM : DVX INMAGNO : N
: CARRVM
: ETARMIS :

XXXIX HERE DUKE WILLIAM: William and a part of his 6,000 knights ride to the shore for disembarking. Preparations have taken nine months, for it is now September 1066.

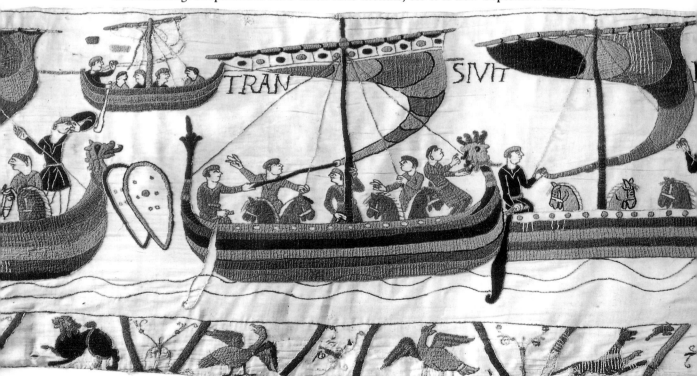

TRAN SIVIT

XLI The armada is spread out in the Channel as it approaches the English shore.

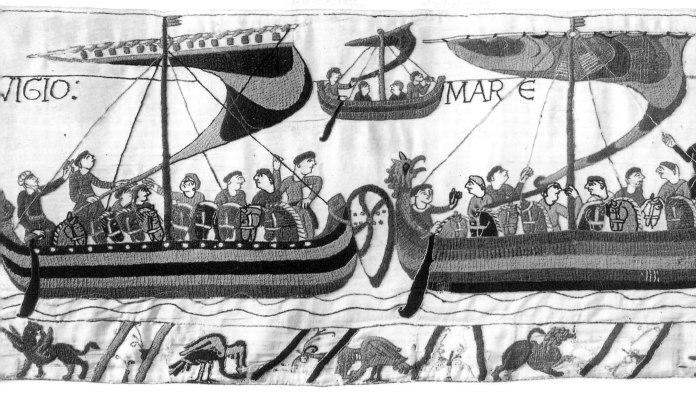

XL IN A GREAT SHIP CROSSED THE SEA: Ships with men and horses aboard raise their sails.

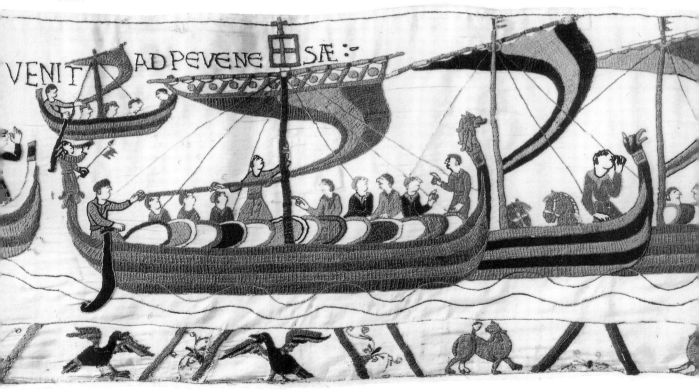

XLII AND CAME TO PEVENSEY. William's own ship is thought to be the one with the cross atop the mast, and a sternpost figure carved to depict a horn-blowing man holding a lance and gonfanon.

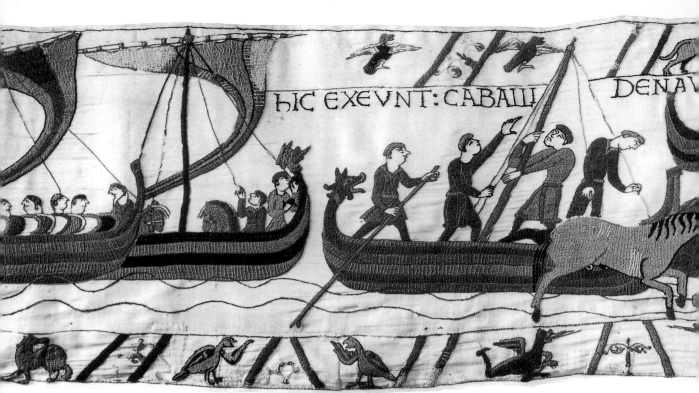

HIC EXEVNT:CABALLI DENAV

XLIII HERE THE HORSES CAME OUT OF THE SHIPS, led ashore, apparently quite happily, by their bridles.

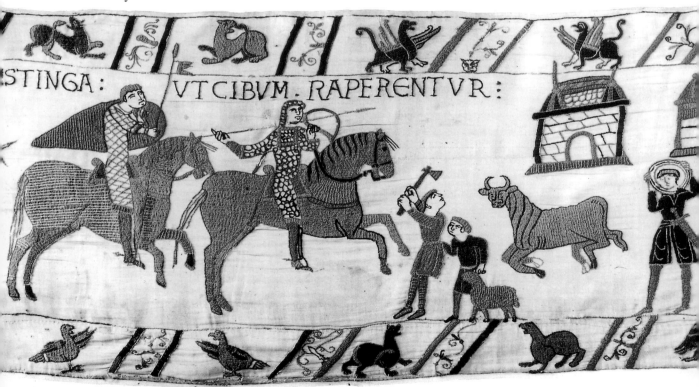

STINGA: VT CIBVM. RAPERENTVR:

XLV TO SEIZE FOOD.

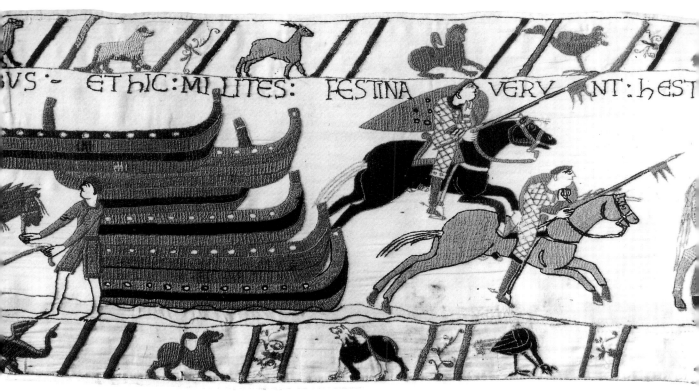

XLIV AND HERE THE SOLDIERS HURRIED TO HASTINGS: While the empty ships have been dragged up on shore, men go to set up camp.

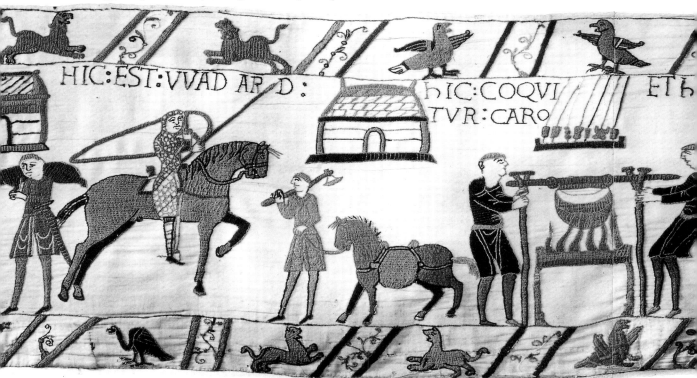

XLVI One of the Norman foragers, a knight on horseback, is identified: HERE IS WADARD. The preparations for a meal begin: HERE THE MEAT IS COOKED

253

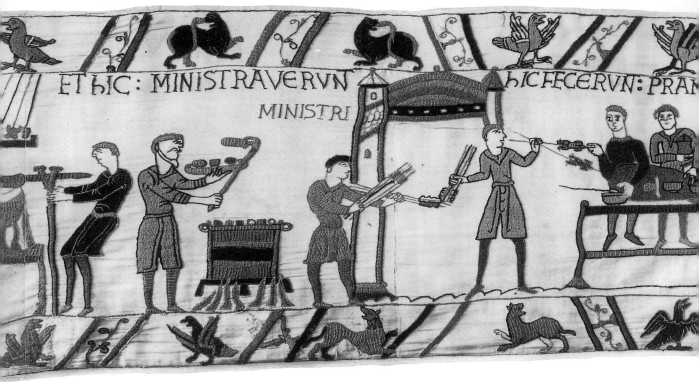

XLVII AND HERE THE SERVANTS SERVED IT UP: The skewered chicken and meats are
passed to waiters who assemble everything on shields pressed into domestic service: HERE THEY
MADE A BANQUET. A horn blast calls the diners to assemble.

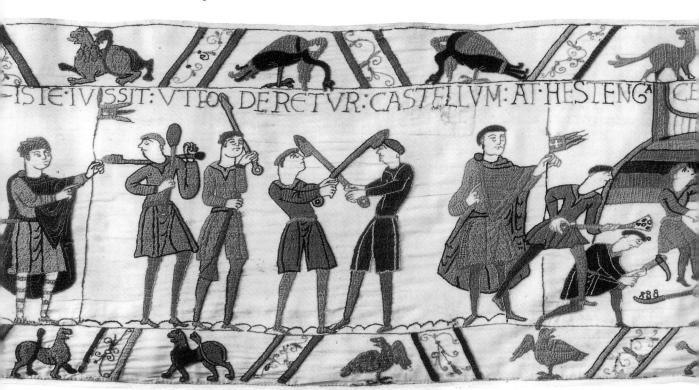

XLIX THIS MAN ORDERED THAT A CASTLE SHOULD BE THROWN UP AT HASTINGS:
A commander and four workers who follow him carry tools; two of them smash shovels into
each other's heads. The whole composition is very curious.

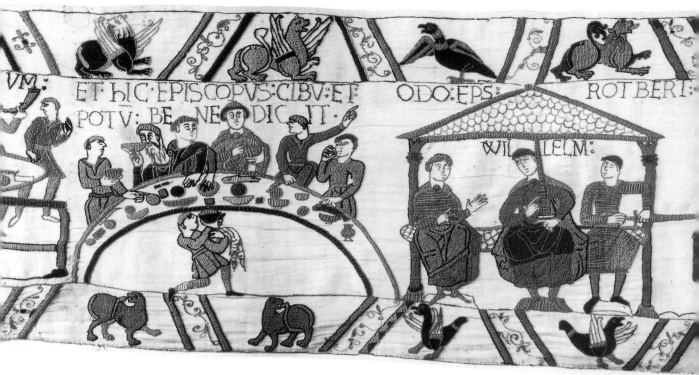

XLVIII AND HERE THE BISHOP BLESSES THE FOOD AND DRINK: At the head of the semi-circular table sits Odo, with William apparently to his right. Note that from here on, the inscriptions appear in alternating colours (Plate 17). A council of war follows, attended by BISHOP ODO, WILLIAM and ROBERT, probably the duke's other brother, Robert of Mortain.

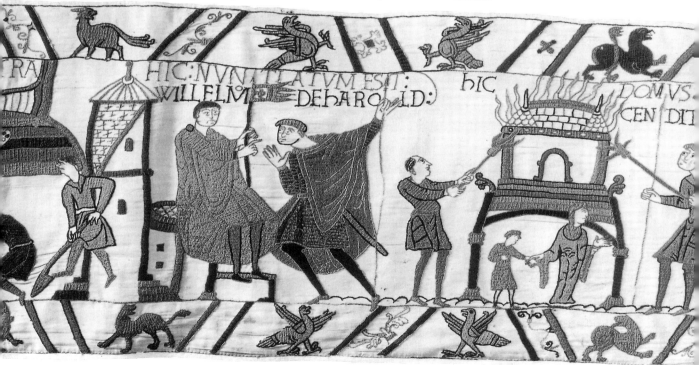

L The fortification is identified as a CASTLE, perhaps because, being a Norman importation, it was such a novelty in England. HERE A MESSAGE IS BROUGHT TO WILLIAM ABOUT HAROLD: No doubt the message is about Harold rushing south after defeating Harold Hardrada near York. The Normans ravage the neighbourhood: HERE A HOUSE IS BURNED.

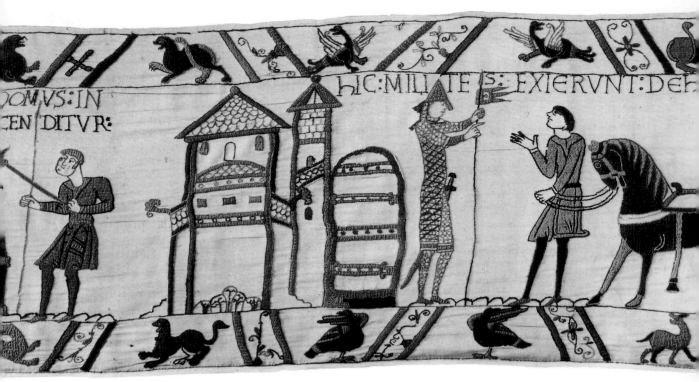

LI HERE THE SOLDIERS WENT OUT FROM HASTINGS. A fully-armoured knight prepares to set out from Hastings.

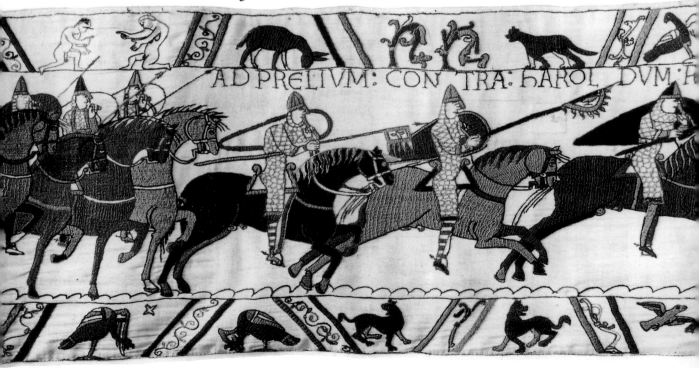

LIII AND CAME TO BATTLE AGAINST KING HAROLD: Some of the Norman cavalry gallop to battle.

256

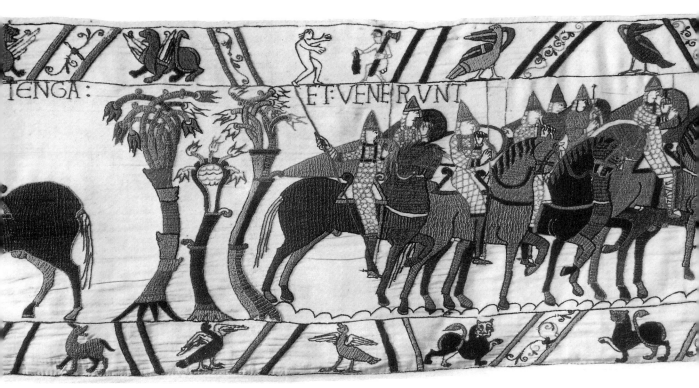

LII A mass of cavalry moves north to do battle.

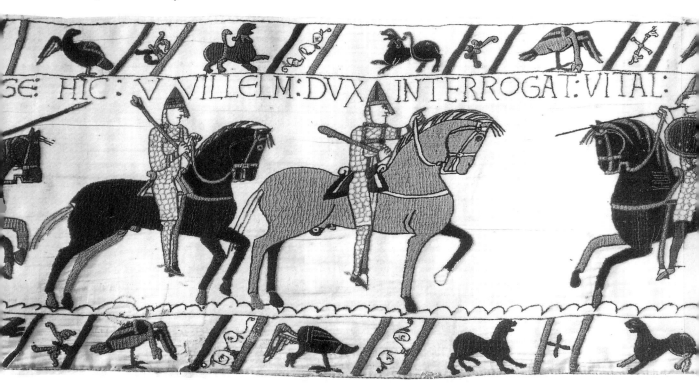

LIV HERE DUKE WILLIAM ASKS VITAL: William is the figure holding a mace on the light-coloured horse, and perhaps appears as well on the darker horse behind, at the head of the cavalry.

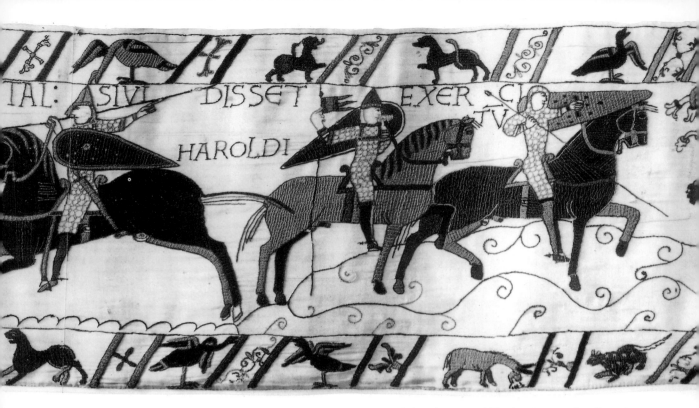

LV WHETHER HE HAS SEEN HAROLD'S ARMY: A knight named Vital points in the direction of the hill from which Norman lookouts have spotted Harold's army.

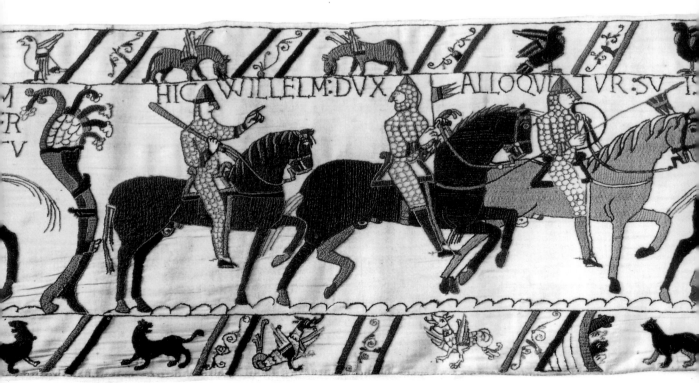

LVII HERE DUKE WILLIAM EXHORTS HIS SOLDIERS: William, on the left with a mace, addresses his men. This extended inscription is the only one in the Tapestry to describe what a person said.

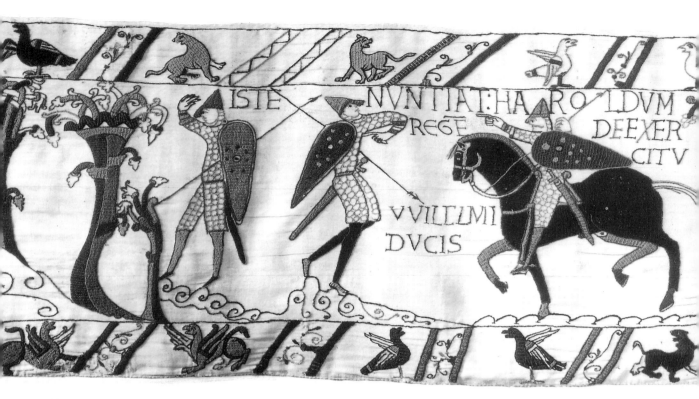

ISTE NVNTIAT HAROLDVM
REGE DEEXER
CITV
VVILELMI
DVCIS

LVI THIS MAN GIVES NEWS TO KING HAROLD ABOUT DUKE WILLIAM'S ARMY: An English scout looks out, and either he or another scout rushes to tell a mounted Harold about the approach of the Norman army.

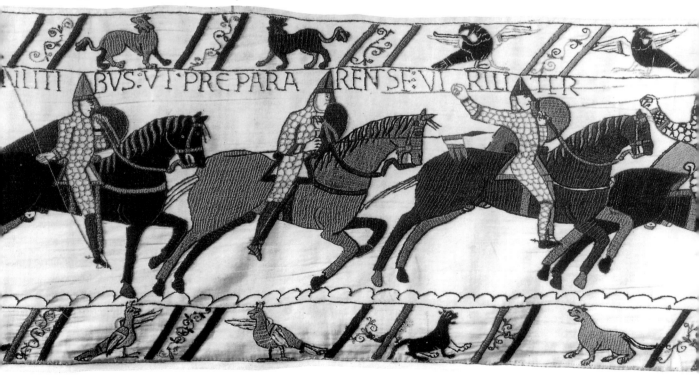

NLITI BVS:VI PREPARA RENSE:VI RILITER

LVIII TO PREPARE THEMSELVES VALIANTLY: The Norman cavalry advances, some couching their lances, others holding them overhead.

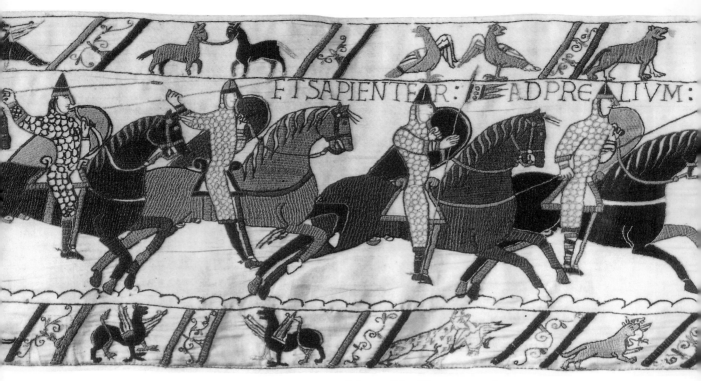

LIX AND WISELY FOR THE BATTLE: More of the Norman cavalry.

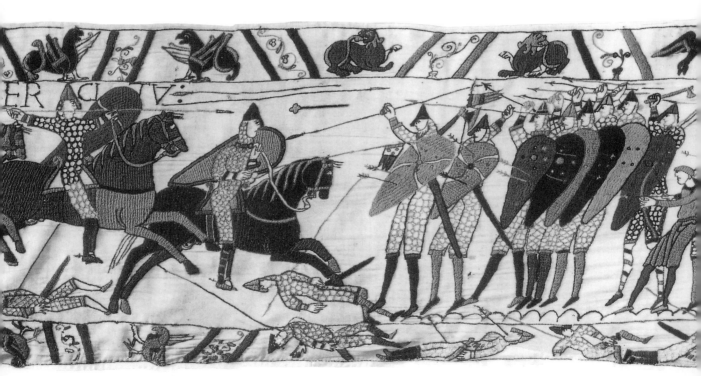

LXI It is Saturday 14 October 1066, and the battle is joined. The two modes of warfare are graphically distinguished, the Normans on horseback fighting with the aid of archers, and the English on foot, forming a shield-wall, here shown having only a single bowman.

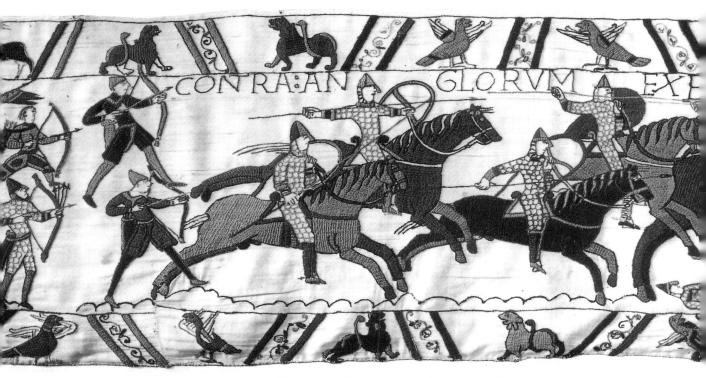

LX AGAINST THE ENGLISH ARMY: Norman archers move out in support of the mounted knights.

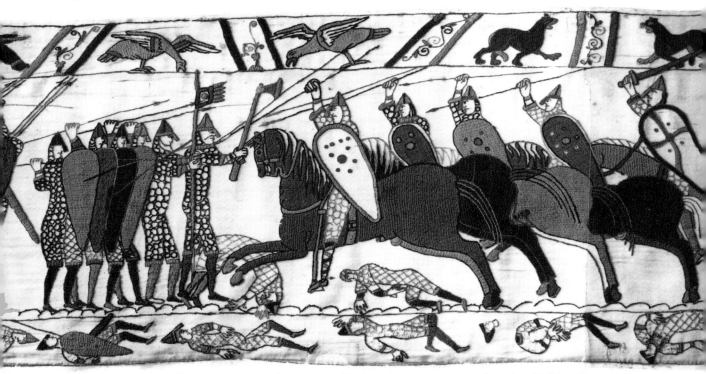

LXII The English suffer losses, some of whom tumble into the lower margin, but the shield-wall holds.

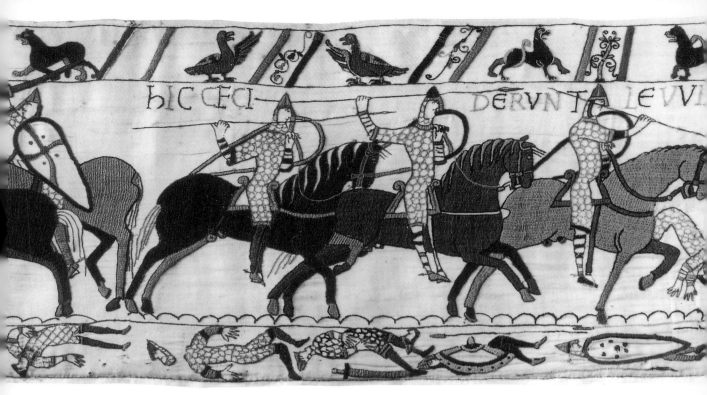

LXIII HERE FELL LEOFWINE

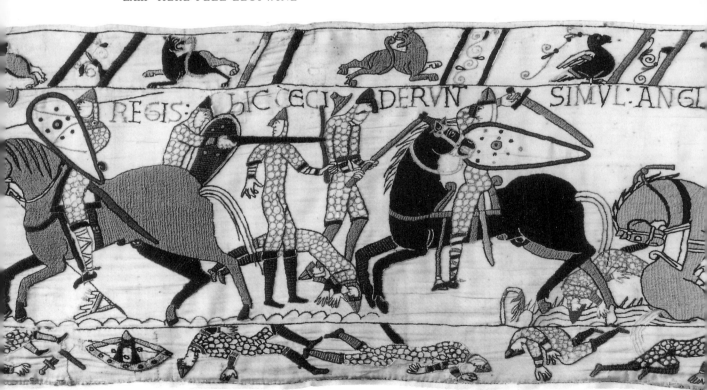

LXV HERE ENGLISH: The battle gets more brutal, with the English inflicting heavy damage.

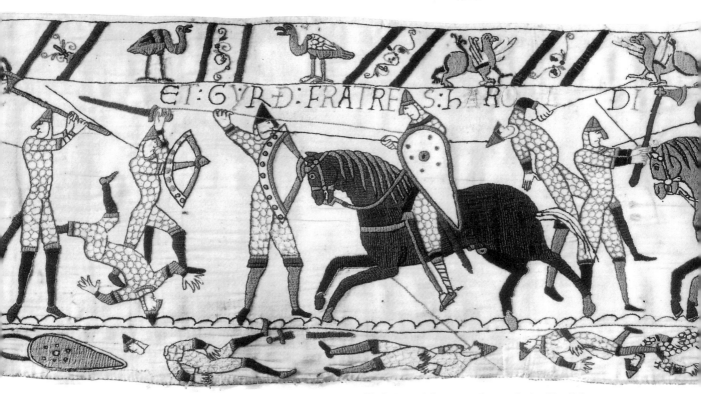

LXIV AND GYRTH, BROTHERS OF KING HAROLD: Fighting with axe and sword, the English suffer losses, including two of Harold's brothers.

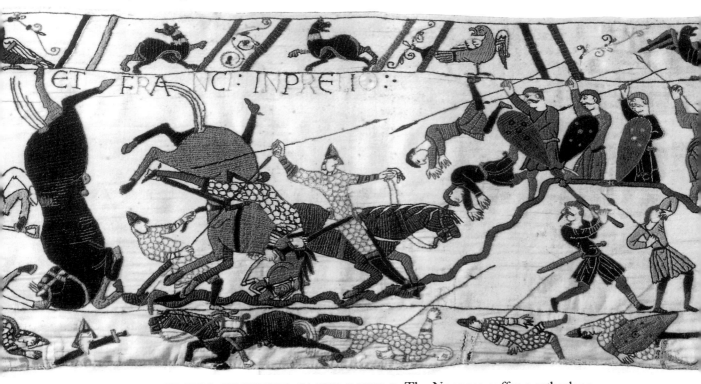

LXVI AND FRENCH FELL TOGETHER IN THE BATTLE: The Normans suffer a setback as their horses tumble; the Saxons fight valiantly, one even daring to grab a saddle girth while a knight rides overhead. Saxons on a hill are attacked and bear heavy losses.

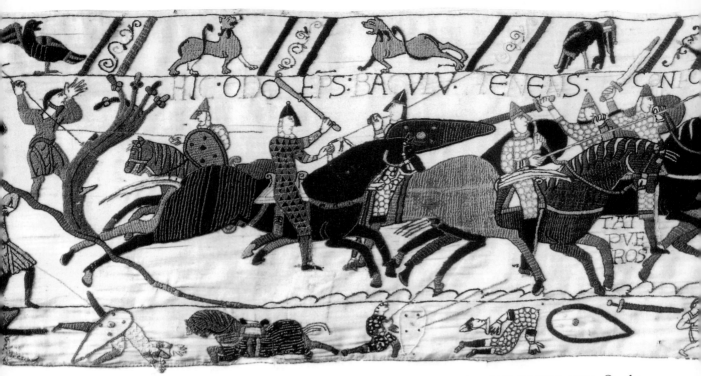

LXVII HERE BISHOP ODO, HOLDING A BATON, CHEERS ON THE YOUNG MEN: On the left, Bishop Odo helps turn the tide of battle by cheering on the young warriors.

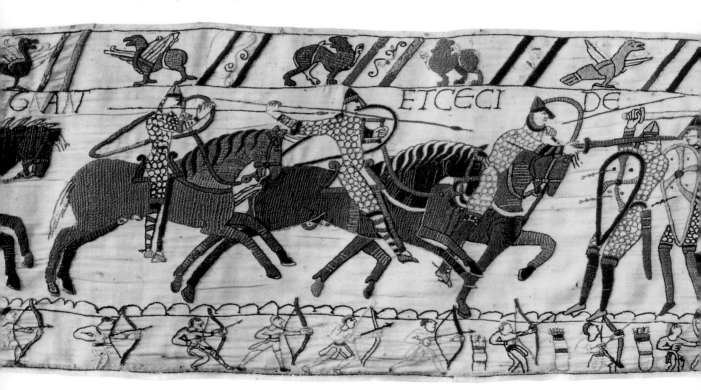

LXIX HERE THE FRENCH FIGHT: The cavalry resumes the attack, supported by archers in the lower margin who aim high in the air.

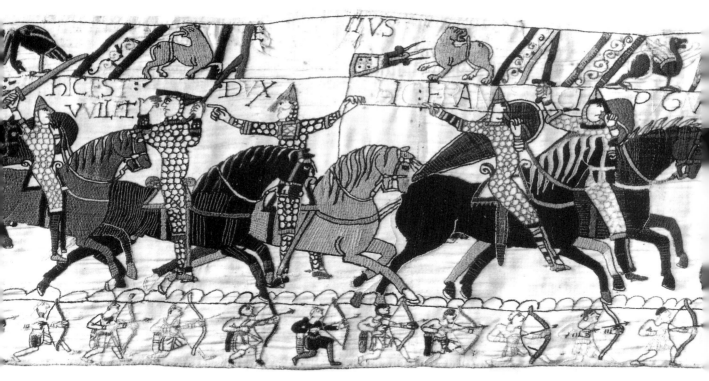

LXVIII HERE IS DUKE WILLIAM: William lifts the visor of his helmet to dispel the rumour that he has been killed, while EUSTACE of Boulogne points to him.

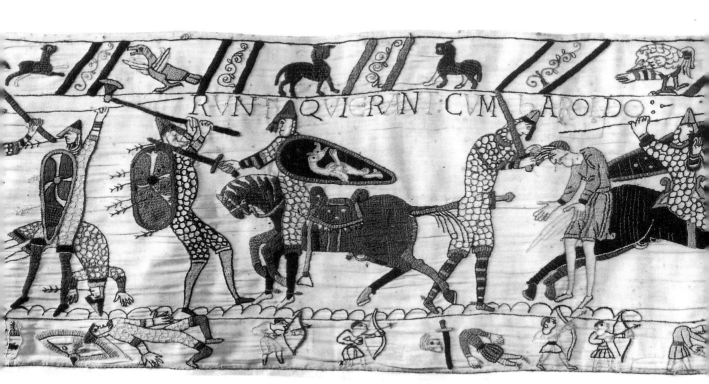

LXX AND THOSE WHO WERE WITH HAROLD FELL: Harold's bodyguard falls.

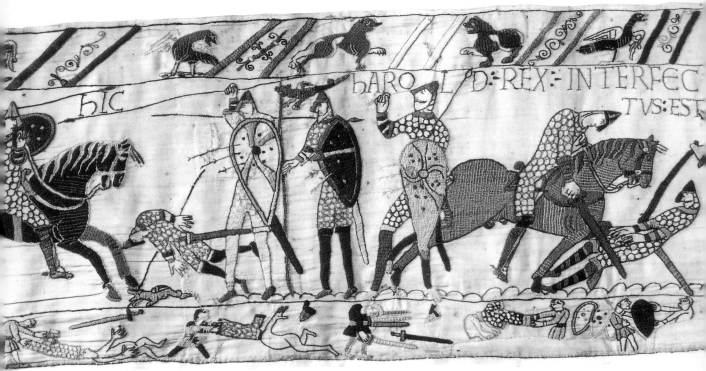

LXXI HERE KING HAROLD WAS KILLED: The climax of the battle. The king's dragon standard is crushed under a horse's hoof and Harold is struck down, probably first by an arrow to his head and subsequently by a mounted knight who slashes his thigh. Looting of the dead takes place below.

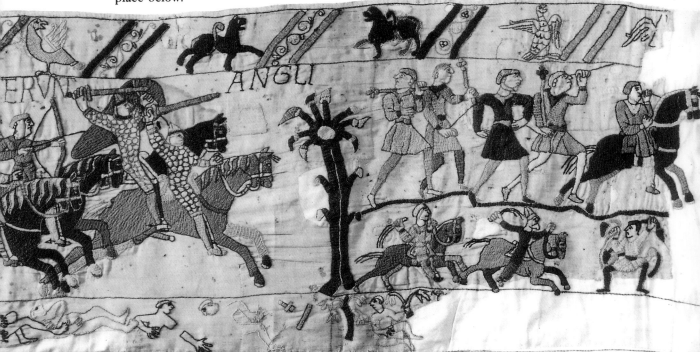

LXXIII With the king's death resistance crumbles: AND THE ENGLISH TURNED IN FLIGHT. Here the Tapestry's story breaks off.

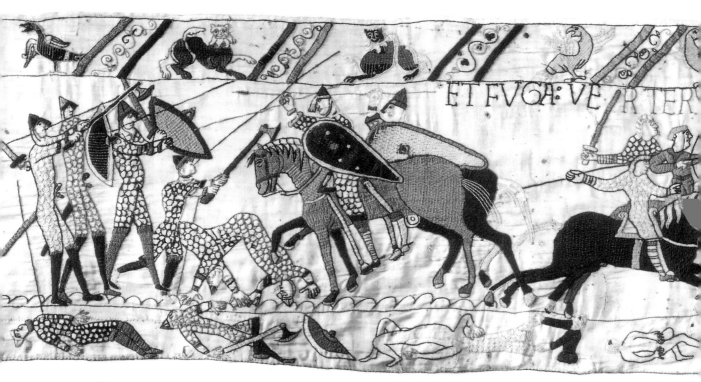

ET FVGA VE RTER[O]

LXXII Norman success is shown here, as when William defeated Conan earlier in the Tapestry, by an attack from both left and right.

PICTURE
ACKNOWLEDGEMENTS

The following sources are gratefully acknowledged for the pictures reproduced here: 62, M. Alix; 21, © William Urry (1967), by permission of The Athlone Press; 72, James Austin; 110, Archivio Salmer, Barcelona; 89, Museu d'Art de Catalunya, Barcelona; 44, 88, photographs by M. Corbière, courtesy of Inventaire Général en Basse-Normandie; 2, 6, 7, 10, 11, 13, 17, 28, 32, 33, 34, 42, 43, 46, 57, 58, 66, 70, 71, 73, 74, 75, 76, 77, 78, 79, 80, 81, 82, 84, 85, 86, 87, 96, 103, I–LXXIII, Centre Guillaume le Conquérant, Bayeux, by special permission of the town of Bayeux; 3, 4, 5, 8, 12, 14, 16, 19, 22, 24, 26, 27, 29, 35, 36, 37, 38, 39, 40, 41, 45, 48, 50, 53, 90, 91, 94, British Library; 18, The Master and Fellows of Corpus Christi College, Cambridge; 15, The Master and Fellows of Trinity College, Cambridge; 69, 92, 93, Cambridge University Library; 67, 68, from M. Parisse, *The Bayeux Tapestry*, 1983, published by Éditions Denoël; 60, Niedersachsisches Landes-verwaltungsamt, Hanover; 64, A.F. Kersting; 97, His Grace the Archbishop of Canterbury and the Trustees of Lambeth Palace Library; 101, Colegiata S. Isidoro, León; 55, 56, 63, Mansell Collection; 65, drawing by Dr Barnett Miller; 107, 109, 111, Pierpont Morgan Library, New York; 47, cover drawing by Rea Irvin, © 1944, 1972, *The New Yorker Magazine*, Inc.; 83, Northamptonshire Record Office; 52, Kunstindustrimuseet, Oslo; 51, Universitets Samling av Nordiski Oldsaker, Oslo; 49, 54, Bodleian Library, Oxford; 31, 98, 105, 106, 108, Bibliothèque Nationale, Paris; map on page 12, after F.M. Stenton, *The Bayeux Tapestry*, 1965, published by Phaidon; 1, reproduced by permission of *Punch*; 25, 61, 102, Biblioteca Apostolica Vaticana, Rome; 20, Bibliothèque Municipale, Rouen; 99, 100, Archivum Capitulare, Urgell; 9, 23, Bibliotheek der Rijksuniversiteit, Utrecht; 104, Biblioteca Universitaria, Valladolid.

INDEX

Note: Manuscripts are indexed where possible by commonly used name and, in all cases, by town where currently located.

Index